THE ART of INTERFERENCE

We do not explain pictures: we explain remarks about pictures – or rather, we explain pictures only in so far as we have considered them under some verbal description or specification.

Michael Baxandall, *Patterns of Intention: On the Historical Explanation of Pictures*

What is the criterion of the visual experience? – The criterion? What do you suppose?

Ludwig Wittgenstein, *Philosophical Investigations*

Emblem is immeasurable.

Emily Dickinson

THE ART of INTERFERENCE

Stressed Readings in Verbal and Visual Texts

Mary Ann Caws

Princeton University Press

Princeton, New Jersey

Published by Princeton University Press,
41 William Street, Princeton, New Jersey 08540

Library of Congress Cataloging-in-Publication Data
Caws, Mary Ann .
The art of interference.
Bibliography: p.
1. Arts. 2. Ut pictura poesis (Aesthetics)
3. Literature—Philosophy. I. Title.
NX175.C38 1989 700 88-34981
ISBN 0-691-06839-9

Printed in Great Britain

For Patrick, Kit, and Gerhard

Contents

FIRST WORD: HOW MANY DOES it TAKE to INTERFERE?

A prefatory remark is in order about the pictures in, and not in, this book, and the one on the cover. How do you choose them, when you are allowed only a fixed number, and which chapters do you illustrate more fully? Are some pictorial statements more important than others, more capable of verbal transmission? (Not that you ever believed in perfect correspondence, of course.)

Apart from the arbitrary and the accidental – those happenings of invention and possibility, of moment, place, and the subsequent page – some other ironies seem worth commenting upon briefly. That, in this meditation on showing and telling, the telling should have had to stand often for the showing, to put such an accent on the implicit scene instead of the explicit one, is sufficiently problematic; but that, specifically, in this book, the chapter on book illustrations should be precisely the one unillustrated, because it is about one reader's memory, should delight a Dada streak in some readers, and will irritate a solemn streak in some others. My own stubbornly unsolemn streak took its own vast amusement in three incidents: I could not figure out at first why the two Boccioni *States of Mind* studies I had decided to use – one to illustrate futurist motion anxiety (*Those Who Leave*) and the other to illustrate romantico–symbolist dragging melancholy (*Those Who Stay*) as they were received in England from the Museum of Modern Art in New York, and then sent back to me in New York, both looked extraordinarily nervous, full of horizontal and diagonal and spinning lines. Consequently, the contrast between them I had tried to draw out at some length seemed out of place, whereas the *Stay* version of the mental states as I remembered it had been marked precisely by a vertical rain-like pattern, upon which I had commented and even quoted Boccioni's own reflections. I saw no vertical lines at all, and

began to distrust most heartily verb, vision, and my own judgement in looking and writing. The true ending of the story is a nice one: the wrong picture had been made, it turned out, because the number on the negative had been read backwards, giving the matter a textual slant I couldn't have dreamed up. *Those Who Stay* had simply stayed in New York all along.

As for current art, I had intended all along to include one of Arakawa's "blank" works, about which I had written – but another picture was sent by the artist as more current still. Yet I mourned the loss of any visual representation of his essential concept of *Blank*, and, through a last-minute rescue by Jacques Dupin and the Galerie Lelong, and with the kind permission of Arakawa, we are using, after all, the appropriate picture: *Forming or Becoming Blank*. But the crowning or at least most colorful irony attaches to the cover. We hesitated over whether, in a book called *The Art of Interference*, one should place the whole picture of *Susanna and the Elders*, or just Susanna, precisely as Ruskin didn't see, or pretended not to see, her. Can interference be implicit, or did we need an elder to do it obviously? How many elders does it take to make the interference visible?

Stressed reading has its own stresses between the visual and the verbal, however their interference is performed, and they are not without their humor.

ACKNOWLEDGEMENTS and NOTE on TRANSLATIONS

Several of these chapters were written in response to invitations for inter-disciplinary lectures: I am grateful for all those opportunities to try out the matter, and the form.

I want to thank, in particular, my colleagues and students at the Graduate School of the City University of New York for their counsel, argument, and patience through the working-out of these essays. I would also like to thank Pip Hurd, Ginny Stroud-Lewis, and Ruth Bowden for their patience and immense helpfulness.

Some of this work was done under the auspices of the National Endowment for the Humanities and the Research Foundation of the City University of New York.

Permissions granted by the following are gratefully acknowledged here: Arakawa and Gins, for the quotations from their work and the painting *Performing or Becoming Blank*: the latter was supplied by the Galerie Lelong, thanks to Jacques Dupin. Yves Bonnefoy, for the quotations from his poems, and for his friendly perspicacity, Ian Hamilton Finlay, for permission to reproduce his "Dryad" and "Shellcade" from *Wartime Garden*. The Archives of American Art, for the quotations from Joseph Cornell's unpublished diaries; Editions Fata Morgana, for an illustration from *Ça suit son cours*, Edmond Jabès and Tapiès. Editions Gallimard for the quotations from André Breton, René Char, Paul Eluard, Edmond Jabès, and Jacques Dupin, and for two pages from Lionel Ray, *La métamorphose du biographe suivi de La Parole Possible*; Alfred A. Knopf and Random House, Inc., and Faber and Faber, Ltd, for "Peter Quince at the Clavier," by Wallace Stevens, and the "Musée des Beaux Arts" by W. H. Auden; New Directions Publishing Corporation, and Carcanet Press, for "A Formal Design," "Landscape with the Fall of

Icarus," "The Hunters in the Snow," "The Parable of the Blind," "Hay-making," and "The Corn Harvest," from William Carlos Williams, *Collected Poems*, Vol. II, 1939–1962. © 1954, 1955, 1960, 1960, by William Carlos Williams; New Directions, for a selection from *A Draft of Shadows*, © 1979 by Octavio Paz and Eliot Weinberger; Viking Penguin, for selections from *Self-Portrait in a Convex Mirror* by John Ashbery, © 1972, 1973, 1974, 1975.

I also wish to thank the copyright holders who have given their kind permission to reprint various contributions of mine which appeared in other publications, and now appear as chapters or parts of chapters in this volume. Full acknowledgement is given at the opening of each chapter concerned.

All translations are mine, unless otherwise stated.

Part I
INTRODUCTION

1

DIALOGUE and STRESS, ARREST and INTERFERENCE

In order to see certain things, what should we believe about them?

T. J. Clark[1]

Thinking pictures, talking pictures, and the stress of it all

Michael Baxandall points out in his *Patterns of Intention*[2] that our description of pictures is usually the representation of our thinking about seeing those pictures. It is a rather "untidy and lively affair": there arise all manner of problems about addresses, relations, and involvement.

For this book, which may indeed be an untidy affair but at the same time aims to be lively, the problematics of address and translation of ideas and forms, of relation and involvement, lead to a reading situation I am calling *stressful, a term I insist upon taking as positive*. "Stress" I mean first, of course, in the sense of a certain anxiety relating to the projects both of comparison and of the expression of that comparison: to *relate* occasions stress. Secondly, as in metric stress, it is an accent placed on certain details in particular, sometimes in a recurring pattern. Lastly, there is the stress of a "stressed" metal, where the trying moment proves some sort of endurance. Such stress is indeed *trying*, since, in its translation from one domain to the next, the accent and the positive energy discharged by the problematics of address encounter each other in a struggle at once vivifying, vitalizing, and agonistic.

So, for Baxandall, talking about pictures is already talking about thought about pictures. He explains how discourse about pictures has been evolving constantly – from the time of Vasari, when the reader could be counted on to have a generic acquaintance with the art work, through to the present, in which the extent to which the general public can be expected to know the work is a good deal less certain. Our whole approach seems to have altered, from the calmly *descriptive* (of an object not at hand) toward the *ostensive*, in which we can show as well as tell, thanks, in part, to technological advance.[3] Baxandall gives the example of a dog in a picture we are showing as we speak

of it: if I say something about its bigness, that must mean it is an interestingly big dog. The word "dog" points verbally, and the interest lies in the *big*. In dialogue with the picture, both proportion and detail[4] count, as much as our speaking to others about it; if we are showing, then the telling takes on, necessarily, a different tone.

The direction in which Baxandall takes his example is as fitting to the circumstances of this book as I can picture it. I shall be trying to see what is interesting about the bigness of the visible dog, as it is perceived by all of us, and also as it is commented on by other texts: of course, this may be a different bigness, but that is part of what the interest is about, and certainly a large part of what is struggled through, and – again – addressed.

Interference, interruption, and desire

The mutual interference of two objects, a visual and a verbal one, involves a dialogue, which the reader or observer enters into and sponsors, and which with other dialogues forms part of a more general conversation. Mikhail Bakhtin's essays in *The Dialogic Imagination* emphasize the development of dialogue as ongoing and active ("Only that which is itself developing can comprehend development as a process"[5]). A living dialogue, he says, is "directly, blatantly, oriented towards future answer-words,"[6] and in the novel, that most dialogic of genres, the dialogic essence deepens in the double-voicedness of prose.

Here, however, I am addressing another genre – interchange of the visual and the verbal – where a different side of Bakhtin's theories comes into play. The visual–verbal set-up has no fewer complications than the novelistic genre, and is no less involved in the representation of itself as the object of representation. This very intertwining of roles within the language of art and text is in large part responsible for the dynamic charge attaching to it and to everything connected with it – what I am calling stress, in the double sense of the accentuation of rhythm, of scansion in our reading, and of the heavy emphasis on certain parts – and the passionate, even anxious, sense we have and give of our own vital inclusion in the process of the reading. Roland Barthes's eroticization of the text, in all its, and our, pleasure, is something not to be returned from innocently.[7]

Gadamer's position on dialogue as that hermeneutical conversation we have with another person's way of looking at the text and our own, is particularly relevant here. In this trans-subjective event, we are "caught in" or "get into" a discussion, and are borne along by the subject matter in a buoyancy of game-playing, a giving of ourselves over to the conversation in a generous going beyond our ordinary limits of perception.[8]

To the dialogic impulse, as explained by Bakhtin ("two meanings parceled out between two separate voices") and developed by the French philosopher

Francis Jacques (especially in his *Dialogiques: recherches logiques sur le dialogue*[9]), there attaches a certain amount of anxiety, of which the brighter side might be called desire, of the other for the other. In that dialogic or interlocutive relation, the I constitutes itself in speaking intersubjectively, so that always "I exist as the other for the other." In that oppositional point of view, with each side enriching the other – for added *interest*, in the economics of relations – and at the same time itself in a cyclical accumulation, there enters, unavoidably, the high and classic stress of embarrassment and interruption, that of the visual object by the verbal, and vice versa, and that of my gaze or reading stare, in turn, by another.

A brief comment on several terms. First, in relation to *intersubjectivity*, I would extend the concept of two-person dialogue to that of a wider-angled conversation, in the sense in which Richard Rorty has dramatically developed it, and emphasize, along with the anxiety of it, exchange, sharing, and community of seeing.[10] Paradoxically, I shall be dealing with community mainly in chapter 9: "Ladies Shot and Painted: Female Embodiment in Surrealist Art." And in that same chapter I take up, briefly, the distinction made by Norman Bryson between the sorts of looking and arrest, the Glance and the Gaze. This is relevant to the entire book, but particularly to chapter 17, on the attack perpetrated against the onlooker by Buñuel's *Andalusian Dog*, and chapter 3 ("Representing Bodies . . ."), which is dominated by the elliptical look, the suppression on one side and the excess on the other. ("Technically," says Bryson, "each stroke of the painting must align itself, as it is being made, according to that vertical orchestration of the Gaze; the stroke's temporality is there, in the aorist and the future of the Gaze, and never in the deictic present of practice, of the body: the body itself is that which our painting always erases." And, later: "The flickering, ungovernable mobility of the Glance strikes at the very roots of rationalism . . . since all it can take in is the fragment. . . . Against the Gaze, the Glance proposes desire. . . ."[11]) The erotics of the double text, verbal and visual, is here a matter of double pleasure, Barthes redoubled.

Along with Bryson's discussion of the essential copy and the readings of representational erasure, one of the very best investigations of reference and "reality," of knowing and not knowing in this domain, of the problematics of semiosis in the interartistic connection, is Wendy Steiner's in *The Colors of Rhetoric*.[12] Here she takes up arguments by Sol Worth and Alpers about how paintings can or can't say "is not," in addition to "is," and about tone of voice as inexpressible in painting. Her optimism about double readings is convincing, and her subtle renderings of Brueghel and Williams are referred to in chapter 14 ("A Double Reading by Design").

There is no doubt in my mind that my readings of surrealism are often colored by my reading of my colleague Rosalind Krauss and by the courses we have offered on that topic and on the theory of representation: her book *The Originality of the Avant-Garde and Other Modernist Myths* and her study of

the photography of surrealism[13] provide the finest available discussions of surrealist art and of contemporary theory, particularly as regards their relation to the problem of representation.

Secondly, *interruption*, as I shall use the term, is something positive: it works towards openness and struggles against the system as closure, undoing categories. This is how David Silverman and Brian Torode define it in their study *The Material World*,[14] and the sense in which Ed Cohen uses it in his analysis of Victorian pornography as it refracts and "interrupts" the assumptions of the dominant culture of that time.[15] Similarly, I see interruption as a positive force against dry historicism and a squishy subjective impressionism.

I want to combine that sense of interruption and the concept of the dialogue of desire with what W. J. T. Mitchell says of the confrontation with the other in the domain of contemporary ekphrasis.[16] Mitchell takes up, and takes on, Wallace Stevens's "Anecdote of a Jar," that unpicturing, unassuming jar both "gray and bare," situated modestly on that little hill in Tennessee as the contemporary equivalent of, of course, the Keatsian urn, but also of the shields of Achilles and Aeneas, as it enacts "the power of the ekphrastic image as intransigent Other to the poetic voice, its role as a 'black hole' in the text." Mitchell argues that the power betrays a gender relation, and all his examples, like the Medusa head, are those of a female other to the male observer, like himself.

> One might argue, in fact, that female otherness is an overdetermined feature in a genre that tends to describe an object of visual pleasure and fascination from a masculine perspective. Since visual representations are generally marked as feminine (passive, silent, beautiful) in contrast to the masculine poetic voice, the metaphor goes both ways: the woman is "pretty as a picture," but the picture is also pretty as a woman.

(What happens, indeed, when the artist *is* a woman?)

Mitchell's brilliant argument includes a lyrical description of the stages of ambivalence with which we all confront the mixture of visual and verbal – among them, "ekphrastic hope" (that we will see it and picture it efficaciously) and "ekphrastic fear" (equally, of the seeing itself, a fear of literality). We must, he says, complete a working-through of these stages, and he holds out a "key," which I in my turn transcribe:

> Perhaps the key to our ambivalence about ekphrasis is simply that it transfers into the realm of literary art sublimated versions of our ambivalence about social Others. Ekphrastic hope and fear express our anxieties about merging with the other. Ekphrastic indifference maintains itself in the face of disquieting signs that ekphrasis may be far from trivial and that, if it is only a sham or illusion, it is one which, like ideology itself, must be worked through.[17]

Finally, on *desire*, Susan Stewart's extraordinary essays on the eccentric in its relation to the desiring mind (*On Longing*[18]) reveal the extent to which we all desire to collect, to enclose, and to keep safe. I have kept all I could, in relation to the containing places of Joseph Cornell and his shadow boxes, those ideal locations of the mind, which seem to render thinking present.

Problematics of distance, containment, and response

In his chapter on the author and the character in *Estética de la creación verbal* (*Aesthetics of Verbal Creation*), Bakhtin brings up the ticklish issues of distance – as in aesthetic distance – and outsideness, of creative reciprocity between the character as read in the text and the reader, who enters into responsive dialogue with, not the author, but the character interior to the writing. He first insists on the exteriority of the observing to the observed:

> The actor creates esthetically by managing to create *from outside* and constitutes that image of the hero to which he will later give a personality, when he creates it as a totality and not in isolation, as a moment of the totality of the drama; that is, the actor creates the author in the moment of being, or then the co-author. . . .
>
> . . . a naive spectator used to be able to take a stable position *outside* of the hero . . . and was able to profit from the privilege of that *exterior* position, helping the hero when he seemed out of strength. That is a correct position with respect to the hero. The problem arises from there not being an equally firm position to take *outside* of the totality of the represented happening. . . .[19]

It is progressively harder to take up any position outside the picturing process and find firm ground, or to take one up within the representation and have it based on any understanding – neither in nor out, but rather both, deconstructively, would be the most probable response to the working-through enterprise that this book is, or means to be. It desires itself to be passionately engaged in the complicated enterprise of seeing and reading and writing, often through the eyes and texts of others, an enterprise in which the problem of response deepens in its unresolved state.

Fredric Jameson's *Political Unconscious* studies the ways in which our interpretive codes work out their "strategies of containment" of other codes, to have themselves seem "somehow complete and self-sufficient."[20] He finds narrative to be the "central function or *instance* of the human mind," so that the analysis of narrative is what counts most of all, in history and in thought. The narrative that concerns us here is that set up between two bodies of representing materials, one visual, one verbal. The narration is that of the observer, and it is often in high stress, in competition with the narrations of other observers, reading against reading, testing response against response.

Many of the later points in this book had their origin in a startled realization that in fact the power of the text written about a work of art – say, a poem by Stevens on Tintoretto, a poem by Char on Courbet, or a prose poem by Ruskin on Turner, in no way less poetic than the Stevens and the Char – was such that the text, commenting, demanded to control the angle from which the observer/reader was to read. I was equally startled to realize that my reaction was, had always been, unquestioning in regard to that demand. What is struggled through here is a group of problems circling about demand, compliance or refusal, about seeing and reading as both coming after each other, as well as before; about stressed reading and passionate response, about ongoing interference and double desire, about the hopes both of continuing and of non-containment.

The essays here are meant, unlike the boxes of Joseph Cornell discussed in chapter 16, to situate themselves in the modes of dialogue, interruption, and exchange, with their borders often unmarked and blurred, their angles interfering with each other. They do not concern *reciprocal containment* so much as *doubled contemplation* and the reactions that result from it, arguably the point of all this. "I will start where I hope not to end. . . .[21]

"Being so caught up", or translation's other

A sure and classic moment of arrest appears in the center of Yeats's great poem "Leda and the Swan," after the foreseen death of Agamemnon, and the dead space of stasis before the lifting of Leda and the letting her go, that final and dreadful fall from indifference, from the lack of the other's passion into nothingness or at the very least uncertainty:

> A shudder in the loins engenders there
> The broken wall, the burning roof and tower
> And Agamemnon dead.
> Being so caught up,
> So mastered by the brute blood of the air,
> Did she put on his knowledge with his power
> Before the indifferent beak could let her drop?[22]

She was, by the other's mastery, surely a being caught up, sharing or not in his passion: therein lies the political problem of the epoch. The *arrest* in the poem is the catch in the whole thing: the moment is marked as very empty or very full, depending on who is caught up by what, or whom. The detail of the arrest is both illustrative and disturbing, making the same sort of bulge in the text as will be, precisely, *taken up* in chapters 3, 19, and 20, concerning ellipsis as it is heavy on one side and falls short on the other. The examples used therein, of Breton's concentration upon one glove, empty since handless and repeated, and Freud's upon the Moses of Michelangelo, with his finger in his beard and

the knob on the tablets upside-down in his hand, should be read as referring back to the notion of arrest, of holding, of catching up in their own obsessional passion. They make a noticeable *bulge* in the text.

As for the specificity of the obstacle which *arrests* the eye and the mind, Neil Hertz[23] convincingly argues that the eighteenth-century terms "baffle," "check," "astonishment", and "difficulty" are equivalent to what we call "blockage," which he relates (as does Angus Fletcher in *Allegory*) to the *turning-round* of the mind as in a religious conversion, while the mind takes pleasure in the very difficulty of the thing. Here the "mixture of pleasure and pain" sets up the true askesis which lies at the base of the "intellectual tension" I have chosen to call stress.

But the translation of or into another's passion is, at the very least, problematic. This is interference at its most stressful, its most thorny. Tintoretto's rendering of Leda and the Swan, with its graceful and implicating swerves, captures the gaze in quite a different way from Michelangelo's intense and intimate treatment of the subject, where wing takes obvious possession of thigh, seen in close-up. A contemporary French rendering of the Yeats poem by Yves Bonnefoy[24] does several remarkable things, among them doubling the initial "A sudden blow" into both shock and wind ("Le heurt d'un vent"), and through homophony stressing the relation of interactive capture between the superbly ambivalent victimized but participating "she" (*elle*) and the "wing" (*aile*), both active and in stasis ("the great wings beating still") – just as the implied *wind* and the stated *wing* resound together in English. Most remarkable of all, the very swan – this *cygne* evocative of *signe* ever since Mallarmé and his swan sonnet ("Le vierge, le vivace, le bel aujourd'hui") – is in French subsumed, somehow, under the simple title "Léda," as if indeed the notion of the sign were made redundant with such a statement of passion, of *being caught up*; as if Bonnefoy were to *dé-signer* his, Yeats's, our Leda. She, then, is *entitled*.

Let that be emblematic of the arrest made by some signal in the poem or the work of art: some seeing with which we are complicitous, as in the elders staring at Susanna; or some presumed or ironic overlooking, yet another purloined peeping, as in Ruskin's claimed ignoring of that same Susanna. In such problems of double reference or *interfering*[25] we are all *caught up*, if we choose so to be.

2

LITERAL or LIBERAL: TRANSLATING PERCEPTION

It does what works of art have always done – externalizing a way of viewing the world, expressing the interior of a cultural period, offering itself as a mirror to catch the conscience of our kings.

Arthur Danto[1]

Language in its transport: reading institutions

Marc Shell, in his *Money, Language, and Thought*, points out the limits of our institutions of philosophy and criticism, given our more than complex relation to economy, exchange, and coinage, particularly in America.[2] Our money complex and our frequent refusal or incapacity to separate the interrelations of coin and paper, cash and symbol, investment and expenditure, are themselves bound up with our production of writing and our theatricalized productions of textual interpretation, with our reading and our perception of all the former. To expand on this thought, then, could we not imagine that what we institute in our thought and speech, and are likely to have instituted, is bound and limited, even as what we think we are defending nationally is the freedom of thinking and discoursing against what would bind and censor?

Any even cursory examination of what it is to *exchange* words about X or to *exchange* views about Y requires hard thought about what it is to *exchange*, period. How do we invest in what we give out, and how do we get it back? In kind, or differently moneyed? And, more crucial to the topic into which I am about to make a foolhardy plunge, is there such a thing as free exchange? And, if so, what is it worth?

How do we perceive worth anyway? What relation does such perception of the invisible system of the initially visible coinage of exchange bear to present visual perception, and then to seeing? And what does perception matter

This essay was first published in *Critical Inquiry*, vol. 13 (Autumn 1986).

anyway, in relation to writing, reading, and exchanging words? Which is primary?

All these questions – in their institutional setting, or then in their freedom from context – can themselves be related to and gathered up into the notion of *translation*, or the carrying over from one side to, and into, another. All we can learn about speaking and the ways it is taught, reading and the ways we learn it, seeing and the ways it teaches us, is translated and transported from the side of production to the side of sign and vice versa, from sight and its constraints and choices to language and its own. How we read both is itself a subject of choice and constraint, of freedom and explicit value-placing, of variety and fidelity to certain ends.

Literal and liberal, closer up

The De Gustibus column of the *New York Times* for December 7, 1985, began with this paragraph: "An unscientific survey of 26 people proves that the vast majority prefer smooth mashed potatoes to those with lumps. Only four of those asked said they liked lumps and only one gave a rational explanation. 'With lumps,' she said, 'I know they are real.'"[3] This might be taken as the perfect example of the difference between literal and liberal, and of its ambivalent irony: perfectly mashed and processed potatoes along literal lines will not have lumps, for they – prepared with blenders, food processors, and mixers – are thoroughly mashed and depersonalized, whereas liberally mashed potatoes – prepared with a simple fork – show a few lumps of imperfection. As to which is the perfect translation of the mashed potato in its essential truth, the lumpers and the antilumpers disagree. The proof of the potato is in its eating, the truth of the translation is in its reading.

In his book *The Gift: Imagination and the Erotic Life of Property*, Lewis Hyde discusses at length the formation, coherence, and endurance of a group when its property circulates as a gift and the fragmentation of that group when the gift exchange is interrupted by "the conversion of gifts to commodities." He uses Lévi-Strauss's example of southern France, where in some modest restaurants each diner, from the individual bottle of wine placed before him, serves the person to his side, who then serves him. By this exchange there is resolved the "state of tension between the norm of privacy and the fact of community."[4] It is in fact a liberal exchange in which there is reciprocation of like for like, not a literal one, such as handing over a token for a plate of those famous mashed potatoes. Now, these metaphors of commodity, translation, and circulation apply to the work we all do in conveying meaning as we see it, freely and in free process of exchange – with some lumps in, with some difference to make visible the real substance of the thing. A little difference permits a lot of conviction about the exchange. Or, then, in conveying the letter of the meaning, no lumps are permitted; we say the conveyance is literal

and gets exactly what it bargained for. Here the well-rounded potato has been exchanged for a heap of undifferentiated substance about which all one can say is: it is exactly opposite to what it began as, while containing exactly the same.

But is there not also some difference between the expression of mashed potatoes and the perception of them? We taste or see the result, but the process is already in the past by that time. To perceive the mashing of potatoes is another thing entirely from perceiving the mashed potato – and yet reader-reception theory continues to put the stress on how we read that mashed-up mess.

E. L. Doctorow, in his "False Documents," contrasts two sorts of language: regime language, societal, institutional, or heavily coded, such as that of the *New York Times*, and free or anti-institutional language, such as that of James Joyce.[5] Insofar as our institutions for the traditional practice of the humanities set limits on the *avant* of our avant-garde in America, these two languages will always remain in necessary conflict, and would even if Joyce were taught and received in beginning English classes. Recent critics' vocal, troubling, and often convincing post-structuralist and post-modern undoing of binary pairs touches explicitly or by implication on this conflict between the institutionally guaranteed or controlled and the liberal or free, even "loose." The matter is complicated in the visual domain by the conflict between figurative and abstract, the former being, in principle, as controlled by its obvious referent as the latter is left open to interpretation; it is complicated in the moral domain by the fact that individual perception does not, for example, impinge upon community freedom the way that crying "fire" would in a crowded theater. But the stress or the accent falls upon the difference to which we can never restore exact equivalence, and upon a celebrated undecidability we should rejoice in, both as visual and verbal interpreters and as translators of the visual and the verbal. A flourishing ambiguity in the translation of ideas and precepts permits certain ways of fitting the verbal or visual garment to the thoughtful idea – the loose and the tight – and betrays the uncertainties rife in any interpretive work. Literal or liberal or hovering between them, our decisions about the perceptual translations that we are bound to make and called upon to defend, about our setting of what we see to what we write and say, and about the interpretations we fence them about with matter most gravely. What the art of seeing teaches, the art of saying has to convey, and (sometimes) vice versa.

Now slippage is bound to occur between right and left, tied and free, referential and open, faithful and liberal, even between meanings consumed and those consumable but as yet untouched. It always occurs between anything known or yet to be known and cognitive methods, and it can only be deplored or then, more positively, passed on as self-irony lest the perceptive translator take far too seriously not the translating mission – serious indeed – but the translating self. Insofar as all teachers and students, readers and

viewers and colleagues convey something to some understanding, freely or sparsely, as they are open or constrained – depending on their views of and talents for exchange – none is exempt from the general title of translator. We translators then are the complicated, complexed, and often troubled mediators of a certain knowledge and value, but in an attitude far from certain of itself. Literal and/or abstract; faithful and/or generous to text and to self; stingy with interpretation or liberal. Already, yet again, the attitude to either/ or patterns in their mutual exclusivity or in their mutual reinforcement depends on our overall attitude toward mediation and translation – even more, perhaps, on our attitude toward perception.

It might well be that the second part of my title, "Translating Perception," is just what might be called a hull. Roger Shattuck, following Coleridge, defines that rhetorical device as the confrontation of two incompatible thoughts connected by an unformulated sensation but with only the appearance and the feeling of sense.[6] In any case, the double sense of my expression is already perceptibly perturbing, in its deliberate and even arch self-reference: (how) can one translate perception, and/or (how) can one have a translating sort of perception? At stake here are the essential translatability of looking or perceiving and the no less essential perceptibility of how one brings over and through or translates, as well as the function of interrelations. In both titular cases and in their interweaving in the single expression "translating perception," the perception of what is to be valued and communicated – to be translated, transmitted, and transformed – influences the conception of how the perceiving is to be done. Performance depends on perception, and here translation is its mode. Values must find performance, or perish; the performance of translation in its literal and liberal senses is what I here perceive as the point of the discussion.

I will be pleading for a translation whose value consists in its very hesitation between what is perceived and what is transferred as the value of that perception – its use value but also its real thickness in the sense of Clifford Geertz's use of the term (taking everything around the event and its transcription together with it into the narration) and in the sense that poetry is thick (*dichten*: condensing its own account of itself). Lingering over the sense, wavering between several interpretations of the initial perception and how to convey them all, we are already participating in poetic thickness even as we translate into conveyed values what might have been seen as simple fact, what might have been perceived as closed. We want to transfer more than any single *a* to single and simple *b*. Wittgenstein's forcing of the *move* we have to make and take into account might serve as our beginning in thinking about perception and about translation as transference and performance.

Imagine you were starting from a language-game with physical objects – and then it was said, from now on *sensations* are going to be named too. Wouldn't that be as if first there were talk of transferring possessions

and then suddenly of transferring joy in possession or pride in possession? Don't we have to learn something new here? Something new, which we call "transferring" too.[7]

The very joy we take in believing we *hold* what we name, possess what we see and understand, depends on how we see. The universe, said André Breton, depends on our possibility of enunciation.[8] We may renounce all our possessions, of course, but not our perception and preferably not our linguistic richness, probably our truest power.

A classic example of perception will serve to translate one version of this issue. The observer is shown a cup in which one-half of the measure is taken up with liquid, and is asked how the cup is to be seen, as half-full or half-empty: the response "half-full" is usually thought to indicate optimism, whereas "half-empty" reveals a depressive, pessimistic outlook. That is to say, the response is translated into what the psychologist thinks he sees that we see. Naming is already performing in our value system: we need to put a *hold* in our performance.

In relation to our perception of that cup and its celebrated classic measure, we have to hold both halves, welcoming the hesitation over such a critical decision. To get more in it and out of it, we want to say that it is both half-empty *and* half-full, and that we perceive it as such, that it must be translated literally and liberally as both, for nothing is decidable about it. Authority plays no role here, and cannot rule; as in many of the examples we live by and test by, the two possibilities held together make the sort of "shimmer" Doctorow describes in "False Documents," speaking of criminal trials and their un-decidability except by arbitrary means: "And the trial shimmers forever with just that perplexing ambiguity characteristic of a true novel."[9] I want to point to the word "shimmer" and to keep it in our consciousness. The judgment we make reflects, in this and in every case, on our own value structure and how free-tempered liberal or how rib-sticking literal it may be. This, in the visual realm (How do we read this image? What does that say of our own perceptive habits and our perceptual possibilities?) as well as the verbal (What does this word mean? How to carry it over, and how is the equivalent equivalent?).

Verdicts: seeing and saying

If we are well-meaning, we mean what we say to be – or at least to sound – true. But, until the verdict (the saying-true) is in, all we can have is the words. The meaning, as Wittgenstein tried so hard to teach us, is the use, and we use liberally and literally, generously and skimpily, our saying and our seeing, depending already on how we represent to ourselves the reading institutions we live in and the canonizing museums and textbooks we teach others to inhabit. Wanting the best, we train ourselves in seeing and saying what we

already value and taking truth from there, rather than from some other ground where it would have its ideal and absolute origin. We can only verify by *seeing* as an intransitive verb, opening out into unlimited inner space. Wittgenstein discusses the English phrase of practicality and scientific experiment "verifying by inspection," finding it external and preferring to it the general and simple "seeing by seeing" in its indefinite internality.[10] I am reminded of Tristan Tzara in his "Note on Art" of 1917, railing against the linguistic straitjacket of verbal descriptions of visual art: "Understanding, seeing. Describing a flower: relative poetry more or less paper flower. Seeing."[11]

And in every case – whatever decision we make, including our possible decision to undecide, to let be, to hold at least two readings in tension – the fragment we are taking as paradigmatic of our attitude, liberal or literal, can itself be read, in Shattuck's terminology, as absolute (sufficient unto itself), implicate (part of a larger structure), or ambiguous (perceived as both).[12] By the branching method of always preferring a double function to a single one, and by analogy of our holding two meanings, I would take this discussion to be an ambiguous fragment, both absolute and implicate – and so on, in loops and continuous branches. Each stopping point – nodal or pressure points I will return to – can be seen, like that half-empty half-full glass, to be a catastrophe of indecision or then a contradiction serving as a *relay* into another mode. "I should like to ask," says Wittgenstein, "not so much 'What must we do to avoid a contradiction?' as 'What ought we to do if we have arrived at a contradiction?'"[13] Now could we not take this arrival at a sensitive or wavering point, this hesitation moment (contradictum, or the saying against), as a *hinge* on which to articulate our further speech performance?

Slowing down our decisions – putting them on *hold* makes room, temporal and spatial, for the thickening or poeticizing of our perception and our perceptive *performance*. Here Wittgenstein's experiments in some of the passages of his *Zettel* teach us about multiple perception, ellipsis, and hinging, as well as about seeing and saying. He speaks of "entering the picture,"[14] and indeed his tricks try out our picture as our thought. They can be linguistic, conceptual, and perceptual, probing us to try them at their nodal or branching points. Ambivalence is assumed. It is as if the imagination were suddenly to be stretched: "Suppose someone were to say; 'Imagine this butterfly exactly as it is, but ugly instead of beautiful'?!"[15] The transfer we are called upon to make includes a *slippage in perception*, the stretching not just of the imagination, but of the transfer point: we see where he delays, and just there forces us to rush, to keep our strongest consciousness of rhythm: "It is as if I were told: 'Here is a chair. Can you see it clearly? – Good – now translate it into French!'"[16]

The aim of free seeing would be a flexibility of function able to accommodate images both ordinary and askew, straight or with perceptual shifts, and to translate them liberally into nourishment for new ways of seeing.

Shattuck offers, with his *Innocent Eye*, two more examples, opposite in structure yet parallel in their way of confronting cliché images by new formulations. Considering, as he does, that the tortoise and the hare are the same animal, but moving at different speeds, he stands a standard riddle on its ear. Later he suggests that Meyer Schapiro's view of Van Gogh's *Crows over the Wheat Field* of 1890, where Schapiro sees the crows advancing toward the foreground, is incorrect and simplistic, since the crows are ambivalent in their direction, or, more probably, move away toward the horizon.[17] Thus he forces us by a detail to look again at both the images, the first conceptual (the hare and tortoise), the second visual (the crows). It is the very demand to look again that matters, not what we look at or how we see.

But all too often the linear structure from which contemporary readers have learned, more or less easily, to tear themselves away in the reading of texts seems to retain its traditional hypnotic effect on our perception. In *About Looking*, John Berger diagrams the distinction between the way photographs are usually used, as conveying one message or moving in one direction:

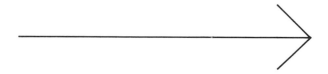

and the way we remember, radially, with a great number of associations pertaining to one event:[18]

The experiments he calls for the reader to make are based on repetition – for example, comparing three photographs of men in black suits (a group of field laborers, of musicians, and of intellectuals), then, for each, covering the faces or the bodies in order to see the distinction in the fitting or misfitting of the costume, the effect of presentation, and the cause of the effect by class and profession. It is, he intimates and then proves, by looking *again* that we learn to see.

Not just to see photographs, of course. Translating his own perception over a period of time into an example, he shows two ways of looking at an artistic object, using in this case the Grünewald altarpiece in Colmar, which he saw in 1963 and again in 1973. The first time, he states, he saw the Crucifixion as the

key to the whole altarpiece, with disease as its own explanation: for a sick world, the need to paint the life of a loved Christ, to portray "the *felt* anatomy of pain."[19] Implicit in this observation, he later says, is the conviction that the very survival of the work of art indicates the possibility of a current overview – one in which, for example, former reactions to art are seen as "theirs," as being embedded in history, whereas our own are seen as being free from that history. "The surviving work of art then seems to confirm our superior position. The aim of its survival was us."[20] But at the second sight of the altarpiece in 1973, after the failure of the revolutionary feeling of 1968, he sees himself as included in this history from which formerly he had felt himself to be free. About his first sighting, with its implications of our freedom, he now says, "This is illusion. There is no exemption from history. The first time I saw the Grünewald I was anxious to place *it* historically. In terms of medieval religion, the plague, medicine, the Lazar house. Now I have been forced to place myself historically."[21]

As part of that second sight, he sees the altarpiece unhinged, with the Crucifixion opening out first on the Annunciation and the Resurrection on the opposite sides, and then opening out once more on the life of St Anthony and the apostles. So reseeing is associated not only with moral as well as aesthetic qualities, with a will to openness along with a refusal of self-excuse and private exemptions, but also with a sharper formal perception – the painting is now seen to be made up of spaces of articulated light set against unarticulated patches of darkness. This observation is itself an enlarging and more inclusive one, morally as well as aesthetically, and the branching continues once more, corollary with the unhinging of the once closed piece, now doubly opened out.

Seeing anything twice means reorienting the vision as well as the object seen and ourselves in relation to it. Once we try to think, like the Quechua Indians, of ourselves as moving not forward in time but backward, with our faces to the past we know about, the future invisible behind us, we add a dimension to our imagination as to our motion.[22] Like the tortoise and the hare reseen and revalued, we can be conceived of as the same persons, moving in two opposed directions, conflicted like Van Gogh's crows also reseen, or like the observer of those crows (Schapiro and his conflicts, as Shattuck points out). Hinging, unhinging, or freeing our ways of perceiving, we translate or transform ourselves from our literal and linear equations (this equals this, $A = B$) and open out into complications, oppositions, and rich ambivalence. This sudden energizing of our perception is what we must, I think, translate into use value. But with a difference.

Energizing perception

Having the freedom of our perceptual conviction would mean the ability at once to challenge institutional presentations and individual visions and to

invent our own fictions of seeing. It just well might be that through those fictions, translated into active seeing, we would learn to perceive afresh – against the ruts and linear literality of worn-out codes and clichés – and then bring that fictive perception into life. André Breton, in the heroic time of surrealism, insisted we should try to see the horses galloping on tomatoes, for then they would; beyond these trivial pursuits lay a land of rich fertility in imaginative fiction and in real becoming. As we speak, so is our world, said the surrealists, or, as we see, so it is.

And, on the other side, we want to learn not just to imagine and spin enabling stories, but also to speak and to see, to render vivid and receive as vivid. Heidegger's conception of *presencing* was never more present than in our histories of self-inclusive process. They are not – any more than deconstruction is – impoverishing and trivial pursuits but rather enriching discourses. We have to revalue both our perceptive renderings and our conceptual and perceptual translations. How a text means, as well as how it is perceived, has to be seen as reading beyond the simplistic one-to-one translations we have all known.

Let me take for my example three brief statements which by their very nature bridge the two fields of the visual and the verbal. The captions Berger places unobtrusively in the texts accompanying his photographic studies are attached to three very different sets of pictures in essays of 1972, 1978, and 1979 (about, respectively, Paul Strand's photographs, Courbet's *Burial at Ornans*, and August Sander's photographs). In each case the statement, made by the persons pictured, affirms or translates correspondence of images into reality. What you are looking at is true. I am true. And insofar as you look, you are also assured in your truth of observation. This initial sureness of equivalence is, perhaps, the first step in the intelligent energizing of perception as it is presented here, by implication.

"*I am as you see me*," says the first caption, of 1972.[23] It is italicized and calls attention to being and to seeing. Along with its existential emphasis, "I am," it brings in also the observer, the action of observing, and the translation of reception into supposed equivalence: "as you see me." The present of existence and observation leaves no room for doubt or for the slippage of identity into confusion. What you see is true: the repetitions build toward the very assurance they literally repeat.

"*This is how we appear*," says the second caption, of 1978.[24] Beginning with the deictic pointer "this," the statement demonstrates a present of presentation and a manner of reading the self in the collective. The "I" has given way to a "we" to be read in its appearance, without any truth being assured. The accent falls upon the "how," free of any "what" or "why" or "observer" or even "seeing." Our passionate need for looking at process is never better translated than here, in all its presencing and presentness, its "thisness." *This* is revalued as it is reseen in process, made thick.

"*I looked like this*," says the final caption, of 1979.[25] Here the deixis is final,

or end-pointed, and inserted into history, into the past and its own assurance. No matter how you see or read me, this is how I gave myself to be seen. Seen in historical light, the picture so verbalized leaves no space for question.

Tracing the three statements in this way – as they are dated not just by the objects they refer to but by their author, who puts these words in the mouths of his own subjects – the reader-become-observer sees herself move from presence and assurance of the correspondence of being to sight ("I am as you see me"); on to the present of presentation and process ("This is how we appear") which makes no assurance about being or about seeing, only about appearing; and finally to the past of history and a reassurance about the thisness of the photographic rendering, reinserted into the truth, if not of being, then at least of perception ("I looked like this"). The motion goes from being (I am) to appearing (we appear, I looked) as the reader moves backward into history, looking forward at the past.

A newly perceptual energy comes from such comparisons of texts and images, undoing the simple and the linear by a cross-cutting of periods and images and conceptions. This is, I would maintain, another way of perceiving or translating translation.

Re-translating translation

In a recent play on how we perceive translation, the contributors to the volume *Difference in Translation*, centered around the translational work of Jacques Derrida, do the job of undoing the myth of fidelity as the requirement of having one language pass into another nuptially, as it were. In "Taking Fidelity Philosophically," Barbara Johnson assures us that the current crises in marriage and in translation are identical from one point of view. "It almost seems as though the stereo, the Betamax, and the Xerox have taken over the duty of faithfulness in reproduction, leaving the texts and the sexes with nothing to do but disseminate."[26] And again, concerning Derrida: "It seems, in retrospect," as she puts it, "as though literary criticism in the United States had long been on the lookout for someone to be unfaithful with. All signs seem to indicate that, in some strata, it has chosen Derrida, perhaps because he is such a good letter writer."[27] Language existing "in the space of its own foreignness to itself" is the basis she posits as that of infidelity, turning around the pressure points of most difficulty, or most violent opposition, through which Derrida works out the "love–hate relation *between* letter and spirit, which is already a problem of translation within the *original* text."[28] Translation renders fruitful the pressure on the key points of difficulty – those pressure points that call attention to the materiality of text – and struggles successfully against the naive belief of "truth" or "innocence" in translation: "The translator must fight just as hard against the desire to be innocent as against what we today consider the guilty desire to master the text's

message."[29] She recommends, along with Lautréamont, that we who long to cross not cross over: " 'Vous, qui passez sur ce pont, n'y allez pas.' 'You who are crossing over this bridge, don't get to the other side.' "[30]

Held in tension, then, the bridge of translation makes for a new perception of what we must perceive and not do. In the same volume Philip Lewis takes "The Measure of Translation Effects," remarking on the privilege pointed out by Derrida that we have always given to the *use*-system of the *us*ual, the *use*ful, and common linguistic *us*age. "To accredit the use-values is inevitably to opt for what domesticates or familiarizes a message at the expense of whatever might upset or force or abuse language and thought, might seek after the unthought or unthinkable in the unsaid or unsayable."[31] Conflicted by the impossibility of *pure* rendering, the translator turns coat or turns commentator. Lewis comments,

> For commentary to supplement the translation is perhaps first to add to it, to correct it, simply to contest its recuperations by exposing them; but ultimately that move, if it is not to acquiesce to the very discursive order of the translation that it questions, *turns* into a replacement of the translation. So let us add, in all the senses of an elliptical phrase: commentary supplies the translation by doing other than translation. In the wake of translation, the mission of commentary is to translate in difference.[32]

So the urge here and the point of my commentary about translation is not to resolve into one way of doing, showing, translating, but rather to rejoice in the difficulties. To concentrate on the nodal points, to force the pressure points, to unthink the already thought: this was, now we remember, the program also of the surrealists. Retranslating the world, they remade vision and the world besides. Deconstructive optimism has been all too often translated and perceived as destructive pessimism. Not wanting to reach the other side of the bridge reveals a struggle against linear progression, to be sure, but an equal desire for the imaginative suppleness that holding teaches.

Now the stress on verbal or translational pressure points – that which calls for the violence of the translator, abusing as she goes – is, as has been pointed out, the parallel of a device in the visual realm which retards the too facile reading of the surface. One of the most usual examples of such deliberately hard to read visual objects is Holbein's *The Ambassadors*, with its globe to be interpreted anamorphically as a skull. Such holding devices, as we can think of them, are elaborate versions of what Michael Riffaterre has, as it were, copyrighted with the *device* of dual signs, as he calls them; they permit us to hold in abeyance the meaning in order to see the process.

In another context, I have studied the notion of the *delay* and of the *retard*: our collective consciousness actively retards our reading, in which we resolve not to resolve.[33] We keep thereby a presentness to perception, even in the throes of faithful infidelity, wanting not to translate as we go, but as we go

nowhere. We cross over in dressing, but not in bridging; we linger over knots in reading visual and verbal texts, knowing lingering to be fruitful; and we long not for resolution but for the energy to delay. Here again, Wittgenstein supplies an exemplary knot, paradigmatic of the shimmer between perception, representation, and translation:

> What about these two sentences: "This sheet is red" and "This sheet is the colour called 'red' in English"? Do they both say *the same*?
>
> Doesn't that depend on what the criterion is for a colour's being called "red" in English?[34]

This is, too, like being forced to walk backward instead of forward in time – and like not closing off a verdict. Translation of the fruitful kind is never finished, no more than is thought.

Teaching about *re*-viewing is surely a collective moral task, shared in by many of our best contemporary critics of perception, whether they refer back, as Arthur Danto does, to Rembrandt's rendering of Saskia and to Duchamp's of a shovel, or, as Shattuck does, to John Ruskin's "innocence of the eye," or, as Berger does, to the photographs of Sander and of Strand as well as the altarpiece of Grünewald, or, as Lewis and Johnson do, to Derridean knots of abusive and transforming translation. This teaching is moral in that it reinterprets traditional readings and the limits of judgment, placing value where it finds it most fruitful and pleading against what has been too easily thought and read. It is deeply moral in its networking of collective intelligence and questioning, of problematic rethinking. It is more deeply moral still in its delay: deconstruction, opposing the linear and the consumption of arrival, *gives us time*.

Field for thought

I want to close by summoning a borrowed image, that of the field on which Berger closes his essays *About Looking*. Visual though it is, it can become a field for thought by a stretch of the imagination – exactly what I want to plead for, liberalizing the most literal expression, the "stretch of land." I am choosing this image as located in relation to such works as Guy Davenport's *Geography of the Imagination*, and in response to – all the while to some extent including – Leo Steinberg's post-modernist flatbed, that printing press stood up on end to give us culture after nature. Those canvases ordered for our perspective in Berger's field can be seen as horizontal bedding. This field which I borrow to end on and in is textual: we get right down to it, this field of vision.

Painted in words of green and yellow and blue, what Berger addresses in his invocation to the field is more than the field of sight, or even of thought. It is field and shelf, paper and print and yet nature, it answers the sun with a

cuckoo sound and yet, holding the jars of pleasure, it is above all intimate, and – though the word does not occur here – immensely present. "Field that I have always known, I am lying raised up on one elbow wondering whether in any direction I can see beyond where you stop."[35] But, and this is the moral I want to insist on, in closing with Berger's image as my text, the field is only lain in when the level crossing is closed, and it becomes then the space of a minute or two wait. "It is as though these minutes fill a certain area of time which exactly fits the spatial area of the field. Time and space conjoin."[36] In this space, events occur – the space is in fact one of waiting.

Yet what is not said in this essay is what matters – for this field of vision, where what happens can be clearly seen and strangely felt, this textual field in which our energies may be newly charged, this field, containing not just a two-minute individual *retard* but an epic and collective delay, is made, most marvelously, to *open out* and in, like the Grünewald altarpiece opening on its hinges, like the textual knot yielding up its unfaithful and violently pure fruit, like the most unfamiliar coincidence in the field of our experience. Berger's own opening-out of the field of sight bears reflecting on, as it is at once literal, precise, and detailed – that field and no other – and yet the most liberal space for vision. In its utter coincidence with what it awaits, it is a perfect translation of what our verbal, visual, and living perception might be at its most free, in process. If I call on its expansive value as being what I least think criticism can afford to lose, if I judge it to be poetry, it will be understood that I am calling upon a field to translate a language, a field to render a vision, a field as what perception could finally teach us:

> At first I referred to the field as a space awaiting events; now I refer to it as an event in itself. . . . Suddenly an experience . . . opens in its centre and gives birth to a happiness which is instantly recognisable as your own.
>
> The field that you are standing before appears to have the same proportions as your own life.[37]

And the field — this one, permitting a wide-range vision together with a close-range experience, mixing event with experience – seems a perfect fit, vital and of real proportions, right for standing before and lying down in. It is the perfect example too of a translation by example literal and liberal, for along its length we can, finally, stretch out.

Part II
MOVEMENTS and SEEING

MODERNISM

3

REPRESENTING BODIES from MANNERISM to MODERNISM: CLOAKING, RE-MEMBERING, and the ELLIPTICAL EFFECT

It is disappointing, if I must lay myself naked here, to play with words, to take on the slowness of sentences. If no one reduces the nudity of what I say, stripping off the clothing and the form, I write in vain.

Georges Bataille, *Madame Edwarda*[1]

What we call "representation," as I would like to present and represent it here, is in some sense an embodiment of mannerism – highly *handled*, intensely styled and stylized. I shall speak of a language visual and verbal in its separation of body parts, and the parts of the body of language, as they are cut off and overvalued, as they are iconicized so that they can be finally re-membered. This aftercoming salute to the mannerist movement is also a salute to the modernist movement in its predecessors, the artists and writers implicitly or explicitly connected with it, and in its successors. The elliptical effect of which I shall speak in closing will be presented not as a solution to, but as a part of, modernist representation.

To *hand*le or *man*age – as in the *maniera* (from *manus*) or mannerist style –

This essay was first published, in abbreviated form, as "Gestures toward the Self: Representing the Body in Modernism. Cloaking, Re-Membering and the Elliptical Effect," in Monique Chefalor, Ricardo Quinones, and Albert Wachtel (eds), *Modernism: Challenges and Perspectives* (Urbana: University of Illinois Press, 1986), pp. 238–56.

and to style the parts of my presentation itself, I shall name them in order to get a grip upon them and upon the subject. This manner, highly coded and partially elliptical in itself, will aim finally at something beyond codes and beyond ellipsis.

What we present or state at first, we then re-present or restate constantly; the body represented is then already not seen for the first time. My general subject is double: how we represent the body and what the representing body represents, as an exemplary case of rereading modernist and mannerist signs.

Representing bodies

Let me pose an initial problem, involving the personal and the professional, and even the professorial, at once, insinuating itself into language which is also its starting point: we might consider it a circular metaphor. Suppose that a body of language is – in whatever language I happen to speak – not just a linguistic body or a language of the body, but a language still more problematic because self-representing and self-questioning, a language body set over against or written into or written on the body of the text, as well as the body of the languages already spoken in the preceding discourse about this representation, this representation already including parts of the so-called feminocentric corpus. There is then no way for me to speak of any representation of the body without at least implicitly including the representatives of a corpus who then become metonymic parts for the body entire, the elements already of a signifying system they might wish to refuse. Language is included and implied and roped into language about the body, and representing by language is already linked, by the inescapable chains of words, into the body of prior and present and future language events. The picture cannot be neutral or objective, being made up as it is of bodies and parts, of visual representations and linguistic presentation, of visual presentations and linguistic representations, in the same circular vice which is the worst of the bodily vices and not the least of the linguistic ones. Appearance is only part of the corpus of the problem, and discourse about representation, itself only partial, is equally vitiated.

But when we speak or write, inscribing the names we give and the lessons we take within a fleshly and corporeal corpus, the corpus of this text is then subject, as we know, to both deconstruction and decomposition as corpse, and this future possibility is what we are writing on as well as in, and against. All the reservations and caveats about what bodily representation is, and how it lasts and how it is decomposed, deconstructed, or undone, have to be built into our presenting of it.

Eyeing the body of the text

A text separated from its context is said to be disembodied; so we should perhaps be mindful in our practice, as in our theoretical talk, of our own vocabulary, as it itself is representative, and not just presentative. Representations, however secondary to first-time experience they are, or seem, teach us how we think about presence and its presentness to us.

In just such fashion, I shall try here to remember the master or overall picture in picturing part by part the textual body I cite, and shall try at the same time to maintain the pictural order, in which the entire scene remains included in the space of the eyes, a visual spectacle representing the verbal one or taking it in. Yet necessarily the scene I envisage is here and not here, and to speak of rendering an image as if it were simultaneously and identically represented to the self as to the other is already to overlook, paradoxically, the afterness of reading what is in the moment present before one. The speaking I is caught in a net suspended between two extremes – one, ideal, of cosmic prevision within individual sight, and the other, of cosmic absence within individual blindness.

The first or adequate vision is adequately represented in a sonnet by Hérédia, picturing a classical scene upon a high viewing terrace, where the whole history about to be written is framed for the hero in the space of the heroine's seeing:

> Tournant sa tête pâle entre ses cheveux bruns
> Vers celui qu'enivraient d'invincibles parfums,
> Elle tendit sa bouche et ses prunelles claires,
>
> Et sur elle courbé, l'ardent Imperator
> Vit dans ses larges yeux étoilés de points d'or
> Toute une mer immense où fuyaient des galères.
>
> (Turning her pale head with its dark hair
> Towards him, drunk with all-potent perfumes,
> She held out her mouth and her clear gaze,
>
> And over her, the ardent Emperor bending
> Saw in her wide eyes gold-flecked with stars
> A whole sea, immense, with galleys fleeing.)[2]

These ideal and historical–mythical eyes include the entire view: their function is adequate to their description. In just such a manner the separated and iconicized or fetish element can include the complete desire, projected into present history, of the one seeing, feeling, and taking the part for the whole, with some reason. This vision presents and represents presence.

At the opposite pole, the eyeing of the text may be limited by a shutting-off of vision into absence, by the black humor of non-sight for the sighted. I shall

only sight Georges Bataille's picture of the narrator's father in *Histoire de l'oeil* (*Story of the Eye*), an example of a text blinded for an insight never to be shared:

> Seeing nothing, the pupils of his eyes were lost in the night under his lids.
> ... Usually when he was urinating, they became almost white, with a lost expression; they had for their object only a world he alone could see, seeing which gave him an absent laugh.[3]

The laugh is all the more terrible in its double exclusion, of him from us, and of us from him: absence indeed.

In between these two visions, between what we ideally see as entire, in the eyes of another or in our own, and what cannot be seen except on the inside, is located the contemporary view of both icon and object, of the language body as reseen and re-viewed in modernism, up to the contemporary poets of L=A=N=G=U=A=G=E.

Having eyed the problem or handled it once over lightly, I shall, in discussing the technique of singling-out, begin with the bottom, or the feet, and work up once more to eyeing the basic text.

Michel Foucault makes an extraordinary intrusion into the interior of vision through a series of embeddings of the eye, which he calls "the figure of being in the act of transgressing its own limit," continuing in like manner,

> The eye, in a philosophy of reflection, derives from its capacity to observe the power of becoming always more interior to itself. Lying behind each eye that sees, there exists a more tenuous one, an eye so discreet and yet so agile that its all-powerful glance can be said to eat away at the flesh of its white globe; behind this particular eye, there exists another and, then, still others, each progressively more subtle until we arrive at an eye whose entire substance is nothing but the transparency of its vision.

But, more essentially, it leads back to the interior of the skull, illuminating it as absence, "nocturnal and starred." Thus his intricately baroque sensitivity itself illuminates the disquiet at the center of sight, so linked with death in the ultimate *vanitas*.[4]

What's afoot?

The twists and turns of poetic mannerism often taught already a concentration of details, a divisionism of the whole for the profit of the part. These teachings demonstrate at once how to read partially in order to read fully, and how to read designs, as well as how to read nakedness. Panofsky's study of the changing representation, in the Renaissance, of Truth and Simplicity as

Naked Woman by the side of the Ornamented Woman displayed either as Wickedness and Worldiness, respectively, or the exact contrary – the shifting back and forth, that is, from bare as true to bare as false – puts a good twist on it all.[5]

We read wholeness through the *blasons* of individual parts, in surrealism as we did in mannerism. If we read Breton's celebrated celebration of the woman-in-parts justly called "L'Union libre" ("Free Union"), we see yet another potential free union beside that of the parts into the whole, and of the would-be unconventional links of love in surrealism: that of the mannerist techniques with the surrealist, which I have commented on at length in my *Eye in the Text*.[6]

The portrait in "L'Union libre," having moved from head to foot, then makes a vertical return, so that the pictured conclusion is held in the woman's eyes as they encompass – like Cleopatra's holding the galleys and the future and the sea immense – all the elements of earth, air, fire, and water: "with eyes of earth level fire level air and water level." The ideal sight completes perception here, and the poem with it.

On the other hand, as it were, and moving once more from head to toe, we might ask what is the present literal sense of the exact modernist vision taken, as the expression goes, *au pied de la lettre*, to the very foot and heart of the letter? I have no urge to toe the orderly line of the proper representation, and will therefore begin by that majestic picture of the Big Toe which Bataille held up before us, and which Barthes again held up before him and before us. More modestly, let me suggest what is now at hand, or, better, what has been recently afoot – often as strange and as fragmentary as the frequent passages in Winckelmann in which he speaks with reverence of the feet of statues or of their navels.[7]

We might think, for example of Duchamp's Dada foot with flies – *Torture-morte* (1959), instead of *nature morte* (still life) – as indeed the foot of undead Dada. If I wander more frequently in surrealist fields with the other madmen, it is because of the intense lyricism indwelling those far from vertical descriptions of the single parts dwelt on by poets such as Desnos, whose unforgettable representation of the feet of women on the sidewalks of Paris in *La Liberté ou l'amour! (Freedom or Love!)*, or, elsewhere, of their ankles, is likely to last as long as any full-length portrait. Those sidewalks are worthy of celebration in great part because of his viewpoint, in no way lowly, however erotic; they carry the charge of all the stairs sung in so many of his passages, for the passage of feet.

Nor is he a master just of the picturing of female appendages; we owe also to him the trace on a staircase at break of day of the paws of some age-old sphinx, in a poem which builds toward their awaited arrival:

> So there is nothing astonishing about seeing the supple silhouette of the
> sphinx in the shadows of the stair. Its claws were scratching the freshly-

waxed steps. The glimmer of the doorbells by each door brightened the elevator cage . . . and suddenly the shadow grew pale.[8]

Here the minimal trace serves as a maximal *pièce de conviction*, a convincing element, in this surrealist dream of day, where the gleam of the smaller lights plays against the shadow, and its sudden paling at the apparition as if in fright. When this daydream, powerful beyond any simple and unsurrealist reverie, has re-entered the realm of the nocturnal dreams which will absorb it, the traces will be left in the soft fresh wax, like an imprint of a stylishly imaginative stylus.

So the sphinx, freed from the elevator cage, illuminated by all the tiny entrance lights at the doors behind which yet other imaginations are dreaming other dreams, rises fully to the occasion of this representation, modernist in kin while recalling the romanticist view – rises, however, by its nails only, and by their indexical trace.

Singling it out

From the minimal scratch of this poem on to Jacques Dupin's entire recent poem set in a nail scratch, or an *onglée*,[9] we sense the whole stride of contemporary poetry on its way, netting in its advance the strokes of Mallarmé, the tracks of the Fauves, the most daily of Apollinairean sounds and traces, one eyelash or one hair creating the universe of Artaud's obsessional Uccello, the portrait painter of Artaud himself, if there ever was one:

> do you see anything else besides the immense shadow of one hair? Of a hair like two forests, three nails, a herb-garden of eyelashes, like a rake in the grasses of the sky? . . . But two hairs next to each other, Uccello. The ideal line of hair untranslatably fine and twice repeated. . . . And in the circles of this idea you spin about eternally, and I chase after you, groping with the light of this tongue for a thread, this tongue which calls me from the depths of a miracled mouth. . . . At the distance of one hair you sway over a frightening abyss, from which you are forever separated.[10]

This major power of reading the all in a minimal space, after Antony so read in Cleopatra's eyes, this ability to focus on still less even than "la trace et la naissance d'un cil" ("the trace and the birth of an eyelash"), permits still now the bodily capture of a whole picture of our epoch within one black or red diagonal slash across a painting by Malevich, recaptured in Dupin's poem on him:

> Fatal
> comme en un glissement pur violent
> premier visage diagone

(Fatal
as in a pure violent slippage
first diagonal face)[11]

or then a landscape upon one fingernail, or one single scratch of another: "Une encoche / dans le buis / seule / signe" ("A nick / in the boxwood / lone / sign").[12] What is razor-sharp as long as it is lean and linear loses its incisive power if it stretches beyond that precision of the minimal: "Trahison de la ligne qui s'épaissit" ("Treason of the line thickening").[13]

As for the iconization of the minimal, I would like to suggest that it is not only as a metonymy or reminder of the thing as entire but also as a substitute or cover-up for something else that the writer or artist often presents or represents the object focused on. Why not, for instance, describe the whole body? The iconization of one single part is a refusal of the corpus seen entire as much as the classic picture of the surrealists in the forest, refusing to open their eyes upon the naked woman's body ("Je ne vois pas la [femme] nue cachée dans la forêt"), refuses to see what it is in principle about. So does the cloak hide, the nail leave no feminine trace, and the substitute act as cover-up. This is, I submit, a sort of advanced and cloaked puritanism, but also cloaked in all the dignity of the metonymic, the paradigm, the representative part. I show you this: you know I understand, have seen, am thinking of the rest.

Unconvinced, the reader ponders. What was it, for example, that Freud saw and did not tell in his own dream of Irma? Her hysteria, however strong a case could be made for it, surely provided a fertile source:

> I took her to the window and looked down her throat, and she showed signs of recalcitrance, like women with artificial dentures. I thought to myself that there was really no need for her to do that. – She then opened her mouth properly. . . . My friend Otto was now standing beside her as well, and my friend Leopold was percussing her through her bodice and saying; "She has a dull area low down on the left." He also indicated that a portion of the skin on the left shoulder was infiltrated. (I noticed this, just as he did, in spite of her dress.) . . . Not long before, when she was feeling unwell, my friend Otto had given her an injection of a preparation of propyl, propyls . . . propionic acid . . . trimethylamin (and I saw before me the formula for this printed in heavy type). . . . Injections of that sort ought not to be made so thoughtlessly.[14]

After dwelling on the connection with these chemicals and sexuality, Freud disarmingly states that he does not pretend to have adequately "uncovered the meaning of this dream or that its interpretation is without gap."[15] The cover still left over it, however thin, and the gap left within its interpretation are – although images opposed in appearance – indications of just the elliptical effect which is my topic here, concerning the representation of the body. The passages of greatest effect, of that sort or of any other, and of greatest readerly

interest are those where the excess covering and the lack of commentary meet, their bulge and their hollow interior forming an elliptical cover for the event, a noticeable protrusion in the text.

Freud has, as he says, and like all authors, no intention of telling all, and so of course we have figured it out with considerable ease; but my point is that his suggestion he is not suggesting is in fact so easy to figure out that he is already spelling out what we are supposed to be excited about by concentrating on what is exactly unexciting – for instance, the chemical formula he sees before him "in heavy type." The rest is in pretty heavy type too, sufficient for us to start thinking about what is surely more interesting for French and American as for Viennese readers: what is he shoving, after all, down our own throats? Or percussing through our dress, with all the bystanders about? Is he not quite simply intending us to read what, in principle, he does not intend us to read?

A shoe-in

That is the way it works with what we read into the body language we confront; is it not, for example, the way it works with feet? With ankles? With the skirts seen passing over those same Parisian sidewalks? To skirt the issue is already to cloak it, and the issue is this: what happens to representing bodies when all you get is the sound of some sphinxy feet? What happens, under the apron, to Simone's "real" naked body in Bataille's *Histoire de l'oeil*? To Marie's "real" naked body under her coat in his "Le Mort"? To Madame Edwarda's under her cape in *Madame Edwarda*? Or, more lyrical by far, to the naked body of Desnos's Louise Lame under her leopard-skin coat in *La Liberté ou l'amour!*, where the exclamation point at the end of the title points to just that bare flesh of the plot. The leopard lays down his coat with love at her door, but is she in?

Let me be visually explicit about absence and what fills it in. In looking at the advertisement, by Ecco shoewear, of a boy contemplating, as he lies on his stomach, the empty shoe of a woman, we may well ask: what is admired here? The woman? Certainly not. The absent leg, ankle, foot? Try out a few captions: "The Prodigal Son killing the fatted calf," or "Now that she is gone," or "Lady Lightfoot." The actual caption is simply "Ecco" – a pointer, saying just "Behold," or a deictic echoing "Ecco"? What exactly are we to behold? The mark of the shoe. No trace is left, no footprint even, of the dame who once filled it. We are left beholding emptiness.

Now, in the case of shoes, van Gogh painted two of them, whether they were for the same foot or not, whether for a peasant woman or just for Heidegger. Meyer Schapiro had in mind at least six shoes, van Gogh's and Heidegger's and Heidegger's peasant woman's, and Derrida had (elsewhere by that time) a good eight shoes, paired or not;[16] we latecoming readers of

those shoes now so many times relaced, knowing we should have all those elements together, have – I would submit – exactly two, the shoes van Gogh gave us in the first place. No woman and no peasant class exhausted and no brilliant readers are necessary to our own picturing of van Gogh's poetic painted shoes. Here a shoe is eloquent in itself.

And who has recently said anything about feet? First we see the elimination of the whole woman for the model, and then the model for the foot, and then the foot for the elegant covering or cloaking of that foot, of that model, of that woman. "The painter," said René Char in concluding his elusive "Artine," "has killed his model."[17] Does not art do that for the body? Who could have stepped into that shoe anyway? Or, in the case of van Gogh, those shoes? It is not only a question of class but also one of motive: the manufacturer makes, after all, with his *manus* or hand, his product – which is to say, us. Inscribed with his initials or his name, the shoes trot upon the Paris sidewalks with or without us or anything in them: it seems scarcely to matter.

Hélène Cixous, in *Le Troisième corps* (*The Third Body*) signals already, in one of her most powerful love scenes, the gestures of the foot as the sign of disappearance. The very gestures are lovingly caressed by the glance of the narrating woman, who is herself the self about to disappear and whose absence is contemplated – gestures all the more intensified by the contrast of her appropriative eyes taking in the man's form, and, within his eyes, the announcement she is making of that disappearance. That passage is, as we would expect, obsessively overstated and overlong, like that just quoted from Freud – these are so many *holds* on our reading.

> The left foot advancing, just as the right one is about to follow it, just grazes the floor with its tiptoe, while its sole and heel rise almost in a straight line. This disappearing movement in preparation holds us, seductively. Today distance lends beauty to our form as it is seen from further and further away. . . . Go on, slowly, no, stop, yes, go on, slowly now, further, further, ah I am causing your disappearance, you are growing larger, I can only see part of you, soon I see disappearance walking.[18]

The approach and drawing back of both figures, the rushes and the delays, the bird's-eye view and the close-up or the zoom – these cinematic techniques increase the paradoxical presence of the disappearance almost about to take place. When the view is seen as a whole, caught in a repetition ("That's what I am saying to T.t., then; my disappearance has the calm of someone not afraid to pass by"), the encapsulated summary manages in its staying power not to pass by, or on.

Fingering the text, or, what's in a handle?

Georg Simmel, in his famous essay "Der Henkel" ("The Handle"),[19] was not concerned with what we are handling here, not even with a light fingering of the text, but rather with the junction of function and beauty, of matter and the idea, of the pot and of its pouring, of what we call availability. How do we get a handle on our modernist handles for our visual and our verbal texts? How do we entitle ourselves to how they are titled, by word or image, inside or out – that is, to their self-pointers?

Before even looking at the hand, we might look at the indexical function of one part of it, that part most strongly gender-marked. In Michel Leiris's *Le Point cardinal* (*Cardinal Point*), a sudden gigantic plaster finger comes down from a crack in the ceiling to designate the central point in the room, the private parts of a sleeping woman at the middle of what is presented as vanishing point perspective: "drawing to itself the molecular whirlwinds and the light rays of perspective."[20] The finger remains pointing there longer than we would habitually stare, fixed in that "immutable direction": this pointer is inescapable, like any index finger of any pointing statue, in plaster, or René Magritte's pointing through a house in *Révélation du présent*. As another pointer, slightly more offensive, because it rather makes a gesture than a point, and a heavy bronze one, the sculptor César's large thumbnail makes a token statement about creation and how it puts the finishing touch or stroke on what is made and judged and thumbed over; such tokens serve as fetish objects whose text is easy to read, like the *bella mano* (beautiful hand) and the *caro guanto* (dear glove) themes in mannerist poetry, hand in glove.

At the opposite pole from, for example, de Chirico's glove, usually left empty (for example, *Enigma of a Day*) and open to interpretations which have been poured into it, the finger seems to designate something specific in the text or outside, designating, to the delight of the mannerists as to the modernists among us, the referral itself. It can be seen to relate to the hand as pointing relates to conscious creation, and so to the author's or the artist's own metapoetic view of the work. These representative and self-representative texts are often proud, and lyric sometimes, and occasionally both, as in Desnos's long and lyric soliloquy "The Night of Loveless Nights" (title in English), where the hands are attached to the body of the text and form an odd handpiece for dealing with it. I quote only a few lines of the many so exposed, beginning with the statement of the catalogue presented:

> Il y a des mains dans cette nuit de marais
> Une main blanche et qui est comme un personnage vivant
> . . .
> Mains abjectes qui tiennent un porte-plume
> O ma main toi aussi toi aussi
> Ma main avec tes lignes et pourtant c'est ainsi

. . .
Ah même ma main qui écrit
Un couteau! une arme! un outil!
Tout sauf écrire!
Du sang du sang!

(Hands in this marsh night
A white hand like a living person

. . .
Abject hands on a penholder
Oh my hand you too you too
My hand with all your lines and still so

. . .
Ah even my hand writing
A knife! a weapon! a tool!
Anything but writing
Blood blood!)[21]

The rapid alternation between the collective hand-play and the singular writing hand, as between the menace and the invitation ("Hand hot with love / Hand offered to love / Hand of justice hand of love"), and the drastic contrast in baroque colors – white hand against the red of blood and the black of ink – calls attention to the role, here glorified, of the masculine use of the revolutionary handling of the text of love as of justice.

The hand Desnos puts his accent upon is generally male: like Magritte's finger protruding from the roof of a house (*Révélation du présent*), or taking up all the room inside, a male member crowding in on, or breaking through, female domesticity, it designates even in its strangeness, and it insistently requires attention to what it points out: "Comme une main à l'instant de la mort et du naufrage se dresse comme les rayons du soleil couchant" ("As a hand at the instant of death and shipwreck rises like the rays of the setting sun"), knowing its signal to be situated at a crisis moment in time: "Il n'est plus temps, il n'est plus temps peut-être de me voir" ("There's no time now, no time now perhaps to see me").[22]

In strong opposition to Desnos's overstressing of the male hand in its presence, the female hand appears to Breton often a menace even in its absence, especially in its suggested trace. Panicked at the supposed acceptance of the teasing suggestion to a visitor that she leave her sky blue glove in the office of the "Centrale surréaliste," Breton assumes his fear to be related not only to this one glove, fragile in color and in kind, but also to the twinning that glove makes with another which the same lady – known only as "that lady" – threatens to bring in and leave, a glove of bronze. This potential heavy-handed gift, masculine in its threat, poses its bulk in the ponderous and noticeably awkward sentence describing it:

I don't know what I found so frightening and so marvelously decisive as
I thought of that glove leaving that hand forever. But the event did not
take on its real and complete importance for me until that lady suggested
she would come back and put on the table, just where I had so hoped she
would not leave the blue glove, a bronze glove she owned, and that I had
seen at her home since then: a lady's glove also, with its wrist inflected,
its thin fingers: I could never resist lifting it, always surprised as I was by
its weight, as it seemed to indicate exactly how much pressure it exerted
as it weighed on what the other would not have weighed on.[23]

Quite unlike the elegant, complicated, lyric prose usually recognizable as
Breton's style, this clumsy passage I take as all the more significant for what it
hides, as it weighs down the text by its obsessive force. Between these two
gloves, one present and one not, one overstated and one absent, any putative
and potential implicit handshake of agreement, understanding, and corres-
pondence has become a mere glove of itself, the empty outside gesture and
what it weighs on. Nothing weighs in it, but much weighs upon it, even
Nadja's vision of the hand flaming upon the water, for, if what we are accept-
ing is that the outside counts as the inside truth it sheathes, then is not the
representative cover of what represents – i.e. the glove on the hand, in its
sheathed or veiled pointing, in its designation as in its creative power – to be
taken as the true representation because it reveals?

We scarcely need another meditation on clothes as language, but perhaps
we should examine the covering or clothing gesture. If we accept the embrace
of two gloves, *en puissance*, as the signal of an embrace of minds because
symbolically an embrace of parts of bodies, how are we to read the embrace
of, say, two fingers of two gloves? And then, minimally, would not any one
finger of a glove suffice, whether or not it covered a "real" finger, to make a
pointing gesture? Would it suffice detached from the glove? What if we did
not recognize it, so detached: is a non-recognizable part of a recognized
emblematic representation of a handshake or a pointing gesture any less a part
of body language than two hands shaking, one finger pointing or, more
pointed still, that finger wagging waggishly?

The scratch as genre

The trace the finger leaves is its own genre: how minimal can a genre be,
defining itself still as a category? Must a genre contain something? Could it
function as the simplicity of unthickness so that it neither encloses nor states
anything other than itself?

I want to contend that the scratch – that paltry, parsimonious, and totally
proud sub-genre of the trace – represents the height of performance strategies,
the completion of a desire for thinness and the elegance of a streak, and, at the
same time (perhaps most important of all), the ultimate degree of violence

condensed. I want to defend this genre of the minimal against all encroach-
ments of the massive sort, against the intrusive thrust of logic and all the
modes of memory. I want to pretend, even, that this oddly satisfactory,
strangely subversive genre has given up toeing the already now epic line, has
forsaken, with some regret, the making of the precise point, to make, in the
wake of Derridean restyling, of a trace a triumph, in the lowly, sometimes
subliminal scratch.

Now, this trace of violence, this deliberately minimal murder, is, I think, far
more lethal than the deadliest wit. The classic expression of the latter, the
time-honored aphorism, conveys, after all, some message, however pithily,
and has been with us from times pre-modernist. As to whether this genre of
the "−" or the "/" is post-modernist *only*, or just also, I will forgo a position on
that, momentarily. It is, in any case, both passing and permanent. It bites into
the page, excising and incising, and is, perhaps in the long run (can post-
modernism have a long run?), as much a concept as a form, and therefore to be
refused by such contemporary thinkers and poets as would permit only the
formal upon their horizons. The genre I am speaking of is allied with the
ephemeral: indeed, Bonnefoy and Dupin (the last of the three poets I adduce
here as practitioners of this genre) collaborated in an extraordinary journal
called *L'Ephémère*, one of the main contributors to which was Giacometti.
There could, surely, be no figurative art more closely allied with the
minimality of the scratch, there could be no figures more ascetically on the
side of the thin, than Giacometti's. The journal, as one might expect, put itself
to an end, destined as it was to be ephemeral.

Ultimately, the scratch is both implicitly and explicitly the manifestation of
some violence done. It claws its way into our texts, and makes therein the
difference of difference. For it separates one side from another, protects one
boundary from the next − like a Derridean membrane − and proves past
action, with an elegance to which thicker genres have no access. This is what
the abyss has become: thick and sentimental. Not so the scratch. It is simple,
and deeply knowing. It knows what carved or traced it, and the likelihood of
how it will be read. It knows, because it has kept so very many secrets, how to
expose only the narrow, hinting only at the profound.

Now for the more purely minimal or the mere visual sign. Of the "−," as
joiner of two elements, or the "/," as separator of two elements, one could
simply say (and it should suffice) that they represent pure assimilation and
pure difference in their bringing together (−) and their dividing (/); that,
furthermore, even the joining element (−), holds apart, and that even the
dividing (/) assimilates. These are the signs of the perfect trace in its horizontal
and diagonal modes. Here follows, however, a brief discussion of the scratch
in its more imaged and verbal mode, as exemplified in the work of three
modern French poets: each uses it in a different fashion, each belongs to a
different school of thought, but a certain tone carries over.

Robert Desnos, one of the most extraordinary members of the surrealist

group before his expulsion by Breton, wrote a celebration of the dawn, that limit time between two times, as haunting as it is mysterious. "Désespoir du soleil" ("Despair of the Sun")[24] commences with a question, or an exclamation, retaining the ambivalence of a hesitation through having no punctuation attached to it: "Quel bruit étrange . . ." ("What a strange sound . . ."). The noise in its strangeness, with a force of attraction sufficient to summon the sphinx from the depths of the very desert, will never – of course – be defined, will only be questioned ("Le bruit quel était-il? quel était-il?" – "What was the sound? What was it?") and its contagious force of questioning will be such as to force the next question, about the heights and foundations of the staircase as the place of rise.

That to the interrogation there be no response made or even possible permits, precisely, the *dream* of day, ensuring the impossibility of that clarity the sun would bring. Such ambivalent art depends on the despair of the clear and the triumph of the improbable.

This poem is based on marvel: specifically, that the sphinx should come from ages past to the very present couch of the wandering lady (who frequents much of Desnos's imagination) is enough to set the reader afloat on the possibilities of dream, diurnal or nocturnal, come from ages past to the very present bed of the wanderer – the mysterious beast, androgynous by its nature, wandering to join the wanderer with her hair disheveled, tousled and thrown over her face, with her sheets wrinkled, from her night-time wandering (a dream of the night, now joining a dream of the day).

Established within the marvelous realm of the daytime dream, at the center of the longest, most breathless outpouring of the poem, is the place (ephemeral, by nature, and narrowly bordered, being just the width of the stair) for the minimal trace of potential violence on a surface politeness: "Le fauve égratignait de ses griffes les marches encaustiquées" ("The beast was scratching with its claws the waxed steps"). Now, the presentation of this momentary and high performance is dramatic in its essence: lights and shadows surround it, situated as it is on its ultimate rise. It combines, agile like its main actors, the active sphinx and the passive sleeper, literality and lyricism mingling, toward the bed (*lit*) of the sleeping wanderer (*vagabonde*), wanderer rising to mate with wanderer. The contrast with such high-rise scenes as that of Charlotte and the Prince meeting upon the stairs at the diplomatic ball in Henry James's *Golden Bowl* is symptomatic of the modernist performance as an exposure of plot, personality, and intention alongside the post-modernist performance, just the nail scratch of some sphinx on some stair. There is, or so I read it, no message about betrayal or about the rising plot itself, Jamesian in its swell – not even about the line of the plot, not even about line. The message is just about the passage and the trace, on those waxed boards of the rising stage.

It brings into itself all the ideas of passage from other reaches of Desnos texts: in *La Liberté ou l'amour!*, the passage of Louise Lame naked under her

leopard-skin coat, laid down before her after the leopard is smitten by love – thus, his enamoured tracks; or, in the same book, the fascination of the Corsair Sanglot for all the female ankles passing on the sidewalk over the Place de la Concorde. All these marks of passage accumulate in the tracks made so sensually and so centrally in this only partially despairing poem.

To continue the animal tracks, the scratch of a claw along the path of a poem, René Char's difficult and painful poem "Marmonnement" ("Murmuring") – a poem of strain and pursuit – centers around the hunt and chase implicit in the bare, unsheathed claw of the wolf or what the wolf signifies of violence and chase. Insofar as the poem (plate 3.1) states itself concerned with recognition, of the central scratch as trace, but cannot name the reality of the wolf or understand it, the violence is expressed in that very lack of co-incidence: invisibility and endurance struggle it out together, but the reader, making her own leap, is guaranteed no recognition, no understanding of any trace within the poem. The genre, I would maintain, here, is not the *poetic genre*; it is again simply the scratch the beast leaves behind, to be read.

The text of offense here coincides with the text of defense, the strategy of one with that of the other: if the reader has very much the feeling that the surface is scarcely scratched, the reason seems to be an innate preference on the part of contemporary poetry itself for suggestion over explanation.

Both poets to whom I have so far attributed the possibility of writing in the genre of the scratch, or of creating the space in which it can be recognized, are associated with the surrealist group, and both the obscurity (seen under a certain mode) and the violence might be considered characteristic of that school of thought. Jacques Dupin, of a younger generation, is not part of that mode, and his minimalism and fascination for the slash, the line of rupture, and, above all, the nail scratch, strike the reader as post-everything with message or depth. His poems bear such names as "The Line of Rupture," "The Shoe Lace," "Trace for Trace," and, above all, "The Nail Scratch" ("L'Onglée"). There is no moment of his later poems which does not have its part of violence, does not etch its blood against some wall. "Where the intense grows needle-sharp," reads one line – and, indeed, the razor-like thinness of his own line, restated, the shame and even treason of a line that would take on any thickness, is firmly inscribed.

Starkness here, intensity here, nothingness here, but also light:

> te voici nue, et rien
> dehors, mais non,
> tu plies, prise
>
> à ce lacet qui brûle, simplement . . .
>
> (here are you naked, and nothing
> beyond, but no,
> you bend, taken
>
> in this lace burning, quite simply . . .)[25]

Marmonnement

Pour ne pas me rendre et pour m'y retrouver, je t'offense, mais combien je suis épris de toi, loup, qu'on dit à tort funèbre, pétri des secrets de mon arrière-pays. C'est dans une masse d'amour légendaire qu tu laisses la déchaussure vierge, pourchassée de ton ongle. Loup, je t'appelle, mais tu n'as pas de réalité nommable. De plus, tu es inintelligible. Non-comparant, compensateur, que sais-je? Derrière ta course sans crinière, je saigne, je pleure, je m'enserre de terreur, j'oublie, je ris sous les arbres. Traque impitoyable où l'on s'acharne, où tout est mis en action contre la double proie: toi invisible et moi vivace.

Continue, va, nous durons ensemble; et ensemble, bien que séparés, nous bondissons par-dessus le frisson de la suprême déception pour briser la glace des eaux vives et se reconnaître là.

Mumbling

Not to surrender and so to take my bearings, I offend you, but how in love with you I am, wolf, wrongly call funereal, moulded with the secrets of my back country. In a mass of legendary love you leave the trace, virgin, hunted, of your claw.[a] Wolf, I call you, but you have no nameable reality. Moreover, you are unintelligible. By default, compensating, what else could I say? Behind your maneless running, I am bleeding, weeping; I gird myself with terror, I forget, I am laughing under the trees. Pitiless and unending pursuit, where all is set in motion against the double prey: you invisible and I perennial.

Go on, we endure together; and together, although separate, we bound over the tremor of supreme deception to shatter the ice of quick waters and recognize ourselves there.

[a] This should be read as if a comma had been placed after the word 'pourchassée.'

Plate 3.1 René Char, "Marmonnement," original text and translation from René Char, *Selected Poems*, ed. and tr. Mary Ann Caws and Jonathan Griffin (Princeton, NJ: Princeton University Press, 1976), pp. 162–3.

The texts here are all of rupture, are all of the *trait de scie*, that sawing motion that divides one side from the other. Again, it is not for the texts in themselves that I am claiming the genre of the scratch – the *onglée* that is inscribed at the source of these pages – but for that part which is the originating scratch, the initial attack upon the pavement or the parchment or the page.

Adrian Stokes, the Kleinian art critic, portrays the first stroke a painter makes against the canvas as a sort of attack upon the breast of the mother: it is that initiatory violence that makes itself felt in all creation, the essential, beginning, engendering scratch of future significance, as if one were to scratch upon the walls of the Lascaux cave. That is, surely, where post-modernism began.

Necking, or man-handling the model

In my steady rise up the body, having announced by Freud's Irma's Deep Throat the bottleneck of the issue, I arrive at the beribboned thing, that cylindrical part of the body from which the voice itself issues and which is, notably in symbolist and surrealist writers and artists, often roped off. The model wears well, but often we see her neckless.

Hamlet playing Mallarmé's *Igitur* wears another sort of necklace, a ruff about his throat; he may think more unconstrainedly than he may speak. He is no less laced about than the Olympia of Manet, reposing beribboned as if guillotined, her voice cut off by a thin black velvet ribbon. For Paul Valéry, as quoted by Georges Bataille, she inspires a sacred horror as she is idol rather than thinking woman: "Her head is empty: a thread of black velvet steals her essential being from her."[26] Bataille himself, in speaking of this Olympia, speaks of suppression, that of the link which connected her existence – including her reference back to Titian's *Venus of Urbino*, "back to the lies eloquence had created." She cannot speak, so she cannot lie; the freedom of representing prostitution liberates the tongue or the brush of the artist, while the woman lies mute. Oh, happy art.

At the source of Manet's painting, says Bataille, is his agreement with Baudelaire's delightful declaration, so fittingly uttered across from the naked model severed from her existence: "we are great and poetic in our ties and our polished boots."[27] Oh, happy fashion.

As for Michel Leiris, gazing with the same fascinated gaze at the lying lady, he celebrates first and foremost the crimson hue in the picture: "The taste of red color. . . . The color of drama as it implies the effusion of blood in order to be properly dramatic."[28] I proceed right away to a mental striptease in dealing with such immediate realities, he says. Setting things properly naked is setting them aright, and the writer has his seigneurial rights to the *mise-à-nu*.

Her ribbon and its bow imply the infinite knot, in a "conventional sign," but also tie him to his own labyrinthean project of writing – guaranteeing, in that maze, the straying step and the loss of self; guaranteeing, at the same time, by

pointing to its visibility, the newness of this picture of its time, an accurate representation on which to reflect. The endless rebeginnings of the sentence like so many reknottings serve not just to beribbon the text, but to slow it down in its frame. The knot itself reads like another decoration of the text whose neck it encircles, as clumsy as the unusually flat-footed passage from Breton already quoted:

> The ribbon encircling Olympia's neck without strangling her, and whose knot . . . distinguishes it from the snake biting its tail and illustrating an eternal rebeginning, this ribbon which, for my own taste whose double desire for realistic exactitude and compactness has never prevented me from being seduced by the vagaries of analogy, suggests far more than is required by its nature, this ribbon modest in its width and length has been the thread keeping me from getting totally lost in the labyrinth into which I was being drawn by writing. . . . The fact that the nude Manet painted . . . attains so much truth thanks to a minimal detail, this ribbon modernizing Olympia and, even better than a beauty spot or a scattering of freckles, presents her as more precise and more immediately visible by making of her a woman provided with her exact ties to a milieu and an epoch, that is what offered itself for reflection, in fact for diversion!²⁹

Pointing to the face and the ear and the neck so severed from the face, this ribbon is the detail that counts, the deictic marker signaling her epoch and at once forcing her to stretch out in what seems its reality. It permits an eroticization of a body that clothed or unclothed was seen often in other days as entire, a text veiled or then unveiled and recumbent – as in Goya's Majas naked and dressed – but always laid out for the eyes of the guys.

Just so, at the borders of surrealism, and in their time, the brightly bowed Delvaux heroines with their pink neck adornments call attention to their own lack of clothes or to that of the neighboring nudes, and to their very modernity in so calling attention to it, stretching themselves as does Olympia. This is surely the deliberate extreme of de-privation, the snatching away and spoilation of privacy, calling attention to the show.

What are the bow girls not saying? Given their replay in pink of the black velvet ribbon of the semi-decapitated Olympia, do we not assume that indeed they have nothing to say? Is this not the Stepford Wife routine, the beheading of the brain for the beribbonment of the spectacle? Voiceless, the dolled-up dolls – in a pitiful parody of the *femme-enfant* – are got up as mock beauty queens, while the trains speed by, with life itself, and they wear their little ribbons. They may wear their ribbons to the party, but who put those ribbons there, and what kind of party is that, with all those dolls just sitting and standing around? What kind of body is representing itself here? And who got a vote?

Guys and dolls

Far more dolls sprawl over the pages and the scenes of surrealism than over the spaces of other movements. Hans Bellmer removes not just the walking possibilities but also the gesturing ones and the thinking ones: what is left in his dolls? The body of these texts can only be handled in an ultimate passivity. But who recognizes the self here? These trunks and torsos can be read, I think, as scandalous only once; what is cut off and is simply absent may be less offensive than what is gagged off or singled out and off. The habit of the broken body has to be broken all over again, perhaps by re-membering. (On the other hand, Beckett's characters in their ultimate deprivation, as they drag along, do no dragging of the text and bear no mute witness to the suppressions of an unwitting author or artist; they are far from mute, and so are no more victims of the suppressive glance or pen than a dismembered character celebrated by Apollinaire.)

A ribboned neck with a fair face above and a fair unclothed body below invites some kind of play, even if of the same sugary sadistic kind as Desnos's spanking of the rosy behinds of the children boarders in the Humming-Bird Garden of *La Liberté ou l'amour!* But the excessive melodrama of Bellmer quenches the wit of the rosy play in tones fiery and sepulchral, black and red. The play can hang very heavy when so colored, losing at once the glint of black humor with a sparkle and the corporeal gleam of the Duchampian rosy joke: after all, "Rrose Sélavy." *Eros, c'est la vie;* love is life.

What crosses from one gender to the other, from Rrose as Marcel Duchamp in drag to Rrose as Desnos in his own would-be penning of a distantly dictated text by Rrose Sélavy, can be read as a transgression of the separating slash, a sort of pre-*S/Z* or a forbidden and therefore fatally attractive crossing of the bar. A bar in Michel Leiris's *Aurora* highlights another transgressive crossing, from the whole to the parts, for it is titled or programmed like a collective intention, a foregathering of the dematched: "Au Rendez-vous des parties du corps" ("At the Meeting-Place of Body Parts"). There, unsurprisingly, congregate all sorts and conditions of specific parts, each illuminated by the veiling of all the rest of the body but the particular variant to be stressed by its exhibition, as if in preparation for an execution: "which could be no matter what fragment of this human in undress: the hand, the foot, the mouth, the ear or just quite simply part of a finger."[30]

Women, says Leiris, make no exception here: "Women were subject to this common rule and also veiled their whole body with the exception of one unique spot, chosen as the most beautiful, and they also mingled their members in these fragmentary assemblies presided over invisibly by a butcher knife."[31]

Why indeed, thinks the female reader – or perhaps any reader at all – would anyone have expected the women to be exempted from the general rule

present in the bar? (Would not they demand non-exemption?) The parts mentioned first – hands, feet, mouth, ear, finger – belong to either sex, so why is the singular mixing of the sexes stressed, and the fact that in both sexes the loveliest feature is highlighted? Presumably that is always the case, or is it that the particular feature of women is to be lovely – whatever part of the body is thus shown up and shown off? In Leiris's reassembly, the representation is made up of parts of members; and in fact it appears, when a second glass of liquid is consumed, that what had seemed to be a stress upon one part of the body, representing by metonymy the whole, is in fact the entire self, partial as it is. If the mane of hair floats so casually about – like the manes of hair in Desnos's poems, waving their farewells ("Adieu disent les chevelures") and signaling their loneliness – it refers also back and forward to all those other manes of hair being combed before mirrors by surrealist heroines: the lady with her fingers "on the wing of the comb" in Breton's poem beginning "Je rêve je te vois superposée indéfiniment à toi-même" ("I am dreaming J see you seated indefinitely superposed upon yourself") or Aragon's Mire in *Anicet*, or Desnos's combing lady in "L'Idée fixe" ("Obsession") to whom the algae are brought as she dreams of the sea.[32]

> Je t'apporte une petite algue qui se mêlait à l'ecume de la mer et ce peigne
> Mais tes cheveux sont mieux nattés que les nuages. . . .

> (I bring you this little piece of seaweed that used to mingle with the seafoam and this comb
> But your hair is better braided than the clouds. . . .)

But the analogical mind of this striptease artist, this voyeur of Olympias and this celebrator of the manes of hair and the parts of bodies, inserts within a portrayal of a body transgressed, rendered incorporeal and inhuman (the windows for the eyes boarded over, rough emery paper replacing the hair and the soft parts, lances sticking out through the breasts), a testament-text of the narratorial adventurer constructing the mockery of the body as an enormous town:

> For a long time now I have been directing my research toward the human body. I have been passionately observing these caves in which more than one monster has come to hide. Atop this high rise of the vertebrae, what watchman has lit those fires? The herd of tactile feelings is grazing on the unlimited meadows of the skin. This evening it will go off to sleep in the dung-head of its stable, sleeping with the goats of smell, the pigs of taste, the bulls of hearing, the horses of sight. Later, hooded with dumbness and fatigue, all the cattle will go of its own accord to lie down before the butcher.[33]

This, says the text, is the proper picture of Man described.

The suppression of the "−": a partial reading

But, as for the lines drawn about the subject, who exactly does the crossing-over? Benjamin Péret's article on armor in *Le Minotaure* makes a visually combative point about masculinity, with its spear protruding, and, conversely, on Tzara's disquisition on certain kinds of hats as emblematic choices by women: hats that imitate men's hats which in their turn imitate female private parts; or a peaked model which does indeed not refer back to them, but simply discloses the uninnocence of the infinitely changing world of sexual representation:

> . . . the marvelous world of sexual representations, more than any other deeply hidden in the psychic structure of human beings, women in particular, subject to a strange law of transcendence and of opposition, a law of continual movement . . . this work seems to be characterized by the value it places upon the different parts of the body for which the ornaments serve at once as a signal and a summons.[34]

As Tzara traces the evolution of this "automatic" conformity to the mode of the time and what it so unconsciously represents, the female reader of the article as of the hat wonders about the Other of this Other. Which is the source and which the imitation? Would one choose to wear one's own partiality or that of another? Whom, after all, does one represent while representing? What does Tzara see, and does it wear well?

De-priving would be taking from the owner that which to him or to her is private, and belongs. To take from the woman or the man what might be thought to be the lion's share and to place it upon, or within, of all things, a hat, is indicative of a desire, however repressed: if the hat of the woman looks a bit *peaked*, it may be by choice. If, to continue, the man appropriates, for his crowning glory, a certain reminder, he places, no less by choice, at the height of his dignity and just above his brain, the symbol of the Other which, then, he can doff or place where he chooses. He could, of course, always place her empty glove in his empty hat, or just remove the hat.

But in fact here, in this picture which represents the representation of the hat, he bends over proudly, for a display of the transfer of parts within the image, Dada or surrealist depending on one's taste and on one's point of view: this is real absorption in the body of the text, taken as ideal. For, after all, what could be closer to Michelet's view of woman in her ideal perfection? "Woman, adorable ideal of grace in wisdom itself, by whom alone the family and indeed society, will be begun afresh."[35]

Saying it all: the recovery of the subject, as supplement

The subject, perfect or imperfect, may, however, be recovered, by just what is covered over, and oddly. What covers up points to what is beneath; the *Sabine Poppeia* is exposed and gorgeous, as she allures; the veil which covers only serves to reveal. Certain pictorial coverings of the body, such as the stripes Man Ray photographs from the shadows of the blinds, design the naked body with the signature of the artist – in other words, place over it the mark of a man-on-the-prowl, as if hunting the big catch, the leopard of the season.[36] The extraordinary torso with stripes he shot as *Retour à la raison* (*Return to Reason*) combines woman as natural with the bestial insinuation of violence done to the natural, even as it is deliberately done in part: these bodies are never, and are never to be, except in our imagination, whole. Under the skin marked like a coat, the body remains exposed, sold by whatever name.

By an added twist – again modernism takes its clue from mannerism – the division of wholes into parts, for the iconization of the parts, can, upon surrealist occasion, lead to the addition of the wrong part, like a *supplement*, as in some of Wilhelm Freddie's photomontages. In the most startling of these, a woman's head is placed upon a pedestal, with stacked-up glasses crowded up against one cheek, and a penis curling about the other, like some baroque construction based on intrusion as on insult. The party over, what remains is glasses to be broken, privacy invaded, the art of interference at its most horrendous. Susanna, bathing with at least her whole body and observed by at least some only watching elders, has nothing on, also has nothing on this beladen lady so decapitated, whose remaining head as image is so terribly interfered with, even if just by some part of some otherwise absent intruder, whatever his age. This kind of special and often obscene supplement serves then as the focus for the vision.

The supplement itself brings added supplement: the training of the sight upon and by what is extra permits the addition finally of the same part in a self-reflexivity characteristic of modernism, after mannerism. Its very embodiment might be a tabled piece wherein Marcel Duchamp is seated several times around a table, as if added to himself: "*fecit*" Man Ray, luxuriously, as the self is recovered and made entire by being multiplied as if in some circular mirror (see plate 3.2).

The elliptical effect

Among the possible ways of recovery is that of saying too much or saying something too many times, or covering over and regathering in a pleat the evidence of what has been excised. I wonder if, by an odd circumvention, the self put to flight by codes and icons, dis-enchanted with disembodiment,

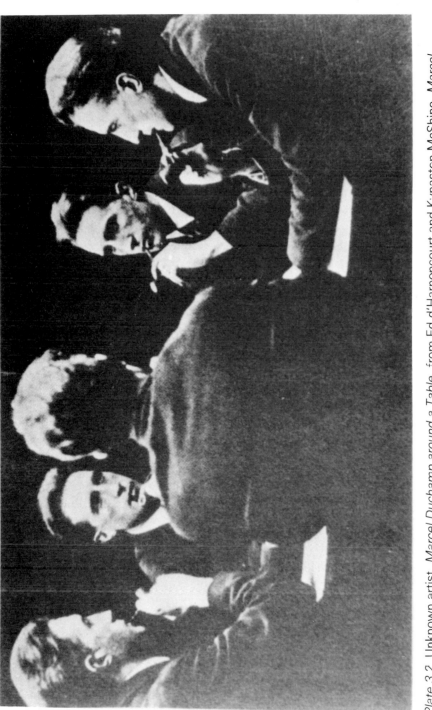

Plate 3.2 Unknown artist, *Marcel Duchamp around a Table*, from Ed d'Harnoncourt and Kynaston McShine, *Marcel Duchamp* (New York: Museum of Modern Art, 1973). Courtesy Robert Lebel.

might not find it high time to reappropriate, by re-membering, the needs of the language of the body. For these representing bodies represent also something else, available only by its own cloaking-off into memory – that is, representation itself as it is, from occasion to occasion, embodied and reconstituted or reincorporated; disembodiment knows, after all, no sex.

The paradox presented here of representing bodies is that something of the naked must be covered for the nakedness to appear attractive, with the shoe or glove or ribbon or veil or draped sheet or decoration as pointer; but that, precisely behind that shoe or glove or ribbon or veil or sheet or stripe, the appendage or part, or even the whole, may disappear. Clothed or naked, saying too much or too little, overstatement is still more interesting than a form without stress and without any pointing gesture to signal it in particular.

The member of the august body seen here in assembly metaphoric and literal may represent his or her own personal corpus prior to corpsedom, but that representation is really only itself assuming its rightful place in the imagination. The matter here is not one for Velázquez or his genial sidekick Foucault contemplating *Las Meñinas* together,[37] not one of where the artist stands or the king, or of doorways or mirrors, or of stance and vanishing point. The elliptical effect I am presenting here in its final embodiment passes through the necessary implied disappearance of the body to be represented for the efficacy of the representational effect. Presented face-on, the body fades; suppressed or only partly represented, it reappears, in strength. Seen entire, the body seems to say nothing; seen naked, it seems to spark no story. Seen in part, it speaks whole volumes; seen veiled, it leads into its own text.

Textually, when too much is shown, it veils what is not shown; when too much is said, the side that comes short or makes its own ellipsis says, by implication or infolding, all the more. This double contradiction is what the elliptical effect is all about. In speaking of the elliptical effect, I am taking ellipsis in its two major senses, both coming from the Greek for "to come short": first, the omission of one or more words in a sentence which would have been needed to complete the grammatical construction; second, the oval generated by two foci, one side being shorter than the other. Then the compensating element of the ellipsis on the short-changed side might be the *pleat*, a denseness or accumulation, an awkwardness or stylistic clumsiness which has to be "taken up" into the material and becomes noticeable, pointing the way to the ellipsis by its very opposition. As it works in the styles of art and of writing, so it works in the body of language itself, which is their substance.

The elliptical effect, presented for both eyes and ears, and with its double generative focus, enables us to come, as it were, full-oval, to a double-focused paradox which characterizes the peculiar rendering and peculiar handling of certain passages and products remarkable in their intensity. This paradox states that what activates the fullest imagination may be itself as fragmentary as a torso, as empty as an empty shoe – provided the foot be remembered with what it stands for; that what sparks the liveliest desire may be as dead as the

coat of some sacrificed leopard – provided it lies over the most naked of skins, or even marks it; that the barest sign, representing the smallest part, may by a classic metonymy suffice to flesh out the whole body of memory. Simultaneously, the convex full text on the thicker side of the oval depends upon the concave or empty token, the one that falls short; these paradoxes constitute the elliptical form. The very emptiness of the token shoe or coat or glove or hat, with all it fetishistically or emblematically resumes, guarantees that what it represents is more than body, clothed or unclothed, and is never trivial, being text. So the rendering of the empty shoe, preceded necessarily by a knowledge of woman, leg, foot, in descending order, appears to be a representation of absence based on a cover-up and a loss, a negative representation, of a body long gone, and yet, in its recalling, re-present.[38]

The mannerist de La Tour points with the same candle as the surrealist Magritte, turning back again to the candle as the illumination of the partial body. Magritte's own image of representation (plate 3.3) is powerful in its heavy outline like that of a stained-glass window by Rouault, powerful in its own right, in its separation of the parts as a full sign. This sign says it all, by showing only part, by forcing the reader to re-member and re-collect – that is,

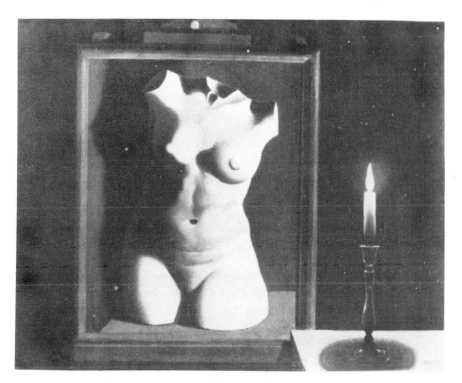

Plate 3.3 René Magritte, *La Lumière des Coincidences*, June 1936, © ADAGP, Paris, and DACS, London 1989.

to re-present. We are forced, then, to recollect and make again, to gather up even through the obsessive restatements – signaling, as we have seen, the ellipsis of which they are the other side. And what we gather is itself the pleat we imply in all our own representing, and in which we are, most profoundly, and most textually, *implicated*.

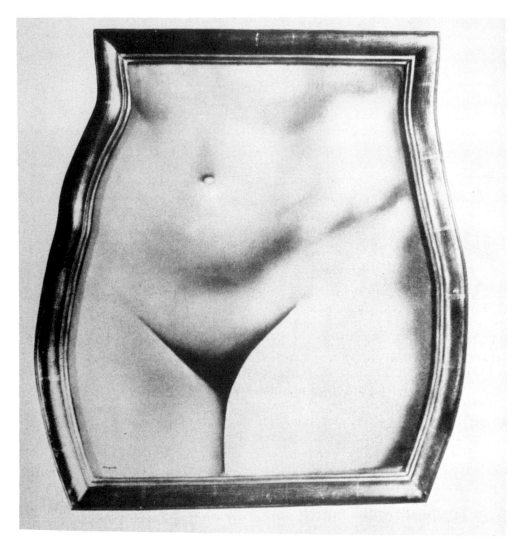

Plate 3.4 René Magritte, *Représentation*, © ADAGP, Paris and DACS, London 1988.

FUTURISM

4

SPEED-READING, or ZIPPING up the TEXT

I got what I wanted – not enjoyment, but a totally new idea of motion, of speed.

<div align="right">

Marinetti on the London Underground[1]

</div>

How should we remember, in its strongest lines, a movement so slanted toward movement as futurism? What is the point of rereading the past of a motion labeled as a future one, which opposes even the best remnants of the past? Down with old palaces, say the futurists, and down with old books in libraries and old paintings in museums new and old: "To admire an old picture is to pour our sensitiveness into a funeral urn, instead of casting it forward in violent gushes of creation and action."[2] Instead, they want the fruit of the modern, machines in bright tones contrasting with the pastels of the past: why should we then, in our turn, turn toward a movement not now the fruit of our own machines, not now, or now no longer, the result of our own art? How, finally, would its memory be linked or linkable to our own present and its future when it is, in its turn, just the past?

The questions that futurism poses for us are, I think, partly questions of representation, yet to a greater extent, questions of aesthetic design and reader or observer *involvement*, with a centralizing effect on the observing consciousness clearly visible in such paintings as Carrà's *The Swimmer*, with its dizzying strokes, or Boccioni's various *States of Mind: Those Who Leave, The Farewells*, and *Those Who Stay*.

In fact, Umberto Boccioni seems to have illustrated, in a profusion at once lyric and imaginative, almost all the more profound tenets of futurism. Just a reading of his titles gathers an extraordinary amount of information about

beliefs, projects, and attitudes: from the simultaneous registering of sequential motion (the horses' hoofs in *The Canter* of 1893, like Balla's more celebrated dog's paw in a sort of pattering walk), through the coincidence of multiple experiences (reminiscent of Tristan Tzara's quadripartite poem "L'Amiral cherche une maison à louer" ("The Admiral Seeks a House to Rent"), in which all four voices talk at once), as in the wonderfully complicated notion and realization of the *Fusion of a Head and Light through a Window* of 1912, on to the vastly and brightly stretchable motion covering the whole canvas of his *Elasticity*, also of 1912 (the title itself stretching over to the France of Blaise Cendrars' *Nineteen Elastic Poems* of 1913 and 1914), through the outward, male-oriented dynamic expansion of a gesture (*Dynamism of a Cyclist and Energy: Form of a Bottle* of 1913, as well as his *Spiral Expansion of Muscles in Movement*).

Somewhere to the side of all this encyclopedia of muscular expansions and simultaneous experimentation is the *States of Mind* trilogy, or even triptych, with its many studies.[3] In the studies of departure and separation and remaining behind, called, respectively *States of Mind: The Farewells* (to be placed in the center of the triptych), *States of Mind: Those Who Leave* (for the left; plate 4.1) and *States of Mind: Those Who Stay* (for the right; plate 4.2), Boccioni saw his own liberation from the rigid and frigid academic cubism that futurism was manifesting against. He was striving, he said, in a lecture given to the Circolo Artistico in Rome on May 29, 1911,[4] for a lyricism that would capture, through a synthesis of various intensities and "dimensions" of vibration and undulations, the felt emotions and sensations of the artist to which the spectator would respond, sensing the rhythms and colors specific to those emotions or states of mind. "We will paint and draw velocity by rendering the abstract lines that the object in its course has aroused in us." The point was also to return, through the spiritualization of what he called "objective elements," "beyond our millennial complexity, to primordial simplicity" and to some universal whole. These states of mind are akin, as he and all his commentators point out, to Bergson's philosophical investigations – more important for the needs of this present study is the intensity of the nervous reaction created by the three mental states, of which the two pictured here are the more contrasted, meant to be read on either side of *The Farewells*, meant for the center, with its thick swirling lines showing the emotional sweep and the movement of the engine, catching the fragments of faces looking away from us within its own churning.

As for those going away, the oblique lines on the left are meant to signify the direction of their departure, and the loneliness and anxiety in their faces, their generally dazed condition, as they feel themselves "carried away by the smoke and the intense speed." The whole frenzied picture with the houses in the background like the fragments of landscapes the train speeds along through may well cause the observer to breathe more quickly, corresponding to the states of mind as represented. That remarkable hinge on the locomotive

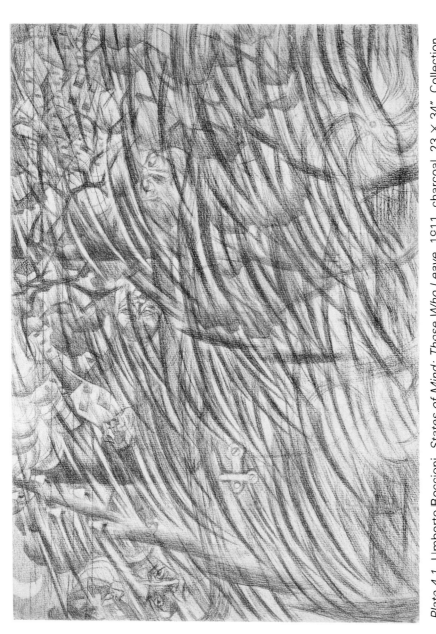

Plate 4.1 Umberto Boccioni, *States of Mind: Those Who Leave*, 1911, charcoal, 23 × 34". Collection, The Museum of Modern Art, New York. Gift of Vico Baer.

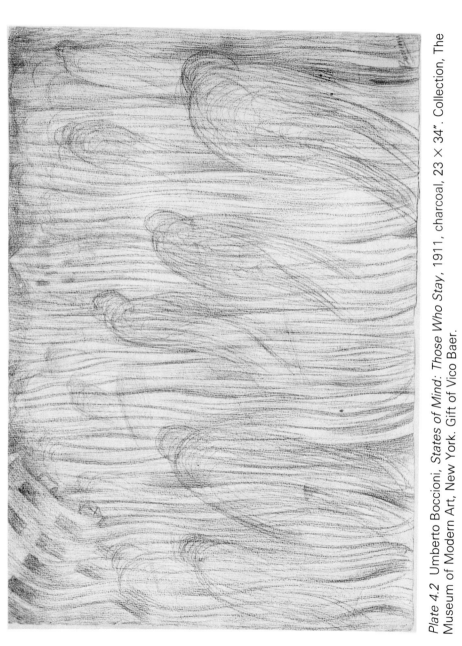

Plate 4.2 Umberto Boccioni, *States of Mind: Those Who Stay*, 1911, charcoal, 23 × 34". Collection, The Museum of Modern Art, New York. Gift of Vico Baer.

door, the head sleeping in the pullman car, the wheels spinning in the right-hand bottom corner and the rails at the lower left-hand corner are all recognizable parts of the ongoing movement, as are the clouds of smoke at the top of the picture. This is a picture of speed if there ever was one.

These lines of rapid motion of the train on its way are set in high contrast to the early train paintings of Boccioni's symbolist period – as static as his picture of the one horse standing in a field – just as the rushing motion of Tristan Tzara's Dada poems and manifestoes and his "Note on Poetry" contrast with his early Romanian symbolist poems and even some later ones – where a horse stands alone upon a hill. The odd lyricism of those lonely and static figures, whether inanimate, like the train, or animate, like the horse, penetrates the frenetic motion and the overlappings of simultaneity in much the same way as the head fuses with both window and light.

This phenomenon seems particularly sensible in the early study for *States of Mind: Those Who Stay*, also of 1911. It is as symbolist, even romantic in feeling as the study and the final rendering of *Those Who Leave* are futurist. It is composed of lonely figures seen against a closely set rhythmical and vertical stroking, entrapping lines to be struggled through and made unhappy by, for those who have made the decision to remain. Boccioni's own description of the picture is understandably a strong one: "The perpendicular lines indicate their depressed condition and their infinite sadness dragging them down towards the earth. The mathematically spiritualized silhouettes render the distressing melancholy of the soul of those who are left behind."

The effect is decidedly tragic, with the figures strongly separated and bent slightly under the weight of the streams of rain. The figures are turned away, each alone and desolate, all, in their separateness, having been – we sense – departed from, abandoned, left forever. In fact, all these three states of mind betray their own anxious longing, and all three bear witness to a feeling and a depth of emotion we would not ordinarily associate with Marinettian futurism. This extraordinarily moving art seems – in its enormous difference from what one thinks of as futurist – in its sensitivity to the symbolic as to the poignant, to the monumentality of the remaining as to the vigor of the mobile, great and lonely, high and sad.

Models and memory

But to begin with memory: in an unpublished manifesto of 1913, Severini speaks of that faculty:

> Memory will act . . . in the work of art as an element of plastic intensification and even as the true cause of emotion, which is independent of any unity of time and place. . . . The spiral forms and the beautiful contrasts of blue and yellow . . . which were discovered one evening,

while living the action of the ballerina, may be perceived later . . . in the concentric flights of an airplane or in the fleeting vision of an express train driven at full speed.[5]

Such a method of mental transportation, taking the matter and the emotion and the shape from one past event to transpose it upon another and later one, requires at least two talents: that of retentive formal and colorful memory and that of analogical perception. Intensification is the aim, and would in fact always have been the aim of futurism: for that reason, as for others, its aesthetic investigations and its paradoxical results are intensely relevant to our own perceptions and aesthetic lack of ease with them, even as our passion for involvement as readers urges us to take another look at our past as at our future.

Speed-writing and its problems

Futurism as a movement loved movement primarily for its speed, realized and potential. In its verbal as in its visual presentations and representations, it aimed at conveying the differing rhythms of action as of perception, of explosion as of absorption. Such paintings as those by Russolo, by Boccioni, by Balla, of street noise and street forces, of a revolt sensed in a city, or of the flight of birds, such as swifts in their soaring, take these "force lines" as their subject, energizing the depth as the surface, to dynamize the ambiance of the whole as the center is revitalized, in an interradiation of currents. The observer – included, placed in fact in the middle of the action – does not have the option of ignorance or those of undersight or oversight, since the lines them-selves are clear and the reading is unavoidably forceful, often far beyond the apparent motivation of its model.

Speed: how can it be represented? "Our lyrical exaltation," says Marinetti, "must freely deform, remold, cut, lengthen, and reinforce the center or the extremities of works, it must be free, also, to increase or diminish the number of vowels or consonants."[6] We have only to examine some parts of what Marinetti performed aloud to see the problem: to read on the page the extension of vowels, the profusion of white spaces, the sounds represented by unrecognizable signs, and to hear them in performance, require two different skills, have two different effects.

sssssss iiiiiii ggggggg
TAANG TOUMB TOUMB
srrrrr GRANG-GRANG (touché!)
boum-pam-pam-pam
allo Ibrahim! Rudolf!
cip-cip allo allo
zzip-zzip[7]

The hissing sounds ("sssssss"), those of shrieking ("iiiiiii") and spluttering ("ggggggg") and rapid-motion zipping along ("cip-cip . . . zzip-zzip") in their high harshness are ranged against the roar or dull and deadly thud of bullets ("srrrrr GRANG-GRANG . . . boum-pam-pam-pam," "TOUMB TOUMB"), straight from the hit to the tomb, with their cries of exultation ("touché!") in a Grand Guignol contrast with the sudden recognition on the battlefield ("hello . . . Rudolf!").

And in the "Trains de soldats malades" ("Trains of Ill Soldiers"), the onomatopoetic clatter and whine and whir of locomotive wheels ("tlac tlac ii ii guii trrrr . . . WHEELS") with all their *curring* and *gurring* in sounds is instantly recognizable across linguistic lines, and related to the Language Poetry movements in Russia's own cubo-futurism and its Zaoum school, all of it at top speed and maximum sound: "GETTING LARGER DEADLY DETERMINED FEROCIOUS METICULOUS ETERNAL CLOUDY DEVASTATED" with no separation and no pause and no let-up. This is the true zippy futurist macho war-hungry sound-thirsty machine in its anti-human spin:

> Hac Hac ii ii guii
> trrrr trrrrr
>
> . . .
>
> (ROUES)
> currrr
> cuhrrrr
> guhrrrrr
> (LOCOMOTIVE)

(GRANDISSANT, ACHARNÉ FÉROCE MÉTICULEUX ÉTERNEL NUAGEUX DÉVASTÉ)[8]

Or, again, the "mechanical atrocious and voluptuous sawings" that go something like this: "Srrrrrrr / Ssrrrrrr / siiiii / ziiiii / rrrrrrr / irrrrrrrrr / urrrrr." Upon the page, these very passages do not hold us; compared to the forceful lines of the pictures, the lines of the verbal text have less staying power. The moment of performance, unless projected from and included in the aftermath of reading, is lost: even here, there are those who leave and those who stay.

But that is, of course, just what we would have expected: futurism, like Dada, was for a time. It rolled unimpeded along the highways of perception, like the greatest vorticist texts, like the Dada texts, and like some surrealist texts. Upon the infinitive, for example, to take one of Marinetti's favorite battle noises, the infinitive which has no inflections to slow it down, the sentence rolls as upon a wheel. The surrealist Desnos thought that also, and his poem called "Infinitive" rolls along a self-reflective road, eschewing the adjectives and adverbs that would retard the nominal and verbal momentum:

Y mourir ô belle flammèche y mourir
voir les nuages fondre comme la neige et l'écho
. . .

ne pas mourir encore et voir durer l'ombre
naître avec le feu et ne pas mourir
. . .

rire aux heures orageuses dormir au pied d'un pin
. . .

et mourir ce que j'aime au bord des flammes.

(To die there oh lovely spark to die there
to see clouds melting like snow and echo
. . .

not yet to die and see the shadow lasting still
to be born with the fire and not to die
. . .

to laugh in stormy hours to sleep beneath a pine
. . .

and to die what I love at the edge of flames)[9]

But even there the questions remain: deciphering the diagram to read, in the French, the names of Desnos and his beloved at opposite ends of the lines (the one running up, the other down) is a one-time feat. So the shock of an energized picture wears off, the visual jolt of a text set down to be startling fails on a second reading to surprise, going static like some still life, a *nature morte*, or a *nature* ironically already dead modifying it. The observer placed in the center as of a whirlwind, in whole or in part, is involved over and over only in choosing to be.

Mechanical reference

Involvement of this kind, while it may take talent for reading, most certainly does not entail what we shrug off as referentiality to any outside world. The futurists were taken for a ride, as we might say, high on speed, in a train like Severini's armored one, in a motorcar and a subway train, and later in a plane, vehicles praised to the sky for their abstract motion – their activity as opposed to the passive and sleepy self that the "habit of energy" wakes by force – and not for their substance:

Literature has hitherto glorified thoughtful immobility, ecstasy and sleep; we shall extol aggressive movement, feverish insomnia, the double quick step, the somersault, the box on the ear, the fisticuff.

We declare that the world's splendor has been enriched by a new beauty; the beauty of speed. A racing motor-car, its frame adorned with

great pipes, like snakes with explosive breath . . . a roaring motor-car, which looks as though running on shrapnel, is more beautiful than the Victory of Samothrace.

We shall sing of the man at the steering wheel, whose ideal stem transfixes the earth, rushing over the circuit of her orbit.[10]

Even when the later-coming Vorticists with their equally violent leader Wyndham Lewis mocked the motor-car as the significant symbol of futurism, they took over energetically much of the energy of the declarations, simply shifting the image to a more abstract one of the vortex as the center of force and point of maximum energy: their macho steering wheel has no less stem and not a very different driver – an observation I want to return to.

About futurist transport, the vorticists had two criticisms: first a specific one about the automobile, as if Marinetti had already been dealing in used cars. "Automobilism," said Lewis, "bores us. We don't want to go about making a hulla-balloo about motor-cars, any more than about knives and forks, elephants or gas-pipes. / Elephants are VERY BIG. Motor cars go quickly. WE could not make an elephant."[11] A delightful light is shed upon this, as it were, rear view of elephants by the tale that Marinetti himself was later found placing beards upon pictures of elephants: "I like beards," he is said to have said. Presumably he liked elephants too.

The second point made by the vorticists, looking back from not many years later at futurism, was that to their very enthusiasm for theory and propaganda the futurists sacrificed the care for plastic qualities characteristic of the best cubist productions, and made of their teachings a tyranny. "Futurism is too much the art of Prisoners. / Prison-art has often been very good, but the art of the Free Man is better."[12] Their high spirits gave them the advantage of some damning examples for Lewis: "They have a merit similar to Strauss's Waltzes, or Rag-Time; the best modern Popular Art, that is. / Sometimes they sink below the Blue Danube, and My Home in Dixie. Sometimes (notably in Balla's paintings) they get into a higher line of invention, say that of Daumier."[13]

Recognition of the subject, that too visible reference, would scarcely do in the work of art. "There should be a Bill passed in Parliament at once," says Lewis in the same article, and in capital letters, "FORBIDDING ANY IMAGE OR RECOGNIZABLE SHAPE TO BE STUCK UP IN ANY PUBLIC PLACE . . . Only after passing a most severe and esoteric Board and getting a CERTIFICATE should a man be allowed to represent in his work Human Beings, Animals, or Trees."[14] The animate is eschewed for the abstract, the sentiment for the emotionally strict.

If there is to be poetry in art, let it be tempered by a chill temperament: Lewis has as little affection for moonlight as Marinetti and the Italian futurists, who, in loving the recognizable, disliked what had occasioned recognizable sentimentality. "Down with moonlight," they cried, and, in a

poem in French, "La Fanfare des vagues" ("The Waves' Fanfare"), Marinetti savors the idea of spitting upon the very visage of the stars. A more romantic image of hero against cosmos would be hard to imagine:

> O sorcières de l'Impossible! Etoiles!
> Prometteuses de néant! Vous voilà donc devant moi, à la portée de ma
> vengeance! O ma joie!
> O! que je savoure l'ivresse effrénée de cracher sur vos visages augustes!
>
> (Oh sorcerers of the Impossible! Stars!
> Promisers of nothing! There you are before me, in reach of my
> vengeance! Oh joy!
> Oh how I relish the frenzy of spitting tipsily in your august faces!)[15]

Who is involved in what?

In his violent opposition to what he called the "female bed of raw emotionality," Lewis defines that hotbed of sin as "the warm and steaming poetry of earth, of Van Gogh's rich and hypnotic sunsets, Rembrandt's specialised and golden crowds, or Balzac's brutal imagination."[16] Since he also claims that "You should be emotional about everything rather than sensitive,"[17] perhaps I shall be, for a moment.

I am assuming, on the given evidence, that emotion is related, for him, to the masculine and not the feminine temperament: females, presumably, do not lean in a self-identifying manner over the stems of steering wheels in either movement, in futurism or the heavily influenced vorticism. In futurism, as we remember, the female temperament is despicable, even for Valentine de Saint-Point, who lauds only virility in the case of both sexes.[18] Could it be that the long tradition of the posed female model has so slanted the position itself of the person that the pose takes over from the being?

Even in Dada, we have often the same reading. Associated with sentiment, with an insipid morality seen as "the infusion of chocolate in the veins"[19] and thus to be rejected by the newly created crystal beings upon the pure mountains that Papa-Dada has, to use the proper word, erected, and also with the slow weight of weakening tears impeding the masculine rush along the rails or down the volcanic slopes, the female or poetic temperament is not noticeably included in the system so very upright, not to say uptight:

> The poet of the last station no longer weeps in vain; lamenting would
> slow down his gait. Humidity of ages past. Those who feed on tears are
> happy and heavy; they slip them on to deceive the snakes behind the
> necklaces of their souls. The poet can devote himself to callisthenics. But
> to obtain abundance and explosion, he knows how to set hope afire

TODAY. Tranquil, ardent, furious, intimate, pathetic, slow, impetuous, his desire boils for enthusiasm, that fecund form of intensity.[20]

It is quite as if the movements whirling in the so-called "hurly-burly and exuberance of actual life" suffered one gender more gladly than the other, preferring the gender given, however erotically, to "violent gushes of creation and action," the gender associated with will and not willingness, with a lively burn and not a quiet ardor: "my nervous flame," as Picabia refers to it in 1907,[21] and its mysterious flicker of distance ("Francis Picabia I understand you less and less"[22]), or the oblong fire lighting up the sky in the Apollinairean rear-view mirror. Whereas light is, as in Balla's study of it, meant for all, speed is, it seems, more easily read through the male eyes for which it is destined, felt through the male body.

Playing with time

Pouncing not just on the moment but on the idea of time itself, Marinetti takes up exactly the opposite position from the one Baudelaire had assumed. When the latter pictured himself moribund by a pool of blood, from his throat there came the rasp of a broken bell ("La cloche fêlée"); here, on the other hand and as if in direct response, the poet sees himself assaulting the wings and voice of Time with a merciless and unmetaphoric action:

> O Temps, je vais foncer sur toi,
> et te casser les ailes,
> et te couper ta voix asthmatique d'horloge!
>
> (O Time, I shall leap on you,
> shatter your wings,
> and cut your asthmatic clock voice for you!)[23]

for a spirit with his massive strength can stretch and shrink the moments in total domination of time itself, giving to an hour the length of a week or then squeezing from it, like some lemon, the juice of fifteen minutes:

> Sachez donc qu'un esprit aussi fort que le mien
> peut donner à une heure l'ampleur d'une semaine,
> ou la serrer dans son poing dur
> comme un citron,
> dont coulera seulement
> le jus d'un tout petit quart d'heure!
>
> (Just know that a spirit as strong as mine
> can give to an hour a week's fullness
> or squeeze it in his hard fist
> like a lemon

from which just the juice runs out
of a tiny quarter of an hour!)[24]

A certain elasticity of the world as it is the mobile prey of the strongly dominant male spirit gives the title to Boccioni's painting of 1912 called, precisely, *Elasticity*, as it had to Cendrars's *Nineteen Elastic Poems* of a year earlier, with the same excitement about human control, by art, over time and space. Perception has the power to retract and expand, to make our environment as we would have it. The problem here is not who molds the world, or who furnishes the perception – both topics would take us further than we can go or wish to – but rather what such a conception does to perception and to aesthetic design.

The problem is, again, not the urge towards speedy creation or the distinction between male and female uses of literary and artistic creation, but the urge to identify the ways in which the representation of speed is and is not efficacious, for observers of both genders. When Apollinaire sets up emotion simultaneous with perception as the emblem of the modern imagination at its freshest, suggesting that, in the fear that some day the sight of a train may no longer be so moving for us, we should look at it quickly ("Crains qu'un jour un train ne t'emeuve plus / Regarde-le plus vite pour toi"[25]), he makes no gender distinction as to sight. When, in the great poem "Zone," he wanders through the Paris and the world of the new and of the old, the wanderer is not set off as one sex or the other, and the constant shift of pronouns for the seer ("I," "you," "he," "we") lends an openness to the experience consonant with the openness to past, present, and future. "I sing," he says, "all the possibilities of myself" ("Je chante toutes les possibilités de moi-même"), giving a cosmic Whitmanesque cast to the proceedings. (Speaking of the latter poet, John Russell finds that Marinetti in translation reads like a Disneyworld idea of Whitman, an observation whose stylistic relevance it would be hard to deny.[26])

Interpenetration

But, along a final line of force – to use the futurist expression – the style of futurism, in spite of its speed and violent thrust, with all the masculine vehemence that term comports, is never that of the sharp or unmingled outline. The interpenetration of forms guarantees that the one is always more than one, being also its surroundings. To the subject of, say, the paws of a dog upon a leash there are the constant additions of other paws, for the walking action is taken as part of a greater whole, motion itself. To the subject of a girl running on a balcony, there are joined parts of the environment. Lines are added to light, those in turn to be added to the head, or to noise to be added to street to balcony to figure: these accretions by formula $(a + b + c = d)$ work,

as this simultaneity plays, against isolation and singleness, and a simple plus or addition sign brings in a whole world.

> In painting a person on a balcony, seen from inside the room, we do not limit the scene to what the square frame of the window renders visible; but we try to render the sum total of visual sensations which the person on the balcony has experienced; the sun-bathed throng in the street, the double row of houses which stretch to right and left, the beflowered balconies, etc. This implies the simultaneousness of the ambient, and, therefore, the dislocation and dismemberment of objects, the scattering and fusion of details, freed from accepted logic, and independent from one another.
>
> In order to make the spectator live in the centre of the picture . . . the picture must be the synthesis of what one remembers and of what one sees.[27]

From the point of view of the observer, then, as from that of the theorist and the artist, the interpenetrations of the outlines into each other work against the traditional figural distinctions:

> How often have we not seen upon the cheek of the person with whom we were talking the horse which passes at the end of the street.
>
> Our bodies penetrate the sofas upon which we sit, and the sofas penetrate our bodies. The motor-bus rushes into the houses which it passes, and in their turn the houses throw themselves upon the motor-bus and are blended with it.[28]

The force lines of the picture and the pictured sensation eventually involve the spectator, and confer, or at least this spectator would so hope, the mixing of outlines upon that of genders, so that the female observer, despicable as she might be to the futurist fathers, may profit from the forceful lines not just of the perceived object, but also of the interpenetration of objects and outlines. So one noun calls for another, a female observer for a male one. Moreover, and always, *The Noise Penetrates the House*, as in a Boccioni realization. Ideally, all the naive separations and gender distinctions in a movement which is so tied up with the imbrication of past memory with present perception and so oriented towards presentness would presumably be overcome themselves in the long run by interpenetration of those very outlines. So does theory come to the aid of perception. It is perception that must not be absorbed by polemic, although it can and should be revitalized by it.

Although futurism, as we read it now, with our present enthusiasms, remains problematic, it continues to place the observer, all its observers, past and ongoing, in a central position. Such is always the point of presentness, in our readings of both past and future.

DADA

5

PARTIALITY and the READY MAID, or REPRESENTATION by REDUCTION

Reading the given

For a long time now, some Dada and surrealist problems – or, not exactly the same, some problems related to Dada and surrealist theory and practice – have seemed increasingly troubling. Among these, especially vexing is the whole constellation of issues surrounding the reading of what we know as the ready-made, in Duchamp's terms. For the reception of such a gift or such a demonstration, like the reception of any found or given object, is complicated by our reading of its finding.

How, moreover, does one treat what is given, already chosen, and pre-digested, before it is received? Does not the preceding choice of the object held out – of whatever sort and for whatever function – work almost as a sacraliza-tion, as a consecration of what we cannot then refuse as trivial, since it is designated by design? We have to make it work, and do. Furthermore, are we not supposed to react in a ready-made way to a ready-made? That is, would a cliché or stock answer not be the most appropriate one in such a situation? In that case, how much of the whole situation could be predicted in advance, and what is our choice?

The whole Dada cycle of presentation and reaction must be related to the notion of objective chance as the surrealists state it, in which the encounter with the "real" or exterior object enables us to find, ourside of us, an answer to the interior question we were not aware of having.[1] There the theory and the texts of Dada and surrealist literature and thought itself encounter what we, as readers, might think of as the "real" issue.

This essay was first published in *The Journal of Aesthetics and Art Criticism*, vol. XLII, no. 3 (Spring 1984).

Timing the response

The issue is at least double, containing the twin question: how are ready-made made and then read? If Duchamp selects his urinal as a "fountain," with all the water-play set in full force, it is all the same true that we have now only the photograph of the one he originally picked, while the original is lost.[2] So what exactly do we have? A mere copy of an act, we might think, and reasonably so.

Furthermore, as to selection, would it matter how it is done? Or would it be only the *fact* of selection which is important, whether the choice is made among several possibilities, like or unlike, or by finding at random? From then on, choice appears absent, and our roles stock ones, like our responses. But what may save the subjective and the singular, in regard to our response, is perhaps the crucial element of timing, of afterness. For, if you knew already what you needed, there would be no merit and no interest in finding it. Only advanced ignorance can validate any such sudden realization.

Take an example of timing and reference: if we consider just the arm, in the case of Duchamp's shovel called *In Advance of the Broken Arm*, we see the problem, as it were, forearmed. If we refer (captives after all, or at least often, of a world of meaning even while we speak of a poetic and non-referential world), if we refer to the use of such a shovel as a work of art, what is the referential status of the arm at least partially included in it, in an essay at least partially about representation and the fragment and the body? To what use is a paper shovel put? Is it efficacious only on paper, and against paper snow-storms? Is the arm needed at all, even in paper? I am of course implying it in this essay, but which one am I implying, and is it the same one as Duchamp implied?

Finding and relating

For whom is the object found, named, and thought about or interpreted? It is a rare thing if the findings of all the finders of the found object coincide: the artist, whom we might call the first finder, yields to the second finder (the critic or interpreter of the work), and on to the third (the reader of that critic or the observer of the work post interpretation). Since all read, at some point or other, along with the work, its title and its use and its intention, the object as we find and then know it becomes only part of an addition, the source of a kind of plus-value, it plus . . . whatever. It plus what it is supposed to be or be read as and then its interpretation, thought after the art work, all that is now what we are given, finders as keepers. Found objects turn into art objects.

The build-up by reading is doubly done, by words and by sight. In all cases, one figure of thought is translated into another, found or selected, with

intention (which we had thought we lost) coming somewhere in between the figures, and the interpretation coming after. Further, the reference of what we see as a new or refound or replaced part of culture to what we know of as a contemporaneous whole can be exterior or interior, just like the interpretation following any intention and stressing the reference of an art work to others or to itself.

The Fountain: relations and entitlement

Might we, for example, call the referring by Duchamp's *Fountain* to the *Mannequin pis* in Brussels a use reference and a culture reference, or even use as culture, use as art? Or, on the other hand, is it really just so much water over the rim? Then we might make some elaborations upon interior relating: what is the relation of the composing parts to each other, the cavity to the idea of containing, the height of the receptacle to the height of the user, the material to the ease of cleaning? Never mind, since we are inside, the smudgy signature "R. Mutt" upon the outside, which of course is part of the work of art, and the distinction of this signed urinal among other mitt- and mutt-stained recept-acles of the less glorious waste products of humankind. Man signing as dog signing as man brings to mind the possibility that a dog's duty is perhaps simply to sign, mutt though he be, in a wonderful reversal of, to take a case at random, life on the New York streets, where mankind's duty is to rush about after dog's duty and undo it, with small plastic bags.

In part, it is still just a question of naming: Duchamp entitles himself to his urinal by signing it and to his shovel by naming it, referring the reader of the name to the snowy sidewalk outside and to the idea of its use included in it. Concerning anything else we bring to the shovel, we are all too well aware that it may be shovelled away. For the title, we might bring, for example, Georg Simmel's essay "The Handle,"[3] or a Stevens or Williams poem on the snow; but are they relevant to what this shovel shovels? As for what we bring, is it ours? Is this essay mine? Who is to say at how many successive distances the work of art is optimally to be framed? Who among us has the final word? The final text?

And, if effaced or cleaned up, the trace or the lack of trace of the effacement bears a different relation to the work. An act of inadvertent vandalism, the removal of the signature "R. Mutt 1917," for instance, in order for it to be cleaned up as porcelain, would also be part of the exhibition. In the case of deliberate effacement, the *Fountain*'s relation to all works of art consisting in the effacement of other works of art, such as Rauschenberg's *Erased Drawings*, would facilitate the effacer's labeling his work as gesture, like this: "Signature on urinal effaced." Would it then be thought to bear a relation to Mallarme's own cold white page? Were the latter-day symbolists to drink a

Virgin Toast in this container as cup, would it be a ghastly parody, or a deeply referring act?

(In Henry James's *Golden Bowl*, directly before their inebriating love scene, the Prince and Charlotte toast their fidelity to their spouses from a tea cup which is the ironic, reduced, discolored, and at least partially parodistic image of the Golden Bowl itself, central to the novel and the very paradigm of a self-containing image. The fragility of the two vessels is, I presume, the connecting term.[4] Of course, the James example is the very opposite of the ready-made images of Duchamp, as most would see it. Relating to that net of goldenly confused imagery heavy with symbolic weight the references in Duchamp's urinal as *Fountain*, more stable, less breakable, and considerably funnier, even in snapshot, is valid only for the relation of the container to the act of containing, and as a Dada act.)

Reading *Représentation*

A very "Ready Maid" indeed, the subservient maid often placed on a postcard and signed by Duchamp, with her apron awaiting our gaze: what is her relation to the ready-made *The Bottlerack (Bottle Drier)*, that graduated series of encircled pointed objects? And how about the potential relation of the maid on the ready to that snow shovel? If what is imagined tends to become the real, as Breton somewhat strangely thought, perhaps at least she could help name the product. Our reading of the relations of that image is probably determined by our reading of the sociological situation in which the image is, and we are, inserted. The institution holds the key, even here.

In Duchamp's presentation of male and female potholders called *Couple of Laundresses' Aprons* – that is, of an object without the maiden – the heavy-duty tokenism cannot fail to refer us to other aproned ladies, partially seen on the job, from the *Victory of Samothrace* to Magritte's own *Le Caillou* (*The Pebble*), showing a lady nestling into her caress of herself in the shower. Now, keeping simultaneously in mind the notions of partiality, tokenism, and the representation of the female, we might look at representation itself, as conceived of by Magritte. His painting of the middle part of a female body, heavily outlined and titled *Représentation* (plate 3.4), with its provocative containment of the maiden, or, rather, of a significant part of the maiden, does its job in doing quite a job on her. The female presented only by her middle region seems to be representing not just representation, but all of re-production itself, engendering the whole issue as well as this picture of herself.

As for the representation of this *Représentation*, it is so darkly bounded, like some isolated glass window rimmed in black to be admired as emblem, that the emphasis seems to fall on inclusion rather than what is excluded. Other and outer relations matter less here than the family of problems so related. What, for example, of the idea of inclusion in representation – as it

includes these parts and frames out the rest? Is it "additive" or "subtractive"? Does it metonymically bring in all the rest, or metaphorically represent reduction?

About the female represented, is she a woman, or woman as a whole, therefore larger than any woman? If a whole, she still looks like a part to me. If that is what we are given, if that is what is found – it ain't everything.

However, a picture called *Représentation* is bound to "mean" the act of representing, but what? The portrait of the male artist as a young woman? The portrait of some of the aspects of the artist as part of a woman? Or just representing and reproducing, and self-engendering, given the part of the body chosen? Art is here in any case its own bare take-off, a sort of striptease representation of another Ready Maid, whom we are back to reading.

Fragments and their fate

It refers also, as I read it, outwards, to legends of fragmentary beings such as the Headless Horseman, although with difficulty, because the sex change is nothing compared to the absence of a horse as well as a head; Lady Godiva would be more like it. More easily it refers to such great torsos as the *Venus de Milo*, who had lost a few things herself by the time she had found her present place of exhibition. Of course she did literally suffer a fragmented fate, for her two parts, once badly matched, even when reglued, left a question. Whether the signed block found by the side of that Venus, and inscribed "Andros of Antioch on the Maeander," is or is not to be read with her (as it is recorded in the drawing of the statue made for David) is another question to be assigned to the set of part/whole problems.[5]

Or, then, changing the sex of this torso to the masculine, its fragmentary nature except as complete representation might refer it to the *Belvedere Torso* Winckelmann raved so over, as did Reynolds, to his students at the Royal Academy in London, about the copy before them: "a mind elevated to the contemplation of excellence perceives in this defaced and shattered fragment, *disjecti membra poetae*, the traces of superlative genius, the reliques of a work on which succeeding ages can only gaze with inadequate admiration."[6] The very picture of Michelangelo kneeling in front of this torso and surprised by a cardinal haunts the imagination, as does, parenthetically, Winckelmann's analysis of the navel of the *Venus de Medici* in its unusual depth and width; this turns our meditation device back upon itself and its own generation of parts.[7]

To extend the discussion, what is the relation of a partly partless statue to the *topos* of the mannequin, so often, as in Hans Bellmer, parceled out into a fragmented witness to a modern mannerism? Apart from the implications of isolating some fetishist object, setting the part aside for attachment, the outside references to other parts and statue fragments, whether classical,

mannerist, or the latter-day mannerism of surrealism, intensify the speculation of the observer as to what the rest might be like, and speculation is, in the clearest sense, what this kind of mirror art is all about. It is after all a reflection on a picture of the representation of metonymy, of the parts not just standing, but also looking as if they stand here, rather significantly, for the whole. This image stands for what stands for.

Does this representation stand as a part of classic beauty, referringly statuesque, or as a part of us, of some of us, or a part of a peeking mentality, or of daring modern exposure, or even of the division of society? (Is it time to consider Duchamp's *Feuille de vigne femelle* [*Female Fig Leaf*] or his *Coin de chasteté* [*Chastity Wedge*] as the Concealment and Protection of the Part?) Or as self-portraiture, done here by the other, not by Mrs Magritte or any such, but of the Other, or part of the Other in us, rather like Flaubert's vacillation between "Madame Bovary, c'est moi" at one time and, at another, "Madame Bovary, ce n'est pas moi"?

De Chirico's fruity *Uncertainty of the Poet* combines a fragmentary lady with a male symbol, like a bunch of keys to the work. And, in case we had not taken his point, he makes in the same year *The Dream Transformed*, like a transfigurative self-interpretation, in which the head of a Greek god in statue form is placed at the left to contemplate two large pineapples replacing the female torso, and, still farther to the right, two bunches of bananas. The reading is, for a modern audience, scarcely in doubt.

Woman transformed

But let us take another classic example of representation in the world of art, as recently brought again before our eyes by Arthur Danto in *The Transfiguration of the Commonplace*: Hendrijke Stoeffels as Bathsheba by Rembrandt, of which the subject is, as Danto points out, Hendrijke-as-Bathsheba and not Bathsheba as such. Rembrandt leaves the folds and wrinkles and fallen breasts upon the picture, being part of the woman he loves. And that woman, with just those marks of life upon her, is Bathsheba, a woman of beauty enough to tempt a king to murder for the possession of her. What we learn here is the framing metaphor of the work. To show that plain, dumpy Amsterdam woman as the apple of a king's eye has to be an expression of the talent of Rembrandt, held up as a model.[8] To hold up Magritte's representation of *Représentation* against Danto's verbal representation of Rembrandt's love as it represents itself is again about as violent a contrast as we could seize upon: a young body and an old; a neutral brush, a photographic rendering, against the brush of love; part of a young lady, of undetermined nationality, this young lady whose parts are partially represented by a Belgian, appears rather different from the entire dumpy Amsterdam matron, by a painter no less Dutch than herself.

What of what all these representations represent for the subjective experience of the individual observer? Do we read a young lady as representative of youth and ladyhood, middle parts as representing just middle parts, and old ladies as representing age? Or is all art about art and love and life and what happens to them?

As a concluding question, which of all these object pictures for art and reading is most useful? You can shovel with the shovel but not with its picture, or at least not very well. You can play with the maid only if your imagination is up to it, and that is really all she is ready for, after all those centuries of tradition: Art as Exploitation of the Lower Classes, or Female Sex Objects Wearing the Symbols of Oppression. A maid or a kitchen apron are found, seen, and, often, worn or worn out.

What, after all then, can you *do* with *Représentation*? How do we transfigure the partial figure? Or, to recirculate my starting fragment, how does one make a ready maid, especially a statuesque one, in an age of mechanical reproduction? If she is aproned off, how do you rope her in, or otherwise frame whatever it is she represents? Art is easy to collect but harder to contain. It keeps relating.

Standing on the real: a footnote about partiality

Duchamp's object lessons have the same wry humor as that shown by Henry James's ironic and dreadful play on art and reading and models, on us and the real, in "The Real Thing." Here the artists' models are more convincing than the real people represented by them, so that finally the real thing is refused because it is too merely real and too merely constant, and therefore not part of art.

And that is only part of it; to give my reflection something to stand on, let me quote from Winckelmann, the great fragmenteer. After reminding us of the highly memorable fact that "the nails are flatter on the feet of antique than of modern statues,"[9] he adds, "Very many beautiful feet have come down to us; so that whoever attempts to designate the most beautiful may perchance omit others fully as beautiful."[10]

At the risk of omitting other useful parts and footnotes, I end with this footnote on selection, a partial sending back to or up of Magritte's challenging version of partiality as *Représentation*, which selects, reframes, and remakes art on the ready, making a serious fragment of a whole body of art.

SURREALISM

6

The MEANING of SURREALISM, and WHY it MATTERS

And this object should be, first of all, what matters; it matters in a way
quite different from the one in which it looks like the sky, or like blood.
André Breton[1]

Mattering

Mattering matters, outside of reference; it is essential to the spirit of
surrealism, perhaps more than to any other of the literary and artistic
movements which characterize the early part of the twentieth century. The
surrealist fact that whatever is chosen to be imagined as real is assumed to
become so is paralleled by the surrealist fact that what is chosen to become
important indeed becomes so. Unembarrassed, the surrealist writer or reader,
actor or observer, decides to have as a matter of concern the fact of being
concerned, however unfashionable; this is quite as important as the meaning
or meanings we might ascribe to the movement.

I am speaking as a surrealist reader, trained over a number of years by the
texts I confront. Equally important to such a reader is the scope of inter-
pretation: if, in the title of this essay, I put "meaning" in the singular, that
singularization cannot be or at least should not be read as a dogmatic narrow-
ing in. In surrealism, no image is tied down, but all are free:

This essay was first published in Mary Ann Caws (ed.), *Writing in a Modern Temper: Essays on
French Literature and Thought in Honor of Henri Peyre* (Stanford, Calif.: Anima Libri, 1984),
pp. 146–63.

Jamais le ciel toujours le silence
Jamais la liberté que pour la liberté[2]

(Never the sky always silence
Never freedom except for freedom)[2]

This does emphatically not mean ever that surrealism means *a*, and not *b*. But it does mean, on the other hand, that whatever I take it to mean, or you take it to mean, or *X* takes it to mean, that it means. These meanings in fact are indeed the matter not with but of surrealism. To quote Breton: "Nothing is inadmissible, in my opinion" (*PJ*, p. 26).

An "open realism," as he defines surrealism, coincides with the "open rationalism" he sees in modern science, disturbing the sensibility (*PJ*, p. 102). A plural meaning, and a serious matter; these are indeed the basic tenets of an open surrealism as I view it now. As we move into what does, I think, mean most and how, and why, I shall give subheadings like would-be landmarks to the mattering of my main heading, and shall be, however implicitly, signaling what, from my viewpoint, does indeed matter intensely about surrealism's meanings, from this viewpoint to the next. First and foremost, surrealism teaches relations and the art of interacting.

Relating and bridging

The unique relation made to the listener or the viewer or the reader by the bearer of the surrealist message is at once a relation of, and a relation between. The relation of a meaning, or a meaning of meanings assembled, gathered, and made quintessential, already defines the bearer of that meaning as a describer and an interpreter.

Creating and evoking are the linkings to the outside of a new power within, whose continual expression it is the highest duty of the surrealist to faithfully relay and relate: "I have never appreciated in myself anything other than what appeared to contrast drastically with what was outside, and I have never had any misgivings about my interior equilibrium. That is why I consent to keep some interest in public life and, in writing, to sacrifice to it a part of my own" (*PJ*, p. 27).

This relating role relates, I think, to the other relating role, that of bridging objects in the world and their perception, the very feel of them and of their own essential message substantially incarnated, and of the spectators who perceive them, which is to say, ourselves. Our selves as relaters, tellers, describers, interpreters, critics, and writers, are essentially and providentially related to our selves as sensitive speakers of an interchange between human and natural forces which is best called bridging, or *interfering*.

Intersecting and interfering

Breton describes Dali as "one of those who arrive from so far off that when you see them enter, and only enter, you have no time to see them. He places himself, without saying a word, in a system of interferences" (*PJ*, p. 67).

In the surrealist notion of the sublime point, the notions of interference, net, and intersection are triumphant already: the point condenses, the sight rays converge, and angles, twists, and curves are all shaped in a subjective pattern: "If we talk here of the highest point, it is only because we wish to clarify those curves whose intersection produces this point with its peculiar significance and to attempt to place it in relation to the coordinates of time and place" (*PJ*, p. 95).

The surrealist temperament bridges love and death, high and low, action and dream, day and night, these communicating vessels spilling over into each other, until they join in a supreme or sublime point: "Everything I love, all I think and feel, inclines me towards a particular philosophy of immanence according to which surreality is contained in reality itself and is neither superior nor exterior to it. And reciprocally, for the container is also the contained. It can be considered as a communicating vessel between the containing and the contained."[3]

"The poet to come," reads another Bretonian text, "will overcome the difference. . . ."[4] A poet to come, and the reader already present: but in surrealism, by a further twist, they are identical. A metaphor such as the communication of the vessels makes evident the possible communicability of future with present as of humans with one another. By the outpouring and inpouring of meaning, a special interference is established of solid as of liquid states, of the real as of the emotional objects: this is for perception, and for their expression; all of language is to be remade. One of the most powerful questions ever to be posed by surrealism arises here: "Isn't the mediocrity of our universe a function of our language?" (*PJ*, p. 22).

Speaking and writing are already making and remaking; the power of analogy, first perceived, then described, at last incorporated, is such that not just the marvelous tends to become the real, but, perhaps more important still, the real becomes, incontrovertibly, the marvelous. Perishable, mortal, ephemeral, no more enduring than Vinteuil's little snatch of melody in Proust, no larger than the little patch of yellow wall: but what could endure longer, or better render to mortals the conviction of immortality through art?

Doubting and desiring

Descartes's doubt was provisional. Many of us who started out in philosophy came, I think, to doubt that doubt, and for that very reason. It seemed poised

there at the entry of his system, providentially chosen and not inflicted; it seemed of short term, and infinitely disposable. But surrealist doubt, grave always, is related to a personal unrest, a profound discomfort at the depth of a feeling surrealism is quick to draw out, and slow to let go. Despair is lyricized, understated, and convincing, as in Breton's "Le Verbe être" ("The Verb To Be"):

> Je connais le désespoir dans ses grandes lignes. Le désespoir n'a pas d'ailes, il ne se tient pas nécessairement à une table desservie sur une terrasse, le soir, au bord de la mer. C'est le désespoir et ce n'est pas le retour d'une quantité de petits faits comme des graines qui quittent à la nuit tombante un sillon pour un autre. . . . Dans ses grandes lignes le desespoir n'a pas d'importance. C'est une corvée d'arbres qui va encore faire une forêt, c'est une corvée d'étoiles qui va encore faire un jour de moins, c'est une corvée de jours de moins qui va encore faire ma vie.

> (I know despair in its great lines. Despair has no wings, it does not necessarily remain seated at a table cleared upon a terrace, in the evening beside the sea. It is despair and it is not the return of a mass of little facts like seeds leaving one furrow at nightfall for another. . . . In its great lines, despair has no importance. It is a burden of trees to make still another forest, a burden of stars to make still another day less, a burden of days less to make my life still again.) (*PJ*, p. 120)

What is not said, but only hinted at, is often just what, in other movements, would be said aloud or shouted; in Eluard's poem "Oeil de sourd" ("Deaf-man's Eye"), the title is already indicative of the compensatory impulse (not hearing, thus seeing). We might associate this with some philosophy of accommodation, were it not for the poem itself, as it stutters along:

<div align="center">

Faites mon portrait.
Il se modifiera pour remplir tous les vides.
Faites mon portrait sans bruit, seul le silence
A moins que – s'il – sauf – excepté –
Je ne vous entends pas.

Il s'agit, il ne s'agit plus.
Je ne voudrais ressembler – [5]

Do my portrait.
It will change to fill all the cracks.
Do my portrait noiselessly, just silence
Lest – if it – unless – except –
I don't understand you.

It's a question of, no longer.
I shouldn't want to resemble –

</div>

The poem is not finished, but left open for the insertion of all resemblances, and yet its very stuttering speech casts doubt ultimately upon our understanding, upon our making of portraits, our interrogations of ourselves and of them, and even and especially our understanding itself. Our portrait of ourselves is often made complete by our taking on of other roles, which, in their very strangeness, in their distance from us, become part of ourselves.

> Oh eternal theatre, you require that we put on the mask of another, not just to play his role, but even to say of what it consists, and that the mirror in front of which we are posing should give back a strange image to us. Imagination has every power except that of identifying us in spite of our appearance with someone other than ourselves. (*PJ*, p. 8)[6]

What we resemble, however variously, modifies us, and increases not just our doubts about our ordinary costumes, but our assurance of our own continuing and refreshed desires, refusing boredom.

Not spelled out, never defined, surrealism's desires, which are supposed to be captured in their very fluctuation, may read like some vague manual of self-intensification combined with an intensification of the world around us: to act in a way appropriate to the lyric relation of person and universe (that "lyric comportment" with which Breton identified surrealism) or to change the world and the word ("change the Word," said Rimbaud, "change the world," said Marx; change both, says surrealism in its highest moments).

But doubt always was to surface, all along the way. There resides in this very uncertainty turned upon itself the very thing some of us persist in valuing above all else. To this tone we might ascribe our affection for surrealist writing and its violent appeal of contraries. "It is time perhaps, to turn back," says Breton, at the height of his marvelous encounter with the recipient and the giver of Mad Love. And, walking together with his new-found heroine so loved, among the garbage scraps tossed on the sidewalk at midnight, he has a moment of utter doubt. This high lyric passage, extreme in its fluctuations of despair and exaltation, ranks with the greatest moments of surrealism and is marked by their unique stamp. It is at once self-questioning, assertive, and meditative; it is poetry at its highest point. It is, like the point of juncture in surrealist philosophy, sublime, a true *point sublime*:

> Of what am I finally capable? How shall I not be undeserving of such a fate? . . . All sorts of defenses become visible around me, clear bursts of laughter rise from the past to finish in sobs, under the great beatings of grey wings in an uncertain spring night. . . . Who goes with me at this hour in Paris without guiding me, whom, moreover, I am not guiding? I never remember having felt such weakness. I see the bad and the good in their crudest state, the bad winning out by all the ease of suffering. Life is slow and we hardly know how to play it. . . . Who goes with me, who

goes in front of me once again tonight? . . . There would still be time to turn back.[7]

How can humans swear their faith, make their promises of lasting fidelity beside the ruins of nature? The same questions asked by the romantics are asked again, answered differently. Everything flows, rushes, crumbles, and we with it. What, then, is immortality, asks the questioner, or what, then, is any promise, or then, death? And the answer, given among others, by Desnos among the greatest, takes its initial term from what seems most trivial, from an advertisement for a brand of soap, with a baby continually wreathed in smiles. From this unpromising beginning, seeming not to matter at all, it soon works out its juxtapositions of reality, irony, and lyric understatement:

It's Baby Cadum, eternally smiling on the wall, it's Robespierre's sublime sentence: "Those who deny the immortality of the soul are doing themselves justice," it's the laurel tree yellowing at the foot of a column truncated on purpose, it's the reflection of a bridge, it's an umbrella glistening like a sea monster spied on a rainy day from some fifth floor.[8]

Definitions redefine always, and repeatedly, in surrealism, and each new one at once raises doubts, desires, and consciousness. Desnos, himself the inspired author of the *Third Surrealist Manifesto* (*Troisième manifeste du surréalisme*), himself the greatest imaginer – eyes closed or open – was not its least great thinker or its least modern mind. This theoretician of the film, this truly great novelist, this poet of the most heartrending texts, sees and sees what matters.

Love is, he continues here, mixed with death in a marvelous concoction, a new potion of *Liebestod* drunk by whatever lovers surrealism may sponsor, never guaranteeing permanence, but only celebrating that which passes, like Baudelaire's celebrated "passer-by": ("O toi que j'eusse aimée, / O toi qui le savais . . ."), loved because the meeting could not last, the love not be put to the trial of endurance.[9]

Desnos explains:

The past and the future are subject to matter. Spiritual life, like eternity, is conjugated in the present.

If death touches me, it is nevertheless of no concern to my thought or my mind, which are not rolled along by even the noblest hearse, but concern rather my senses. I can imagine no love without the taste of death mixed in, stripped of all sentimentality and all sadness.[10]

This is not provisional doubt, but real awareness of mortality, heightened and intensified to the level of exalted lyricism heard at the moments of greatest surrealist expression, never devoid of that awareness, but rather taken through it to a state far on the other side of pragmatic movements in which other things than mattering come to mind. "The limits assigned to expression are exceeded once again" (*PJ*, p. 145).

Perception and revolution

An odd aspect learned from surrealist writing in surrealist reading is the enforced vision or the peculiar focus. Amid the details of what seems an ordinary description, the sight is made to concentrate, in a space progressively narrower, upon an element of singular nature, like some condensation of plot or character traits. The view of the onlooker – obliged to compactness or compacity and obliged with that to an intensity and clarity not always available to a wide-range vision – is trained upon the detail, moving in closer and closer.

Take this quite unhidden passage found at the end of Dali's *Hidden Faces*: "All things come and go. Years revolved round a fist more and more obstinately closed with rage and decision, and this fist, since the character was sitting in a large armchair with his back to us, was the sole thing which it was given us to see."[11] Here the fist controls our vision with its own intrinsic violence.

Now, the point of the surrealist revolution is to upset the forces of stability, of sedentary-mindedness, of a world, as Artaud puts it, "delivered to the forces of desiccating reason, to the copying tendency struck in the mud of centuries."[12] The flatness and dullness, the boredom and certainty of a world to whose perceiving we are too accustomed to see it afresh is attacked by exactly this concentration upon one odd point, with the "concrete irrationality" recommended by Dali, as it mixes with his "irremediable lyric contagion," in a dialectic far removed from the static and reasonable madness we might want to appropriate, and to use.[13]

Surrealism refuses, as we know, to be used. Present surrealist reading refuses to separate one tendency from the other as outlawed or unsurrealist in nature. Meanings are all present in the delirious image, one of the finest offsprings of convulsive beauty. Ecstasy – the counterpart of delirium – depends on the vivid and the vividly expressive, the totally consuming and consumed experience. An experience both convulsive and occasionally comestible: "So it was a question of building a habitable building (and furthermore, as I saw it, edible) with the reflection of lake waters, this work displaying the maximum of naturalist rigor and *trompe-l'oeil*. Let us shout what a gigantic progress this is over the simple submersion practiced by Rimbaud, sinking a salon in the depths of a lake."[14]

From there to the most rapid conversions of sight into taste, the most drastic appropriations of the universe by the all-appetited devourer, is only a step. At the feast table in *Hidden Faces*, the sadistic Grandsailles is seen

> bringing the light very close as if in calling attention to the budding curves of Solange de Cleda's breasts exposed above her décolleté. Here her skin was so fine and white that Grandsailles, looking at her,

cautiously dipped his dessert spoon into the smooth surface of his cream cheese, taking only a small piece to taste it, snapping it adroitly with the agile tip of his tongue. The slightly salty and tart taste, evoking the animal femininity of the she-goat, went straight to his heart.[15]

The brilliant and deforming rage of the host transforms nature into the unnatural, twisting the images of the guests into "their own animality. As if in an instantaneous demoniac flash one saw the dazzling teeth of a jackal in the divine face of an angel, and the stupid eye of a chimpanzee would gleam savagely in the serene face of the philosopher."[16] But the absorption of the outer universe in the interior world of the transformative senses leads eventually to the same despair of boredom at having absorbed too much, eaten too avariciously, seen too lustily, for the lust to last.

This grave despair gnaws at the heart of surrealism. All the glorious rage of revolution leads to the inglorious and halting speech: "I have seen," says Breton, "Tzara without words to order matches in a café"; "one might well say to the woman loved and found again after a year's absence, not Bonjour, but Adieu."[17] I want to propose this very irresolution, paradoxically, as one of the summits of surrealism, and of the surrealist revolution in perception and feeling.

For the uncertainty of self-identification coincides often with the uncertainty about oneself as it seems to the other. René Crevel, committing suicide, taped to his wrist his name in large letters: "René Crevel." For whom? A signal full of meaning, or an empty signal, to use a term of Eluard? To name oneself after death as oneself is surely an obsession with inscription as ascription; Crevel is ascribed to Crevel, just as he is named.

Artaud dying with his shoe in his hand, that shoe with which he beat out the rhythm for the incomprehensible words he shouted; Crevel naming himself at the moment of death; Jacques Rigaut propping up his wrist upon a satin pillow so that his firing hand would not tremble as he directed it upon himself; Jacques Vaché, used to drugs and knowing their use, overdosing with two friends as if by accident – which of these is a tragic death, and which is an inscription by will and by design upon a universe desperately appropriated, if at all, by this poetic plan? We do not now make those large gestures, those of us grown accustomed to reading them, inscribed as they are now only in their own time. What we ourselves do with texts, what we do with tragedies for others and ourselves, may indeed seem to have nothing to do with surrealism and its signals, empty or full, with surrealism as it sang itself in its heroic period, which we may now vicariously see as our own.

But what we do with what we read is surely the question, and cannot be turned aside. Not how we admire, or even what we emulate or put off, or turn away from, but what, in fact and in our freedom to judge and to be and to write, we do. For each of us, I have to suppose, there is a separate answer. To the extent that we absorb what we have as it is most lasting, not making of it

our property, but rather our inner life, to that extent, what we choose to read matters, just as what we are becomes coincident with what we choose to be. Reading matters, then, like being.

Being

Surrealism is never less than realism, and always more. When Breton accuses his age of what he calls "miserabilism," it is an accusation of settling for the less instead of the more. He turns towards an intensity luminous and resonant even in its strangeness, so willed and chosen often so far off.

> Orient, victorious Orient, having only a symbolic value, dispose of me, Orient of anger and of pearls! In the turn of a sentence as in the mysterious strain of a jazz melody, let me recognize your manner in the next Revolution, radiant image of my dispossession, Orient, lovely bird of prey and of innocence, I implore you from the depths of the kingdom of shadows! Inspire me to be from now on the one without shadows. (*PJ*, pp. 28–9)

And yet, in close and even ardent contact with the real, the surrealist sensitivity draws near to the object even when mystifying it, rather than taking its distance: "That this bunch of flowers I am about to smell or this catalogue I am leafing through seems in advance to exist should suffice for me; but it does not. I must be assured of its reality, as we say, I must make contact with it" (*PJ*, p. 11).

This is, clearly, a hands-on movement, quite unlike some of the other twentieth-century movements, such as the existentialism that follows so closely on its heels. To contrast the two, we have only to compare the attitude of Sartre's Roquentin in *La Nausée* toward those viscous pieces of matter that bring the nauseated feeling for the touch, and even the kill, with Dali's hero Grandsailles in *Hidden Faces*, rolling the piece of cork tree between his palms, delighting in the very matter of the tree: "And in passing he would tear off a handful of cork-oak leaves from a low branch, squeeze them tightly and roll them in the hollow of his hand, enjoying the sensation against his fine skin of the prickly resistance of their spiny contact whose touch alone sufficed to isolate the count from the rest of the world."[18] The surrealist leans forward, chooses, touches, and believes him- or herself, as Breton puts it, unique and selected to carry a message out toward the world from the world inside and from the world outside to the world in:

> Beyond all sorts of tastes I know myself to have, affinities that I sense, attractions I feel, events which happen to me and only to me, beyond all sorts of gestures I see myself making, emotions I alone endure, I try, in relation to others, to ascertain in what my difference consists, without

even knowing why. Doesn't my consciousness of this difference govern my self-revelation about what I alone have come into this world to do, and what unique message I bear for which I must be responsible, at my own risk?[19]

Seeing and revealing

This common butterfly forever halted near a dry leaf, I wondered one whole afternoon how it happened to confer this special importance on the tiny canvas that I had seen that very morning in Picasso's studio. The objects towards which I had subsequently turned, objects which I appreciate among all others, had seemed to me freshly illuminated by it – I wondered how it came about that this unique emotion depended upon its perfect incorporation into the painting which, once it takes hold of you, provides incontrovertible evidence of a sudden revelation. (*PJ*, p. 144)

Picasso's canvases are directed, says Breton, toward the complete consciousness of self, but also toward the revolutionary goal of making the universe conform with that self ("Picasso dans son élément" – *PJ*, p. 151). And yet, no matter how extraordinary the revelation made to us by such canvases, or by the *papiers collés* in their joyous brilliant abandon miraculously or at least marvelously – like *le merveilleux* – identified as works of triumph, no matter how unlike the Dada abandon and the statement it makes, no matter anything at all, the perishable so sung perishes.

I want to make what I suppose can be heard as mostly a personal statement: we all read surrealism, as we read anything else, differently from each other, and from ourselves as time takes us on – time, that most surrealist element, according to Dali. When I first worked on surrealism, over twenty-five years ago, I read it as what I then thought it was, a youthful protest, a revolutionary statement against all that was over-academic and chilled, against research and resolution and structure and system, a statement whose excess was its delight, and which was overheated if anything, and had nothing of the academic about it. The particular irony of "making one's career" (a quite peculiarly dreadful expression in any case) by writing and speaking and thinking about such a statement was its own statement, funny and flawed, the one as it was the other, or then the triumph of trying both at once. But then I never thought of surrealism as other than that lyric comportment Breton guaranteed it to be, and have never read it otherwise.

Yet in one sense I no longer read surrealism in the way I used to read it; that is, I now locate its high lyricism at points other than those in which I used to locate it. Let me continue on the theme of the perishable, as one of the things that endures, ironically and magnificently, in surrealism, and quote just

what Breton sees, afterwards, in the traces of Picasso's works on paper. As I do so, I hope the reader will particularly remember that, after all, all we others do, as artists of the everyday, is also doomed to this fate, whether we write on paper or in actions or both. Because it may be fated too, to this kind of aging.

> The twenty years which have passed over them have already made these scraps of newspaper go yellow, those scraps whose fresh ink went a long way in 1913 toward the insolence of the magnificent *papiers collés* of that epoch. The light has faded and dampness has in some spots deformed the great blue and rose cutouts. That is the way it should be. The stupefying guitars made of inferior wood, real bridges of fortune tossed day by day across song itself, have succumbed to the headlong course of the singer. But everything is just as if Picasso had counted on this impoverishment, this weakness, even this dismembering. As if, in this unequal struggle, in this struggle whose outcome is in no doubt, but which is waged even so by the creations of the human hand against the elements, he had wanted to bend ahead of time, to reconcile to himself exactly what is most precious, because it is ultra-real, in the very process of perishing. (*PJ*, p. 152).

This is the response to the doubts that plagued the Night of the Sunflower, the crisis of wondering about turning back in the midst of the wanderings of Mad Love. Nothing endures at its colorful height or its rate of initial speed, which is not to say that nothing keeps its promise. The promise kept is the promise earned, and not just granted. If I defend surrealism as one of the highest forms of humanity, it is – you can be sure of it – not because of its bravado: going down to shoot the first person in the street was no more Breton's real program than it is ours, and the great menaces proffered in the manifestoes were less manifest than the intensity of the positive style and the reach.

And it is also in this response to what perishes, as to what endures, that surrealism speaks to us now, as we ourselves are, in some sense, of a fading light and a diminishing color, as even our revolutionary instincts are dampened and our energy slowed. It is by this means too that lyricism triumphs over life itself, by loss itself, and, especially, by love. Breton chose that way, certainly, like Picasso, and like the poet he was. What Magritte lights up in the painting called *La Lumière des coincidences* (*The Light of Coincidence*; plate 3.3), with his candle still burning, after all the paintings of *vanitas*, of the *memento mori* theme from ages past, is not de La Tour's *Madeleine à la veilleuse* (*Magdalene by Her Vigil Lamp*), rather a lady less whole, if you like, selected and framed differently, yet no less luminous. No particular lady, having neither face nor name nor nationality, being, then, all of us or our idea. Only a part of a lady, you may say, as in his *Représentation* (plate 3.4), similarly framed. But this is indeed a case where the part exceeds the entire person: what is represented is as much as what all of Proust's desperate and enduring search for lost time represents: life as art.

Integrating

The poetic spirit, over whose demonstrations there fly two flags, black and red, is thus inscribed under the signs of anarchy and revolution. These form the "collective myth" to be flown as the standard of our generation and its successors: "Poetry and art will always keep a special place for everything that transfigures a person. . . . Whether we like it or not, there flies – above art, above poetry – a flag now red, now black. There too things hurry by: we must take all we can from human sensitivity."[20]

Bearing just as surely a witness to sensitivity as to a violent concern with non-institutional truth, this spirit marked with a double sign-language is an integrative one. It gathers, unites, resolves. For all conflict exterior to the surrealist temperament, the person possessing it, described by Breton, is to be the resolution, having become what he terms a poet: how could we find a better term?

> Nevertheless, poets over the ages have provided us the sensitivity which alone can restore us to the heart of the universe, abstracting us for a moment from the kind of adventures which dissolve the personality, reminding us that we can be, for every sorrow and joy outside of us an always more perfect place for resolution and echo.[21]

Integrity combines exteriority with interiority, and puts a high moral value on the combination; but the mixture is anything but adaptable to our rigid structures of church and state. Surrealism as revolution was first termed "The Surrealist Revolution," then, "Surrealism in the Service of the Revolution," and then "Surrealism, Itself." That last says it all, and I would stick with this all-inclusive, all-integrating term, already containing, as vessel, and communicating, as one of the vessels which express exactly that prolongation into the heart and mind and spirit of all that surrealism was ever to be and to mean.

Manifesting and meaning

If surrealism at its best is permeated with an intensely moral sense, what it manifests is no less dangerous to what the French call *les assis*, or the comfortably seated. And that is, probably, all of us as we read or speak or hear of surrealism, now. Once that meaning is comfortably absorbed into exhibitions or expositions, explanations or explications, it is itself analogized, and ciphered only to be deciphered.

Is this not, even here, the temptation to rely on what is already seen, as opposed to the surrealist tendency, to thrust toward what has not yet been? ". . . the constant temptation to confront everything that exists with everything that might come to exist, bringing forth from what has never yet been

seen the very thing that might persuade what has already been seen to make itself a little less dazzlingly visible."[22]

Poetic theoreticians hold forth on "The Surrealist Metaphor," linked or not. Poetic imagicians – how far, alas, from what surrealist magicianship could have been – discourse endlessly on "The Surrealist Image." Poetic-genre enthusiasts explain "Surrealism as a Non-Genre" or divide its own manifestations up into "The Surrealist Theatre" or "Surrealist Poetry" or "The Surrealist Film" and the like. No movement worth its salt is, of course, to be taken in by such generic nets, by such divisive categories. And yet which of us is not guilty of that divisionism, if it is considered a flaw? I can in no way, for example, count myself outside the dividers, post-movement seers of what there was, genuinely, to see.

Readers are always afterwards, nor does it take any blush off the Bloom to see or to say that. Strong readers or writers or critics are just a little more strongly reactive. What is, among other things, miraculous about surrealist reading of surrealist writing is very precisely its presentness, no matter how after it seems:

> Are poetic creations meant to assume immediately this tangible character, to displace in such an extraordinary fashion the borders of the so-called real? The hallucinatory power of certain images, the real gift of evocation which certain people possess independent of their faculty of remembering, will not go unrecognized any longer. The God dwelling in us is not about to rest on the seventh day. (*PJ*, p. 25)

Surrealism, in rejecting the Fall, rejects, and movingly, all doctrine of sin. It gives back, deliberately, to the apple its prelapsarian taste, forgiving even the fruit. Forgiving it because it is, as we are, perishable, and therefore beautiful. The apple neither condemns, nor, in its inevitable rotting, sours: "The poet-to-be will overcome the depressing idea of some irreparable divorce between action and dream, will hold out the magnificent fruit of the tree with the tangled roots and will know how to persuade everyone who tastes it that it has nothing bitter about it."[23]

Or, again, in one of the most radiant poems ever written, Breton speaks of what comes after the Fall, redeeming the apple tree by mingling it with the ever-returning spring and the all-forgiving sea:

> . . . la preuve par le printemps
> D'APRÈS
> De l'inexistence du mal
> Tout le pommier en fleur de la mer[24]
>
> (. . . the proof by spring
> OF AFTERWARDS
> Of evil's nonexisting
> All the flowering apple tree of the sea)

But, then, symbols are, like us, transient. We knew that all along, without phrasing it, perhaps, quite in that manner. When we first read in Proust what we are in ourselves, did anyone indicate to us that the madeleine dipped in the tea might someday take on a cast of marble, so ensheathed was it to be in literature and the subsequent literature of literature? When we first read of roses, and how, lest they were plucked in their first crimson by some rowdy poet (Ronsard, I was told, was fortyish, with bad breath, and balding), did we cast them in reddish bronze to make them last? Did that swan of Mallarmé's, so eternally imprisoned in that lake of ice, turn itself to crystal beyond the possibility of flight from out the whitest page? I think not. I believe not, even, for, were the sublime and frailest images of literature to become hardened and cast forever in the surest bronze or marble or glass, how would literature endure as emotion in the present?

Surrealist literature and perception, like romantic literature and perception before it, celebrates the transient as transient, refusing its entombment as the permanent. It does not cling to what it creates, nor consider it eternal:

> I see Picasso as great because he has constantly defended himself against those exterior things, even the ones he drew from himself, because he never thought of them as anything but moments of intercession between himself and the world. He has sought out, for themselves, the perishable and the ephemeral, against everything which generally serves the artist's vanity and his pleasure. (PJ, pp. 151–2)

So there is no after, but only now. So the highest point of surrealism is at its beginning, and consonant at once with its end, therein included.

Importing and ending

Surrealism is always just starting out. How to say this of a movement which began when the century was in its teens and ended, so think some, with its founder, in the late sixties, if not before? Because, were it not to be so, it never was. "Toujours pour la première fois . . ." ("Always for the first time . . .").[25]

Surrealism sings not a faith that failed, not an illumination that fades, but the hope of undoing itself, sings, then, "la lumière qui cessera d'être défaillante," the light which will not cease, until it ceases to be failing.[26] This is the "avenging arm" of the great idea, the idea that – some will say – had its time.

But the time it had is not even fully yet; and there are some who would maintain, and with all the force of their most ultimate conviction, that we might all be, or each of us, that "perfect place of resolution and echo," were we so to resolve. Were we each to become, and one becomes in this sense only by believing and being, the poet Breton thought we might indeed be. For Breton's key passage on the real key to the fields, not just where madmen and

children roam, but the fields, still more real, of life as it is lived and struggled, won, and finally lost, I give a reading of the key noun, *le poète*, and the key pronoun, *il*, which sets the passage differently but perhaps no less really, for us all, now these many years later. It is my response to the presence now of surrealism, reread:

> Let all poets look for the key said to be lost, for we have it. We can only rise above those fleeting feelings to live dangerously, and to die. Let us scorn all taboos to use the avenging arm of the *idea* against the bestiality of all beings and things, and one day, vanquished – but vanquished *only if the world is world* – let us greet the discharge of our sad guns like a glorious salvo.[27]

This interpretation of that passage betrays my optimism; not the poet "he," as Breton would of course have had it, nor even the poet "she," as some would have it, nor yet the poets "they," to be what is often called safe. No, the poet "we": here my reading of surrealism remains subjective, and thus, I would submit, surrealist in itself.

Whether the world is world, or whether it is not quite only that, surrealism maintains that the becoming of a poet is what will always count, and that this meaning of surrealism is, in the long run, what will most have mattered.

7

POINTING at the SURREALIST IMAGE

All things come and go.
Salvador Dali[1]

I would like to point at the surrealist image, at what it holds out for the reader or viewer, and in what ways it is pointed out or at. Many of my quotations will come, deliberately, from two contrary sources: from Salvador Dali, whose *Hidden Faces* makes a reflecting foil for French surrealism, and from André Breton's poems.[2] Holding these two image-makers and vision-changers together, in what the surrealists call a "precarious enclosure," is already to take a risk by opposing the leader of surrealism and one expelled from its enclosure – that is, Breton the spokesman and Dali the salesman of himself, "Avida dollars," but all the same, or perhaps because of that, a good man with the image. Like some meta-image of the surrealist image, sometimes invaded by the Dada image, taken from two different fields and views, as in the famous method proposed to us, and held briefly in what I hope is a luminous contrast, this hold I take is full of willed contradictions and, I hope too, of active and provocative pulsation – not so much of desire as of vision, unless, of course, one chooses to equate the two.

"Après les tempêtes cerclées de verre . . ." ("After the storms circled with glass . . ." – "Rendez-vous" *P*, p. 36): it is the glass circle or the transparent chain which involves us, and the hold in glass which will hold this intermittent discourse. I shall enumerate as I work, or pass them, the links of my chain, never claiming however, as could Breton, that no link is lacking.

The last section of this essay was first published in *Proceedings of Triennial Conference, International Association for Comparative Literature* (New York: New York University, 1983).

Reading contraries

Like Magritte's *Révélation du présent*, with its finger pointing through the roof of a house, as if to designate domesticity both self-signaled and self-transcending, pointing beyond itself, Breton explicitly emphasizes the deictic in his poetic prose style.[3] "C'est ici" ("Here it is"), he announces of one thing, and then "C'est là" ("There it is") of another. His constantly self-referring presentness as he points to the image is not without its own paradoxical distance, for referentiality will scarcely have been the overriding issue in surrealism. But such distance is not the occasion for any reluctance to designate the required view: "Le doigt a désigné sans hésitation l'image glacée" ("Unhesitatingly the finger has pointed out the frozen image" – "Cours-les-toutes," *P*, p. 185). Frozen, this image is caught like a fly in amber, with all its latent activity, in the potentiality of its own wing-beat, held vibrant and shimmering. Such a baroque presentation is proper to the surrealist image, caught and held, forever complexed and contradictory – conceptually and structurally – with and against and across from images preceding and following. A crucial ambivalence is at work, and a whole aesthetics at stake. A single image will suffice to illustrate it at the outset.

Any reading of René Magritte's *Les Vacances de Hegel* (*Vacations of Hegel*), that object lesson in upside-downness and reversal – where a water glass is posed delicately upon an open umbrella – involves the reader in a pattern of contrary attractions, demonstrating what is so felicitously called "reciprocal inclinations." The vibrations persist after the initial shock: the oppositions work visually, syntactically, and conceptually. They are posed in this condition of vacation or "vacancy" (*vacances*) and, as such, refer as much to openness as to the ironies of collecting in a glass what one is protecting oneself from. The black umbrella with a glass of water on top is nonetheless a sign of openness, for all its irony about potential rain. What leaves the present open is the vibrations of the contrary signs (catching and holding as precious what one is being protected from; open and closed; and so on). The deferrals and contradictions in *Les Vacances* remind the reader of Magritte's *Homage à la dialectique* (*In Praise of Dialectic*), where a window opens on another room with a house in it. These readings upset singleness of mind and linearity of reading, and are thus vacations from logical thought.

In the contradictions and reversals of surrealist imagery, typically, a confrontation is set up: so a masked man is seen to be standing before a naked woman, a contrary-to-fact projection preparing an inside–outside opposition: "Si seulement il faisait du soleil cette nuit. . . . Que ne grêle-t-il à l'intérieur des magasins de bijouterie?" ("If only the sun were shining tonight. . . . Why doesn't it hail inside the jewelry store? – "L'Aigrette," *Clair de terre*, *P*, p. 149); or in the words of another poem in *Clair de terre* (*Earth Light*), "Le soleil blanc est noir" ("The white sun is black"): all this fits Breton's

oxymoronic and contrary phrasing of vision: "C'est le *style* du cadran solaire à minuit vrai" ("It's the style of the sundial at true mid-night").[4] No particular preparation is needed or offered: the clash of contraries suffices as self-justification.

Now, what might be called a convulsive aesthetics, that of the contraries in opposition, makes an arrest at the summit of its action. (See Rosalind Krauss on convulsive beauty and its fruitful dilemmas pictured.[5]) The dancer whirling to illustrate this ardent glacial beauty, pictured in *L'Amour fou* (*Mad Love*), or the crystal which Hegel called the union of contraries and which then became, thanks in part to Gaston Bachelard's representation of it, one of the privileged "objects" of surrealism: such convulsions resemble the hysterical fits of the patients Breton had dealt with in his psychiatric work. In the same line, the calmer fluctuations of action, such as "La main dans l'acte de prendre en même temps que de lâcher" ("The hand in the act of taking and at the same time letting go" – Breton, "Les Etats généraux", *P*, p. 220), still manifest the style of contraries, and determine a good part of surrealist poetry and poetics. Like the fly caught in amber, whatever image or animal is caught under the glass, in its baroque agitation, seems hysterical in its self-opposition, beating its tail or coda in time to surrealist music:

> Un poisson rapide pris dans une algue et mulipliant les coups de queue
> . . .
> A la vie à la mort cours à la fois les deux lièvres
>
> (A quick-darting fish taken in algae, multiplying its tail-beats
> . . .
> Towards life and death run both hares at once)

> ("Cours-les-toutes," *P*, pp. 158–62)

Dali prepares his contrasts by temporal, visual, and emotional markers, pointing at them in a visible overdetermination. The following passage is grammatically set aside and announced early on by a temporal signpost. The expectancy is further stressed psychologically by the adverb "Breathlessly," and the visual setting for the extraordinary contraries permits the pictorial to flourish. Object and place reflect on the idea of reading, for a crystal ball, indicating the potential scaning of the future, makes a visual contrast with an ebony banister – reminding us of all the ascents and descents of such celebrated poetic pictures as La Forgue's *Encore à cet astre* (*Still to that Star*), Marcel Duchamp's ascending and descending nudes, and Robert Desnos's climbing sphinx in "Pour un rêve du jour" ("For a Dream of Day"). The clash of the crystal with the black ebony dramatizes the presentation, like the prayer of the surrealist that the crow replace the dove as a mascot for the poetic trip, or that the volcanoes be flaming with snow. The baroque oxymoron is spotlighted here in Dali, set in several *turns*, as the brilliant projection of a wall winding, of the wavelike pattern on the green and shiny marble as if in

some underground watery scene where Madonna and sphinx may meet appropriately:

> When Grandsailles rang the downstairs doorbell, Solange could not restrain her eagerness. She rushed out to the landing, stood there, tightly holding with her two hands the crystal ball that adorned the top of the ebony banister. Breathlessly she listened. . . . Standing thus, in the dim electric light that bathed this spot, her expectant figure resembled that of a chimera, a celestial Madonna's face attached to the equivocal, full-curved and half-animal body of a sphinx. (*HF*, p. 167)

Surrealist reading demands flexibility of outlook: these mismatched sets show up in reversals and crossings over, along the horizontal axis (Breton's "day and night exchanging promises") and along the vertical axis (up and down stairs), and in combinations of both.

Delay, displacement, and deferral

Directly apposite to the doubt present in surrealist reading of situations is the aggravated sense of frequent put-off or deferral. The latter functions by placing extraordinary value on the postponed and awaited thing or event, as in Magritte's *La Réproduction interdite* (*Forbidden Reproduction*), where the reflection of the man in the mirror is indefinitely extended out beyond the conceptual lines of the picture, reflected in an indefinite delay. The glass-cold overtones in the mirrored surface are reminiscent of the glacial end to the book placed upon the mantelpiece before him: Poe's *The Adventures of Arthur Gordon Pym*. His face will never be seen, as he recedes always into the mirror facing forwards, glassed-in and glassed-off, like a humanized version or mirror image of Duchamp's delays and "stoppages," or his *Large Glass*.

In much the same way, the many reflections of Marcel Duchamp seated in replication around his own table (see plate 3.2) can be read as so many put-offs of his real reflection, keeping his image in vibration and delayed, even as it is given over and over again. This positive use of repetition intensifies that life of "presence nothing but presence," which occurs in an early poem from *Clair de terre*. What is refused is a simple interpretation of the moment as fixed in one category of time, in favor of a moment deferred. To be sure, in the deferral of ordinary presence, there is felt some regret at the sacrifice of a solid state of things, as in Breton's "Plutôt la vie" ("Rather Life"):

> La vie de la présence rien que de la présence
> Où une voix dit Es-tu là où une autre répond Es-tu là?
> Je n'y suis guère hélas

(The life of presence nothing but presence
Where a voice says Are you there and another answers Are you there
I am scarcely ever there alas)

<div align="right">(P, p. 44)</div>

For what is expected there is substituted what the observer cannot substantiate or locate in any ordinary system of values. Magritte is a great trainer of displacement, transposing the cloud seen in *Le Faux Miroir* (*The False Mirror*) into the eye itself, or, in *Le Chant des sirènes* (*Sirens' Song*), relocating, by metonymy, into the glass upon the table directly behind the man some of the ocean he stares out at. The first image illustrates the exchange of the organ of vision with the object beheld, as in Breton's famous dictum in *La Surréalisme et la peinture* (*Surrealism and Painting*) about the necessity of interchange between the surrealist seeing and seen; the second plays on the expression "Ce n'est pas la mer à boire" ("It's not the whole sea to drink"), and is reminiscent of the Greek concept, as exemplified in Anaxagoras, that there is something of everything in everything. *Displacement*, in category and in fact, rules the two images which work on shifts of space and size, interior and exterior, containment and freedom, to illustrate surrealist vision.

Breton's instructions are no less explicit concerning the code and the interpretation of images, as he supplants an ordinary expectation with some sign or direction indicator, as if more should be found than is looked for, as if, in fact, that were to be the meaning: "Il y a un message au lieu d'un lézard sous chaque pierre" ("There is a message instead of a lizard under each stone" – "Epervier incassable," *P*, p. 33). Of course, the reader has to want to look under the stone to see the signal put there. Surrealism requires a certain curiosity. Once messages and signs are expected, the text is read differently, in a fresh and interrogative attentiveness.

Inserting

Often the categories of surrealist imaginings can be seen as indicative of an expectation gone awry or mocked. But, on the positive side, one view may be discovered within another: imagine, as Breton did, Mallarmé as a pictured as well as a textual predecessor inserted into surrealist journals digesting him – see the article "The Marvelous against Mystery," where Mallarmé's striking head occupies the center of the page. Thus does surrealism absorb symbolism's great father within its own maw.

In the highly charged surrealist atmosphere of amorous celebration, Breton's self-introduction in his beloved's dream demonstrates one of the ways of handling sight, insight, and flexibility of conceptualization:

Mes rêves seront formels et vains, comme le bruit de paupières de l'eau
dans l'ombre

Je m'introduirai dans les tiens pour y sonder la profondeur de
 tes larmes

(My dreams will be formal and useless, like the sound of water's
 eyelids in the shadow
I shall enter yours to test the depth of your tears)

("La Mort rose," *P*, pp. 72–3)

Here the water of dream is that of tears, and the emotion is produced by the
image of the emotion itself; by contrast, and contrary to the typical Breton
image of doubleness, the following image recounted by Dali is a sterile
inscription of nothing into the white of the eyes gone visionless, the sight
wiped out. Brilliant and blinding, Dali's exemplary text in *Hidden Faces*
enstatues or enmarbles just that form of the *Nihil* with which, implicitly or
explicitly, he signs his texts.

In this novel, Solange de Cléda stands with her eyes fixed upon a stretch of
green marble: its hardened waves the direct opposite of the water represented
by Magritte's sea or in that of Breton's dream. They base their aesthetics on
presence, on symbolic fluidity, and on the implied power of transformation,
whereas Dali incessantly links water to a fixity of gaze and a dramatic motion-
lessness of person. Even in the celebrated fluid clock, the atmosphere is one of
nightmare rather than one of transformative dream. Solange is posed un-
moving by the stairway where the hero vanishes; the picture is explicitly
brought nearer and nearer to the watching eye, but only to reveal a drastic
absence:

> if at this moment someone had had the curiosity to draw near and look
> between her half-shut eyelids he would probably have been terrified to
> observe that they were without sight and that in the slits between her
> lashes, instead of fixed pupils, only the whites were visible. And it is in
> the whites of these eyes, smooth as those of blind statues, that Salvador
> Dali's imagination wishes to engrave, and thereby immortalize them at
> the end of this chapter, the Latin word, "Nihil," which means
> "NOTHING." (*HF*, p. 169)

The negative side of surrealism is perfectly represented here, profiting, for its
shock value, from the world of classical tradition by the insertion of these
Greek statues with their prominent eyes and antique smiles into the con-
temporary text. But it is finally and inescapably marked by the sign of that
"nothing."

Piecemealing or parting

Against totalizing mythologies, surrealism stakes out its permit for stressing
the particular, the single finger pointing, as in Magritte's so-frequent images

of houses and a pointing forefinger, either inside or out – like a singular designation; or in his imaging of the organ of sight, one single eye, in *L'Oeil* (*The Eye*), where one lonely and lovely orb is sharply caught in heavy framing, or in *Le Faux Miroir*, where cloud fills the eye taking up the entire space of the picture, or again, in *Le Portrait*, where the slice of ham on the plate contains an unappealing slit of an eye, like that of some jellyfish laid flat in front of us, for our forced conceptual and visual digestion.

The technique of splitting up an image traditionally considered a whole into its parts (the hand into its fingers, the two eyes for seeing into one, for an insolent and passive using), or the word into its sections, may work at once its verbal, psychological, and material operations. Detailing does not, of course, entail permanent disintegration or destruction. The word for the simplest object is divided into its syllables, swinging on its hinges like this door: "La por por porte por / la fe nê tre" ("The do do door do / the wi nd ow" – "La Porte bat," *Mot à mante*, P, p. 209). And thereby the door swings doubly apart into its pieces, opening.

Given the surrealist insistence on the identification with what is seen and what sees, it is only fitting that the surrealistic perceiver be equally split into an active and a passive part, losing neither personality nor life, gaining in ardor, even in dream: "Je me dirige vers la chambre où je suis étendu / Et j'y mets le feu" ("I head for the room where I am lying / And set fire to it – "Vigilance," P, pp. 78–9).

The most memorable example of division through love is probably that of the famous poem "L'Union libre" ("Free Union"), where the parts of the beloved's body are celebrated one after the other, as in the Renaissance *blasons*, each of them taking on the metonymic force of the emblazoned and celebrated whole, each bringing its own qualities, adjectival, verbal, and cumulative to the entire statement:

> Ma femme à la chevelure de feu de bois . . .
> Ma femme à la taille . . .
> Ma femme à la langue . . .
>
> (My wife with woodfire hair . . .
> My wife with her waist . . .
> My wife with her tongue . . .)

> (*P*, p. 65)

Or then the object celebrated in the same divisive and emblematic fashion discovers or uncovers its whole beauty through its partial description:

> Les belles fenêtres en chemise
> Les belles fenêtres aux cheveux de feu dans la nuit noire
> Les belles fenêtres de cris d'alarme et de baisers

(The lovely shirtclad windows
The lovely windows with fiery hair in the black night
The lovely windows of alarmed cries and kisses)

("Noeud des miroirs," *P*, p. 92)

Repeating, multiplying, and extension

But in fact the splitting-apart can work as simply a dull repetition of not the other or the parted but the same; once the view of the whole is splintered, the repeats read like the same thing. Just so, and in a far less positive fashion than in the celebration of the beloved's body, the watcher at Magritte's window is typically invaded with fear or fatigue, as windows lead only into windows. In his *Homage à la dialectique*, already referred to, as the artist describes it to the reader of the image in his writing on the subject, "I had you see through the open window, in the façade of a house, a room itself containing a house."[6] Here,

Je suis à la fenêtre très loin dans une cité pleine d'épouvante
Dehors des hommes à chapeau claque se suivent à intervalle régulier
Pareils aux pluies

(I am at the window far away in a city full of fear
Outside men with melon hats one after the other at regular intervals
Just like the rain)

("Non-lieu," *P*, pp. 74–5)

Such accumulation may seem excessive, being still the monotonous same, as in Breton's poem "Le Verbre être" ("The Verb To be"), where his repetition of Mr The Same and Mrs The Same with their children The Same and The Same, instills a real sense of horror and dread of the everyday.

Fantastic focus

When the surrealist sight zooms in to focus on a salient detail, it is often unforgettable. Witness Magritte's pointing fingers in his canvases, or Leiris's pointing finger in his novel *Le Point cardinal* (*Cardinal Point*) as it designates the most private part of a female's anatomy, or Duchamp's picturing of a foot covered by flies or Bataille's rendering of a big toe, which so tellingly illustrates the cover of Rosalind Krauss's book *The Originality of the Avant-Garde, and Other Modernist Myths*.[7]

Such close vision can be difficult to contemplate, concentrating as it must on the salient and odd conjunctions the images force into being. For example,

Dali points hard at the feet in *Hidden Faces*, making faces from them, but then lacing them up so they can neither walk nor speak. This is a double insult: "When the orthopaedist who gave Soler the order to make the helmet showed him the radiograph of Baba's skull, Soler was shocked. 'Good Lord! It looks like the bones of the feet rather than those of the head!'" So the humanist discourse seems to stand its head on its feet and *vice versa*:

> And Baba's helmet became a technical, even an artistic, triumph. The helmet was divided longitudinally by a network of geodesic lines marking the adjustable sections that supported the frontal and occipital bones, just as other sections, likewise joining in geodesic and transversal lines crossing through the frontal ligatures, compressed the two parietal bones. Each of these meridian divisions was edged with holes through which passed laces of greased leather, as on a shoe. (*HF*, p. 142)

As art is transposed into nature, and the foot is placed in place of the head by wilful and artful substitution, so even the foot where it belongs is still invisibly held by art, in Dali's Raphael imposing his thong upon the woman's foot, however unwilling:

> this arched foot, with its matt skin, its blue-tinged dimples, free of the stigma of the slightest redness touching or profaning its toes, of which each articulation of each phalange seemed to rest on the ground beneath Raphael's approving glance, and as on the feet painted by him, the big toe was widely separated from the other toes, as by the effect of the strap of an invisible sandal. (*HF*, p. 159)

Surrealism has had its troubles with feminism: a woman on too much of an erotic pedestal is easily manipulated head to foot. But also these impositions of art upon nature, these denaturings of face and foot, do not add to the visible or the knowable, but rather subtract from them. A recent advertisement for Ecco shoes typically removes foot and woman, and leaves only the shoe, caressed by an adoring man stretched out full-length. The image, though replete, and more than replete seems to me de-pleating, and even depleting, just the opposite of the unfolding and enlarging sensibility Breton aims for in the "La Lanterne sourde" ("The Deaf Lantern"): "Alors tout se déploie au fond du bol à la façon des fleurs japonaises" ("Then everything unfolds in the bottom of the cup like Japanese flowers" – *P*, p. 227).

This unfolding and opening out is the goal, natural and aesthetic, of the surrealist poem as of its artist, and of its images as best the artists see them. What Magritte, or de Chirico, or Arp, achieves for the imagination is not just the imposition of one reign upon another, but the transformation of each by each, in a superb coincidence invented by the seer: what holds the present open is the convergence of what we reflect upon and hold.

> C'en est fait du présent du passé de l'avenir
> Je chante la lumière unique de la coincidence

> (We are through with the present past and future
> I sing the unique light of coincidence)

$$(P, \text{p. } 143)$$

Nowhere is the light of coincidence brighter than in the many reflections of Marcel Duchamp seated around his own table (plate 3.2), in an illustration of the possible multiplicity of the same, and a reflection of the Boccioni multiple self-portrait of 1906, *Io–noi–Boccioni* (*I–We–Boccioni*).

A silk hat, said Breton in an early poem ("Age," *Mont de piété*, P, p. 11) "inaugurates my chase with reflections". Surrealism offers multiplied and repeated reflections, often thoughtful and thought-provoking, starting with that first vision with the multiple facets of the self given in a top hat – given, that is, highly clothed – and leading to the shattering and deforming of the image of the diners at the feast table in the Dali novel, like a parody of the traditional *set piece* in so many novels, giving coherence to the consciousnesses so gathered around.

Here various anamorphic transformations and reductions, the innings and outings of sight and their vagaries, bring back the past into the present faces, and into the present facets of experience, not in order to support them as in the classic dinner scene (we have only to think of the dinner parties in Virginia Woolf's *To the Lighthouse* or *The Waves*), but to undo them. The faces become Lilliputian in size, the concavities and convexities of the silver pieces reflect and distort and yet reveal the affinities with the ancestors,

> mercilessly caricatured. . . . Thus in one of these reflections, fleeting daughters of the magic of chance, it was possible to see emerging from the outline of Beatrice de Brantès . . . the corseted and strangled figure of Marie Antoinette, or the infinitely more extended one of a hunted weasel, which the Queen hid in the depth of the destiny of her decapitated royal head. (*HF*, p. 32)

Indeed, then, the present faces are hidden, as Dali's title indicates, by the overlays both of past memories and of presenting imaginings; and the crucially real present – whatever its truth might be – is hidden with them. The reflections and deforming alterations seem to be the only currently available truth. Caricature makes presence bearable, but renders improbable all notions of messages and meanings transmitted and true.

What is left is the image of surrealism as it transmits its own odd strategies of reading: the reading teaches, at least, about future readings.

A slant on surrealism: aesthetics as preparation

There ought to be room for more things, for a spreading out, like.
John Ashbery, "The Double Dream of Spring"

Surrealism has prepared us. And not just for surrealism, but for the reading of a number of contemporary narrators and poets, inscribed as they are in its wake, particularly in the light, or then the shadow, of its aesthetic attitude. If I choose to speak of the shadow in speaking of the light, it should be understood in the same lineage, that of contrary assertions and passionate involvement in the contradiction as a fruitful source of the poetic, its language as its vision. My topic will be – implicitly – that preparation as it is illustrated, better, illuminated, by examples of present reading, with its shadows.

Already the translation of the title of Octavio Paz's *A Draft of Shadows*, for his *Pasado en claro*, indicates the path I want to follow, where what seems evident, clear, bright, inspires its own reversal, where the detail takes precedence over what might have seemed major, and yet wins out, its triumph the triumph of the surrealist imagination – which is to say, depending on one's point of view, that of poetry itself.

Here, various forms of detachment make clear what is whole, while the upsetting of custom invigorates both sky and earth, themselves reversed in their direction. Surrealism's own separations and meeting points have laid the ground for the reading of this volume, as for the celebrated "Eagle or sun": there is no choice to make, for we have here both eagle and sun, both light and shadow. Poetic junction and division claim for themselves the justification, beyond logic, of a world unaccustomed but not unprepared. We can read, without disbelief but still with wonder, in these pages, of the separation of a face from its wrinkles, of the beloved's dipping his hands in the breast of the woman he loves, or of the habitation of a woman by a wind, of the walking of the sky upon the land, of the sinking of water to the level of the trees, and the rising of the heaven to the lips of man ("El agua baja hasta los arboles / El cielo sube hasta los labios"). And we read too, still in the shadows of that forest, which since the time of Góngora's *Soledades*, has been one with human speech and wandering, of the voice of a tree falling silent, and the dark projection of a foliage upon a page of letters, and again of a forest from which the wandering of the poet is observed as he turns about in the middle of his own sentence now being written ("Estoy en la mitad de esta frase") or as he wanders lost in his own being ("ando perdido en mi proprio centro"). The human voice defines the human being, and is the universe, already:

> Estoy en donde estuve:
> voy detrás del murmullo,
> pasos dentro de mí, oídos con los ojos,
> el murmullo es mental, yo soy mis pasos,

oigo las voces que yo pienso,
las voces que me piensan al pensarlas.
Soy la sombra que arrojan mis palabras.

(I am where I was:
I walk behind the murmur,
footsteps within me, heard with my eyes,
the murmur is in the mind, I am my footsteps,
I hear the voices that I think,
the voices that think me as I think them.
I am the shadows my words cast.)[8]

The narrational puzzles of Borges and Cortázar are equally prepared by the surrealist aesthetic we have absorbed. If the poetry requires acceptance of division, reversal, transferral, and all-inclusiveness, the prose requires no less. Julio Cortázar's own texts have the disturbing quality Borges attributes to great writing: their inspiralings and interferences, inclusions and identifications call for just the attentiveness and expectation that the surrealist *état d'attente* requires in everyday life, as in the textual life interwoven with it. The patterns of sudden enlargement, involvement, identification, and replacement, awaken us to what we have seen and read as to what we now perceive and absorb. The mazes and incompletions, confusions, and insettings of Cortázar's *Hopscotch* as of Robbe-Grillet's *In the Labyrinth* take us back to Mallarmé as they do, more recently, to Leiris and Desnos; the play of its endless paths constructed by the reader and foiled by the text has briefer parallels in his stories such as "Continuity of Parks," with its brilliant ironic placement of the armchair for reading with its back to the door, so that we shall finally be forced to sink in it as well as in the plot.

What I am calling the intrusion is prepared with a mixture of sensuality, as a hand caresses the green velvet of the chair, and intense aggravation, as the emptiness of all the surrounding space works on our nerves, until the final inclusion of readings, by the man in the armchair reading of our reading of him. The camera zooms into a close-up, as the reader is pulled along to the center of the scene by the highlighting and velvet caress, a soft touch but just as sure: "At the top, two doors. No one in the first room, no one in the second. The door of the salon, and then, the knife in hand, the light from the great windows, the high back of an armchair covered in green velvet, the head of the man in the chair reading a novel."[9] The spotlighting of knife and head spells out the menace in a delay, still encased in the green velvet cover, as in the covers of that novel which we approach like some target from the back, on to realize that it is, in fact, identical with this tale. This trick recalls Desnos's intrication of himself and us within his page, so that the date upon a calendar becomes our own, his lament at his own banality in the narration of love becomes our lament too: to be included is at once to perceive as we are read and to read how we are perceived and read.

The celebrated story "Blow-Up," a close-up study of interference, brings to the eye of the mind René Magritte's canvas called *Le Faux Miroir* (*The False Mirror*), with its clouds and its sight interchangeable, the outside sky superposed upon the seeing orb itself, blocking or clouding the sight and again, looking back at the eye they mirror and reflect upon. The intrusions made in the story upon the vision as it is controlled by the apparatus recording it, free of judgment, are all placed on the same level: a pigeon, two or three sparrows, and a murder, treated with equal importance with the *objectif* of the camera. The camera as arm against neutrality (the "level-zero" of passive acceptance) claims a vivid attention like the surrealists' valuing of the state of expectation itself, creative of the event. The objective eye selects and heightens events, bringing them to life as they are brought to sight, valueless in themselves and all valuable as facts recorded: "in all ways when one is walking about with a camera, one has almost a duty to be attentive, to not lose that abrupt and happy rebound of sun's rays off an old stone, or the pigtails-flying run of a small girl going home with a loaf of bread or a bottle of milk."[10]

In this tale then told through the viewfinder itself, with a tree included to "break up too much grey space," the aesthetic attentiveness and its chance result take precedence over substance, over thought: "I got it all into the viewfinder (with the tree, the railing, the seven o'clock sun) and then took the shot."[11] To "get it all in" is thus to possess it, as with the catalogues in the poems of Apollinaire and the surrealists after him. Later, the enlargement of the photograph in repeated stages works like the gradual enlargement of a surrealist rose in a poem of Desnos, where, as the rose is compared to more and more elements, each is added on to it as the image finally outstrips the poem, growing steadily larger and larger, snowballing down the page after an initial solitude. In the story, the photograph increases with the formal details visible through the eye of the lens, whose focus replaces the "normal" human focus of vision, until the detail becomes the whole, and the eye becomes the lens, "something fixed, rigid, incapable of intervention ... my impotent eye."[12] The replacement of the personal and living by the impersonal and immutable of this move into the picture by the lens is accompanied by the regular rhythmical sway of the branches of the tree – that deliberately selected interruptor placed here, we remember, in order to break up the grey space within the frame of the picture. The regular rhythm calls for its contrary, as attention is suddenly forced upon an irregularity in the object world, the place where the railing is tarnished, and in the human world, upon a desperate close-up into the horror of identity: "The woman's face turned toward me as though surprised, was enlarging, and I turned a bit, I mean that the camera turned a little, and without losing sight of the woman, I began to close in on the man who was looking at me with the black holes he had in place of eyes ...," closer and closer, increasingly rapid until "the game was played out," and the picture cropped, until only the black tongue of the man occupies the center, and the horrified spectator, who is the narrator, breaks into tears at last.

The Magritte picture *Le Faux Miroir* returns, as clouds make their way again across the eyes and their own sky, as rain falls over the picture in the final shot with its reversal and its clearing: "like a spell of weeping reversed, and little by little the frame becomes clear, perhaps the sun comes out, and again the clouds begin to come, two at a time, three at a time. And the pigeons once in a while, and a sparrow or two."[13] The reduction of the build-up and the close-up to the sparse accompanies, in a lyric simplicity, the clearing of the sight at just the moment when the emotion of the spectator is transferred to the picture and the focus shifts from inside reaction to outside climate. So the clouding and the clearing, of the sky, the eyes, and the camera lens, all in a mirror at once False in its illogicality and now Real in its traces, permit the drastic enlargement of blow-up not only of the picture but of our parallel perception.

The prose poems of W. S. Merwin's *The Miner's Pale Children* encourage the same suddenness of peculiar vision, focusing on the irregularity or the *insolite* of things, where a man's shadow is sunk inside a stone, and his fear is what must not be lost, but on the contrary, protected: the reversal of ordinary expectations takes on a singular lyric quality as the hero profiled against the sunrise makes of himself his own building, growing his own wall and roof to protect the fear and the shadow:

> The days move past me now on every side. The birds fly all around me and plunge into the new distances behind me. I have added to the sky. The fear is the same as ever. It is safe now. Even when the roof falls and the walls collapse and the cliff is not even to be thought of and the daylight floods everything and I am forgotten, the fear will survive. Even if it cannot be seen its features will be known, and its existence will be in no doubt. It will be at home everywhere, like oblivion itself. I will not have lived in vain.[14]

The intense consciousness of in and out, and of their communicating, permits the clothes in drawers to muse upon the different life of clothing outside, permits a boulder to be welcomed into the center of the living room – like the abyss coming into the house in an early collective text by Char and Breton and Eluard. The consciousness of reversal permits meditations upon the un-chopping of the tree, the wanderings of the ends of shoelaces, the icebergs turned away by men for their tragedy, permits men to be their own abysses of despair they are trying to cross, as it permits black clover to grow in the sky. The memory of Breton's call upon humanity to destroy its machines for rationality permits men here to lose their machines (even though they are for remembering) and still go remembered. The result of Merwin's poetry, like the great prose poems before it, is not loss or despair. As much as anything, it is the insertion of the outside object into the inner experience: "And yet everything in the world," you insist as you go down the steps, "still has its door."[15]

The final example I want to cite of our acutely prepared attentiveness is that

of John Ashbery, whose sense of the halted moment in its ironic self-reflection is peculiarly appropriate to a time of shading:

> A look of glass stops you
> And you walk on shaken: was I the perceived?
> Did they notice me, this time, as I am,
> Or is it postponed again?[16]

Everything, in these poems included in *Self-Portrait in a Convex Mirror*, points to the center of the experience about to be, after the recognition of a new language ("New sentences were starting up," stopped in dead center as the moment mirrors itself between two lines of black print, capturing doubly the narration as it does the narrator, "as I am." The frequent switching back and forth between pronouns ("you . . . I . . . they . . . I") is reminiscent of a celebrated passage in Apollinaire's "Zone", where all the persons of the narrator, the reader, and the joint consciousness they become, are reflected, multiplied, and preserved.

In a film poem, like Cortázar's photographic story, shadows repeat shadows, with the glare focused in the exact center from the beginning, like the projection of a consciousness simultaneously craving black on black and white upon glaring white:

> The shadow of the Venetian blind on the painted wall,
> Shadows of the snake-plant and cacti, the plaster animals
> Focus the tragic melanchology of the bright stare
> Into nowhere, a hole like the black holes in space.[17]

The bright and the dark, the convex and the concave, the look and the closing off of the look: all the series of ubiquitous contraries united from two far-distant fields in surrealism, as it has taught us how to read, these last black holes mirror the bright glare – emptiness reflecting upon too great an illumination – and that play itself takes the reading back and forward to the initial "shadow of the Venetian blind" and its subsequent set-in-play. The double force of the word and image "blind" here suggests both the blocking off of sight and its release, in the only motion contained within the poem, concentrated in this balanced play of the object along a vertical line, pulled dizzily up and down:

> Zip! Up with the blind . . .
> The blind comes down slowly, the slats are slowly tilted up.[18]

That tilt, directly before a blank space in the center poem, shuts off the sight precisely by its back-reference to the "blind." The closure is at once central and preparatory for the conclusion as interrogation: "Why must it always end this way?" This "end," as of some affair more poetic than those of Graham Greene, and indeed not being yet the end of the poem, has also been initiated by the drawing down of the blind, as of the eyelids, recalling in human gesture

the dark beginning in the object world, with shadow upon shadow in the whole poem arranged like a pattern of black upon black. The blind is repeated and echoed until the voicing of "death" and its terminal image, set into the deepest background shadow and the final one:

> The indoors with the outside becoming part of you
> As you find you had never left off laughing at death,
> The background, dark vine at the edge of the porch.[19]

This "death," the conceptual wall against which are shown this film of a poem and this blind picture of a pictured blind, makes an intrusion here from text into life, by the reversal of the ordinary "real" and the conventional "art" into the substance of the poem:

> Things too real
> To be of much concern, hence artificial,
> yet now all over the page. . . .[20]

For the communication of such vessels we are amply prepared by surrealism and, before it, by cubism. The effect can be compared with that of Picasso's celebrated *Chair with Caning*, where the "real" but pictured caning for the "artificial" chair of a picture works doubly as the unreal.

"City Afternoon," another freeze frame of a film, is seen first through a haze or a filter of fog, protected from ordinary sight as by a further shadow strengthening the recall by the trace:

> A veil of haze protects this
> Long-ago afternoon forgotten by everybody
> In this photograph, most of them now
> Sucked screaming through old age and death.[21]

Like an echo for Duchamp's *Large Glass* in its trace of the act as its meaning, and like Cortázar's close-up of a trace exploding as it is enlarging, is this commemoration by photographs of instants which have been "forgotten," as the echoing oblivion: "forgotten/forgetfulness," makes a shadow spreading also to the body as text and even as country. This country – which we would grasp – may well be as real and as great as any living one, and perhaps it may be best grasped in just this way:

> If one could seize America
> Or at least a fine forgetfulness
> That seeps into our outline
> Defining our volumes with a stain
> That is fleeting too. . . .[22]

The figure defined and outlined is also stained, for this is a poem of city and of twilight. The stain prepares a mixture of gray among the memorial garlands which would normally be green, but are grayed in memory. Only the green

traffic light is awaited, and any other green color is suppressed in the wilting of "this long-ago afternoon," in this photograph. The series of present participles forms the main vertebra of the photograph of the poem itself: waiting–lifting–reflecting, against which, amid the fleeting and all the change of life and lives, the reversal pattern of the "one upside down" is caught and held, in the very center of the focus, in the camera's lens and an image of a reflecting pool, as the multiple is unified, the threesome reduced to one, and the game of waiting to the realization of the result, reflecting upon itself.

Again and again, a question is asked about perception, inspired by the irregular, the special, the particular sight, arouser of occasional unexpected answers to insistent questions we were not aware of having, as Breton once put it in his *Les Vases communicants* (*Communicating Vessels*). The question of sight, object, and subject sends the reader back to the initial question in the first poem of the volume, "Was I the perceived?"

Here, in the subsequent pattern of speed-up and delay, knowledge is, like perception, always to be imperfect, indefinite and unfinished, like our lives moving at a "Grand Galop," and their institutional programs and nutrition:

> And today is Monday. Today's lunch is: Spanish omelet, lettuce and
> tomato salad,
> Jello, milk and cookies. Tomorrow's sloppy joe on bun,
> Scalloped corn, stewed tomatoes, rice pudding and milk.[23]

But even as our institutional costumes are suspended, exhibited from the horizontal, a doubt forms about the exposure of self not only to perception but to language; the names we have applied cannot catch up, for "we have moved on a little ahead of them" and we must wait for them now yet again. In this poem, with its questions and self-questionings, the wait and expectation are constant and the aspect undefined, until the dance is about to end, "and the thing we have fulfilled we have become." Some statement may seem to have appeared, with its bloom still on, by chance, justly lauded, and finally the whole poem becomes a statement of its own closure, set against its own shadow:

> But now we are at Cape Fear and the overland trail
> Is impassable, and a dense curtain of mist hangs over the sea.[24]

But all these shadows, these accelerations and delays, these worked-on expectations, however limited, cross and echo in the fabric of what America and Latin America might well claim as most real and most central – in all its great heritage from other countries and other literary movements – the shading of light and language into life, where everything reaches beyond the shadow, and is spreading out, in its, and our, own room:

> But there are, again, things to be sung of
> And this is one of them. . . .[25]

8

CONTRARY RELATIONS: SURREALISM in the BOOKS

This world is only very approximately up to our thought.
Surrealist manifesto, 1924[1]

Art teaches seeing and the seeing of the self, often at an angle. I want to discuss some of the odd angles of Dada and surrealist perception, and misperception, as they hold us, in our memory of them.

By one of the laws of perception, the presentation of an image should exert some control over its subsequent reception – or its readerly creation – to some extent simply by the relative size of the image and the text. That is, in the case when a brief text comments on a large image, we could presumably read it as the larger's title, caption, or explanation. On the other hand, in the case of a small image and a long text, we could think the image illustrative of the written text, its visualization. As an example of the latter, we might take a text in a dictionary, for instance a series of definitions: the small image represents the plant or object the definition defines. Or we might take a story for children and grownups alike, where the image will *illustrate* the story and its events, for it is the story that counts and is recounted. But in surrealist texts the correlation is plainly odd, with a long text illustrated by small pictures seemingly not to the point, or a series of pictures accompanied by a brief text of no apparent relevance, or no text at all. The disquieting effect stimulates a renewed form of reading, which I think of as *reading on the side*.

Disquiet on the bias

The pleasure of the singular reading and seeing on the side as it is encouraged by surrealism, and Dada before it, is developed, even strengthened, by the long

This essay was first published in French, as "Relations contraires: le surréalisme dans les livres," *Melusine*, no. 4 (Lausanne. L'Age d'Homme, 1984).

practice of reading according to a surrealist angle, in a few images as they are presented differently to us over a long period in books and journals we from time to time leaf through. I would call this an *aesthetics of disquiet*, working itself out. Of this disquiet in reading and in seeing, strongly felt like a moment of *apparition*, we make the real phantoms of our creative reading. "We say phantom," we might someday announce, replacing Mallarmé's celebrated "I say a flower": we say "phantom," and directly before us there rises just that, Nosferatu the vampire in Breton's presentation of him.

Now, just in that discussion of this figure, one phrase continues to haunt us as it haunted Breton and his friends: "*When he had crossed the bridge, the phantoms came to meet him.*"[2] However, these electrifying words are not the ones that accompany the image of the vampire with his hand over his heart, silhouetted against the window, as we see him in Jacques Brunius's article on the film in *Le Minotaure*, and, later, in a reprint of the essay in one of Breton's books. Breton places by the image a quite different sentence from the text, as if to pour into the visual image all the electric charge of the written words. But we, haunted like him, may hear or read the other, obsessive phantomatic phrase through or under the words we really read – a sort of subjective–collective *phantom* substituting for the printed *fact* and producing a memorable anguish inextricable from the fascination of the text as we read, hear, and see it.

And this is exactly the point I want to make: that the experience of surrealist reading is a complex one, often double as well as often sideways in its presentation. In the domain of and in the very matter of surrealism, we have to cherish and protect the anguish of reading itself, profiting from its charge in order to pass it on.

Rich relations

The image easily dominates the written text in such compilations as *The Collages of Jean Lévy Commented by Gilbert Lély*, where the original images are so strong that the texts do not have to correspond: the temptation is simply not to read them.

On the other side, the face of Baudelaire about which Eluard spins his text of anguish and praise called "The Mirror of Baudelaire" remains precious to us in the text itself, and Mallarmé's pure and noble face with which Breton illustrates his essay "Le Merveilleux contre le mystère" ("The Marvelous against Mystery") loses nothing of its dash as it is absorbed by the text stated in eulogistic terms: "oh splendid nineteenth century ... an extraordinary fermentation which we no longer know ... the singular curve. ..." In neither of the two cases is it the face that illustrates the text, but rather the face become text, and the text then becoming itself the expressive face. That is

what we would choose to be forming in our commentaries on surrealist authors: text–faces.

In this face of Mallarmé, which we read now reversed, how should we not see the face of Breton, as that of surrealism in symbolism, in our newly obsessed reading?

How to read

By contrast with the obsessed and obsessive reading of surrealism, we shall first make a clear and non-oblique reading of some Dada images. Kurt Schwitters' famous collage with the conjunction "UND" in huge letters in its center teaches us to read from its central and centralizing element, calling for an additional or conjunctive reading of the fragments dispersed around and below it. Contrary to what we might ordinarily think, I maintain that many of the visual and verbal Dada texts offer their own indications of the sense and the direction of their reading. Thus, "AND" presents itself not only as the unifying link between the fragments of image in this frame itself, but as the future possible *conjunction* between this picture and the other fragments in the surrounding world as it is read before and after. It is also the echo or the pre-text of this sign and found in a smaller form beneath it, like a visual rhyme marking the entire object, including those objects found in the street and stuck on top or therein, like the parts of a universe retained and regrouped in its elements, by a centralizing and conjunctive attraction.

That is an example of reading from one element to the whole, and, simultaneously, of the reading of a title as a direction. Some of the objects of pop art, all these years later, work toward the same flexibility of reading techniques. An example is provided by Claes Oldenburg's *Tomb in the Form of a Punching-Bag*, which, according to its accompanying text (if we can accord it some referential value), presents a ball or a "drop" of rubber filled with air, suspended from a halo-shaped or parasol-shaped disk called "tomb." The very form of this halo reminds us of a protective shield, while it is the contrary, both in its verbal meaning and its actual function. For, as a tomb, this punching-bag falls, and the drop contracts like a fallen fruit drying out. Poetic reading is nourished by such fruit – we think of violence, anger, protection against the assault of the desiccating enemy, breath and life and their extinction. Here, in the marginal imagination, the "Tombeaux" of Mallarmé and the fruit of one of his Idumean nights meet, ready for battle, on a poetic verbal and visual field.

But there is more in this fruit for an avaricious reading. Oldenburg places across from this poetic object two other objects which are no less poetic: two cigarettes, one still smoking, which he says form a bat which would be the equivalent of this tomb in the form of a punching-bag. If the bag spreads out and the disk becomes smaller and thicker, the smoking cigarette looks like a

punching-bag. The handle of the stick can be seen as a thicker version of the disk. In that case, the bat is like a punching-bag. The elements thus work like the communicating vessels of surrealism, with the addition of the symbolist tomb, as in Mallarmé's "Tombeau de Baudelaire," "Tombeau de Poe," and so on. Where there is smoke, some textual fire may have been, or still be, albeit under a confusing smokescreen.

Reading Dada-Max

John Russell says of Max Ernst's collages that "they have few rivals, whether in art or in literature, among the imaginative adventures of our century."[3] To see a hyper-parody of dictionary illustration and story-telling combined in one, we could look at some photomontages constructed by Ernst in *Une Semaine de bonté* (*A Week of Goodness*), where the written text is lacking, since it is implicated in the image. For instance, on the back wall of a drawing room containing some absurdly melodramatic seduction appears a neatly framed picture of a tree stump with all the attributes of a hand. Like a partial cutting (in the sense of a tree cutting, and the image cut out as partial from a whole), this object mocks and underlines the melodramatic violence of the act about to be committed in the other and larger neat frame of the drawing room. The insertion, like some picture-book example of a tree-shaped hand, explains, by a reference out beyond those four walls, what happens within them. But at the same time the act on the verge reinforces the horribly human quality of the tree, as it and the act are handled, each in its enclosure.

Elsewhere, a statue, blindfolded and standing on one leg with the other bandaged, sets the corridor in which it stands slightly askew, from the point of view of normality. Whatever scene occurs by its side will be seen as over-looking something, and with a limp. The presentation itself is presented as fractured and as accidental, thereby casting some doubt on the veracity of the rest of the event as seen. The inserted image does nothing to reassure the spectator about the principal figuring in the picture, which we therefore see with a Dada slant to it.

Here matter is given over to a collage operation, to an ironing-over and weighing-again (*re-passage* and *re-pesage*) of what is to be thought out freshly. Let me suppose this: that the Dada sign in these images is more or less readable. That hand pointing out the way shows us exactly the path to take just as the pointing finger signals the essential (or at least pseudo-essential) parts of the Dada manifestoes. In the image already discussed, with the tree–hand, the nails illustrate the erotic extraction of the roots of the tree stump reread as the enlargement of some violent hands-on encounter of a bizarre couple. In all these images, the interior picture framing the enlargement of some part of the body functions on at least two levels of reading: (1) an exterior one – what we read first, trying to situate the total image, which is

precisely unsituated; and (2) an interior one – starting from the meaning apparently included in the framed image, violently *mise-en-abîme*. For example, an animal skin flattened against the wall in the inner *abysmal* image closely resembles one of the dictionary illustrations, and points, at the same time, to the flattening and the violence done to the corpse and to the body of the young lady frightened by the monster in the door as in a dream occurring in bed, this bed offered over to a foe-like and monstrous reading; it is all as if some swinging door were to have an image pass through.

Elsewhere, the mouth-to-mouth meeting framed on the wall intensifies the polite *tête-à-tête* relations in the outer picture, themselves nevertheless undermined by the serpent's tail attached to one of the figures: these are therefore dragonesque or snaky relations. Such details cause us to read on a new slant, and with a new twist.

Or take the way the angle of a book held by the young lady above the body of her partner rhymes visually with the angle of the knife upon the wall – a rhyme twice repeated, picking up the innate violence of the book. The double image is particularly pertinent for the reader of Mallarmé, for to such a person the V made by the lady's legs suggests the opened pages of a book, reddened as if by violence. Putting it in English, we might say, "She is reading the book at him," doing him violence by the reading of the text, and that we do in our turn, doubly, by the way we see and hear a double text. It is unnecessary to justify such subjective readings and such readings in correspondence, since by nature and by culture what is perceived is understood in the eye, the ear, and the individual tongue independently of linguistic, pictural, and poetic authorial intentions.

This last theme may be illustrated by an image still more imbued with violence. A raised whip points to (presumably) an eye absent from the interior picture, for the portrait contains only the ear to hear the cry which is not uttered; this absent eye is referred to in a still more marked manner by the vacant eye on the architectural molding, seeming to mock the human scene. If we, as English-speakers, venture to hear and to see how this eye is "cropped out of the picture," punning on a riding *crop* and the idea of *cropping* (exclusion) by the frame (the chosen limits of representation), we can scarcely be accused of falsifying an image already so fraught with the stress of partiality, and so loaded with metonymic violence.

I shall refer then constantly to my subjective interpretations in discussing the collective Dada and surrealist images with their own odd games. Their frenetic meaning is not undone thereby: violence is symmetrically done, as in a dance step, in a rhyme whipped up to a point which no Dadaist or surrealist would have rejected, into a further wrinkle or plus-pleat – a *pli-en-plus* – for the implicating text.

Finally, when Max Ernst illustrates "Le Troisième poème visible" ("The Third Visible Poem") of Paul Eluard, the lessons for reading multiply. The multiplication in the row of hands in their mutual grip, in the absence of all

bodies, operates with the efficacy of a comic strip. Energy invites the reader, whose eyes travel from left to right, saluted by the image, as if drawing ever closer. In the same way, the fertile or multiplied eyes of another illustration in the same volume, the two sets looking directly at each other but with one row slightly higher than the other, seem, when they are seen by our own eyes, to accrue all the more dynamism from the difference in height. These eyes and these hands function like the iconic emblems of the mannerists, for whom the *blasons* or "compliments" illustrate the individual parts of the body as they are chosen and set in splendid isolation.[4]

This multiplication proper to Eluard is also typical of the surrealist grand manner. We remember not just the parts of Breton's "L'Union libre" ("Free Union"), with the detailing of the parts of the beloved's body, but also the eyes of Nadja, of which we see four pairs, so to speak, superimposed on each other. In one edition they are found directly across from the garter belt of the statue in the Musée Grevin, forcing us to read the emblem as erotic – all the more so in that it deals with seeing.

Hands on

When we read, under the foam-rubber version of a single breast used as book cover, the injunction "Please touch," this text sign counseling the opposite of what does not usually need to be stated jars oddly with the way the book is usually wrapped in its de-luxe versions in the rare-book rooms where such curiosities are usually found. With some slight sense of humor, even the contemporary equivalent of Breton's surrealist "waking dreamer" may associate with this paradoxically touching object a recent advertisement in the *New York Times* where the "unique" doorbell ready for sale takes the form of a breast, where it is paradoxically visible that, if we do *not* touch, we shall not enter. So much for the following of instructions, explicit or implicit: unique indeed.

The parts of the body separated and repeated, as the eyes of Nadja are repeated, act in the first place to represent convulsive beauty, and, in the second, to represent the hysteria of the image as it acts on the nerves of readers. I think here also of Tzara's repeated "r r r r r r r" in a poem, and then, in capital letters "HERE THE READER STARTS TO YELL," quite as unnerving as the letters themselves. The images aggressively unseat our habits of staid readership.

Reading on the side

"What I care the most about saying is far from being what I say the best." Our approximate reading of these words of Breton which haunt the impassioned

imagination will furnish the angle with which I close the reading of what I have tried to leave half-open, this angle through which we can observe objects sideways, obliquely, on the bias.

Two photographs by Benjamin Péret in *Minotaure* give us the keynote for our subject. The first is a picture of ruins, seen at an angle. The second is a photograph of a suit of armor, where the gigantic form of the lance is read as obscene, or, at the very least, highly suggestive. This very unordinary angle strongly contributes to the power we sense in surrealism's images, seen often at their best on their side, for it is there that they enter most suggestively into the imagination.

The surrealist image such as we appreciate it in the rare edition "de luxe" or in the standard and ordinary edition teaches us to reorient our view. By these techniques of multiplication, of mirroring, of framing, of iconization, of bifurcation, it teaches us to read against the ordinary meaning and directions of meaning a given. We could think of "Toujours pour la prèmiere fois" ("Always for the First Time"),[5] Breton's poem where all the images are set at an angle – the pickers of lavender, the curtains at the window, the oxen stopped on a slant in front of a cliff. We think above all of the strength of the oblique, and of the doubled power of all these images set on the side.

For example, in Jacques Brunius's article mentioned earlier, Nosferatu the vampire is seen standing at the top of the page while below, lying down, the child dreamer in the movie *Peter Ibbetson* reclines. The attraction of this contrast – the old man standing, bent over, across from a text of Breton ("In the shadow where the glances meet"), with the child lying down – is immense. No less great is the attraction of this same image of Nosferatu placed on its side across from a text of Breton as, in the cheaper edition, it falls on the page. The text is at once a "sliding fact" and a "cliff fact," as Breton discussed them, each of them inviting us to dream, with more or less force, in the disquieting strength of the surrealist image, depending on the speed with which we fall.[6]

In *L'Amour fou* (*Mad Love*), where, to take a formula of Breton, "Everything I have loved the most began," many things are shown on their side: the mask which so attracted Giacometti at the flea market; the shoe–slipper of Cinderella, where we see the wood change to glass before our eyes, according to Breton; and even the crystals illustrating that celebrated glass house that Breton would have liked his poetic dwelling to resemble: "The house I live in, my life, what I write: I dream that all that would appear from far off as these cubes of salt crystal appear from close up." In the original text of *Minotaure*, these crystals are presented straight up, on a surface apparently rigid, across from the dancer representing the quality of "fixed–explosive." But, since they are falling upon their side in my paper edition of *L'Amour fou*, this glass house is all the more unsettling, all the nearer to Breton's "Maison insolite" ("Unsettling House"), in his poem of that title. For it is this image, and not the other, which haunts me, as Breton's face has for such a long time, where everything "we have loved the most", and continue to love the most, first began.

But, to end on this, *L'Amour fou* and the other books we love in a surrealist fashion preside absolutely even now over our present imagination, over our reading which absorbs with passion all these contradictions. If, in this mad love which has become our own, so many things present themselves on the side – this mask and this spoon, these crystals, these flowers, these plants – their revelatory capacity such as we read them is all the more efficacious. Our own obsessed love of the surrealist text is augmented by the angle, our visionary angle rendered all the more acute and, thus, all the more penetrating, once it has taken the extreme bias of the visual or verbal text.

And so, today, crystals perfectly arranged and plants growing straight up seem not so real to me and not so revealing. It is the angle that enriches the imagination: the world is only impoverished, I am convinced, by *perceptual rectitude*. The textual *memory* of images creates the things in which I continue to believe, in a fashion as surrealist as it is Proustian. And even now, in this twentieth century just as "splendid" as the ones gone before, I am told in vain how the world around me is constructed, what it looks like, and on what axis it is soberly oriented – this world that others persist in calling "true": I shall never sacrifice my reader's memory enough to arrange "properly" and in all evidence the things for which I live.

9

LADIES SHOT and PAINTED: FEMALE EMBODIMENT in SURREALIST ART

I think that is absolutely amazing, really phenomenal. Talk about complications.

André Breton, to Pierre Unik

Conspicuous consumption: caging in and out

When Pierre Unik told Breton that he consulted, in lovemaking, his partner about what he enjoyed, Breton was amazed. Why not? asked Unik. Because, replied Breton, her likes and dislikes "having nothing to do with it."[1] Indeed. Breton's attitude may strike *us* as phenomenal, given our present assumptions about an egalitarian society, about an equal ardor consuming both and all members of unions – but of course, talk about complications, surrealism had a few.

I want to reflect on some problems in the representation of female bodies in surrealist photography and painting, touching first their canonization, their consecration, and the laying on of hands, and then the relation of this representation to the supposed consumer, for his or her conspicuous or clearly visible consumption. Since, in the latter concern, *we* are plainly concerned when we look (whoever we are assumed to be), just as where we speak or write, we may be assumed to be looking at our own gaze (*con-spicere*, to look intensively). Problematic above all is the notion of our own consuming of what we see as if in collusion with the artist or photographer.[2] For both the representation as produced by the agent or manager or mediator of the reading – artist or photographer – and the reactions of the onlooker or reader of the image must be re-exposed in the light of a certain recent criticism

This essay (excepting the section "Deep process") was first published in Susan Rubin Suleiman (ed.), *The Female Body in Western Culture: Contemporary Perspectives* (Cambridge, Mass.: Harvard University Press, 1985).

putting into question the whole binary system of subject and object. This is a revision overdue and all the more problematic in surrealism, which already wanted to overcome the split between seer and seen, visionary and view: thus, a problematics of the problematic, and how it is received.

I see this, speaking from the point of view of onlooker, as a tripartite problem: our view of the object – in this case, the woman portrayed in whole or part (of which more later); our view of the agent or mediator or middle person; and our view of ourselves as consumers of the object as mediated and managed. To talk, again, about complications: insofar as it is a question of women's bodies, the female onlooker is – willing or not, partially or wholly – identified with the body under observation and under the rule of art. Her reaction to the middle term or the management will be colored by that identification, her consuming function modified by the pleasure or anger with which she differentially views what I have been calling the laying on of hands (*management*, from "hand," like "mannerism," and – of course – like "handling").

For how could we possibly think that a seeing woman writing about women being touched with the brush, perfectly *captured* in paint, or accurately shot by a camera's eye, about these artistically ogled and consumed beings, would have an "objective" point of view? Her lens will be at least set with an angle to it, since there is no stranger's summit on which to stand aside and above. She, we are bound to think and say, is implicated, heavily.

Implication is nervously involved in looking at André Masson's rendering, for the Surrealist Exhibition of 1938, of a mannequin at once painted, caged, and captivated (plate 9.1). Her head is imprisoned in a bird cage, her face caught exactly within the cage door and her mouth masked, with a pansy directly over the opening. Under her arms, pansies match that one, so that neither in speaking nor in making gestures is she able to present herself unmediated or untouched, unornamented. The cage is not domestic but rather of the jungle variety – thus her presentation as vaguely exotic, beflowered. Over the join of her thighs is a complicated decoration for a double thrust of hiding and priding, as we might read in the peacock eyes (or, reread, the evil eyes) with the curving plumes in the form of fallopian tubes.

A found object, severed in the middle as mannequins may often be, she is set up with odd lighting so that one breast seems larger than the other: it is marked above by lines of shadow, significantly in the form of a spider, as if entrapment were to be in fact the key to the reading of the object. The shadows under the left eye and the dark circlet just below the neck stress the embattled nature of the shady and shiny lady with her jungle hat. She cannot speak; she is entrapped even as she is decorated, wearing at once too much and too little, dressed up and dressed down, naked and rendered mute, added to and subtracted from, but most of all entrapped. We've come a long way, baby, from the fig leaf to the chastity belt to this prize covering flower.

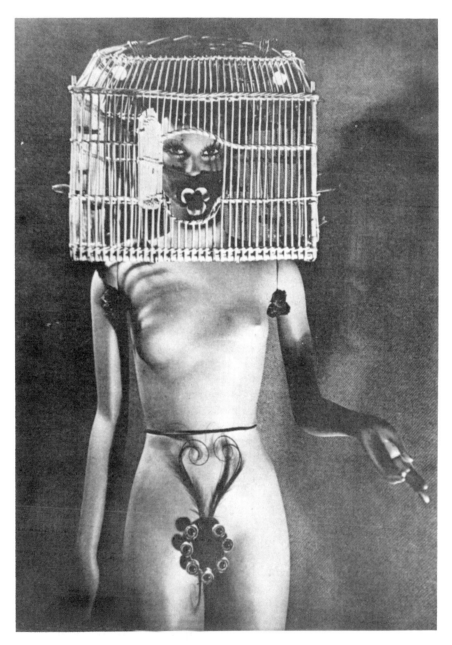

Plate 9.1 André Masson, *Mannikin with Bird Cage* (for the Surrealist Exhibition of 1938), © DACS 1989.

As for the head so encaged, it calls strongly to mind another female entrapment, this one the capturing by Man Ray of a live female model whose torso is bare and whose head is perfectly netted in a wire mesh hat, through which her eyes look out, as unsmiling as her mouth (plate 9.2). Is this a reflection on hat styles, on consumerism as negative display, or on capturing a prey who is rendered simultaneously mute and speaking of objecthood? The slope of her shoulders denotes a submission to the netting and the capture, and the caption is a quote from Breton's piece "Il y aura une fois" ("There will be a time"), which the photo illustrates: "These girls being the last ones to point themselves out in a haunted house scandal. . . ." The haunting, I submit, is more than a little sexually oppressive and less than innocent.

Xavière Gauthier's attack, in her *Surréalisme et sexualité* (1971),[3] on the male surrealist artist and writer's point of view regarding the female sex object has often come under attack itself for its "reductionism" and its "simplifications." A contemporary re-examination of the issue – of which this can only be a preliminary sketch – might well want to take into account two more recent works, neither directly concerned with the male–female issue, but both of indirect and yet certain relevance. The first is that of Rosalind Krauss, in her chapter entitled "The Photographic Conditions of Surrealism" in *The Originality of the Avant-Garde and Other Modernist Myths*, where she examines the techniques with which surrealist photographers rob – by their spacing and delays and doublings – the image of the sense of presence. Quoting Jacques Derrida on the split between the time of the meaning of the sign and that of the mark or sound as its vehicle ("The order of the signified is never contemporary, is at best the subtly discrepant inverse or parallel – discrepant by the time of a breath – from the order of the signifier"), Krauss explains how, for Derrida, this spacing can be "radicalized as the precondition for meaning as such, and the outsideness of spacing . . . revealed as already constituting the condition of the 'inside.' "[4] Thus "spaced," she continues, the photographic image is deprived of the sense of presence which – since it is the mark of the object – we have counted on. Doubling, or the showing of this spacing by a double imprint, is the most important strategy in surrealist photography for letting the sense of difference and deferral penetrate the image (and so, we might want to add, the imagination). "For it is doubling that produces the formal rhythm of spacing – the two-step that banishes the unitary condition of the moment, that creates *within* the moment an experience of fission."[5] Doubling destroys the impression of singularity, of the original.

Since, as Krauss says, surrealist convulsive beauty depends on the belief in "*reality as representation*," and since "Surreality *is*, we could say, nature convulsed into a kind of writing,"[6] her discussion is crucial to the points I want to make about the representation of the female image as I consider the writing of the female into the making and the seeing of surrealist art. The denial of presence is exactly the problem with such photography, as we see ourselves

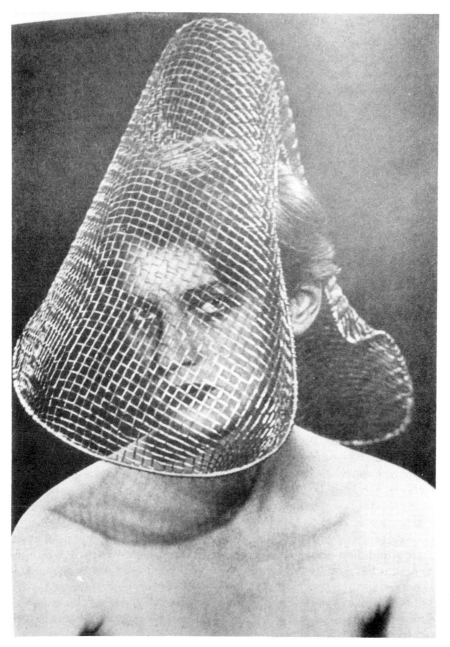

Plate 9.2 Man Ray, photograph in *Le Surréalisme au service de la révolution*, no. 1 (1930), © ADAGP, Paris and DACS, London 1988.

seeing ourselves in it. In the image by Man Ray, *Monument to de Sade*, which Krauss takes as one of her two initial examples, a woman's posterior is seen rotated to the left and up, to echo a simple cruciform design imposed upon it: "Never could the object of violation be depicted as more willing."[7] So the issue of depiction, collusion, and consumption are massively complicated even by the formal echoes, as we read them.

If we consider the point of view of a leading modern female exponent of surrealist views, looking at the identical posterior and the identical cruciform shape as they fit each other, the difference in interpretation takes on its complicated colors to color our own text. Annie Le Brun, reading the same image of the *Monument to de Sade*, finds it the supreme example of revolutionary eroticism, the very illustration of the nudity of loves, and gives it the caption, "this condemned part of our history, the splendid return of the flame of human freedom against the idea of God"; and for the blurb of Jean-Jacques Pauvert's volume *L'Anthologie de lectures érotiques* she comments, "Whether we like it or not, the body remains our only means of transportation, body of the other, body towards the other, body neither of one nor the other, body always other."[8]

I have worried before, in the case of modernism, about representing a body as if speaking before some parliament and about some body that should speak for itself, yet finds itself, instead of representative, just represented;[9] I have tried, elsewhere, to consider the image repeated and even integral in a series of representations of the fragmented body as a piece of the whole body of art.[10] She who would understand that body, in its own figure and embodiment, is obliged to *take it up*, and this taking-it-up is already taking a position, this position taken already implying its own struggle, hoping to find therein its own strength.

The body laid flat to be exposed, the body bedded and eaten by the eyes after the camera or the brush – this body demands, it would seem, a completely other point of view from the body sighted in the polite nineteenth-century garden picking fruit, or cuddling a child, or simply and politely seated or tabled, as in Mary Cassatt's women taking tea, chatting and consuming, as if the proper response there were to be a tabling and a sipping, a gentle consuming of impressions as opposed to the more violent surrealist mode.

But the artist's point of view is of necessity manipulating, and not just in mannerism: all art is derived from the hand, after the eye. By the hand this model is treated and seated, tabled and bedded. Linda Nochlin has shown us convincingly (and graphically) how, since the nineteenth century, the woman's body has been presented for the man's erotic pleasure, rarely the man's body for the woman's.[11] Commenting on the woman's nudity as she has been traditionally exposed before the eyes of all, John Berger contrasts, quoting Kenneth Clark's *The Nude* as his source, nakedness (the state of being unclothed) with nudity (a conventionalized way of seeing), summarizing the argument as "Nakedness reveals itself. Nudity is placed on display." He then

points out that the display is always for the male spectator.[12] The woman's exposure is not – and Breton would surely agree – a matter of her own sexuality, but one of the sexuality of the observer, whose monopoly of passion is such that bodily hair (assumed to represent sexual power and passion) is not ordinarily placed on *her* objectified body.[13] Alienated from her body and from its probable representation, present and future, the model suffers in fact the destiny that René Char predicted at the end of his own classic surrealist text of 1930, "Artine": "The painter has slain his model."[14] Char refers here to an interior model as replacing the exterior one: we who have been the model so often exterior may learn at least to exteriorize our anger over some of the manhandling.

Pleasurable fictions of presence

But back to the binary. The idea of a union, so desired, between painter and object of gazing and creation, fictional as it is, and of a specific problematic, may suffice to create a general fable which can so depart from the apparent realm of fiction as to become real. These are fictions indeed, these unions of body and brush or sight, but real fictions, sustaining as they – and only they – can the object of art as the representation of any onlooker's desire. The problem is, of course, the "any." Whose *is* the body of this art, and whose the fiction? Whose is the pleasure, where is it taken, and from whom? And, apart from the commercial *gain* of the management, what is its fruit? Who consumes what, however surreptitiously, and who is consumed, even by a glance?

It is, true enough, just as we are often told, a privilege to be photographed by, to be *captured so well by*, the camera or the brush of a great artist. How could we ever, either as model models or as model onlookers, have thought that any model would refuse to bear or enjoy the fruit of the entrails of mother art itself, at the hands or through the lens of its most celebrated representatives? We have then, it is supposed, to give credit, photographic and artistic, to the great mediators of the image as they pass it on to us; since they are also, in this cycle as I see it, the mediators of us to ourselves, we might want to pause before giving entire credit to the entire story, or to their descriptions as our story.

Narrative always fecundates; more stories are ceaselessly produced for us to live and read them, for them to efface our critical doubt, however dubiously we first begin to participate in bearing and having and seeing. Are we to refuse looking as part of being looked at? The whole issue of looking at ourselves as looked at calls into question how and where we may be thought to possess ourselves, within this fiction of painless consuming of images-as-other. They are not, in this case, entirely other, nor can we pretend to see them as such. We are folded up in and into – implicated – and even tied up in and by our seeing.

Implications: taking our place, and whose pleasure?

Are we obliged to be represented by, to participate in such problematic representations as that of a body offered in a caged display? What of a woman looking at an Other Woman clothed or caged, naked and yet neat and perhaps even integral, or dismembered like a doll of Hans Bellmer, untidily lying somewhere on some stair or floor, or then stretched out and spread out even more awkwardly like Marcel Duchamp's nude half-body with her legs wide apart, hidden and revealed behind his wooden door with its peephole in his construction called, aptly enough, and in the plural because, in fact, so much is given, *Etant donnés*, or *Given*? Does the woman looking take the stance of another or of a same, and what pleasure does she take in spying? Is the prey *taken* or the likeness perfectly *caught* in art *given* to her too, only as she can be co-opted into spying?

Only in utopia, some might say, would spying on the other have no place, whichever other we are not the same as. But the pleasures of participating and showing, modeling and making, consuming and enjoying the other – all these would seem to depend on a binary system. Michael Fried's examination of Diderot's attitude in front of Tintoretto's *Susanna and the Elders* is one of the most relevant texts in relation to such spying, for the Tintoretto renderings pose a special problem about a gaze seen as illicit. "The canvas," says Diderot, "encloses all of space, and no one is beyond it. When Susanna exhibits herself bare before my look, opposing to the stares of the old men all the veils in which she is swathed, Susanna is chaste and the painter too; neither one nor the other knew I was there."[15] John Berger points out about the version Tintoretto made of Susanna looking at herself in the mirror that she joins the spectators of herself, whereas in the other rendering, as she looks at us, we are the obvious spectators and she judges us as such, as female nudes usually do.[16] In either case the spectator is committed, along with the old men, to gazing at Susanna.

Is there some way of looking that is not the look of an intruder, some interpretation from which we could exempt ourselves as consumers? Julia Kristeva reminds us how the verbal play of debt, of nearness and presence, is found from the beginning implicated in the notion of interpretation (*interpretare*, to find oneself indebted toward someone, based on *praesto*, meaning "near at hand" – *praesto esse*, to be present; *praestare*, to present, like some object, money in particular). But, she says, "the modern interpreter avoids the presentness of subjects to themselves and to things. For in this presentness a strange object appears to speaking subjects, a kind of currency they grant themselves – interpretation – to make certain they are really there. ... Breaking out of the enclosure of the presentness of meaning, the *new* 'interpreter' no longer interprets; he speaks, he 'associates,' because there is no longer an object to interpret."[17] Here the dimension of desire appears, and

interpretation as desire returns the contemplator and participator in surrealist art back to the very subject: how might we desire to function so as not to be implied in the *incorporation* and *embodiment* of the desire of another, when our body is interrogated, subjected to the act of painting as to the act of love, but without choosing our partner?

There again difference sets in, between the gaze and the glance, for example – the latter implying less presence to the painting or photograph, the former requiring a lengthy implication in the folds of the scene or portrait. Norman Bryson, in his remarkable study *Vision and Painting: The Logic of the Gaze*, examines the distinction between two aspects of vision, the gaze or look he calls vigilant, dominating, and "spiritual," and the glance we could think of as subversive, random, lacking a principle of order.[18] The look, as he explains, implies an act always repeated, an impulse that would want to contain what is about to escape, as in the expression *reprendre sous garde = regard*. This gaze gone hard, this stare, tends toward a certain violence, a will to penetrate, to pierce, to fix in order to discover the permanent under the changing appearances, which implies a certain anxiety in the relation between spectator and object seen. The glance, on the contrary, creates an intermittence in vision, an attack, as in music, which withdraws afterwards into the calm of non-seeing; this would be the plebeian aspect in contrast with the aristocratic nature of the gaze, visible to the gaze of the other.[19]

The gaze fixed into a stare would not permit the other thus transfixed to leave the battlefield or the pleasure bed, or the canvas. It would hold the other there, at the table of consummation and consuming. In contrast, the glance inflicts its momentary violence, and sometimes on the slant, with no return permitted, leaving to the other a certain freedom. In surrealist painting and photography, I would submit, the gaze or the stare and the glance seem often to be called for as if simultaneously, summoned and as it were renewed: "Always for the first time," as in the Breton poem of that title ("Toujours pour la première fois"). The sustained gaze will then be subject to momentary impulses of the glance as violent assault, under which the model will be obliged to sustain the onlooker's spontaneous desire in a paradoxical permanence.

The surrealist body represented, taken (in) by the gaze and glance of the spectator, presents no margin of interpretation. By the desire of Breton as critic, all distance is to be suppressed between seeing and the object seen, between the look of desire and the prey, between two objects imagined or seen together.[20] Unless the female – for it is usually *she* – submits actively to such a stare, giving what is in any case taken by the male, she will have no role except enforced submission. The *prise de vue*, that expert taking of the view, that shooting of the model, is a one-way venture, far from the erotics of exchange, open only to a willing relation of dominator and dominated.

Translating business

What is rendered by surrealist art is rarely qualifiable as totalization. More frequently than not, only a fragment of the body is exposed to brush or lens, as in mannerist emblematics: an eye for Magritte, either seen in the crack of a door (*L'Oeil*) or in sublime solitude, divorced from its other and with clouds floating across it (*Le Faux Miroir*), or (in *Le Portrait*) delicately placed in a slice of ham upon the plate; a breast for Duchamp or Eluard, sometimes ornamenting a book cover slyly enjoining us "Please Touch"; a series of clasped hands or wide-open eyes for Ernst (to illustrate Eluard's *Répétitions*); a photograph of legs repeated, or of one glove, for Breton's *Nadja*. This process, by metonymy and synecdoche referring to the whole body by the handling and exhibition of one part, can of course be considered celebratory, as in Breton's famous poem "Union libre" ("Free Union"), in which each part of the woman loved is chanted in turn. This would be a traditional translation according to a mode now classic, no more troublesome than the instant interpretation of such famous lines as Ronsard's "A ce bel oeil dire adieu," which we read as saying farewell not just to one gorgeous orb, not even to both, not even just to the face, but to the whole being, in a crescendo which has – by the time we get there – lost all shock value, to become a standard reference point.

But modern views about translation, such as those expressed in the volume *Difference in Translation*,[21] teach us about misuse as being more creative than standard use, about mistranslation as a possible challenge to a too simply $A = B$ relation by exercise on the pressure points of textuality, in which a relation of surface is also kept, and not just a relation of substance to substance as ordinary useful merchandising.[22] The *business* of translation as textual business too puts a new light on the light put on the surrealist body and its polyvalent representations. We cannot just refer the fragmentation of the surrealist body back to mannerism with a good conscience, but must see it with the *presentness* demanded by modern art and theory. Thus, the female body seen by Hans Bellmer as a lifeless rag doll, rounded and thrown down like some cast-off propped up for the picture, may enrage as it enlightens us; the double exposure of one pair of breasts above another in a photograph in the *Minotaure*, one of each pair larger and in profile, the other smaller and pointing the other way, like four eyes unwilling to meet the observer's stare, may send us back to the vertical superpositioning of many pairs of eyes in *Nadja* as well as to the other repetitions of fragments of females, but it will not add up, however we calculate, to wholeness. In each pair there is a visible difference, which the repetition only aggravates. Horizontal opposition plays against vertical sameness in an image contrary to all intuition. This is a perfect image of delay and spacing, as in the analysis done by Krauss, wherein presence is abolished from the photographs.[23]

Deep process

Man Ray, as a photography master, offers to the reader of the partial portrait a picture of a throat (plate 9.3) no less passive and no more oppositional to the offering than the preceding pictures. As they are all of a certain imprisonment, of a violent encapturing, and have thrust upon them each an odd thrust, so

Plate 9.3 Man Ray, *Neck*, © ADAGP, Paris, and DACS, London 1989.

this throat, uplifted as if for sacrifice, is extended as far as possible. This surrealist view takes an odd slant, and betrays a pictorially high romanticism, for such extreme clarity of the whiteness against the black background, such isolation of the object, contextless, makes the very gorge rise to a summit of horrifying perception. This throat – so like a male member in full erection – is a perfect example of androgynous rendering, of the female by the male, to the look of both genders. Women, in surrealism, are surely up for sacrifice; are surely straining every member to be pictured in the oddest and most effortful of stances and positions, clothed and bare, to be breasted, waisted, and necked.

On the other hand, in the solarization of 1931 (plate 9.4), a woman's face and hand and neck are pictured as if netted, both being offered for sacrifice, and emblematically solemn. The networking is more clearly marked on the skin, whereas on the other parts of the picture it is far less clear. In her frontality, without a smile, she presents two fingers on the right hand, and three on the left, but the thumb and its shadow point directly to her lips and neck. Looking at her solemnity, the observer reads the image as if she were trying to enter a plea for help, with her hands up.

It will not be forthcoming, now or ever, in this picture. For what is in all probability *not to be helped* is the relation between the observer – male or female – and the model so accepting of the representation and so posed. Any slightest suppositional relation between the reader of such images and the implication of the images as posed, and necessarily accepted in the reading, is more than problematic: it is complicitous. Even as one figure bends back as if swimming, with her long mane dangling, or thrusts back her luxury against the light and the air, burning her cigarette like herself as she goes, the model is performing, and we are the receivers of the performance she so pointedly gives. Another tightly wrapped performance Ray gives us is no less our show: how not to react to the section of female body preserved in moiré, to the bulge of the breasts, the indentation of navel and crotch, the swagger of the oily creases? That is to say, we may personally not delight in such exhibitions, but even to look, even to look aslant at the slanted presentation, is to meet the challenge of those arms with their blatant suggestion of the hands-on-the-hips posture: what do you make of this? Well, what is to be made of such presentations, and where would it possibly have its making, but in the mind of the observer?

We may well read the thrust of the exposed throat above as a threat to our own, doubled with an exhibitionist rendering of a member in whose club we may or may not be. The object *qua* object is surely one of the strangest unions of extension and foreshortening ever to be shot; bared to the knife or bared to the camera lens, what difference? The victim is us all.

In contemplating the crucial image in what I am presenting as this series of representations of the female model in relation to our reading, we are in all likelihood the netted and the captured, even as we are become the guilty party

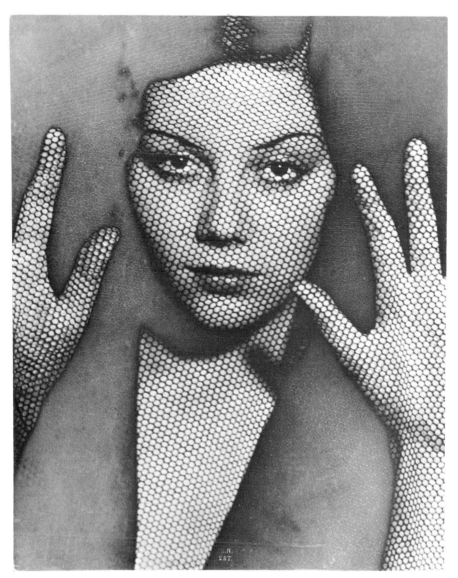

Plate 9.4 Man Ray, *Portrait through Wire*, © ADAGP, Paris, and DACS, London 1989.

of watchers, unable to respond. The shadow of that thumb feels, upon re-reading, like the shadow of some well-trained gun or, at best, some phallic desire, aimed at the satisfaction of some secret upon which those lips will never make a statement, other than this mute and enigmatic one. Observed in our very reading, caught both in the separating net and in the possibility that it

is we who are netted, we are screened in with the other observing us, divided between the female captor and our notion of ourselves, this division reflecting the other between the parts of the two hands, with the exposed fingers numbering just one. From this net, whichever way it works, whoever the captor and whomever the captured, there is no escape, nor is there one from the projection of the shadow – or whatever violence, desirous or menacing, it is read as indicating.

Another kind of reading from the implicatory one necessitated by Man Ray's confrontational figures is aroused by the distortions of André Kertez. Here there is no indication of our involvement in the situation: passive as she is, the model looks elsewhere and not to us for her reading of herself. Her oddness is plainly a matter of the camera's manipulation, and it seems in no sense to include or require any reaction at all from us. Whatever the model awaits, it is not our gaze, either for pity or rejection, for attraction or disgust. She is irremediably *other* to our gaze, an object whose fate and fortune do not seem to implicate our own. A woman shot, to be sure, but whose shooting in no way precludes our objectivity towards the operation. *Non-participatory surrealism*, I would call this approach, the direct opposite of the complicitous demands of Man Ray.

The zenith of the distancing or objectifying mode is wittily represented by Kertez's celebrated rendering of a couple of statues at a dormer window of a Paris roof. Between the decorative architectural coils, the face of an old Greek philosopher and the torso of a young maiden peer out, each looking left and into the distance. They take up the lower half of the window, divided as it is into four parts, with a division-marker between them. Never, we might read, will the two faces of wisdom and beauty mingle, never will their gazes coincide or be permitted each to strengthen the other. It is certainly not a case of the reader having to choose between the two, divided as they are in their representation, and distanced as the reader is from them. Forever they instantiate distance and division: forever, even should their gazes meet, in some other setting, would the distance be part of their gaze. For his head is twice the size of hers, as hers is seen in retreat, the bosom bared, the angle that of a *contrapposto*, her body turned towards us and her head slightly away.

What they are seeing, we cannot see; our separation from them, like theirs from each other, is entire.

Emblematic, as if in some attic of the mind, these heavily contextualized figures stand watch over what might come to pass, somewhere else, when we are not watching. Like watchers-out in a surrealist state of permanent expectation (that *état d'attente* surrealism provokes, encourages, and even demands), these figures even in their division represent gender difference, male contemplation and female beauty, each trapped in their separate lives; what they await is probably not destined to change the state of things or their outlook, and it will, in all likelihood, not alter ours.

Parts and the politics of the whole

When a fragmented image is said to represent us, as we are supposed to represent woman, we may either refuse such synecdochic enterprises of representation or demand, if not totalization of the model, then at least reintegration, according to terms both private and public. To be sure, being partial prevents our being seen as homogeneous, and thus acts against the exclusion or appropriation of "all of us," all of our mind and body, since we are seen only in part.[24] We learn our politics in various ways, and these displacements and impositions may lead to rebuttal, or then to a demand for differentiation between the brilliant and revelatory, and the simply deforming and defaming. What we see as we are stared at may inform our own returning stare, or our own newfound anger, or help us to see something about ourselves, to accept it, refuse it, or change it.

One of Magritte's images, *Les Liaisons dangereuses* (plate 9.5), playing on Laclos's novel of the same name, shows a woman down to her ankles, her head bent down in profile. A mirror is located exactly in the middle of her body, with the middle part – that portrayed in the mirror – reversed in the center of the image. It is also reduced and raised, so that the parts – upper, central, and lower – have no way of matching. The deformation can be read as central to the self, for the woman divided is also watching herself – without seeing us see her from behind. The mirror she holds is, as traditionally, the sign of *vanitas*, which, as John Berger points out, condemns her and has her connive in "treating herself as first and foremost, a sight."[25] Not a pleasant sight, and conducive rather to self-loathing.

The awkwardness invades every inch of what is presented as vision on the interior of the frame. Never, in this body pictured and centrally interrupted, is the center to be either focused in the right sense or beautiful; never is the flow of vision to be integral; never is grace to visit this figure, from which the middle is forever excluded. Beneath her chin runs the hair continued, seen from the back, like the beard of some Slavic god; and more mythical figures are called in to help us read the picture, which is never satisfactory, and from which we are always shut out. Turning away, her posture resembles that of Cranach's Eve, with her back forever framed, her belly lit by a thin lighted line. Her head droops like that of a dead woman, or the bent head of a Madonna. She refuses to meet our eyes, as if desperately seeking the privacy she is supremely denied. This enormously pessimistic picture, with which – strangely, and perhaps because of the echoes – it is hard to empathize, into which we cannot enter, might be read as "Woman reading woman."

This negative view is forever bound to be that of Magritte's self-regarder as she fails to locate her image in the mirror image, an image as reversible as it is inescapable. Self-loathing is presented as part of female presence. Now, to this image such contemporary reflections as those we might make upon the pride

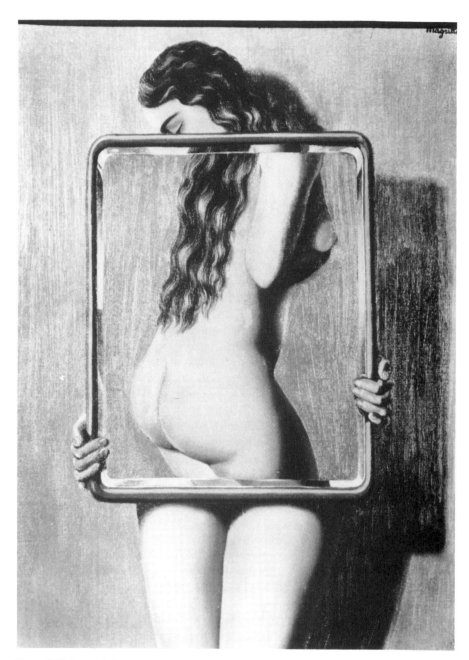

Plate 9.5 René Magritte, *Les Liaisons Dangereuses*, 1936, © ADAGP,
Paris, and DACS, London 1989.

and glory of the naked state (from Eve to photographic models) are totally foreign: the picture, as picture, makes no room for pride – only heavy astonishment at there being no frontal state to observe, for either insiders or outsiders. Deprived of natural frontal beauty, seen only askance and from the side, completely under the domination of the male painter, the model simply exhibits the shame of self and the difficulty of self-reading.

Quite to the contrary of such formulations – baldly categorizable as the nude ashamed and self-concealing, the fragmented doll, and so on, images setting up the display of the female, reading herself or as she is read, for the delectation or violent pleasure of male eyes – would be the free exchange of the ideas of possible images, between sexes as between persons and nature, all these translations at once erotic and artistic, the translations of difference which we could freely enjoy under the light of the narrative fecundated by a couple or many. I want to examine in particular a few images of the positive, or then of the double-edged or ambivalent, in photographs by Man Ray and in two paintings by Magritte.

Man Ray's extraordinary image of a female torso called *Retour à la raison* (*Return to Reason*), reprinted in *La Révolution surréaliste* (no. 1, 1924), is a film still from his three-minute film of the same title. Made by the capture of a female body moving behind a striped curtain, this torso appears with stripes of shadow across the bare flesh like those of a tiger, one snaking up the center, all like some elaborate body painting. The torso, leaning slightly backwards, inviting the gaze, is posed against the rectilinear form of a window, so that the curves of animal and human play out their contrast. Nature is brought to the human, and the curved to the straight. The diagonal stripe across the torso echoes the window line, whereas the slightly fuzzy or at least irregular shadow to the right echoes, as if with human hair, the subjective statement of the photograph itself. This is, it seems to me, a positive image, adding to the beauty of the female form. This imposition is quite unlike the imposition of the penis against a woman's nose in a photomontage by Wilhelm Freddie called *Paralysexappeal*, in which the addition can only insult and enrage a female observer. The Man Ray imposition of the natural on the human can be read only as beautiful; in no way is the body deformed – it is rather augmented by its natural possibilities. Thus do we learn about merging the one with the other, as in the surrealist game of *l'un dans l'autre*, the one in the other, where one object is considered as augmented by the other and each rendered more interesting: their union is not forced but imaginative, and multiple in its possibilities.

In another but frontally posed torso, the imprint of the curtain with its meshing pattern over the bareness works a strange and convincing convergence. The bare body behind the grill, or its representation, is nevertheless liberated, as it is, precisely, baring its breasts; the baring is all the more emphasized in relation to what appears to be a binding corset, dropped to expose the navel, thus creating a double liberation, above and below. That the face of the

woman is seen in only some versions, not in *Retour à la raison* nor in many of the other Man Ray photographs with the bare torso striped or bound, permits the body's presentation as emblematic, and as emblematic of beauty itself, in all its splendid convergence of the bound and the free. The protrusion of the breasts balancing the indentation of the navel is marked as the other, and natural, opposition, whereas the body exposed by the side of the curtain which would be thought to cover and to veil makes the drama of the whole presentation. This, like *Erotique-voilée* (*Veiled Erotic*; plate 9.6), celebrates a complicated ambivalence in paying homage to simple unadorned beauty, celebrates the art of photography in paying homage to nature, and, in encouraging the juxtaposition of the notions of superimposed pattern and evident freedom, celebrates the play of the intellect in relation to the body.

To this union of possibilities, human and artistic, we might compare, for the blend of figure and nature held in exchange, the extraordinary photograph by Brassai which appeared in the surrealist journal *Minotaure* (no. 6, 1934) of part of a naked woman's body from shoulder to buttocks, seen from behind as she lies stretched out with her ridges and furrows and monumental beauty responding to the long body of a mountain's profile, matching curve to curve beyond her, and above it the sky, as if reclining in like pose above the mountain, its bright curves mirroring the light body of the woman against the darker ground, like two female bodies stretched out to hold between them all the earth and its own full and swelling beauty. Surrealism's flexible and often sentimental vision serves to encourage such harmony between natural landscape and the culture of art, holding in poetic embrace contrary elements past their binary opposition, as in Breton's memorable and significant expressions "the air of water" and "the flame of sea." These expressions illustrate the surrealist basis of convulsive beauty, the reading of one thing into another. The image can in fact be read equally well from the top and from the botton, in perfect figural harmony.

Breton's statement, in *Nadja* and elsewhere, that "beauty will be convulsive or not be" is illustrated by Breton's own choice of an image by Man Ray to accompany his essay on this subject in the *Minotaure*. The image is full-page and striking; its title, *Erotique-voilée*, marks it as at once open and secret. Méret Oppenheim is pictured leaning on a gigantic and complicated wheel, nude and facing us, with her left hand and arm raised, imprinted with grease, while her right hand presses on the metal. In the upper right-hand space between the outer rim and the spokes, chosen elements of her body are as if *caught*: the hair under her raised arm, appearing just under the rim, and her left nipple, appearing just over the spoke. This image is emblematic, I think, of the double reading of surrealism's celebrations of *blasons* or separate body parts, for the elaborate divisions of the wheel stress, above all else, the disjunction of parts.

According to a first and positive reading, all the pressure here can be seen as light – the eroticism also, even as it is veiled. The interaction between machine

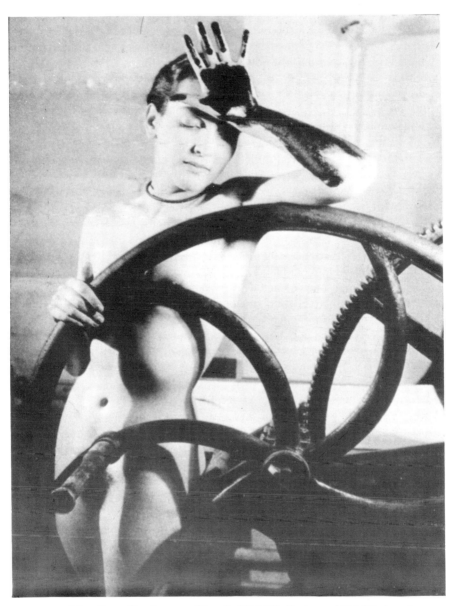

Plate 9.6 Man Ray, *Erotique-voilée*, © ADAGP, Paris and DACS, London 1989.

and woman is entered into with complicity and elegance, as Méret looks down with a slight smile at the wheel itself, which, although it could be seen to interrupt her body quite as definitely as the Magritte mirror interrupts the self-reflective woman, is also the instrument of her willing revelation – in parts – and the object of her admiration. She has no shame about her body and no fear of the wheel: around her neck is a simple black circlet, like a visual echo of the wheel shape, and her lips are closed over her teeth, while the wheel has tooth-like notches on one of its vertical spokes. In a visible yet subtle complementarity, the wheel reveals what she conceals; it both adds and subtracts.

In this upbeat reading, the medieval spinning wheel brings its long tradition to the song of the body, spinning out the tale of how woman harmonizes with her partner, the object, from ancient to modern times. She is in complete understanding with her mechanical lover, so that even the orifices of her body (her navel, her ear) rhyme with the openings of the wheel; the elements are strengthened each by the other, force without forcing. The woman shot is here celebrated by both wheel and camera, to both of which she may seem to give, smiling and thus as if freely, her bare form to be caressed and pictured, with no intrusion upon her intimate secret. Art and mechanics wed the modern female form, which learns to reread itself as if by a printing press, the wheel replacing for us the spinning out of our tale. The woman awakens in her new image against the traditional rhythm to be hummed or sung, now to be printed against the background of the past. Here the primitive strength of the domestic meets a more contemporary magic of imprinting and metallic repro-duction: woman in the round, we might read, and about to be multiplied in so many images.

An opposite reading is equally possible. Here the wheel allies itself with the grease marked upon the body as referring to a torture wheel, for Saint Catherine or any other woman foolish enough, unfortunate enough, to be caught by it. In this grim tale the potential violence of convulsive beauty remains implicit, as does the reflection of the wheel upon her body; the aggression of the metallic form, that deliberately segmenting master, is as divisive – she will be, like us, torn apart – as it is permanently imprinting for the surrealist design. This reading joins the photograph of what is both openly erotic and openly veiled to the stance of those other Man Ray photographs, where cages are placed over the woman's head (bodyless in the photo) and body, metallic over living. Here the living weds the metallic, only to reinforce the latter.

But the photograph published in *Le Minotaure* is a cropped version, and the longer original says still other things in this second reading. The etching wheel is moved by handles, and the handle of the outer and smoother wheel now appearing makes a definitely phallic protuberance above the intimate region formerly cropped from the photograph. Adding this reading is like adding an appendage, an appurtenance, to the photograph and the female form within

it. Already, as we know, in the 1950s and 1960s the printmaking tradition, or the lithographic revival, inspired the rolling of models in printer's ink to inscribe their *real traces* as art. Here, the model, having become a partner of the printmaking process, still suggests her own implication, by the ink upon her arm and hand (she is the artist Méret, after all) which was already visible in the cropped version, and by the smile now seen as even more complicitous even in the act of photography. The two photographs make an odd doubling, for the smile seems somehow to change its focus, as she looks down at her exposure, the handling of it, and the *handle* to it. At this point, and in this rereading, we think back to the Magritte rendering of *Les Liaisons danger-euses*, as the woman closes her eyes to her own exposure in the mirror and behind: these relations in their accent on process involve a still other danger and, I would submit, the viewer is far more involved. Even the act of second reading is a confession of further involvement – for, otherwise, why would we feel the need to look again? *In what process are we indeed involved?*

An equally ambivalent reading can be made or *taken* of Magritte's painting called *Représentation* (plate 3.4), a painting seen as a mirror, or a mirrored form painted as a painted form, showing quite simply the mirrored form of a woman from her lower stomach to her thighs, with the heavy frame around it shaped to its outline, as if deliberately keeping and holding just that part of the woman, metonymic of the way she is seen, with the mirror object as discreet and appealing as a statue, and not much more lifelike. What represents here, and what is represented? the reader is bound to ask. Is it the self-reflexivity of the form looking at itself as framed, by itself, as a mirror? Does the title indicate that to represent is to mirror, that to frame is to wed outline to form, that to look at ourselves framed up is already to represent ourselves? More than any of Magritte's other works, this one is surely about how the metaphor of representation works, how it makes a whole from what would seem a most partial part, a public artistic statement about what would seem the most private form. This is *representation* itself, and how we react to its selection out from the rest, to its enframing in its fragmentation, may depend on what credit we give to the representers of representation, as well as on what credit we think they give to us.

The final image I wish to comment on is itself of a complication worthy of mirroring the spoken complications with which I began. ("Talk about complications!") Perhaps the most captivating and most complicated of all the representations of the female body that Magritte is responsible for is *La Lumière des coincidences* (*The Light of Coincidences*, plate 3.3). Upon a table stands a frame, in which there is pictured a statue of a female torso, stumps marking the arms and legs, while upon another table nearer to the observer there stands a candle, burning like the famous candle in de La Tour's repentant Magdalen pictures, with its very substance lit by the flame. The heavy metaphysical light of a *vanitas*, of a *memento mori*, shines here, and the implicit weight of the statue, representing female form in massive beauty,

sculpted instead of painted, mixes these genres for an odd reflection on representing. A statue is painted as a statue in a painting about painting: the mixing of genres, of conceptions, adds to our own perception of what representation is, what painting may be, and how complicated a simple form can become. Like the representation of representation just commented on as emblematic of how we look at looking, this picture is about seeing, enframing, and models in their treatment as parts and as wholes.

Here the frame and the included statue are *tabled* and *set up* for our own illumination, surely, while the raised stumps of the statue seem to summon help and love, or at least our willing perception of the summons. As is proper for a *vanitas*, the shadow of the statue within the box is reflected on the wall, while the front table, tipped up, intersects with the box, until the objects in the painting and their harmonies of dark and light are doubly boxed in and framed, until containing and self-containment seem to reach perfection in their very shadowing. Nothing here is cut off by its intersection; nothing feels lost even as it is severed; nothing feels merely painted or merely caged. The substance is adequate to the meditation, uninterrupted and profoundly lit, poetic as it is erotic, contemplative and profound. This we are given; how we interpret it depends on our relation to meditation and to its partial giving, its partial concealing and its partial lighting.

Ambivalent or monovalent in the reading, stuffed, shot, and shown, in our dismemberment and our displacement, captured and presented to the gaze or the glance, aging into observers of ourselves as object, we can still hope that past the fragments of our exposed individual bodies there may be imagined, in all its deepest integrity, our own representing body. Our interpretation must move past the easily assimilable and its confines as just *representation*, to incorporate our delight in the modern as we imagine it and our refusal of dumb mastery.

Giving credit and giving the lie

To what might we choose to give ourselves and our being seen, and, more especially, why, and to what end? The gift, Marcel Mauss reminds us, must circulate, and in its interior country. What interior country has the artist's model, real or painted or shot, that naked lady in the iron cage? In Robert Desnos's great novel *La Liberté ou l'amour!* (*Liberty or Love!*) Louise Lame (the Lady Blade, as it were, Jack the Ripper's rival) is naked under her leopard-skin coat. She has, however, the privilege of laying it down, and takes that privilege, giving it as a leopard would his spots. But the caged lady, not measured here against some beast as in the celebrated story "The Lady and the Tiger," has little privilege and no choice. To be able to give or to give oneself, one must know oneself to be free. To be given in free exchange, to be willingly kept in ocular circulation, to serve as object for readerly and visual reception,

not to hold out on the viewer, is already surely an act of generosity, if not forced. We have to be able to refuse it; and the portrayal of the bare self as caged even if smiling, even if the cage is chosen as a fashion, should make us grit our teeth, and, more properly, arm our wits and tongues.

Lewis Hyde's recent book entitled *The Gift: Imagination and the Erotic Life of Property*, which takes its point of departure from Mauss in order to apply his theories on the gift to poetry as a human (and therefore giving) relationship, redefines the word "erotic" under this angle. To the theories of Mauss Hyde adds emotion in the place of economics: what cannot be given does not exist as a gift, including the gift of talent, or a body and spirit of lyricism. A gift, he says, is anarchist property, "because both anarchism and gift exchange share the assumption that it is not when a part of the self is inhibited and restrained, but when a part of the self is given away, that community appears."[26] The fragmented self – even a part of us – thus given away uninhibitedly, after mannerism into surrealism, and to all observers equally, may redeem, should we acquiesce in it, the sort of communal vision that a more classic holistic tradition was not able to save. Instead of yielding our minds up with our modeled and remodeled bodies, we must give our readings of our representations, and our opinions as to which deserve anger and which celebration. We must, in short, read freely and choose how we are to read our representing. Good and true reading is a gift, one we must hope to develop, and one on whose exchange we must work.

This, indeed, is what giving is about. "A gift that cannot be given away is not a gift. . . . *The gift must always move.*"[27] To *contribute*, says Hyde, "one's ideas to a journal, or a colloquium, or a book and thus to *share* them, is the mark of a gift which has learned to circulate."[28] We are creating, then, a network of giving by this circulation, giving a part of ourselves to the community of readers. The more a gift is shared, the more it is sacred; what is given leaves a free place, so that energy accrues in the procedure of free circulation.

In the major images I am presenting or *giving* of ourselves as *taken*, painted, and shot, our individual and collective interpretations must move past the paralysis that might set in from too prolonged and too accepting a stare at those fragments of our exposed bodies. We must at least glance beyond the "imposing" *Paralysexappeal* of Wilhelm Freddie as well as the conforming and constraining frame for our confinement that Magritte presents as representation itself; beyond the mechanics of our delight in our own modernness, as in Man Ray's picture of Méret Oppenheim and the printing press, a contemporary celebration of the textual in which the nude is seen in (sado-masochistic) textual and visual collusion, replacing both the torture wheel and the only seemingly innocuous spinning wheel of an earlier age.

Collective integrity

In networks and interpretive communities, to use Stanley Fish's term,[29] in their embodiments of our imaginations, our desires, and our truths, we would find an integration of ourselves, not just represented by representing. Refusing totalization as a *masterly* concept and preferring integration in its place, we are already making a strong statement about how we can deal with fragments and how we do not have to deal with tyranny and its currency of forced consumption. Giving credit where credit can be read as deserved, if it is not always necessarily and truly due, our free reading of images positive or even ambivalent makes its generosity out of sharing what it feels and sees.

This reconstruction of us all – of these bodies dismembered, violated, and undone on the one hand, of these bodies harmonious and celebrated and supplemented by nature, art, and even the machine on the other – cannot take place until the very speaking core of our interpretive community takes its truest pleasure and deepest joy in the exchange of our ideas taken up and understood together, in our essential difference and in our common comprehension, in our joint understanding and speech and work – in short, in our equivalent of the philosophical *conversation*.[30] We would put our ideas in common for a free exchange of views, the ideas of all those "whose Ideas are Eaten in Conferences."[31] Our will to discussion as to art, not just as passive models and dolls gone to pieces, but as inducers of the circulation of idea as of talent, turns us from consumer and consumed to creator and life-giver, after all that labor. "In a modern, capitalist nation," Hyde concludes his chapter called "A Female Property," "to labor with gifts (and to treat them as gifts, rather than exploit them) remains a mark of the female gender."[32] Our true labor may be working out the greatest possible realization of some conversation about sharing and female networking, developing it toward a collective wholeness that our final gift to each other may represent.

From our free reading of the renderings we encounter, from our discussions there may develop – in time as in our texts and those we contemplate – the collective integrity we would most want, as a body, to work toward: *beyond* the traditional candle and mirroring frame, as a reminder of our deaths and of the life of our art, in their marvelous coincidence and their unequaled flame. Modern like the wheel, striking like the straight-on stomach shot, old-timey like the candle, representation – with its complications mirroring and complicating our own – is our recurring concern. Our willingness to share in it and discussions that include our part in it, partial but shared, prove our strength abiding and most whole.

10

EYE and FILM: BUNUEL'S ACT

Everyone charges what he sees with *affectivity*; no one sees things as they are, but as his desires and his state of soul let him see.

Luis Buñuel[1]

Preparing the action and the eye

When the eye is slit by the razor in *The Andalusian Dog* (plate 10.1), by the most aggressive act conceivable, it is the spectators who, having come to *see*, feel attacked in their very sight. The aggression – actually carried out on a

Plate 10.1 Salvador Dali, *The Andalusian Dog*, still: slit eye, © DEMART PRO ARTE/DACS 1988.

mule's eye – carries its irony with it, for it is precisely the viewers' willing participation as the receivers and consumers of the surrealist film which makes them sitting ducks or passive targets for such an attack. The entire history of the eye as the privileged organ, receiving the usual (even cinematic) representation as fixed, whole, unassailably reasonable, is thereby assailed, and the increasing fascination with perception and representation is previewed in total violence. In this one supreme gesture of eye-slicing, the initial (supposedly female, by the context) vision is plundered as well as destroyed, by the razor as the precisely aimed extension of the (male) hand, and the screen itself – as I shall argue – is slashed erotically and sadistically as a loved object. From this attack, from this metaphoric rape, the modernist film text is drastically generated.

The act is profiled against a notable background of seeing and sharing the spectacle, for this particular *histoire de l'oeil* (history of the eye) has a long history. Like an attack on a cherished fetish, the singling-out of one orb for attack implies the valorization of that object, either in itself or in its metonymic representation of the whole, like the partiality of and for the amorous conceit, prevalent from the Renaissance to surrealism, as other discussions in this volume indicate. The part of interest to us includes Magritte's famous *Le Faux Miroir* (*False Mirror*), with the clouds floating across the eye itself, proving the practice of the imaginative vision to be efficacious within the very eye itself. It also reminds us of the fusional practice typical of surrealism, whose eventually convergent images are to be taken from two absolutely opposed fields, with the prior assurance, given by the cubist Pierre Reverdy, that the greatest distance will provide the most brilliant illuminations.

But a more specific interest revolves around the singleness of the object attacked, as it emblematizes the seeing of a whole movement: Dada as it continues into surrealism. Man Ray's photograph of a human eye mounted on a camera in *Emak Bakia* doubles the view of a mobile and capturing "intellectual eye." Picabia's "Cacodylic eye" is surrounded by swerves, his "optophone" circulates in circles, both emphasizing the dizziness potentially provoked in the observer by the patterns of seeing and their exterior expression.[2]

To laud or do damage to this one exceptional part is to offer praise to or to inflict bodily harm upon the entirety of the being, condensed in the one focus on its sight. We shall see traces of this all through Dada and surrealism, where there proliferate pointing fingers and single eyes (for example, in Magritte and Ernst) in contrast to the two emblematic orbs in Fitzgerald's *Great Gatsby*, whose seeing eyes suspended supervise our own seeing, like the age-old representation of God as an eye peering at us. The singling-out impulse reaches its surrealist summit in Breton's poem "L'Union libre" ("Free Union"), with its celebration of each part of the woman one after the other, from up to down, from the eyes to the legs and back up to end with the eyes.[3]

Yet one other emblem is as ubiquitous as the eye, that of the hand and the pointing fingers, emblems of the baroque and then of surrealism.

In Breton's *Nadja*, a hand rises above the waters, a single blue glove is left and found as a talisman, exchanged then for a single bronze glove as its remaining reminder, still now remaining on Breton's desk preserved in his apartment at 42 rue Fontaine, Paris. From a fully significant seeing eye and pointing finger to an emptily significant glove is a properly surrealist step. We do not have to turn back beyond de Chirico's metaphysical paintings with an empty glove or a red-gloved hand on a chess set, themselves inspired most probably by Max Klinger's whole suite of drawings, *The Glove*.[4] As the singled-out eye seems to privilege sight, so the singled-out finger, hand, or its glove as container privileges touch: the initial image considered here depends on the conjunction of both.

The act of penetration is, in addition, witnessed, unlike the comparable act in standard narratives of nuptial nights, for example, where, to remain sacred, it had to be elided in the telling.[5] The eye-opening is only effective once as it is seen, for many viewers may turn away on seeing the film a second time. This probability both contradicts and complements Breton's line which I take as emblematic of surrealism itself: "Always for the first time."[6] The surprise does not wear off, nor does the horror of the spectacle: the violent act, even as it destroys, preserves the virgin moment of shock.

This act, moreover, is the apparent aggression of a male hand and male weapon against a female victim singled out and prepared, although the final act is displaced to the mule's eye, where presumably the gender makes less of an effect. The very idea of a razor blade brings with it a heavy male baggage, philosophic as well as psychological, from Ockham's razor reducing arguments to the male morning ritual, that sacred shave imitated by adolescent boys, some of whom may grow up to perpetrate the rape of some lock or even another eye. A penetration of the other's sight without permission asked or given: no one asked the woman or the mule.

I say, said Breton, that the eye is not seeing unless it is in ceaseless exchange with what it beholds. This is the overriding promise of surrealist art, that it will *donner à voir*, will give us to see differently by our own engagement in what is presented and in what we represent as ourselves. This is especially true here, where the image of the eye is utterly slashed. Both seeing and non-seeing must be taken into, as it were, personal account.

For surrealism, if it is not *personally convulsive*, is nothing. Three years earlier, in 1925, Antonin Artaud had predicted the violence to come, and had immediately voiced it, in his *Manifeste en langage clair* (*Manifesto in Clear Language*): "There is a knife I do not forget," he said, and ever since we have not been able to forget it. It is the lesson and the threat included by implication in many of the great enduring emblems eyeing us.

One of the more remarkable stories in surrealism concerns Victor Brauner's fateful painting of himself with one eye blinded: that this event should finally

have befallen him and thus rendered the painting predictive in retrospect is taken as an indication of surrealism's prescience of the truth, far beyond any aesthetic value.

The blood-streaked cheeks of the blinded lovers in *L'Age d'or* (*The Golden Age*) can be seen to make the same point: what is *engaged* or involved is not free: love is blind, as in the cliché, not being freedom either linguistically (clichés being controlled by social norms) or spiritually. *Liberté ou l'amour!* (*Freedom or Love!*) reads the title of Robert Desnos's most famous book, suggesting that freedom and love are either identical or mutually exclusive, or, most probably, apparently mutually exclusive but forming a symbiotic whole, as surrealist teaching would lead us to conclude. ("I have already sacrificed my liberty to my love," said Buñuel, himself answering the questionaire sent around after the release of *The Andalusian Dog*). None of us, in what we are held by, in art, life, and love, is free to see.

The way the gaze captivates and takes hostage is perfectly expressed in the scene opening another of Buñuel's films, *Wuthering Heights*. Its high romanticism is an ideal match for his fascination with suffering and the infliction of suffering and the suffering of the erotic impulse. We watch in that film, for what seem hours, the delicate bodies of butterflies as they are chloroformed and pinned for his collection, with cruel and precise delight, by the husband. In just that way, the two women – Heathcliff's tragic bride and his beloved half-sister – will struggle, uselessly, against their own enslavement, the latter doomed by what she contains, the baby after whose birth she will die. The precise targeting of the object is what the observer ironically "collects" and recollects from this premonitory scene.

Questioning

How we understand, as we know, depends on our frames of seeing and of fitting in the information we take in. Marvin Minsky defines a frame as "a collection of questions to be asked about a hypothetical situation."[7] This peculiarly liberating openness which never asks for answers or closures, even in its very discussion of frames and enclosures, permits the application of philosophy as of psychology to the questions we ask about what we see. Hans Gadamer in his *Truth and Method* speaks about his understanding of understanding: "The voice that speaks to us from the past – be it text, work, trace – itself poses a question and places our meaning in openness. In order to answer this question, we, of whom the question is asked, must ourselves begin to ask questions. We must attempt to reconstruct the question to which the transmitted text is the answer."[8]

The frontal assault on the eye which we have all witnessed so often, in this frame and in others, might be termed a calling into question of sight itself. The very virtuosity of this attack (the phrase comes from *L'Age d'or*, where it

serves as the scorpion's motto) depends on full knowledge of the result, blindingly obvious as it is; not on any use of symbolism, which Buñuel eschewed in his films, but on the deepest poetry ("cinema poetry struggles to come to the surface and manifest itself" in all films, he said[9]). In no sense an empty lyricism, as it is in no sense a simple symbolization, this full poetry takes into account its psychological results as well as the aesthetic force of the image thrust forward with the dramatic force of a rape, poeticizing sight even as it deprives it of sense. Not only are clichés made real – the eye is opened, love is blind, and so on – but we are forced to see directly what we cannot see around, the violence implied in what we would prefer not to see or to deal with. In his memoirs, *Mon dernier soupir* (*My Last Sigh*), Buñuel recounts incident after incident of a violence with which his films have been able to deal, for him and, in the long run, for the observer.

In *Mon dernier soupir*, Buñuel describes events which seem to have motivated some of the violence of the shot. Repeatedly he emphasizes the connection he sensed, early on, between death and love; twice he does so in connection with a scene including a donkey. In Calanda, he says, he discovered how these two forces informed his adolescence: one day he found, led to it by a repugnant and sweetish odor, a donkey on whose swollen body a dozen vultures and a few dogs were feasting. So sated were the vultures that they could scarcely fly, and so impressed was he by the scene that he could scarcely leave it. Again, he says, in *The Andalusian Dog*, when the man caresses the naked breasts of the woman, and suddenly we see the face of the cadaver, this link between apparent opposites is of conscious importance for him.[10]

Even more relevant is his experience at the bathing resort of Saint-Sebastien, where he used to peep through a partition at the ladies undressing on the other side. To stop themselves from being spied on, those ladies had no hesitation in jamming their hatpins through the holes, even at the risk of piercing the eye of the observer. (So, he says, he and his comrades used to put little shards of glass in the holes to protect their eyes.)[11]

These experiences, and his first encounter with the "traveling forward" or the sudden close-up of the perceived object in the film, converge to make the celebrated slicing of the eye the event it is for today's observer of Buñuel as the creator of that scene. It is surely something to remember him by.[12]

Seeing

A recent critic has analysed the ways in which *The Andalusian Dog* sets about breaking the frame of our expectations trained in the avant-garde film – for example, by opposing its own straight cuts to the avant-garde montage.[13] Its real and innovative displacements are located in the narrative structure, and here the multiple shifts in perception are seen to work like the Don Juan search

of the "elusive female with multiple identities" in *This Obscure Object of Desire*. "The refusal of the film to fit into a narrative frame is a formal device mirroring insatiate sexual desire."[14] Constant slippage of diegetic space within the narrative – for example, from the razor to the moon to the female eye to the donkey's eye, or from the door leading into another, identical room to the door leading out onto the beach – marks this frame-breaking device. Alain Jouffroy's description of surrealist sight explains it: "The revolution in seeing consists in the mental displacement which obliges us to revise our judgements and to readjust our sentiments in relation to an ideal level of perception. . . ."[15] Surrealism, as we know, requires us constantly to readjust.

This real revolution in seeing is set up by the surrealists themselves, against the purely formal revolution of the avant-garde. The poet Robert Desnos, a great surrealist critic of the cinema, displays the difference in an article of 1929, blaming the persisting influence of Oscar Wilde and the aesthetic movement of the 1890s, as it is manifested in the works of Jean Cocteau, for instance, for what he calls the "deadly confusion" of the two revolutions:

> An exaggerated respect for art, together with a mysticism of expression, have led a whole group of producers, actors and spectators to create a cinema said to be avant-garde, remarkable chiefly for the speed with which its productions go out of style, for its total absence of human feeling, and for the danger in which it places cinema as a whole.
>
> Let me make this perfectly clear. When René Clair and Picabia made *Entr'acte*, May Ray his *L'Etoile de mer* and Buñuel his admirable *Andalusian Dog*, it was not a matter of creating a work of art or a new esthetics, but of obeying deep and original movements, needing a new form. . . .
>
> Nothing is revolutionary but frankness. . . . And it is this frankness which permits us today to place on the same level the true revolutionary films: *Battleship Potemkin*, *The Gold Rush*, *The Bridal Symphony* and *The Andalusian Dog*. . . .[16]

The world of cinema and of painting must be as persuasive as the outside world: Desnos calls the cinema our modern temple, for its combination of dreaming and persuasive interior action. There, he says, the great revolutions are made. And surrealism is surely that, or it is nothing.

What all the surrealists agree upon is what we might call the call to the concrete image. In Aragon's novel *Le Paysan de Paris* (*The Paris Peasant*), for example, the call comes most clearly as a refusal of all abstract words and thoughts, as an enduring love affair with what is most inebriatingly obsessive, to the point of fetishism, always in a wave of the specific sweeping over the observer as lover. Outside of that, no love and no poetry: the creeds and the manifestoes and the definitions all have this assurance about them: "There is no poetry except of the concrete object."

Desnos begins an article on Eisenstein's *General Line* in just such a tone:

"To render concrete! this elemental goal of all art, of all expression, and of all human activity is not within the reach of everyone."[17] Dali, Buñuel's frequent collaborator, is of the same mind: "My whole ambition in the pictorial domain is to materialize the images of concrete irrationality with the most imperialist fury of precision. – In order that the world of the imagination and of concrete irrationality may be as objectively evident, of the same persuasive, cognoscitive and communicable thickness as that of the exterior world of phenomenal reality."[18]

Screening

What we feel in the eye attack depends, of course, at least to some extent, on what we know and feel and have read outside of it. Melanie Klein's development of screen-image theory is peculiarly relevant here, as are the reflections to which it has led the art historians Anton Ehrenzweig and Adrian Stokes.[19] As the oceanic impulse combines, according to Stokes,[20] "the sense of fusion with the sense of object-otherness," that integration of the beholder and the object beheld, even as it is both other and the same, explains the thrust of the act. For Stokes, the first brushstroke of every painting, as the artist confronts the virgin canvas, marks an attack on the breast of the mother. Thus, against the matrix and oceanic image – by a fitting irony termed the *screen* – there is set this intensive attack of the weapon of creation. The act is both generative and fatal. In this light, *The Andalusian Dog* represents cinema itself, the screen and its textual process, the spreading-apart of the very lips of the screen for the violent visual birth to take place. That the attack should be leveled against the very eye that sees, that identifies with the screen as in an embrace with oneness and with the integrative nourishment, is the simultaneous summit of identification, aggression, and separation.

"A man in chains has only to close his eyes to have the strength to blow up the world." In a lecture he gave at the University of Mexico in 1958, Buñuel commented on these words of Octavio Paz with this statement: "If the white eyelid of the screen could reflect the light which is its own, that would be enough to blow up the Universe."[21] What is blown up here, in the initial act, is the identification of viewer and screen image; what is produced by such an explosion is the very notion of the passive self.

Another figure must enter here, to introduce the closing meditation. We might have noticed running through *The Andalusian Dog* the Oedipal thread engendered by the phrase "Faire intervenir le boiteux passionné" ("Have the passionate cripple intervene), which brings in just the limping lover we need for this interference, for, as the sound "boîte" ("box," the same one we see in the film) is allied with the passion, Oedipus may indeed enter.[22] I would see him making that primal attack on the screen image literally, in the blinding of the screen and the severing of our identification with what we see. We look

away, even as birth is given to sight paradoxically in its blinding, in its very screening, even as we are brought in, inheriting the crime as perpetrator, as victims, and as birth-givers, even in our turning-away.

What I want to question, in concluding this voyage around the eye, is the way in which this attack on the perceiving subject and on the perceived object links up with some of the most forceful surrealist poems, which are as cinematic as Buñuel's cinema is poetic. The eye-opening attack is prophetic as it is violent, pointed toward the future as it slashes against the past ways of seeing, challenging our mental and visual grasp, our *handling*, professional and personal, of what we see and write on and deal in. By the slash which changes into differentiation and violence our very identification with the screen as screen image, parting the lips of the screen itself, the picture emerges as process. Now, it is the very shape of the wound that interests me, for in its horizontality it opens and widens the very screen itself, eventually deepening it by the paradoxically surface effect in this self-reflexive act of spectacle, in all senses a spectacular act. It is still a matter of what we see, of what calls that into question and deepens it.

Let me contrast two sets of images, with a visual and a verbal component to each. Jasper Johns' painting *Target* (1957) shows the circular forms to aim at and implies the potential attack. Above the target are, in separate cubicles, parts of the body emblematic of the other senses: an ear, a finger, a mouth. Deprived of their body, literally disembodied, they too indicate the target as the focus of attention and attack. Pierced or slashed, the targeted eye endures to see. Johns' painting is thought, but it is not, I think, poetry. The differences between it and the cinema poetry I am discussing here, in both the film and the poem, are marked. Breton's poem "Curtain Curtain" ("Rideau, rideau"), for example, functions like Johns' target, even as it implies the penetration of the object by what is aimed at it, to pierce it. The narrator is watching, in one of the "vagabond theatres of the seasons which will have played out" his life,[23] a character moving about the hall with a mask of his own features, which predicts his featured self as target. The bullet which will pierce him, like the potential bullet invited by the Johns painting of a target, like the rifle shot aimed at the butterflies in *Belle de jour* and the precise piercing and pinning of the butterflies for the opening collection in *Wuthering Heights*, will make only a hole, that minimal opening, and not the slash against the screen which opens it towards something else. So, in "Curtain Curtain," the final melodrama of the closing line leads nowhere else but towards destruction: "the basement was marvelous there appeared on a while all my silhouette fire-specked and pierced with a bullet in the heart."[24]

That leading to nowhere else composes one of the main differences between the Johns target and Buñuel's targeted eye, which has occupied so much space here and elsewhere, and forms the visual part of my second exemplary set of images. Like the film, poetry as Breton envisages it asks, "what happens in dream to time, space, and causality?"[25] Yet it will happen concretely, and the

new causality, the lyric one, will deal not in abstractions but in images, and these images themselves will turn inward. This is, I think, the answer to the question we might have wanted to ask: "After such an image of destruction, what could heal our seeing?" The answer is directional, and not substantive. "Reduce, reduce, reduce was my thought," says Marcel Duchamp. "But at the same time my aim was turning inward."[26] I want to end, then, with the idea of target and of *aim*, for both sight and mind.

In a celebrated poem of Octavio Paz, called "Blanco," the target (*blanco*) is also the blank page: this is one of the finest of Mallarmé's own progeny. The title turns us inward, toward thought, and so does the initial image of that film which is my text here. An *inward turn* of such a nature occurs in the major poem of Breton I wish to end with, quite unlike the poem just cited. This last poem I see as complementary to the Buñuel image instead of to the Johns target, being in fact about what *The Andalusian Dog* is about, not a substantial subject, but a subjective and yet specific inner space, and the act by which we enter it. In order to enter the space, violence is perpetrated upon its very threshold, and that violence must be *seen*, cannot be elided or turned away from. Like the Buñuel film, the poem is both brutal and healing, healing the image of division and violence to vision implicit in our consciousness, to which both film and poem respond. In Breton's vigil over his own vision, appropriately called "Vigilance," the narrator enters the room where his body is lying to set it afire. This split in the act and actor, this doubled personality enacted, is *facilitated* by the division in sight with which we began. The poem is about the essence of sight and sensing and how we burn away what is unnecessary to the essence. It is both romantic and surrealist, like Buñuel's films.

Pour que rien ne subsiste de ce consentement qu'on m'a arraché
. . .
A l'heure de l'amour et des paupières bleues
Je me vois brûler à mon tour je vois cette cachette solonnelle de riens
Qui fut mon corps
Fouillée par les becs patients des ibis du feu
Lorsque tout est fini j'entre invisible dans l'arche
Sans prendre garde aux passants de la vie qui font sonner très loin
 leurs pas traînants
Je vois les arêtes du soleil
A travers l'aubépine de la pluie
J'entends se déchirer le linge humain comme une grande feuille
Sous l'ongle de l'absence et de la présence qui sont de connivence
Tous les métiers se fanent il ne reste d'eux qu'une dentelle parfumée
Une coquille de dentelle qui a la forme parfaite d'un sein
Je ne touche plus que le coeur des choses je tiens le fil

(So that nothing will remain of the consent wrung from me
. . .

At the hour of love and of blue eyelids
I see myself burning in turn I see that solemn hiding place of nothings
Which was once my body
Probed by the patient beaks of the fire-ibises
When all is finished I enter invisible into the ark
Taking no heed of the passersby of life whose shuffling steps are heard
 far off
I see the ridges of the sun
Through the hawthorn of the rain
I hear human linen tearing like a great leaf
Under the nails of absence and presence in collusion
All the looms are withering only a piece of perfumed lace remains
A shell of lace in the perfect shape of a breast
I touch nothing but the heart of things I hold the thread)[27]

And so, after the initial and liminal violence – whether a knife or a fire marks the full entrance into another state and space – we touch nothing but the truth of things, hold nothing but the thread, arriving at the heart of what surrealism's vision is finally about, as it works through and against the *screen* and our identification with it, to give birth to sight itself.

11

The GREAT RECEPTION: SURREALISM and KANDINSKY'S INNER EYE

You must open your arms wider.
Wider. Wider.
Kandinsky, "Seeing"[1]

It all began with what Kandinsky sees as *non-recognition* – his own, in relation to Monet's haystack. "And suddenly," he recounts (a beginning we recognize as the classical setting for a statement about conversion or deconversion, the timing of which has to be sharp, immediate),

> And suddenly for the first time, I saw a picture. That it was a haystack, the catalogue informed me. I didn't recognize it. I found this non-recognition painful and thought that the painter had no right to paint so indistinctly. I had a dull feeling that the object was lacking in this picture. And I noticed with surprise and confusion that the picture had not only gripped me, but impressed itself ineradicably upon my memory, always hovering quite unexpectedly before my eyes, down to the last detail. . . . And, albeit unconsciously, objects were discredited as an essential element within the picture.[2]

Whether it was indeed, in this conversion or deconversion case, the lighting, the angle, some mistake or other – an upside-down hanging, as one legend runs – the result has nothing mistaken or strangely lit about it.[3] It leads to the great discovery of Kandinsky, whom the surrealist Breton will honor as "one of the first and one of the greatest revolutionaries of vision."

Now, in the description of that non-recognition experience in all its suddenness, I am reminded of John Ruskin's sudden great "unconversion" experience at Turin, while the sermon was taking place in the pulpit and all nature was taking place outside. Ruskin left an institution, to found a new belief; he never looked back, nor did Kandinsky, to what they conceived of as a narrower outlook.

In the case of the haystack, it took the text of the catalogue to identify the subject. A haystack, it said, belonging to Monet. But now the text came in for interrogation by Kandinsky, the seer turned reader for the occasion. And he was not persuaded, he said later, looking back, by the catalogue title – that is, the *verbal* haystack. "I had the feeling that here the subject of the picture was in a sense the painting itself, and I wondered if one couldn't go much further along the same route."[4] Kandinsky, we know, went further, whether it was along the same route or not.

Metapainting

But is this metapainting, the painting about the painting, really the subject Kandinsky would stick to? In the final reaches of the inner soul, that soul he explicitly and repeatedly referred to, that soul he sought in all things and in all shapes and in all symbols, is the subject really just the painting itself and the painting of that painting?

"It took," Kandinsky admits, "a very long time before I arrived at the correct answer to the question: What is to replace the object?" The answer he found to this question seems not to have been "The painting itself," but the way the painting fuses freedom and necessity, a resonance of inner certainty and outer discovery, a harmony of spiritual sound made of the ideal tension of contraries, the holding-in-painting of a high-tension "internal pulse" (*CWA*, p. 828) Kandinsky's colors, vibrant on the surface of what we see, infuse and inform the depths of what we read: "I love colors simultaneously in two different ways; with the eye (and other senses) and with the soul, i.e. for their content – one would be perfectly entitled to use the today prohibited word 'symbolic'!" (*CWA*, p. 738). These tensions, tightly held, control the rhythm of his verbal and visual work, based not on the limiting choice of "either/or" but on the conclusive and decisive word "and," so that his paintings, rather than reducing, cumulate, enlarge, widen. "You must open your arms wider. Wider, wider," claims his poem about seeing (*K*, p. 21).

These are not lessons for painting only, but life lessons, like life models. "Art," Kandinsky says, "does not seem able to follow life. Or was it maybe life that was unable to follow art? I would like to answer 'yes' to this question. A very energetic 'Yes'" (*CWA*, p. 801). Art is what the soul imagines according to its inner dictates, to use another of Kandinsky's expressions: "The artist 'hears' how something or other tells him: 'Hold it! Where? The line is too long. It has to be shortened, but only a little bit!'" Or; "Do you want the red to stand out more? Good! then add some green. Now they will 'clash' a little, take off a little" (*CWA*, p. 799) One must know how to "listen" when the voice sounds: it is on this point that he feels different from the surrealists, distinguishing his inner dictation from what the surrealists term "knocking on

the window of the unconscious," the hearing of which he conceives of as an outer voice.

Of course, the surrealists, far from refusing any relation to romanticism, found themselves, as Breton said, "the tail of romanticism, but how prehensile a tail!" I think we should consider first, however, that surrealism in its specific artists, and surrealism in its writers, still more in its literary aesthetic theory, do not always converge even to the extent of other movements. The theory of surrealism as of Dada before it (Dada being more congenial to Kandinsky and far more than just the high-camp dress rehearsal for or the negative ancestor of surrealism) has much more in common with Kandinsky's theories and practice. Far from simply receiving the outside world, or just building along-side it a surreal one, as one might think from Kandinsky's initial statements about it, surrealism is absolute in its refusal of the ordinary and the exterior: witness Breton's repeated insistence, for example, in his essays for *Le Surréalisme et la peinture* (*Surrealism and Painting*), on an "interior model," believing, along with Pierre Reverdy, that "Creation is a movement from the interior to the exterior and not from the exterior over the façade."[5]

Wit and passion helped Breton to formulate surrealism's rejection of the external element or "furniture surrounding us":

Non-Surrealist and, to our way of thinking, regressive, is any work turned toward the daily spectacle of beings and things, that is, participating immediately in the animal, vegetable, and mineral furniture which surrounds us even if the latter should be rendered optically unrecognizable by being "deformed." The Surrealist work banishes resolutely anything in the realm of *simple* perception. . . . If the jug remains enemy number one here, it is understood that the Surrealist means to put in the same sack the little ship, the bouquet of anemones, and the obliging lady who used to pose either dressed or naked.[6]

Surrealism, in rejecting the still-life arrangements of jugs and flowers and café scenes, as in cubist works, together, "it is understood," with the coastal scenes and live models of impressionism and traditional French art, means to create a new and inner sense of being by the analogical energies of the human mind. Wanting more than art has given before, surrealism states its high conviction of the internal necessity of the linking of elements, sensed in the

spontaneous, extra-lucid, insolent relationship which is established, under certain conditions, between one thing and another that common sense would never think of bringing together. . . . The primordial contacts have been cut: these contacts, I say, that only the analogical impulse succeeds fleetingly in reestablishing. Whence the importance assumed, at distant intervals, by these brief and infrequent sparklings of the lost mirror.[7]

The receiving eye and its creations

In the journal *Koncretion*, Kandinsky describes the vision of most importance to him: "this experience of the 'hidden soul' in all the things, seen either by the unaided eye or through microscope or binoculars is what I call the 'internal eye.' This eye penetrates the hard shell of the external 'form,' goes deep into the object, and lets us feel with all our senses its internal pulse" (*CWA*, p. 832). That it is within this eye that Breton will feel, or sense, or wish to feel and sense, the warm reception he will ascribe to Kandinsky suggests that this particular eye is not just a neutral image to be overlooked, but determined, even overdetermined, by the context and by sight itself.

Contemporary critics, imbued with reception theory of all sorts, may find themselves particularly sensitive to this projection by a poet into the eye of an artist, to what it entails and how it might be read. For in its light there may seem more fruitful topics for discussion about Kandinsky's relationship to the surrealists than are offered by, for example, his attitude towards them in his letters or his public statements – such as his guarded references to their "romanticism" in their attitude toward the exterior world:

> It seems to me that the Surrealists give precedence to the "romantic," while abstract painters, on the contrary, give precedence to the "classical." They are, nonetheless, inextricably related, since in both one can see the two forms of expression: Classicism and Romanticism. . . .
>
> Finally, the difference between these two species is that the Surrealist uses nature in his work (albeit in a surnatural way) as if it were a "plus," whereas the abstract painter omits nature as if it were a "minus." (*CWA*, p. 743)

That relationship is based upon the bringing-together of distants and contraries upon the working field of surrealism, freeing surrealism, as it also frees abstract art, in both theory and practice, from what Kandinsky calls the "tyranny of the practical–purposive" (*CWA*, p. 541) into the intense and liberating resonance of inner sound, inner order, and inner depth. The non-purposive, alogical play and work of art gives full rein to the forces and tensions dynamizing the inner space where oxymorons and bipolar opposites are held in creative harmony – in the point, as it holds in check multiple tensions in the smallest visible space. Kandinsky's famous celebration of the point and Breton's equally famous celebration of the "point sublime" can be taken as the double metaphor for the poetry of surrealism itself, alogical and transforming in its intense illumination.

"If," says Kandinsky, "by magic these tensions were suddenly to disappear or die, the living work would instantly die as well" (*CWA*, p. 548). The goal of poetry, as of art, says Breton, is to work against "the false laws of conventional juxtaposition" and easy evidence, so as to multiply just those short-circuits

provoked by the blinding flash of contraries chanced upon or created. The "red-hot 'stuffing' inside an icy-cold chalice" (*CWA*, p. 781) for which Kandinsky longs finds its double in the baroque blaze of explosive surrealist metaphors: Breton confessing his hope that the crow will return instead of the dove, the fiery hair in the black night, the bones of sun seen through the hawthorn of the rain – "oh flame of water lead me to the sea of fire." Admittedly the images are those of a romantic temperament, in contradistinction to the starker vision of Kandinsky's 1935 article called "Toile vide" ("Empty Canvas") for the *Cahiers d'art*: "understanding better how to go upward and downward at the same time – at the same time 'up' (toward the heights) and 'down' (toward the depths). This power no doubt always involves extension as a natural consequence, a solemn tranquillity. One grows on all sides" (*CWA*, p. 782).

But this expansion he saw himself working towards, the "polyphony" he aimed at, does not write a different program from that of the surrealists, only a different technique, different materials. They both were seeking that "inner cohesion achieved by external divergence, unity by disintegration and destruction. In the midst of anxiety, tranquillity, in the midst of tranquillity, anxiety" (*CWA*, p. 783). Stretched out, every empty canvas, says Kandinsky, each empty page, says Breton after Mallarmé, is potentially a field of shock: "In appearance: truly empty, keeping silent, indifferent. Almost doltish. In reality: filled with tensions, with a thousand low voices, full of expectation" (*CWA*, p. 780). The surrealist *état d'attente* or state of expectancy, transferred to the canvas or to the page, was this projection of interior tensions to the exterior surface. Against that resonating ground, the sublime point of the surrealists, conceptual rather than perceptual, and Kandinsky's graphic point, his dash extended into line, are outlined as the figures of a new art, expectant and never yet complacent.

What they were really seeking, both these revolutionaries of the eye, was the conversion of dispassion to passion, of the practical to what is beyond practice. "The accustomed eye responds dispassionately to punctuation marks. . . . The accustomed eye slithers dispassionately over objects. The dulled ear accumulates words and transmits them mechanically to the consciousness" (*CWA*, p. 423). To transform that dulled eye and ear to the "astounded eye and ear" (*CWA*, p. 424) is both the graphic point of the artistic revolution and the real point of the inner enterprise of which I see them both, unabashedly, as true heroes.

Exchange and the East

The overriding attitude Kandinsky so convincingly calls the "mutual supervision"[8] between feeling and thought Breton sees as the awareness of a

continuing artistic and poetic effort named after a scientific experiment. In these "communicating vessels," he sees container and contained held in a perpetual exchange whose intense and alogical mixture of possibility and impossibility is determined by an interior freedom and interior necessity the parallel of Kandinsky's. Breton calls the awareness of this combined freedom and necessity a "lyric behaviour": rereading this in the light of what we are contemplating here and today, it might not seem so distant from Kandinsky's own spiritual in art. That behavior has as its primary characteristic the recognition of the analogical marvelous, making possible that "insolent relationship between things" that alone can reveal those "brief and infrequent sparklings of the lost mirror" to which I have already referred.

The contacts re-established, in their continuity and their sparkle, bear witness to the always instantaneous clash of opposites whose reverberations render the work dynamic. Kandinsky's speculations about the ways in which these tensions energize even the empty white canvas and reside in the inner soul, the enormous potential of contraries holding against each other without resolution to lend their energy to the created work, work in his images just as in the surrealist *creed of clash*. To this Kandinsky's oxymoronic titles bear sufficient witness, from *Stable Mobility*, and *Hard, but Soft*, up to *Delicate Tensions* of 1942.

The goal of the point uniting contraries, like that of the surrealist "communicating vessels" holding container and contained in a perpetual exchange whose mobility is determined by an interior freedom and interior necessity, is what Kandinsky calls "mutual supervision" of feeling and thought. Whether in the popular language of Dada, where the yes and the no meet on street corners like grasshoppers, or in the loftier language of Breton, from whose sublime point or poetic viewpoint death and life, past and future, real and imaginary, height and depth can be seen to communicate, the goal is not to remain on that street corner or to dwell in that point: as Breton points out to his daughter, to dwell in it would be to lose it. The goal is rather that exchange of vision and the view, seeing and the seen, whose very exaltation of tone motivates Breton's own projection of his welcome within Kandinsky's vision, and of what he terms the stars of his sky with Kandinsky's thought, until their happiness seemed to him mutual, their experience shared, and their vision common: "vos oeuvres qui sont faites de la poussière des temps où l'on a été ou l'on sera encore heureux" ("Your works made of the dust of times when we were, and so will be again, happy").

This is not just wishful thinking on Breton's part – the idea that, because he so loved the art of Kandinsky (not just the two watercolors he purchased but his way of being), Kandinsky would share his vision – but what we might call projective thinking, or projective vision, or better still, *enabling* vision. Breton, who was to turn progressively from politics and the politics of revolution to a lyric and almost mystic celebration of some inner mysteries of human possibility, was never to lose the tensions, delicate and less so, between the two

poles of his theory, outer and inner, in that balance Kandinsky was to call inner harmony.

Always Kandinsky equated, implicitly or explicitly, poetry and this balance of tensions between outer and inner, as of all the other dynamics of psychological creation: "Every true painting," says Kandinsky, "partakes of poetry" (*CWA*, p. 783). And, elsewhere he insists that the true critic "would . . . need the soul of a poet, for the poet must be able to feel objectively in order to embody what he has experienced subjectively": he must understand the "internal necessity" of creator and creation. Breton's advocacy of the surrealist *disponibilité* or availability, this openness to outer experience or inner dictates, enables the poet to remain in touch with the "inner harmony," to hear the fundamental "inner tone" Kandinsky had seen in Munich, in 1909, as characteristic of Eastern art:

> It is precisely this general "inner tone" that the West lacks . . . we have turned, for reasons obscure to us, away from the internal towards the external. And yet, perhaps we Westerners shall not, after all, have to wait too long before the same inner sound, so strongly silenced, re-awakens within us and, sounding forth from the innermost depths, involuntarily reveals its affinity with the East. . . . (*CWA*, p. 59)

And Breton evokes, in an essay on Max Ernst, an "Orient of anger and of pearls" in a lyricism based on the tension of contraries, typical always of surrealism at its emotional height: "You who are the shining image of my dispossession, Orient, beautiful bird of prey and of innocence, I implore you from the depth of the kingdom of shadows! Inspire me, so that I may be he who has no more shadow."[9]

The inner tones that Breton and Kandinsky heard was not so different, nor were their views about art. Breton's high poetic language, imbued with memories of Proustian longing, made it possible for him to seize, repeatedly, the very tone of experience remembered which is so moving in Kandinsky's *Reminiscences*, especially in the passage which cannot fail to remind us of Proust and the steeples of his narrator's childhood on which he first practiced writing. Kandinsky shows himself here a poet, and not just of childhood, describing

> the red, stiff, silent ring of the Kremlin Walls, and above, towering over everything, like a shout of triumph, like a self-oblivious hallelujah, the long, white, graceful, serious line of the Bell Tower of Ivan the Great. And upon its tall, tense neck, stretched up toward heaven in eternal yearning, the golden head of the cupola, which among the golden and colored stars of the other cupolas, is Moscow's own.
> To paint this hour, I thought, must be for an artist the most impossible, the greatest joy. (*CWA*, p. 361)

That the artist became the one we know, in whose inner vision the outer bell tower took on a new shape and a new reality, whether we call it abstract or adopt his sense of the word "concrete," in no way lessens either his initial experience of the bell tower or the poetry of his style. That very poetry, later found in other guises, is what I think Breton was reacting to so strongly in his admiration for Kandinsky. Not just the colors, or the shapes, or the technique of what he painted, but what he was able to see with his inner eye. The "lyric behavior" about which the surrealists cared always and deeply has not to do with one's manner of living or doing politics or not doing them, or this or that, but, and most genuinely, with how one sees and with what depth that is transcribed.

Color, slant, and slippage

What is most striking about Kandinsky's writings on art may not be his frequently stated concern about the inner necessity, the inner eye, and the inner element, but rather his accurate and strangely precise meditations on specific issues. I am thinking here of the quite remarkable passages on, for example, what happens to the color red by itself, with its potential energy, or in combination with other colors, or painted on a tree, or a dress, or a horse – those passages comparing the color to music (if darkened, it is like the middle or lower registers of the cello; if brightened, like the clear tones of the violin; if warmed by yellow, like a church bell, a contralto voice, or a viola playing a largo; if cooled down, like the cor anglais). His meditations are full of nuance about the psychology of perception and association, as about punctuation: the period or the point and its introversion, its concision, and its concentric tension; the dash as the extension of the point, and how it comes to play a role beyond that of the practical–purposive on a canvas; or the graphic arabesque "often seeming deceptively like a world of total freedom, but which conceals its servile subordination."

If we are tempted to think that Kandinsky's later writings on art became, with his conversion to the concrete, less poetic or any less rich in surprises in perspective and odd slants of vision than in his reminiscences of Moscow, then we have only to read the conclusion of his essays called "Toile vide," published in Christian Zervos's *Cahiers d'art* in Paris, 1935, from which I have already quoted. The conclusion runs, "I look through my window. Several chimney stacks of lifeless factories rise silently. They are inflexible. All of a sudden, smoke rises from a single chimney The wind catches it and it instantly changes color. The whole world has changed" (*CWA*, p. 783). This passage too is about color, as in the writings on art just commented upon, but is more profoundly about seeing, as was his poem "Seeing" (quoted earlier) read in 1916 at the Cabaret Voltaire. It is also, more broadly, about the sensitivity to detail that can best be called poetic, in the wider sense: "The critic would need the soul of a poet . . ." (*CWA*, p. 249).

With that concentration on detail, with that special looking ("Seeing") of Kandinsky, whether with the inner or outer eye, Breton's own angle of vision of the same period was completely congenial. From the 1934 poem "Toujours pour la première fois" ("Always for the first time"):

> The elusive angle of a curtain
> A field of jasmine I found at dawn by a road near Grasse
> The diagonal slant of its girls picking[10]

"The whole world has changed," we remember Kandinsky saying. To thank him for the drypoint Kandinsky had sent for a volume of his poetry, at Breton's suggestion, René Char sent him a poem called simply "Migration" (1934). Its very beginning echoes the same feeling of change, of sudden angling, of displacement:

> Le poids du raisin modifie la position des feuilles
> La montagne avait un peu glissé.
>
> (The weight of the grape alters the leaves' position.
> The mountain had slipped a little.)[11]

By this displacement, all three poets and seers are placed nearer our own present perspective, surviving in part by that ability to detect a slippage in our grasp of things.

Now, Breton, of course, was not just a critic with the soul of a poet, but a poet with the eye of an art lover, understanding angles, caring about the slant of the object seen, and knowing about the reception of a view within the eye. How we read is really what is at issue here: not so much how Kandinsky read the art of surrealism, not so much what he borrowed or included from Miró, for example, as what of surrealist theory and vision, what of its real pulse and its real soul, past the hard kernel of its actual or supposed form, might indeed have merited that only projected reception in his inner if not his outer eye.

For, if surrealism found in itself a passion for the essential conjunction of inner necessity and outer chance, in relation to which encounter its expectancy was endless, and a passion for the unity between inner perception and its linking power, these are exactly the qualities Breton finds to praise in Kandinsky. His high lyric tone of celebration is equivalent to Kandinsky's loftiest prose, and makes me surmise it no accident that Kandinsky should have given him a piece called "Volant," or "Soaring." Breton's preface for Kandinsky's exhibit at Peggy Guggenheim's London gallery in 1938, as translated by Beckett, emphasizes the essential, the analogical, and that fusion we find also in Kandinsky's poem "Fused Chain," comparable in its longing for continuity to Breton's crystal chain discoverable by analogy: "I know of no painter more apt to distinguish the essential from the accidental of circumstance. . . . He has found a punctuation that fuses into one the firmament of stars, a page of music, and all the eggs of all the nests under heaven."[12]

Viewing and reflection

The view surrealism took of itself and of its own risktaking can be shown to parallel the view Kandinsky took of his art and of its ancestral figures. *Du côté de chez le Douanier*: the figure chosen by Kandinsky and whom I would choose here, among possible others, is that of the Douanier Rousseau, with his frontally posed forms and his will-to-flatness, effecting an extraordinary iconic isolation from conventionally pictured "reality" and simultaneously from other ways of seeing. He projects from within, which is exactly that quality Breton salutes in him, cherishing it as emblematic of his own endeavors.

Breton's celebration of the Douanier, through whom, he said, his own sinuous and freely chosen *non-party line* could be seen to pass,[13] of this Rousseau whose work he saw as exchanging sparks with that of Jean-Jacques,[14] and whose genius he saw as a force moving outward to expression from an interior strength, implies a defense of that in-to-out direction rather than a capitulation to or reception of the exterior emblems of any institutionalized grouping, including that of surrealism itself. It is this isolating social and artistic risk which is undervalued when Breton is limited to the all-too-easy identification with the more obvious products of visual surrealist art.

Breton is not without self-reflection, I think, in recalling "The jeers that greeted, but did not discourage the artistic effort of the Douanier Rousseau, who had vowed to develop his potential for instinctive expression independent of any school."[15] Breton's own projected reception in Kandinsky's sight, which had so warmly received Rousseau, should be read in terms of self-recognition and self-definition, worked out through the reception of the other.

"Every true painting partakes of poetry," said Kandinsky, celebrating what he himself termed an *open eye*. It was just this sort of vision he was gifted with – not the eye of reflection but that of creation. It envisions continuities:

> I say that the eye is not *open* as long as it limits itself to the passive role of a mirror – even if the transparency of that mirror offers some interesting peculiarity: exceptionally limpid, or sparkling, or bubbling or faceted. . . . It was created for the purpose of throwing a line across, of laying down a conduit between things of the most heterogeneous appearance. This line, pliable in the extreme, should enable one to grasp in a minimum of time the relationships which link, with no continuity to explain them, innumerable physical and mental structures.[16]

With what I hope is an equally open eye, I have tried here to rediscover the inner links between two critics and visionaries, whose own continuity is not obvious, even in the fused syntagmatic space of artistic discourse that was, and is, Paris. Between these two seers, opposed in appearance and in character, the relationships could have only been understated on one side and

unstated on the other. Meyer Schapiro points out that, in Kandinsky's case, "The most responsive spectator is ... the individual who is similarly concerned with himself and who finds in such pictures not only the counterpart of his own tension, but a final discharge of obsessing feelings."[17] Breton's celebration of Kandinsky's eye and his projection of his own reception within it is more than a touching artwish. I have taken it as a clue not just to one of them, but to both.

Finally, to return to Kandinsky's statement about surrealism as turned toward the outer world: in the actual consciousness of reading-as-exchange of inner and outer, the present rebellion against fixed categories in their supposed stability as yesterday's too-facile limits see themselves deconstructed, might not the reader question whether the absolute opposition established here between the two poles of in and out is not already challenged by the pulsations painting and writing create? The surrealist faith – "What is possible," or, elsewhere, "what is imagined, tends to become the real" – has as much to do with inner dictates as did the dreams of Henri Rousseau, and his dictated painting. It is, in surrealism, the outer world which reveals the inner, some chance encounter showing us, as Breton so movingly puts it, "an answer to the question we did know know we had." But the chance is to be waited for, the surprise to be prepared, and the burden is not, finally, on the outside world but on us. What Kandinsky calls an "inner directive" or intuition is finally not so different from the directive discovered inside at the epiphanic moment when an exterior encounter – of an object, a person, a voice, a painting – becomes what I would call an *enabling object* or encounter, like Kandinsky's own encounter with the Monet haystack.

Now, with a certain poetic or critical license, I want to imagine a tale, or at least a comparison, on the following lines. What if, against the received opinion of the diametrical opposition between Kandinsky and the surrealists he was not always prone to laud, Breton's own gradual turning-inwards, after his disillusionment with political revolution – that turning-inwards for which he was and is frequently under attack from the more politicized surrealists and surrealist sympathizers of then and now – came to crystallization when he came under Kandinsky's spell at Jeanne Bucher's gallery in Paris in 1936? Writing to him after the exhibition, he projects a strong feeling of companionship:

> I haven't had the time to tell you what a strong spell the works I saw chez Madame Bucher cast over me. They are made of the essence of all the times we have been happy and will be happy again. Do you know, dear Kandinsky, that, to speak the language of astrologers, many of the stars of my heavens have met a warm welcome in your eye?

Earlier, as I suggested, he had been warmly impressed with Kandinsky, recommending him to René Char for a prefatory drypoint illustration for Char's celebrated *Le Marteau sans maître* (*The Hammer with no Master*, now

doubly celebrated through the music of Pierre Boulez), those oddly powerful texts of dream and waking quite as inwardly directed as Kandinsky's own. *Seeing* (the title of Kandinsky's text read at the Cabaret Voltaire on one of those Dada evenings, the source of my epigraph about width of vision) is quite surely what surrealism was and is mostly about – seeing wider and deeper, and seeing into the profounder self we call soul. The distance between Kandinsky's art, whether he called it concrete or abstract, and that impressionist or romantic figuring he turned away from is one Breton and Char, in their different ways, traversed also: Breton, towards a passionate engagement with the innate possibilities of dream and inner revolution; Char, towards a conception of poetry which was to link the moral with the aesthetic, like the most modest and well-tilled land with the highest texts that land could nourish, with its inner gods.

We recollect the "fused chain" of Kandinsky's poem of that title. Breton's vision of a crystal chain in the necessary and inwardly seen connection of the universe and human sight, that chain "where not one link is missing," has nothing of the logical about it. "Art," says Breton in relation to Kandinsky's paintings, "has never been logical" but has rather been alogical. It is with that perception of alogicality – linked with inner and not outer necessity – that Breton was to celebrate, more than once, Kandinsky's vision, and to merge his own vision of a crystal chain: "His admirable eye, merging with his faint veil of glass to form perfect crystal, lights up with the sudden irridescent glitter of quartz. It is the eye of one of the first and one of the greatest revolutionaries of vision" (*CWA*, p. 938). For, with that inner determination of all great artists, and all great revolutionaries of vision, Kandinsky and Breton both sought the "reciprocal permeation" of inner and outer, the "inner tone" and the "inner eye" informing that high-tension chain of exchange, the vibrations of inner objects whose sounds and colors only we perceive, stretched to their very innermost limits to create the pulse and the "interior pressure" of a possible art that life could follow, were it only to dare.

Kandinsky's poem "Seeing" begins by starting afresh: "That's where everything begins . . ." (*K*, p. 21); and concludes by a brief warning the critic with a poet's soul might see as directed to some deconversion from a simpler art, moving from non-recognition to recognition. "You can't go back," as he says in "Water" (*K*, p. 65). That great Dadaist and early surrealist Tzara, for whom Kandinsky illustrated a book called, not unsignificantly, *La Main passe* (*The Hand Passes*), had spoken in 1917, in a "Note on Art," of how the making hand joins with sight at its most intense. No better rendering has been made of what links Kandinsky to the surrealist mode of seeing: "Art is at present the only construction complete unto itself, about which nothing more can be said, it is such richness, vitality, sense, wisdom. Understanding, seeing. Describing a flower: relative poetry more or less paper flower. Seeing."[18]

CONCRETISM, SPATIALISM, and OPTICAL POETRY

12

EDGING and HEDGING, or READING in the CONCRETE

To render present or to re-present an image or images with which the mind has already some acquaintance is one of the major goals of framing or reframing: the outline may thus be shifted, the included parts may change focus, shape, relations. The process may be accidental – as when we come across an image with which we are familiar inserted in a text we see for the first time; the image, by its insertion or reframing, is presumably altered for us, this alteration itself teaching some perceptual techniques for deliberate future re-presentation of what we already know. We then seek images embedded in other texts, hoping to see them afresh, and ourselves with them. Representation as we find it or see it can then function like an autobiographical projection, like the *incitamentum* or the incipit of our own reading as our text.

The following essay concerns the reframing of verbal and visual elements and works of art in a new representation, ranging from the simplest possible type, concrete poetry, through the more complex semiotic representation of works of art as they are touched up, to the actual enframing of paintings within a self-examining text about thought and perception, and, finally, the dual simultaneous reading of text and image when they are related to each other by choice.

This essay was first published, in a fuller version, as "Edging and Hedging in the Text," in *Annals of Scholarship* (on concrete poetry), vol. 2, no. 3 (1981).

Reading concrete

Patterns

Gregory Bateson maintains, in his *Steps to an Ecology of Mind*,[1] that our conceptual system should led us see the art object or the "message" as internally patterned and as part of a larger patterned universe. He diagrams this as

[Characteristics of art object / Characteristics of rest of culture]

where the "square brackets enclose the universe of relevance, and where the oblique stroke represents a slash across which some guessing is possible, in one direction or in both." The problem is, as he says, what correspondences *transcend* the slash. After some discussion about verifiability, he gives a larger diagram illustrating how the relation between parts of a patterned whole can inform us about a still larger whole:

[("It's raining") / raindrops / you–me relationship]

where "a redundancy across the slash mark within the smaller universe enclosed in round brackets proposes (is a message about) a redundancy in the larger universe enclosed in square brackets." There are, then, patterns of slashes, he says, across the verbal message and across the raindrops also, since the rain is patterned and structured, but there is no simple correspondence between these two sets of slashes. But, on the other hand, a picture works differently from words. Here Bateson's remarks can be related to some of the problems of the transfer of the framing analogy from art to literature, as well as to the specific problem of concrete poetry, illustrated in the next pages. I shall quote Bateson at length, on the question of levels, of perception and of coding, all of which are essential to the discussion of framing:

> If, instead of a verbal message, I had given you a picture of the rain, some of the slashes on the picture would have corresponded with slashes on the perceived rain.
>
> This difference provides a neat formal criterion to separate the "arbitrary" and digital coding characteristic of the verbal part of language from the *iconic* coding of depiction. But verbal description is often iconic in its larger structure. A scientist describing an earthworm might start at the head end and work down its length – thus producing a description iconic in its sequence and elongation. Here again we observe a hierarchic structuring, digital or verbal at one level and iconic at another.

The layering of consciousness and the levels of mind and attention call for different framings of each: the following examples of reading are located within the frame of play and of visual/verbal encoding and detection.

Availability

Concrete poetry takes advantage of its instantaneous availability to present its words and images to us at once directly and indirectly, for they are and are not the same as those elements of everyday life we ordinarily see: they are re-presented. I shall take some examples, each to illustrate a different angle of sight, beginning in each case with the reading of a single element which forces the rereading of the whole, stage by stage.

Now this is the point I want to make about interference as it concerns the reader's mind confronted with a concrete poem: what is seen, presented often (in commentaries on Apollinaire's *Calligrams*, for instance) as going deliberately against the current of the accustomed motion of the eye line to line by its requirements of take-me-in-all-at-once-ness, is in reality, upon a closer look, a far more complex issue, even as it seems most simple. I have chosen on purpose to comment on two texts which are elementary in appearance, and only open out in time, upon a number of readings, each of which changes the object.

In the first example (plate 12.1), Arrígo Lora-Totino[2] shows what would seem to be an undifferentiated page of the same word ("INFINITE") repeated, except that it is cut in two across the center with the same letters, this time in lower case, with an ironic result, the finite opposite of the first word. The capital letters, taken not as signifying, but as simply picturing, play verticals against diagonals, the upright T and I and the stable E with its horizontal branching-right against the diagonal sweep of the N, dizzying if sufficiently observed and for long enough.

1 By a natural recognition of the smallest sense-making element before the larger ones, I read first EIN, or one, and then FINITEIN, or a finite one, for the sweep of the capital letters permits me to cut wherever I like. In this first reading, I do not even recognize the infinite, only the finite.

2 On the other hand, in the second stage, when my eye hits the lower-case line, I am forced to read "infinite infinite," because of the prominence of the "f" and, secondarily the "t"; in this stage, the little "e" and "i" and "n" or the erstwhile elements forming my first one, "ein," are lost in the *infinite*, which now absorbs all the space.

3 This second step of reading that small line now forces the third stage of reading, where the large letters permit once more the reading of the "ein," but *also* the "infinite" reread; so that, finally, the tug of reading between the small and large sets up a vibration which gives to this apparently stable page a liveliness characteristic of concrete poetry at its best. Its apparent simultaneity in fact requires a number of successive readings.

The poem by Timm Ulrichs (plate 12.2), turning about a rose,[3] is a particu-larly good exercise in training eye and brain, in edging or hedging, and in just plain reading. The poem can be inserted in a long line of traditional rose

FINITEINFINITEINFINITEINFINITEINFINITEINFINITEINFINITEINFINITEINFINITEINFINITE
FINITEINFINITEINFINITEINFINITEINFINITEINFINITEINFINITEINFINITEINFINITEINFINITE
FINITEINFINITEINFINITEINFINITEINFINITEINFINITEINFINITEINFINITEINFINITEINFINITE
FINITEINFINITEINFINITEINFINITEINFINITEINFINITEINFINITEINFINITEINFINITEINFINITE
FINITEINFINITEINFINITEINFINITEINFINITEINFINITEINFINITEINFINITEINFINITEINFINITE
FINITEINFINITEINFINITEINFINITEINFINITEINFINITEINFINITEINFINITEINFINITEINFINITE
FINITEINFINITEINFINITEINFINITEINFINITEINFINITEINFINITEINFINITEINFINITEINFINITE
FINITEINFINITEINFINITEINFINITEINFINITEINFINITEINFINITEINFINITEINFINITEINFINITE
FINITEINFINITEINFINITEINFINITEINFINITEINFINITEINFINITEINFINITEINFINITEINFINITE
FINITEINFINITEINFINITEINFINITEINFINITEINFINITEINFINITEINFINITEINFINITEINFINITE
FINITEINFINITEINFINITEINFINITEINFINITEINFINITEINFINITEINFINITEINFINITEINFINITE
FINITEINFINITEINFINITEINFINITEINFINITEINFINITEINFINITEINFINITEINFINITEINFINITE
FINITEINFINITEINFINITEINFINITEINFINITEINFINITEINFINITEINFINITEINFINITEINFINITE
FINITEINFINITEINFINITEINFINITEINFINITEINFINITEINFINITEINFINITEINFINITEINFINITE
FINITEINFINITEINFINITEINFINITEINFINITEINFINITEINFINITEINFINITEINFINITEINFINITE
FINITEINFINITEINFINITEINFINITEINFINITEINFINITEINFINITEINFINITEINFINITEINFINITE
FINITEINFINITEINFINITEINFINITEINFINITEINFINITEINFINITEINFINITEINFINITEINFINITE
FINITEINFINITEINFINITEINFINITEINFINITEINFINITEINFINITEINFINITEINFINITEINFINITE
FINITEINFINITEINFINITEINFINITEINFINITEINFINITEINFINITEINFINITEINFINITEINFINITE
infiniteinfiniteinfiniteinfiniteinfiniteinfiniteinfiniteinfiniteinfiniteinfiniteinfiniteinfinite
FINITEINFINITEINFINITEINFINITEINFINITEINFINITEINFINITEINFINITEINFINITEINFINITE
FINITEINFINITEINFINITEINFINITEINFINITEINFINITEINFINITEINFINITEINFINITEINFINITE
FINITEINFINITEINFINITEINFINITEINFINITEINFINITEINFINITEINFINITEINFINITEINFINITE
FINITEINFINITEINFINITEINFINITEINFINITEINFINITEINFINITEINFINITEINFINITEINFINITE
FINITEINFINITEINFINITEINFINITEINFINITEINFINITEINFINITEINFINITEINFINITEINFINITE
FINITEINFINITEINFINITEINFINITEINFINITEINFINITEINFINITEINFINITEINFINITEINFINITE
FINITEINFINITEINFINITEINFINITEINFINITEINFINITEINFINITEINFINITEINFINITEINFINITE
FINITEINFINITEINFINITEINFINITEINFINITEINFINITEINFINITEINFINITEINFINITEINFINITE
FINITEINFINITEINFINITEINFINITEINFINITEINFINITEINFINITEINFINITEINFINITEINFINITE
FINITEINFINITEINFINITEINFINITEINFINITEINFINITEINFINITEINFINITEINFINITEINFINITE
FINITEINFINITEINFINITEINFINITEINFINITEINFINITEINFINITEINFINITEINFINITEINFINITE
FINITEINFINITEINFINITEINFINITEINFINITEINFINITEINFINITEINFINITEINFINITEINFINITE
FINITEINFINITEINFINITEINFINITEINFINITEINFINITEINFINITEINFINITEINFINITEINFINITE
FINITEINFINITEINFINITEINFINITEINFINITEINFINITEINFINITEINFINITEINFINITEINFINITE
FINITEINFINITEINFINITEINFINITEINFINITEINFINITEINFINITEINFINITEINFINITEINFINITE
FINITEINFINITEINFINITEINFINITEINFINITEINFINITEINFINITEINFINITEINFINITEINFINITE

Plate 12.1 Arrígo Lora-Totino, "Infinitein," from Eugene Wildman, *Anthology of Concretism* (Chicago: Swallow, 1969), p. 95.

poems, of the *carpe diem* variety (let us pluck the rose ere it die, and so on), based on the observation that beauty withers and love fades out, its ephemeral nature rendering it still more precious.

The subject, then, a rose garden, sets the reader up to notice the displaced "eros" as anagram at the bottom of the poem, the two terms reverberating with the same tension as that in the preceding poem between the finite and the infinite, the one and the endless. But, for the moment, we might consider the frame before replacing the "eros" within the bed of roses which love apparently is, at least here. A certain claustrophobia makes itself felt, as the flowers are hedged in: the row of letters "r" at the left, with fixed bayonets

roseroseros erose

roseroseroseroserose

roseroseroseroserose

roseroseroseroserose

roseroseroseroserose

roseroseroseroserose

roseroseroseroserose

roseroseroseroserose

roseroseroseroserose

roseroseroseroserose

roseroseroseroserose

eros

Plate 12.2 Timm Ulrichs, "Eros," from Eugene Wildman, *Anthology of Concretism* (Chicago: Swallow, 1969), p. 69.

seeming drawn and on the ready, points at and protects the round and innocent "o," as if surprised, with a sure, enclosing border.

On the other edge, the right-hand border is open to continuation, in the letter "e" so unclosed that the reading pursues itself without termination. So on both sides the repeated "rose" takes meaning from its edginess, being perfected as flower and as emblem of beauty, edged in and preserved as a good sample of the garden variety of cultivated and cultured nature. Although no rise can be detected in this rose, the layout of this garden being horizontal, without any letters raising their heads like the "t"s and "f" in the previous poem, the same vibration is established between the displacement of erotic love and the placid flower protected on one side by its own shape, and easily read moving toward the other side. If, by the reader's active intervention as interpreter, the "eros" is replaced in the top edge of the garden, from which it

was detached, this filling in of the one-time break in the frame then permits the reading of the entire poem as "eros" itself. At that point, the poem has been perfected as the extreme of eroticized reading, one element forcing the re-reading of the entire text, and thereby effecting a rape of a once-innocent reading.

About the interference in our reading of other readings, even in these exercises which seem so simple and so spontaneous, all of one piece: they are usually not. For into the reading of a concrete poem there comes the reading of other concrete poems one might have performed, thus, for example, some poems on space and on silence might penetrate our reading of the "Infinite" and "Eros" poems. I shall comment only briefly, just in order to give the picture, since the pictures cannot be given.

To close the reading of concrete poems into the most quiet of frames possible, Eugen Gomringer's "Silencio" – a very early poem of 1956 – creates a super-silencing of the word.[4] The vacant center is framed on all sides by one word, a word that when repeated into a resounding vacancy capable of great resonance has the emptiness of what we would think of as the very shape of silence. On the other hand, however, since everything around it is marked as "silence," even the literal marking makes such a noisy message of overstated overdetermination that only its borders are read as hushed. Here the white center protrudes from the text just as we would imagine it to be in recession, while the silent background shouts. Seen from the center, the reading is opposed, so that the entire poem expands and contracts into noise and sound-lessness, depending on the point of view or of hearing.

A responding poem by Arrigo Lora-Totino, simply called "Spazio," shows space – whose reading could not possibly be misinterpreted in any language – *spelled out*, and playing again with literalness. The space itself disperses the order of the white and quiet center; or, once more, the silent center protrudes to the sight, against the black backing, letting space recede around it.

As with Mallarmé's swan writing, in his white sonnet, a constellation white against the dark of the night sky, both these poems work on our conception of figure and ground, and on their reversal. A figure, then, would ordinarily be the noise against the quiet ground, or the composition formed against the space sensed as empty, but here in both cases it can be read either way.

Semiotics on the half-shell

Nature and culture: picturing parody

The four texts I have chosen particularly to comment on – "Grove," "Lyre-Bird," "Shellcade," and "Dryad" – from Ian Hamilton Finlay's *Wartime Garden*,[5] presented with Ron Costley, parody and pay homage to well-known works of art, send the reader back to myth and out to the world, out to culture

Plate 12.3 Ian Hamilton Finlay, *The Wartime Garden*; "Shellcade" and "Dryad" (reproduced by kind permission of Ian Hamilton Finlay, The Arts Council and The British Library).

and to nature, dealing, as they can, with war and the world of men and women, fighting or at rest. Of the latter contrast, the oxymoronic title already gives a suggestion with its machine of war and its garden of peace.

These pictures bring the world of war into the natural world: "Grove" picks up the foliage from Poussin's celebrated and much-discussed *Et in Arcadia Ego* (*The Arcadian Shepherds*), as it is seen afresh by the authors, after Erwin Panofsky's famous commentary, before Louis Marin's own

response.[6] But the tranquil grove of Arcady is invaded anew by death speaking in both the outer and inner frames, even here: "Even there am I."

Homage-paying can get you in a lot of hot water. When Finlay's *Homage to Poussin*[7] presents a green ink tank, another and parallel rendering – green for nature now – of the shepherds' tomb in Poussin's *Et in Arcadia Ego* as an instrument of war (death as sign and process), it has a label invoking (I would have supposed ironically[8]) a goal that is indeed provocative – "To do Poussin over again, for the sake of the War God"; and the following tank picture, but in a sort of splutter of leafy camouflage, bears the label "Quite literally a net of leaves." Finlay's most intelligent commentator, Stephen Bann,[9] points out the complications of discussing the work, caught between a too-simple dichotomy of binary oppositions based on the inconveniently large (the structuralizing contraries of land/sea, of garden/ocean, or the "timeless abili" of earth and sky and sea) and the "intractably small fragment." Even in the fascinating shift from page to stone as the support for inscription, and the "irreducible cognitive stages through which such a shift has been prepared and consolidated," the ontological need is stressed, for some way to make and remake a world. The project, as Bann points out, is both Heideggerian (dwelling poetically, inhabiting however doubtful a space in some sort of ordered shelter), and like Harold Bloom's "transumption, or far-fetching" the mark of our current post-romantic culture calling back our past. Finlay's work, his Arcadian tomb or his Orphic Lyre, travels the distance from the ancient to the current times: Bann cites its hyperbolic and violent form, due to its long crossing.

It is up to us, now, to read, as best we can, with the most we know, the inscriptions: *Grove*, *Lyre-Bird*, *Shellcade*, *Dryad*.

"Lyre-Bird" plays along the same register of contrary reactions as the Poussin pieces, resounding back to the ancient world of Orpheus and his lyre, while the present bird, seen as a warplane soaring on wing, brings only destruction: thus the text suggests itself as a *liar*, by phonetic preparation in the *lyre*. Art is thus undercut by the *lyric* tradition it so knowingly plays on, within, and against.

Reading backwards from the lyre, the reader is led to insert the bird into his proper groove or *grove*, opposed to that inhabited by live-in tanks and their exploding foliage, where camouflage and concealment take the place of the opening leaves or flowers that would give an extraverted signal of spring. Bush and potential blossom are both threatened by ambush: "ambuscade." Furthermore, into this seasonal frame of false blossoms and foliage, of un-natural animals flying at dangerous heights, two maidens are placed, one standing and one half-reclining: in a diagonal reading, the standing Venus would respond to the flying bird, the reclining one to the grounded tank. Directional sense depends here on visual impulse.

Venus and the Maja

The maidens each have at least one reference in art which already frames the look: the parade maid in Botticelli's *Birth of Venus*, rising from the shell upon the waters, and the dryad in the forms of Madame de Récamier (couchless), of a Goya *Maja desnuda*, or rather, semi-*desnuda*. Together, the young lovelies make a stand-up/lie-down team or a "dyad," and each negates half of that name. For each is showered despite the first syllable of "*dry*-ad" with petals of red (not in color here), and each is maidenly and modest, covering at least half of her charms, despite the exhibition of the world of publicity: "*dry-ad*." They bring at least the world of humans back to what might have been a mechanized text, not only transposing the "model" world of bare beauty into the "real" one of the trappings of war, but, by their simple bareness, shaming both the hypocrisy of politics and the complexities of conflict.

Yet the forced insertion of these figures into books, catalogs, and discussion, so caught up with each other, proves the grove a deadly one, as the guns are aimed full tilt at the new Venus upright, and, making the phonetic suggestion "come true," proves the lyre a liar, for each martial image menaces the peacetime images in the necessary interreading. The crimson petals associated with beauties suddenly seem to suggest no longer a blush of maidenly charm, but the red of blood, while the self-protective attitude of each half-robed object of the reader's gaze functions as shield no longer just against the importunate glance but against the shells spit forth by tank, plane, and the images representing them in the text. They hold their pose even in such a frame-up situation.

Venus on the rise

Of the four pictures, "Shellcade" makes the most complex statement, summing up all the themes so far stated, representing nature and the human in a world of culture, and of war, but also culture in a world of nature. The shell motif plays with and against that of the city in double time: it asserts the world of legend and of the found object, the shell upon the beach, the shell as birth-place of Venus, the shell as trace of a life – all those assertions being set against the constructed world of the city. But the shell all tanked up for a motorcade potentially martial, destroys the city for nature, humans, and culture.

Venus rises from the half-shell, leading the parade, a rather chilly figure, keeping on ice and at a tilt. Upon her fall depend both the sending of the shells from the tank and the loss of well-wishing petals: the "fall" is the mediating term to which the "cade" presumably also refers, as in the Latin (*cado, cadere*). The horrible substitution: seashell for flower, bombshell for seashell, works along the same line as a girl's graceful swerving stance outlined against unswerving lines of the buildings, represented, for a second glance, as a

cultural, but natural, antique being, young always, in a foreign and modern land.

The petals' fall makes and marks the end of the scene, the curtain of the frame. The text, read as a sign and also as training for perception or "visual literacy" points toward one crucial ellipsis and one notional play. By a *branching procedure* and a filling of the blanks, we transpose from "shell" to that of which it is a brand name, while on the other hand, we work from the falling of petals to the ending – "cade", reread. A possible missing term is hinted at, twice, and this reader now supplies it:

Venus as a beauty queen is afloat, although upon a car, afloat still on waters and foam; she is in triumph, even if ambushed. As the leaves and petals fall with the change of season, of age, and of culture, so the birth and rise of Venus give birth and rise both to the text as given, and to the perception its ellipsis hopes to encourage in the reader, whether borne aloft in sympathy on the foam, or leaning heavily into the fall. Whether we read on the recline or the rise, and however we represent the text, we supply our own frame of sight.

13

SEEING the SNAG: OPTICAL POETRY and BEYOND

Il m'est interdit de m'arrêter pour voir. Comme si j'étais condamné à voir en marchant.

(I am forbidden to stop to observe. As if I were condemned to observe while walking.)

Jacques Dupin[1]

I want to project a state of things in which the present poetic complications become the lyricism of the future. What is advantageous about difficulty, as it now presents itself in reading, paradoxically, is simple: given a smooth or readable surface, the difficult patch will focus attention upon itself, enabling the glance to be slowed down, the mind to grab onto a particular detail, the participatory intelligence of the reader to function at its fullest. I have elsewhere investigated the problem in art, where it is often a question of "not losing the surface" when we are concerned with significance. (We might think here of Sartre's distinction between poetry and prose, the former being what we see the surface of, the latter being what we see through, rapidly, to its message.) The anxiety of this loss concerning a surface texture is anything but superficial.

To slow down the glance, optical poetry is particularly efficacious, as we know, impeding the linear rush from beginning to end, forcing attention to sides and center; the relation of the optical to the verbal creates its own problems and thus its own creative delay within the text, holding it up, and slowing it down for greater insight.

A recent avatar of the concrete or optical poets, combining poetry and what might seem to be prose with typographical details, Lionel Ray plays coolly with and upon the picture and its insertion in the text. His own verbal pictures are interesting above all in the questions they raise: in plate 13.1, the text of

This essay was first published as "Optical Poetry and Its Opposite," in *Dada/Surrealism*, no. 12 (1983).

sa joue effleurait un ruban vert jusqu'à la nuit voici
la femme contre l'arbre à feu les lointains froids et
les lents instants : j'étais un texte je volais je mour
ais mal paroles dans un voil
age radieux noué aut our des
voix il cachait nuit la tris
tesse des bouches et rien ne
bougeait dans la mer dans l'
élan des lampes rien sur son
poil humide ses rose aux fad
eurs de lune et rive à fleurs
il n'eut femmes non dans un

> parmi les CHAMPS DE
> LA LIMITE — — —
> — — — à des amis
> variables — — — ces
> paupières de mes em
> pires — — — — —

tourbillon d'ardeurs comme de fécondes phrases mais de
bout sortant des solitudes avec des joies au vent lui
donnais ce don ce nom entre tous pendant neuf jours je
lui donnais des incendies on
vivait de cristal sur un col
de nuées d'émois d'abîme ses
yeux figeaient l'haleine des
éblouissements je la voulais

> cherchant la soif et
> Nostalgie — — —
> — — Dame des lacs

dans les oiseaux les estuaires les chiffres la langue
amère des serpents je la voulais jusqu'aux os dans les
croupes les fleuves l'anéantissement j'écoutais ici le
ciel fuyant l'herbe à sons
toit tu étais mon ange-voy

> parmi les bonds

elle et le moment d'une fontaine au couchant des voix
de l'autre côté du mot
matinée ils viennent a
vec le vent leur voisin
arqué dans l'éclair à
l'extrême froid sous l

> tout parle ici — — —
> — — — — — même
> quatre — — — — —

es courbes dociles ils entrent dans la phot avec des
jardins ils rasent les phares les mains les fatigues
réveillent les roues déplacent les crépuscules ils po
seront leurs visages dans leurs lunettes et joindront
leurs rêves aux bouches des cailloux ils seront proch
es et tolérables comme la menthe comme la mort que j'
ai rencontrée hier sur un visage de merci écoutez-moi
j'ai vu des lettres
comme leurs mains,
des initiales comme
leurs poignets puis

> — — — — — fables
> en forme de sein : — —

j'ai vu des chats dans l'herbe agressive lécher leur
ombre il y avait du jaune dans leurs gestes mais à d'
autres étapes on reconnut les couloirs de la seconde
fois (ainsi le programme de nos
soirées) ils se sont assis en p
leine soif (le texte des blessu
res) ils disaient l'impossible

> LA NEIGE — — —
> AU NOM DE NEIGE

avec des arches dans les yeux du vert tous les déluges

Plate 13.1 Lionel Ray, *La Parole possible* (Paris: Gallimard, 1971),
pp. 108–9.

which (like that of his other pictures) is taken from a volume centered on potentiality and called *La Parole possible* (*The Possible Word*),[2] the statement of identification of narrator and writing, at least in the past, is primordial: "j'étais un texte je volais je mourais mal paroles dans un voilage radieux noué autour des voix" ("I was a text I was flying I was dying badly words in a radiant rigging knotted about the voices" – p. 108). This personalization of the text intertwines with a third-person description, "il cachait" (he was hiding), and the alternating persons provide an interior monologue couched in the lyric stream of consciousness in the past, signaled by the convergence of hyphenated word and single moment remembered: "j'écoutais ici le ciel fuyant l'herbe . . . tu étais mon ange-voyelle et le moment d'une fontaine au couchant des voix" ("I was listening here to the sky fleeing the grass . . . you were my angel-vowel and the moment of a fountain at the setting of the voices" – pp. 108–9).

Within visually inset rectangles of words, the interior monologue contains another, set still more deeply, and here the ellipses or gaps depict what is in fact missing on the level of reading. The fields contained in the first inset rectangle are those of limit and border, capitalized for their significant location on the very verge of limit itself. Here the variables suggest themselves as both intimate and changeable: "des amis variables" (variable friends); and over the fields a shutter is placed with the eyelids lowered, like a dark curtain of closure, where the gaps flower as they may. The enclosure is marked off from the rest of the text already by the rectangular frame, and still further, by the dark created within the inner vision as it retires from what is spelled out, ungapped, whole, and placed in daylight. If indeed "I was a text," then this text is what, in all likelihood, I was. And what we might well expect poetry to be.

Other inset rectangles respond to this, and continue the interior vision, full as they are of thirst for the past, nostalgia, and legend ("cherchant la soif et Nostalgie . . . Dame des lacs"). And pushing back toward the past, they project toward the future, for the lady of this darkened lake, like some surrealist Melusina, a woman-child over whom time has no sway, frequents not just the dark liquid imagery of the unconscious but the convulsive beauty of the surrealist imagination always to come and always at its most intense, seen pictured in another inset: "parmi les bonds." This leap forward, in time and space, reminds us of the famous *saccade* or jolt found at the end of *Nadja*, associated with the train leaping and jerking in the station of Lyon, always only about to leave and never leaving, the privileged image of the convulsive beauty surrealism cherishes, leading to endlessly future fables, first in the form of a fabled breast ("fables en forme de sein"), then of "SNOW – – – IN THE NAME OF SNOW" ("LA NEIGE – – – AU NOM DE NEIGE"). The snows of yesterday have yielded here to those of tomorrow: Mallarmé's white page will have produced this, in the place of the black of print. (Again in the present, Jacques Garelli's poetic title "N'ai-je ma raison?" ["Haven't I my reason?"] points coldly along the same pale path as we hear the snow inside it: *neige. . . .*)

Across from a radiant candle-flame (p. 114; plate 13.2), the windows framed in a high rectangle rest almost on their perpendicular verbal support in the lower window-frame: "PÂLES: MOTS" ("PALE: WORDS"). About these windows in the habitation of words a poetic world is constructed, literally, within the surrounding text, where the patient linear construction goes on in the center of the picture – "je maçonnais un monde ligne à ligne" ("I was constructing a world line by line"), the perfect and pictured justification of the builder who is at home in the world of words and in the state of poetry, defined at the base of the page: "homme de nul écart dans l'état de mots" ("man without swerve in the state of words"). His only diversion will be toward the future.

The questions posed by this pictured state of things in the poetic habitation are themselves part of the construction worked over by reader and text: the building of this difficult state of things, without swerve, requires if not answers, then at least meditation, upon the surface of things as it is framed off for our deliberate contemplation. What does it mean, in the case of these literal picture windows now reread ("fenêtres pâles les mots") to be able to see through words, which after all they are, as they are framed to be window panes? For the pictures of the words as framing windows themselves play on the notion of seeing through or transparency, and that of meaning. We see through them even as they hold up our sight and our thought: this is a paradigm case of positive and creative difficulty, a maximal opening, supposing what will come to fill in the picture.

In the text of Jabès as illustrated by Tàpies (plate 13.3),[3] the minimal art of the line and the two first numbers, just a one/two, sets up a rhythm of an utter simplicity. The text demands an ultimate birth within the nuances of the blinding white, seen in succession as sound or murmur; as image, or the petals of an implicit flower (suggesting Mallarmé's absolute container of a vase defined as an "absence of all bouquets"); as the concept of a double departure and a double denial, scratching out or crossing off a name left unwritten. All these are taken as the range and degrees of white itself, in its oxymoronic oppositions leading from glacier and summit snow to the white-hot sheet burning with a name finally uttered behind the dazzling surface, uttered as the potential fill-in for the space set apart, the white heat of a leaf kept in reserve for its name.

But how does the numerical seesaw the artist sets up to accompany the text here work its visual and conceptual balance in relation to these words, or, rather, how do we read it? Subsequent to the text, it nevertheless demands our attention, as if it were simultaneous. The line across the page, with its second number rising above the first, is not the sort of illustration that refers one back to the text for a clue about itself, but produces, rather, a delay in the reading mechanism working itself out. One might read it in this way: as one progresses, lifted to the next number, so the whole white text, like Mallarmé's white page, is made to rise to the next power above it, yet connected to the line

en gros caractères : vous savez, la maison à clefs l'
iris aux cheveux fourbes? plus loin un vieux chapeau
comme on en voit sur les ci catrices ou les hautes

grilles de peupliers ni c hauds ni froids des sal
ves de fruits morts à ch aque volet se fermaient
sur un jardin envahi de genoux à quoi corresp
ondent l'étiquette rou ge et les rivières en
deuil « nous allons gra nd train » dit-elle à
demi renversée alors l **ì** e corps malléable gr
andissait immense com **C S** me une parole inexp
lorée duvet lunaire jus **I E** te un charme l'on
descendait par cette l **T R** ongue nef à marée f
urtive dans l'odeur fr **O É** iable des herbes ma
rines dans l'eau des fl **U S** eurs atterries jusqu'à
la maison sous les voy **T U** elles aux hanches dou
loureuses aux lumières **M** tristes, puis en guise
d'écluse la tourbe du som **F** meil avant un nouveau
départ pour de longues ap prochées cueillaisou des
simples élixir mon poison d'eau fraîche ma vivante é
criture fleuve indolent qui va de l'univers à l'univers
j'ouvrais aux portes un pays il n'est blé que de vents
ce moment égaré des lèvres pour ralentir un arbre puis
en lieu amer je voyais le souille maniant les couleurs
e'était avant le pas des fleurs écrasant leurs ombres

inventer les espaces comme étoffe entre
les mots labours bor nages contrats d'h
orlogo (Odéon 84-00) **F** marchand de plumes
ornait le paysage pi **E** geons partout le t
emps brisait des mél **N** ancolies des chain
es retour d'ombre re **Ê** tour de vague je m
archais dans les obl **T** iques rayons le tr
èlle de pages je mac **R** onnais un monde li
gne à ligne (à la ga **E** re il était midi)
les enfants mâchonna **S** ient les syllabes
corps apprivoisaient la différence leur
sexe inventait les illusions mais autre chose la jeune
fille aux acacias tremblants elle a dit oui à des bouq
uets maisons où il y a des lits laqués désordre où je
cherchais mon nom elle ouvrait
ses bras d'ou s'é **PÂLES : MOTS** c-hap-paient
mes consonnes la chambre aux
rideaux c'était fête homme du langage j'entrais dans l
'eau d'un souffle e'était ile, homme de nul écart dans
l'état de mots de vols d'oiseaux irréductibles phrases

Plate 13.2 Lionel Ray, *La Parole possible*, pp. 114–15.

Que tout soit blanc a fin que tout soit naissance.

> *(Blanc, le murmure.*
> *Blanc, le pétale.*
> *Blanc, le départ.*
> *Blanche, la tature.)*

Tant de différences dans le blanc ! Blanc liquide, poudre blanche.

Combien de degrés dans le blanc ! Du blanc glacial des sommets au blanc chaud de feuillet gardé en réserve pour son nom.

Plate 13.3 Edmond Jabès, *Ça suit son cours*, illustrated by Tapiès (Montpellier: Fata Morgana, 1975), pp. 108–9.

of reading. The title of the facing page, entitled "V'herbe," suggests both the notion of grass (*herbe*) and that of the Word (*Verbe*). The entire text becomes, visually and verbally, "La mise en accusation de l'oeil," a prosecution of the eye or a verbal trial of the seen-as-the-read exactly equivalent to what is taking place within the reading itself, rendered difficult by the simplest syntax of double vision, in a delay.

In many of the contemporary poets, the chosen difficulties can be seen to work in a net of relations or a sort of system of problems to hold in delay or

reserve the reading of the text. For example, Michel Deguy is often concerned with the poetry of self-cancellation or of loss or of unfinishedness. ("I have already forgotten what is going to begin," ends one poem). Ironically, a text about the *rapprochants*, or the bridges bringing elements together, ends with the quintessence of the unfinished: "To invent bridgings [*rapprochants*] . . . which bring nearer the" – and here, with no conclusion, the text simply ends. The mind is brought to a halt with a jerk: precisely that which is to be brought nearer is absent, so that the near is typically the furthest off of all. These are exemplary snags, deliberate delays, purposely never integrated into a system.

It seems to me that of all contemporary poets, Jacques Dupin has had, for a long time now, a clearer and more meaningful sense of the system of his own difficulty, not chosen but sensed as inevitable. By all the myriad poetic techniques and summonings of the hard concept; by his almost obsessive use of the oxymoron; by his imagining of such quasi-impossible figures as "the only woman following me, and she does not follow me,"[4] and the wonderful ambivalence of such pictures as that of the cart wheel "bluer from being discolored,"[5] by his frequent ellipses, celebrations of fragmentation and rupture, of the jolts of language and vision, he succeeds in sharpening and intensifying the edge of his language. "L'intense écriture s'aiguise" ("The intense writing makes its edge finer"). Even a few lines from one of his early prose poems, "L'Ordre du jour" ("The Order of Day"), give the tone of the special kind of self-enclosed density he masters, displaying, even as the concept is closed off, a kind of high language joyfully impenetrable to para-phrase and self-exaltation: he has done for French poetry what Henry James does for the English-language novel, wreaking difficulty upon it and opening it to the future.

D'élire domicile au coeur de l'entr'acte, acquiescement et refus obligent qui les creuse. Par l'incorporation du hasard à la chair, j'incarne enfin la transe originale, j'accueille la foudre du premier rapt. Je suis le moment d'oubli qui fonde la mémoire. . . . Au haut crucial où s'abolit la danse, l'expiation commence et l'acte nul. Mais de l'opération qu'ils impliquent et renoncent, j'augure ironiquement d'un orgasme définitif.

De ce mal qui s'étire dans la longue saignée des siècles, je suis l'exacte et pure abstraction,

– le noeud d'asphyxie formelle.

Ignorez-moi passionément!

(To choose domicile in the heart of the intermission, acquiescence and refusal oblige those who hollow them out. By the incorporation of chance into the flesh, I finally incarnate the original trance, I welcome the lightning of the first seizure. I am the moment of oblivion that founds memory. . . . At the crucial height where dance is abolished, expiation begins and the null act. But from the operation that they imply and renounce, I ironically augur a definitive orgasm.

Of this malady which stretches out in the long bleeding of centuries, I
am the abstraction, exact and pure
– the knot of formal asphyxia.

Ignore me passionately!)[6]

The difficulty of this text and the others like it comes from the obvious depth
at which the original is situated, and not from any surface complication or
delay. The invitation to trance and lightning, to expiatory operation and
ironic inauguration, are all knotted within the final oxymoron, "Ignore me
passionately!" and allow it to be unfolded as delayed and projected.

My final example is from the opposite kind of poet, less apparently "hard"
as he is more "simple." Lorand Gaspar, speaking often of the renewed
experience of loss and insufficiency, is haunted by the desperate or anxious
retention of whatever appears to matter: "Tenir, tenir. Qui guérira notre main
qui se crispe?" ("To keep, to keep. Who will cure our hand as it clenches
tightly?").[7] Yet the human mind as it takes its own measure, for instance in
self-reference against the sea, is constantly haunted by the realization of not
being up to nature:

Il y a toujours un soir où tu t'arrêtes
insuffisant devant la mer.

(There is always an evening when you stop
in lack before the sea.)[8]

What now is the relation of the insufficiency experienced before nature and
before death to that of the poem as it would help us retain?

The close of the volume called *Approche de la parole* deals with this, as best
it can, and I read it also, as best I can. The surface here poses no question, for
those come in this poetry from the depths of things. Here the writing itself, as
it speaks of loss, speaks of what cannot be lost, kept within that very cup of the
hand, as in a natural hollow:

L'écriture effacée, en ce creux qui t'attire, la haute tension d'une
parole perdue. Elle était toutes les lignes du monde et tous ses manque-
ments. Peut-être.

Mais tout poème est un poème perdu, l'obscurité d'une parole à
jamais oubliée.

(Writing wiped out, in this hollow attracting you, the high voltage of a
lost word. It was all the lines of the world and all its lacks. Perhaps.

But every poem is a lost poem, the darkness of a word forever
forgotten.)[9]

And, yet, the clarity of light and sea, the "grande page du matin aux rives de
pierres où le jour nous vient de l'aveugle citerne des yeux" ("the great page of
morning with the banks of stones where the day comes to us from the blind

cistern of the eyes"), where walking and breathing are questionless and speak of no returning, are these not too simple to attract a reading accustomed to the difficult?

> Mais qui lira une si simple écriture?
> Poète est plus sévère que silence.
>
> . . .
>
> Dire et se perdre: il reste sur le sol d'homme le visage limé dans
> le torrent absolu.
>
> (But who will read such a simple writing?
> Poet is severer than silence.
>
> . . .
>
> To speak and to become lost: there remains on the earth of man the
> face whittled out in the absolute torrent.)[10]

This is then the real difficulty of the contemporary poet of the simple, turned toward and anxious about the difficulties of the future, making his hard construction of what seems less hard, but may be more enduring. When the surface detail will no longer hold up the reading, when the gaps are sensed not in the verbal or visual text or in their correspondence, but in the insufficiency of the human experience and of human language itself before the sea or before silence, the difficulty is no longer just visible, audible, or conceptual, but perhaps of more matter: in the difficulty of living and seeing as of reading, and in reading that sight, hardest in what is most elemental. What the "man without swerve in the state of words" works out in the language and the construction of the poem must be seen straight on, not snagged or gapped, or held up within itself, but measured only by what surrounds it and what it questions, which is about to be all of being, as we shall read it.

Part III
READING in PARALLEL

14

A DOUBLE READING by DESIGN: BRUEGHEL, AUDEN, and WILLIAMS

But here the speakers fell silent. Perhaps they were thinking that there is a vast distance between any poem and any picture: and that to compare them stretches words too far. At last, said one of them, we have reached the edge where painting breaks off and takes her way into the silent land. We shall have to set foot there soon, and all our words will fold their wings and sit huddled like rooks on the tops of the trees in winter. . . . But since we love words let us dally for a little on the verge, said the other. Let us hold painting by the hand a moment longer, for though they must part in the end, painting and writing have much to tell each other: they have much in common.

Virginia Woolf[1]

The act of reading a poem devoted to a painting (itself perhaps devoted to a myth or a legend, to be read in its turn) is, like making the poem or the painting, an experiment in one of the possible forms of representing. There is, of course, no way to avoid the twin perils of what we might call afterness (after the painting, after the poem, thus in third place or third-order experience, unless there is a legend or a story to begin with, in which case it is in fourth place or fourth order) and aboutness (not involved in the drama or the story or the landscape of the picture, or in the making of either text). The distance Virginia Woolf speaks of, between words and brushstrokes, is surely increased in the work of the critic reading both texts. But might we not take the opposite tack from a pessimistic one and consider that these necessary distances we must take from what we are reading enable a re-vision of the very act of our double reading? It might be thought that we can gain a greater understanding of exactly what process we are following at this arm's length from it.

This essay was first published in *The Journal of Aesthetics and Art Criticism*, vol. XLI, no. 3 (Spring 1983).

Several forms of refuge or attack are open to us. We can, first of all, refer to only historical and art-historical or literary criteria of moments, movements, and schools and read the period and style into the works, thus setting correctly and even exhaustively our point of view. Or we can refer to any number of works on the interdisciplinary matters which concern us and take comfort in some particular comparative mode. Or, full of contemporary reading theory, we can plunge into textual things, knowing we are armed to the gills, making our attack a fashionable one, based on Lacan, Derrida, Marin, Lyotard, or whomever we choose. Or we can develop a modest theory of critical and imaginative perception, in accord with the particular texts we are examining and the way we believe it best to examine them. For example, a literary critic might reflect on what it is to perceive the work of art and its verbal response with an eye in-structed or trained in and on matters more verbal than visual: I have tried to do this in my *Eye in the Text: Essays on Perception, Mannerist to Modern*.[2]

This essay will take the last tack; and will have as the matter of its chief concern the development of a form of reading appropriate to the specific texts it deals with. Coming after, being about, it tries nevertheless for a form of creative seeing which takes its direction from the twin objects of sight themselves, following their inner cohesion and instructions as to reading and being read. The subject will be celebrated poems about celebrated paintings of Brueghel, about which a good deal has been written; but, instead of referring out to the secondary works, it will take its own directions from within the texts, without other theories or explanations, limiting itself to what exactly we can know from the poem about its own reading of the painting and, in the first examples, of the legend related to it.

This post-creation is meant to suggest, quite simply, a way of reading and seeing, of re-viewing or re-vising[3] our view of certain works, themselves already joined by the painter, in the case of legend, and always by the poet.

Bordering and designing

The cohesion comes in the first instance from the accumulated references in the poetic text to design, to reading, and to how things are linked. William Carlos Williams's *Pictures from Brueghel*[4] are about, among other things, the relation between form and seeing. His poem about the Cluny tapestries concerns designing, bordering, tethering or linking, and enclosure:

A Formal Design

This fleur-de-lis
at a fence rail
where a unicorn is

confined it is a tapestry
deftly woven
a milleflor

design the fleur-de-lis
with its yellow
petals edges

a fruiting tree formally
enough in
this climate

a pomegranate to which
a princely
collar round his

arching neck the beast
is lightly
tethered

"A Formal Design" as a poem teaches us how to look at a tapestry and a poem, how they are bordered or fenced in,[5] at first invisibly, by their very form and formality. It teaches also how a design may create what is to be brought, by design, into existence, which is in part the lesson of the unicorn. The focus falls on the smallest detail to initiate the glance, as in the *mille-fleurs* pattern of the garden, usually fenced in. Here the glance is doubly focused by the linguistic emphasis on the deictic pointer, "This," and the visual rhyme, the border forming the front and the end of the line – "This . . . lis . . .," and also the end of the third line, "is" – so that the decrescendo in length (four letters to three to two) works in tandem with the crescendo in semantic importance toward the verb "is," signifying the existence of the single thing in the tapestry whose existence can be put in doubt: the unicorn, which here is, is not. And the paradox is underlined, or tethered to the text, as the verb of assertion, "is," is further stressed by the excessive repetition within the weave of the text which "is a tapestry," and repetition of the verb within the flower design ("the fleur-de-lis"), then by the echoes, both visual and phonetic, in the rhymes at the end and the beginning of later lines: "*his* . . . the beast *is*."

The tapestry of poem and silk words and works its way deftly and delicately back across the page toward the left, against the ordinary run of the glance, from the "lis" to the "is" in the penultimate line, to repeat the stress laid upon the fabulous existence, created by the poem itself, and within its borders. This existence was already included within in the pointer "This," beginning the poem, which in fact confines the unicorn, the confine itself suggesting thematically the birth of the beast from the beast, in a confinement or a gestation gestured to.

The definition is made clear, at the outset: "This fleur-de-lis . . . it is a

tapestry." And in its design, double, verbal in text and visual in weave, the unicorn is created with the borders illustrated, exactly at the edge of the first three stanzas, where they *hinge with* or *edge upon* the last three, "formally enough . . . in this climate." The creation is confined between the edges, and in the circular fence, gently held by the light tethering of the poem.

Light, because the circle of the fence is apparent only in its ellipsis: we know of the fence and see its visual echo in the collar around the arching neck, in what we know to be a delicate confinement. The poem is itself gently tethered and edged, taking these terms from its body, to tie it with its own substance. It is contained, shaped, and circled, so deftly woven in its pattern as to link the stanzas each to the next in the delicate S-curves of a no less absolute binding, as part of a compound's verb split is from the other part and thus leads to mind to it:

Verb is separated from object, act from that which is acted upon:

and possessive adjective from thing possessed:

The design is a graceful one for seeing and reading, teaching us to observe the lightest of curves and links. As Rilke describes part of this tapestry in *The Notebooks of Malte Laurids Brigge*, "Everything is there, Everything for ever."[6]

Williams would not have made such a claim for his own poem, of course, for it is rather in the exclusions it makes from the design which encloses it that it finds its own light grace. To spell out even the flowers within the fence would be to lose, necessarily, the very medieval and underplayed splendor of what is seen. This is one of the first lessons the aesthetic critic might learn: suggestion is, and not just for Mallarmé, not always explication. Fencing or framing or pointing is sufficient without delineating each detail. I am

concerned above all with the way the pointing (as in the unicorn's horn in the tapestry) and the fencing in (as in the poem about the relation between fence and picture) mark themselves as essential. The gestures of enclosing and relating in fact point to themselves, in the poem as it winds from one stanza to the next, in speaking of how borders border.

Insertion (about Icarus)

For a further reflection on how the painting includes the story, and encloses it, or edges it, or inserts it within its own matter, Williams's poem on Icarus can teach us something about setting. The distancing of the event at the outset marks the edge of the text, its entrance, all the more perceptible and significant as it responds to the way in which legend enters the text and the scene.

Landscape with the Fall of Icarus [plate 14.1]

According to Brueghel
when Icarus fell
it was spring

a farmer was ploughing
his field
the whole pageantry

of the year was
awake tingling
near

the edge of the sea
concerned
with itself

sweating in the sun
that melted
the wings' wax

unsignificantly
off the coast
there was

a splash quite unnoticed
this was
Icarus drowning

Each poem in the series about Brueghel paintings has this type of initial firm line: authority is attributed elsewhere, in this case, and the reference is not

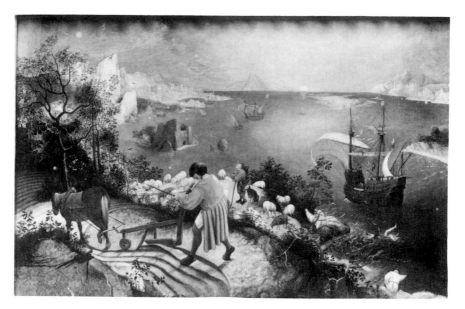

Plate 14.1 Pieter Brueghel the Elder, *Landscape with the Fall of Icarus*, © A.C.L. Bruxelles.

only explanatory – by the quotation of an outside source – but temporal and locative: a picture of 1555, in the Musée des Beaux Arts, in Brussels. ... Already this initial and border stanza is structured with the contrast that is a frequent characteristic of edges: since the contrast is, however, only implied, an interpretive burden is placed upon the reader. The *fall* "when Icarus fell" is the contrary of "it was spring," and suggests, on a second level, a contrary convergence between the motions of falling down and springing up, the contrast assumed and intensified, with its conceptual and visual and phonetic elements merging to make the interest of the framing pattern.

Moreover, the legendary event, placed in the past tense, is placed in a series of present participles, set off by the leading one, "According," placed in the stressed position. Together with the spring, this *incipit* is a temporal pointer, and leads to the labor of ploughing, erotic work centered in the picture, and that in turn to the verb "tingling," as in the light of an expected event, eagerly anticipated: the spring serving as a border conveys the notion of something about to happen, seconded by the adverb "near" and the noun "edge," those key words marking the pageantry not as passive, but as an active wait. The sharp edge pictured between sea and land is the source of the verbal edginess, expressed by the participles, of which the first is "ploughing," including, as in the French for "ploughing," the reference to hard work: *labourer la terre*. The participle system is continued by the verb "sweating," which itself already

contains the wing as a metonymy of and a figure for the disaster of Icarus, so that the flight, however heroic in its attempt, however legendary in its outcome, will be always, is, and has been made and seen within the human context. As the human failure at transcendence is inserted in the natural system of human labor, the disaster is rendered understandable: unaided, flying simply does not work.

The bottom edge, marked by the disaster, although the action is never to be completed in picture or in poem, retains the present participle and the observer within it by a frontal gaze, directed at the pageantry, at the sweep of soil against sea, and at the event which is drastically decentered in the moment of the initial gaze: it happens both "unsignificantly" and unnoticed, not by the reader perhaps – indeed, certainly not – but by the tiller of the field and the observer of the sky, both realists engrossed in the natural, blind to the legendary. Only the sky and the soil are readable for them, and the legend would be lost, but for the reader, and the title which keeps up the tradition.

For, in picture as in poem, each element is presented as ultimately concerned with itself: the sea is, Icarus was, we are. This a statement, not a sermon, and no morality attaches to the scene. There is a proper time for ploughing, as in the proverb on which the scene is based, and another time for adventure, whatever its motive and its end.

Intermediary in position between the working man and the doomed boy, the sky-gazer takes another text than ours, but serves, albeit unknowingly, in joining sky to soil to sea. The painting reads like a tale of three gazes: the worker's at the soil, his companion's at the sky, and our own, at Icarus, blinded and submerged. Thought plays against sight, sight against blindness, to increase our paradoxical involvement in the picture, highly aware of itself within the poem. Just as at the beginning of "A Formal Design," the poem opens with a pointing finger, showing the exact moment:

> when Icarus fell
> *it was* . . .

The expression prepares the presentation of the full pageantry of the year, which also *was*, and the two final stress marks and markings which center the gaze on the exact middle point of the event, which we might have supposed decentered in the picture:

> *there was*
> a splash quite unnoticed
> *this was*
> Icarus drowning

That the entire poem should end with the drowning event already prepared by the system of present participles and its initial recounting impulse ("According") shows this event to be deliberately set within a systematic, a linguistic frame, which stresses its own reading:

The innermost point of the *insetting* is, in this rereading, also the most significant, inserted as it is within the space and time of legend and of the deepest presence of sight. The Landscape, in this insighting, is to be read with and in the Fall.

In line with this insetting and on the side, as Brueghel's Icarus is far to the side of the canvas including him, Auden's Icarus poem deliberately sets the legend at a distance from the edge of the poem as the figure is distanced in the canvas. This poem delays even the mention of the painting itself until the second stanza, and then turns away from it, the reader's eyes trained only on the aesthetics of the picture: green sea and white legs, ploughing borders and a splendid ship. Brueghel's own paradoxical picture takes a decentered image in full knowledge that it will catch our eye, even from the title: it is in fact so desperately displaced as to fascinate the gaze. All the pointers point in fact to that figure, and the whole paradox of decentering played against the pointers focuses still more accurately, if ironically, the mind upon the fall. Icarus, in the Brueghel picture and in the two poems I am chiefly concerned with, is deeply inserted and inset within frames both locative (where his picture is, where he falls, where we should be or not be looking) and seasonal (it is spring . . .).

Musée des Beaux Arts

About suffering they were never wrong,
The Old Masters: how well they understood
Its human position; how it takes place
While someone else is eating or opening a window or just walking
 dully along;
How, when the aged are reverently, passionately waiting
For the miraculous birth, there always must be
Children who did not specially want it to happen, skating
On a pond at the edge of the wood:
They never forgot
That even the dreadful martyrdom must run its course
Anyhow in a corner, some untidy spot
Where the dogs go on with their doggy life and the torturer's horse
Scratches its innocent behind on a tree.

Brueghel's *Icarus*, for instance: how everything turns away
Quite leisurely from the disaster; the ploughman may
Have heard the splash, the forsaken cry,
But for him it was not an important failure; the sun shone
As it had to on the white legs disappearing into the green
Water; and the expensive delicate ship that must have seen
Something amazing, a boy falling out of the sky,
Had somewhere to get to and sailed calmly on.[7]

Auden's 1939 poem begins with the locative and general title: the Musée des Beaux Arts in Brussels houses this canvas, and others, being the home of "The Old Masters," who read as a secondary title, after the announced topic – "About suffering" – as if it were a course to be taken. When the actual title of the picture is mentioned in the second stanza, it is already displaced from its ordinary initial position, the reference to the actual painting situated or inset far inside the frame of proper names and places, at once centered and off its normal position in the title place: it lies, of course, at the heart of the text.

The same form of insertion and insetting works for the specific topic of suffering in its relation to the boy, and to his fall:

Enframing its figure deep within the outer borders, the poem raises some essential questions as to the reading of and even detection of its proper center. How do we in fact see what is central in the poem? Is our perception reliable? Are there several centers? Suffering cannot have an answer, but the reading of it may be itself central to the reading of a life, as of a text visual or verbal.

All the expressions in the poem which mark the edge of the world seen as a picture, in whose corner the legend takes place in terms both of the painting and poem, mark the edge of perception itself, mark the margins of what we see: "the edge of the wood," the "corner" of perception, the legend demanding to be read in a sense at once semantic, linguistic, and poetic. All the edges prepare the turning-away of everything from the seemingly unimportant

disaster; the "turn" of the poem coincides exactly with the turn of the sight and feeling: the observer's eyes are to be averted, as a boy is forsaken in his cosmic plight. For the disaster is not, we are told, really very important, if we compare it with the aesthetic stress of the picture: ship and sea in their splendor, dwarfing the human fate.

The cosmic frame gives the picture its place, in legend and in life, and assigns the values: "the sun shone/As it *had* to," the ship "*Had* somewhere to get to," and it got on. Even as the repeated sibilants ("expen*s*ive," "*s*een," "*S*omething," "*s*ky," "*s*omewhere," "*s*ailed") anchor the final lines of the frame, the meaning is forced outside the time of the poem as event and its visual space to somewhere beyond, as in the poem's very last word: "on." Both the Auden and the Williams poems and the picture are concerned with individual suffering, but they are also concerned with continuity, with the way the universal may triumph over individual failure, simply by continuing past each human disaster in its legendary presentation, no matter how real, no matter how close-up, or far away.

This kind of insertion of the figure in the frame, then, leads the eye and the mind to a flexible position where the central thought can be read, even at an angle, and yet inserted in the main glance. The opposition of the two points of view on Icarus and on his insetting and side-setting is instructive as to how we should direct our own glance: such flexibility of perception is essential to the parallel reading of visual and verbal texts, and can be carried over to our own reading.

Directing a reading

Williams's poem concerning *The Hunters in the Snow* gives verbal instructions for directing the gaze within the picture. Already, in the title, the snow claims our attention, as does Icarus in the *Landscape* which includes him. The winter setting of white clarity, not unlike a page, is given from the outset – "The over-all picture is winter" – and given as pictorial. The exemplary detail of weather focuses the gaze, upwards: "icy mountains." The vertical distance, thus immediately inscribed in the poem, will force the movement of the gaze as all the texts considered here undertake to do, in varying degrees of coercion.

The Hunters in the Snow

The over-all picture is winter
icy mountains
in the background the return

from the hunt it is toward evening
from the left
sturdy hunters lead in

their pack the inn-sign
hanging from a
broken hinge is a stag a crucifix

between his antlers the cold
inn yard is
deserted but for a huge bonfire

that flares wind-driven tended by
women who cluster
about it to the right beyond

the hill is a pattern of skaters
Brueghel the painter
concerned with it all has chosen

a winter-struck bush for his
foreground to
complete the picture . . .

The poem is to be read just as we read the picture, with a glance from overall whole to part: from winter to winter mountain, from the vague backdrop to the advancing figures – "in the background the return . . . sturdy hunters lead in," advancing, as the poem says, "from the left," exactly in the direction of the reading gaze, toward the right, where the women cluster to balance the other group of sturdy figures – men leading to the women, left to right, poem to picture. As the text scans the visual arrangement, preposition answers preposition, for proper placing: "lead in" leads to the "between" and finally to the "beyond." Through these directions the gaze finds at once its place and its time: from the initial statement of winter, of evening, in the general sweep of vision in the overall canvas, down to the final arrest by winter, circling the poem in its white pattern.

But the directions for seeing are still more explicit: the gaze finds a notch to center it with perfect horizontal and vertical lines, through the antlers of the stag. The cross as sighting frames, up and down, and across, when the picture is seen through these borders: "between his antlers the cold inn yard." So the picture of the poem is presented already patterned by the gaze of a painter, rather than by subject matter. Neither Brueghel nor Williams is really concerned with hunting or skating: rather, they are concerned with the pattern of sight itself:

the hill is a pattern of skaters
Brueghel the painter
concerned with it all . . .

Brueghel the painter, and Williams the poet, have framed the scene so as to concentrate the attention first upon the season, then upon the time of day,

then on the procession and the sign on its broken hinge. Its imperfect juncture attracts our attention to the frame, to focus once more upon the reading.

The line of sight, finally, begins with the near ("inn yard"/"women"), and goes toward the far ("beyond the hill is a pattern of skaters") before returning to the foregrounding as the proper focus of the painter "concerned with it all" for the satisfying completion of the picture, both his and ours. That the completed picture should end with the imperfected sign of suspension only leaves the broken hinge hanging there, for future sightings.

Reading on the slant

The Parable of the Blind [plate 14.2]

This horrible but superb painting
the parable of the blind
without a red

in the composition shows a group
of beggars leading
each other diagonally downward

across the canvas
from one side
to stumble finally into a bog

where the picture
and the composition ends back
of which no seeing man

is represented the unshaven
features of the des-
titute with their few

pitiful possessions a basin
to wash in a peasant
cottage is seen and a church spire

the faces are raised
as toward the light
there is no detail extraneous

to the composition one
follows the others stick in
hand triumphant to disaster

In "The Parable of the Blind," the initial half-rhyme "parable"/"horrible" places an immediate stress upon the very awfulness of the picture, presented

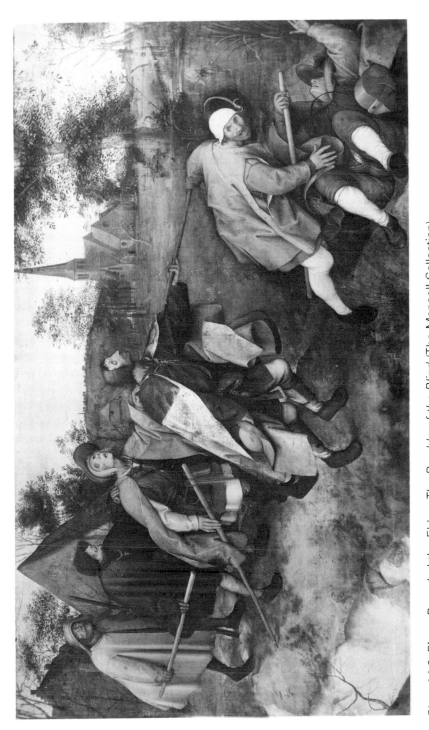

Plate 14.2 Pieter Brueghel the Elder, *The Parable of the Blind* (The Mansell Collection).

with an accent on the terrible irony of painting a painting of the blind: *Painting the parable* is then to picture the kind of fall from which no lesson can be learned, and yet this painting is about leading, as the Icarus picture is "About suffering." It is, in fact, *not* without a color red, as art historians have pointed out, with some surprise at the awkwardness of the poem on this point: since Williams probably saw the painting in Vienna over twenty years earlier, had he forgotten it? Had he not seen the man's red stocking?

The answer is, I think, more interesting than the question might suppose. What it in fact leads us to is quite simply the reframing of the statement, as it is read, here reread figuratively and aurally, because, in a place of blindness, nothing, whether or not vivid in color, can be *read*, in any composition, however artistic. Art for the eyes only is sure to fail in the land of the blind.

Words occupy the center, partly in their sound, and nothing can back them up by reference to sight, so that the painting itself bogs down. Because "no seeing man / is represented," the community of non-seers reinforces the sense of the "pitiful," a word stressed at first visually and then phonetically, as it is (with its prediction) coupled, the terms sharing a typographical profile:

> *destitute*
> *pitiful*

Four letters in each protrude by their height, the rounded and exactly mirrored form of the "d" and the "p" followed by the three upright consonants, thin and terrible forms of the destitution toward which the roundest of forms must move in that bleak land, on its way toward death.

The figural irony is awful, for the faces are raised, the stick is in hand, as if in readiness for an act of violence, whereas the violence is for the sightless victims: all they can perpetrate upon others is a sense of pity. In the downward slant of the inexorable tragedy, we are forced as readers not to be blind, if we would see the painting. For the initial and terminal chiasmus, clearly marked in two framing edges, enables those two edges to fit together in a cross-reflection:

> horrible but superb
> triumphant to disaster

Those fitting edges frame the conceptual chiasmus implied at the center:

> cottage (but) spire
> spire (but) bog

Edges and images join to reinforce the reading of the diagonal thrust, so that the figures are read, and by the sighted, into the final bog.

Reading designs

From the light tethering of the texts here chosen initially as a design and an indication of how to read these instructions for reading, to the slant and the final fall, these verbal images, however shuffled, however light or grave, comic or tragic, seem perfectly keyed to the pictures they picture. They can be read in terms of insertion and framing, of centering and decentering, of edging and junctures, from left to right, background to foreground, and on a slant. It is up to the critic as reader of double texts, visual and verbal, to learn how to see, to design, to tether, and to interpret the forms and functions of such parallel readings, illuminating the double images given or chosen, as they shape reading itself, perhaps on its way to sight.

As I began with a reflection on painting and myth, I might close with one, repeating, in the form of this essay, that of the circular fence we saw at the outset. All the accumulated myths of relations between the arts are often no more than that: what we see and read is often, and now finally, the best clue we have as to how we should be looking and seeing and knowing.

As a unicorn among the flowers with its lady, or Icarus falling, is neither a right representation nor a wrong one, the conviction and the concern about it lie in another realm altogether; the conviction, and the relation, are not that of the poem or the picture to outward reality, or to fact or "truth of representation." What matters is rather the response of the poem to the myth and to the tapestry or the painting; we do not care what unicorns might really look like among flowers, or what Icarus looks like under water, but only how they may be enclosed in the tapestry and the painting and the page. What counts is the relation between the unicorn and the fence, Icarus and the ship and the water, between fence and frame, between ship and the passing of the pageantry, and our perception of all this. It is my conviction that there are, within these texts and others like them, clues about both our relation with the texts (what we might call the "reading relation") and theirs with each other, about how we should read all the relations concerned here. It is to this sense of relation of this story – that we should relate, by the design of the text and by our own.

15

INTERFERENCES, or READING BETWEEN: WHISTLER, CLAUDEL, BONNEFOY, and CHAR

To paint as some do even today, taking from color which, as soon as it is placed on the canvas, rises above sense, and dispels our memories, addresses nothing but the self, they will say: we can think of that as the immediate, and that the veil as been rent.

Yves Bonnefoy[1]

Two kinds of interference or crossing-over will be my concern: the first, that sensed between the members of a generation of poets whose writings as critics of art have far-reaching implications as they reflect upon their own writing; the second, that between the seer or poet and the visual object seen, not in life but upon the canvas. The view is, in all these cases, mediated through another view and another creation. My own reflection – which can scarcely be transparent – makes another mediation, contributes another warp to the view, so that the discussion is, as would be expected, yet still a question of inter-weaving, a textual interference.

In this textual canvas with its visual components I want to weave now, Claudel and Valéry and Proust will find their interface with Char and Dupin and Bonnefoy, as the latter find their own with Corot and Courbet, with Piero della Francesca and de Chirico. I shall be concerned here more with the conception than with the brushstroke, more with the thought behind the subject than with the latter in its reference and non-reference to reality; thus I shall move from the essay to the poem, from critical language to poetic or artistic object, without further apology.

This essay was first published as "Interferences, or Reading Between: Whistler and Claudel, Valéry and Bonnefoy" in *L'Espirit créateur*, vol. XXII, no. 4 (Winter 1982).

Knowing, interruption, and exchange

Claudel's *Traité de la co-naissance au monde et de soi-même*, in title and in fact, depends on an exchange of words and of prepositions, being a treatise on the "Knowledge of / Co-Birth to the World and Oneself."

"Knowing what things are like each other," says Claudel, "is knowing or being born together."[2] Our knowing and our perceiving are equivalent to our calling upon the exterior world in its being and its relation to the way we name it, see it, figure and prefigure it: "Knowledge: or awareness of the general figure according to which we are apt to know. Intelligence: or repetition inside the word which *calls* each object to be in relation to us."[3] Knowledge passes through language; sensation passes through form. In both form and language the limits between inside and out serve also as links from the sometimes perceptible but often imperceptible subjective to the generally perceptible, and exterior objective. The point at which this dividing line becomes the link between the two, the steady interference or interface, remains, for the moment, an "interruption" between the two. The question of interruption is to be read as positive in the sense that interference is positive – no less so than the question of bridging.

The term "interruption" is a key one. For Claudel, sensation itself is a "special manner of being interrupted" by an object, within the field of rays which our senses consistently and constantly emit.[4] The interruption is revealing, helping us discern what is out there, making itself of primary and not secondary importance; it is second to the outer fact, but not lesser. What we were doing or giving or giving off before the interruption is of almost no interest compared to the way in which we are interrupted, and how we react to that interruption. So far, the general principles sketched out include knowledge by limits, interruption as the other side of juncture, and exchange as a mode of perception in art.

Choosing and arranging

Valéry uses Corot as the model for the very picture of the self-painting artist for whom nature is a model of certain poetic arrangements, and not, as it is for Delacroix, a dictionary. So we could look at nature, and at the culture of art, through Corot's glance as it is seen by Valéry: a chosen example of the interfering gaze, of the interruption of sight by sight, of the interweaving of possible seeing texts. Inside us, as Corot shows, there is a whole universe of possible relations, toward which we might turn, and toward which, having sufficiently investigated the exterior world, we shall wish to return. As we stare at a forest, with an artist's eyes, and as Valéry perceives Corot's point of view, we see not the trees before but, just as surely, and surely with more

poetry, the trees behind us: "One day in the forest someone watching him paint a tree asks anxiously: 'But where, Sir, do you see that lovely tree you are putting there?' – Corot removes his pipe from between his teeth, and without turning around, points with his pipe to an oak behind them. . . ."[5]

To take the point a bit farther, seeing in terms of front and back and of writers and poets different from these: if Zola, for instance, believes in things and their enumeration and their *infrontness* in relation to us, Mallarmé would be at the opposite pole, choosing his readers as well as, or rather along with, his objects as the obviously selected concomitants to the product. We see that Zola inventories, but Mallarmé selects.

Color and register

In the poetic state, which Valéry calls the "state of resonance,"[6] the plain black and white of the world suffices, and it is indeed that sufficing of the simple which defines as poets, artists such as Rembrandt, Claude Lorraine, Goya, and Corot, all able to use the slightest degree of what we think of as color, and yet all known as "colorists." Valéry compares them and their state of poetry to what Leibniz does with numbers, using only the sign of zero and the number one, deducing from them an entire metaphysics. So, Valéry says, the elementary white and black is enough for the master of painting; "But I don't know quite how to explain why black and white penetrate more deeply in the soul than colored paintings, and why, considering only its differences of tonality, a work reduced to light and shadows touches us, makes us more deeply thoughtful than the whole register of colors."[7]

If I may permit myself what may seem a black-and-white herring, I would like to quote Whistler, his one white lock of hair leaping forth to the sight above his white and black vestments, and to look again at his *Arrangement in Black and White* (and sometimes grey), his famous mother, hung in France, to his delight and to the critics' scandal. The scandal was no less in the case of the portrait of Miss Alexander, called *Harmony in Grey and Green*, or the *Arrangement in Black and Brown* of Miss Rosa Corder, the attacks on which are quoted at length in Whistler's ferociously and ironically mistitled *Gentle Art of Making Enemies*. For example:

Miss Rosa Corder, and Mr H. Irving as Philip, are two large blotches of dark canvas. When I have time I am going again to find out which is Rose and which is Irving.

Miss Alexander, almost in Black and White, and about the most unattractive piece of work in the Galleries.

Nobody who sets any value upon the roses and lilies that adorn the cheeks of our blooming girls can accept such murky tints as these as representative of a young English lady.[8]

Finally, along the same lines: "There is character in it, but it is unpleasant character. Of anything like real flesh tones the painting is quite innocent."[9]

The point is, of course, that nature is what is being appealed to by the critics of art, nature considered as reality. Harmonies, arrangements, structural or formal properties should, according to the enlightened seers of Glasgow and London and Paris, take second place to the objective truth we are supposed to see. Flesh, in short, is not to be green, even that of Baudelaire's children, and nor is it to be grey or grey and black and white. Flesh is to be "flesh color," but English girls are, as we all know, just like roses. The less they have to do with French poetry and its sickly tints, the better; and, again, the less they have to do with the formalistic and non-referential stark elements of the master-painters Valéry mentions, the better still. Reality, in short, is what art has to represent to be art, for these observers of daily life.

To remake the world

But color has a way of remaking the world, especially for the contemporary writer. In his *Trois remarques sur la couleur (Three Remarks on Color)* Bonnefoy imagines a land in which the colors blue and yellow, for instance, would be called "violet," and the color green would be known as "red and white." Here the number of colors multiplies infinitely, and, says the dweller of the land, the world is newly rich, its face freshly washed by the invention of this second speech. No, says the traveler, the world is poorer, for the word is now deserted. As Bonnefoy explains, Bonnefoy the great commentator on Mallarmé, seen here as the traveler, this is not to render a purer sense to the words of the tribe (in Mallarmé's words) but rather to lose what we have built and chosen – that is, our words as our world.[10]

By contrast, Bonnefoy says of Mantegna that his object "exactly found, exactly reproduced, will furnish the vocabulary whose act would be syntax."[11] He is able to make of monochrome, or grisaille, the celebration of the noblest facts of the mind, the black and white of values, in the moral world as in the world of art. Colors and multiplication are not needed in the simplicity of this new Hamlet of underinterpretations, who answers with silence at the "Hour of the spiritual testament." Mantegna, who needs no categories other than his own, becomes the first painter in history to live only in his name; what is done and has no marks outside itself suffices.

A continuer of black and white lines, Jacques Dupin (Bonnefoy's colleague in the ephemeral world of the journal called *L'Ephémère*, which lasted for only twenty issues) constructs a long poem on Malevich. It contains the violence of a "pure slippage," permitting not just the confrontation of red and white, but also of black and white, as in some Mallarmean inscription, and, more memorably still, the intrusion of the black into the white and the interference of the two: "que le noir coupe le blanc / et que le blanc revienne

du bord / ou de l'absence de limites" ("that black is cutting white / and that the white comes back from the border / or from the limitless absence").[12] In this "fulgurant geometry," space rises living from color, in the polyvocal and polysemic suggestions of the same elemental hues: "à la vitesse oblique d'un rayonnement qu'accelère amplifie le hante de son sommeil / le blanc de / l'espace enfin / habilité" ("at the oblique speed of a radiation increasing haunting him with its sleep / the white of / space finally / rehabilitated").[13]

Yet I think of Dupin as a colorist. In the somber hues and the minimal spaces his thought can inhabit – as in his poem "L'Onglée," about a thumbnail and its trace – his unequalled and essential modesty would prevent him from making such a claim. But Corot comes back to us, with his small dot of the color red, amidst blacks and whites. The violence done to the "normal" perception and the "real" world outside is still proper to the state of resonance which is poetry, seen now through art.

Bridging

What must be recontemplated here is what it is to think and see *between* – for instance, between exterior and interior, between perception and thought, between model and mind. One thinks here of the transparency that Proust discovers, literally, for us within our own world as his own models ours forever. The different overlay of experiences at two different times is itself the bridge between the opposed objects, finding its culmination in a Proustian reflection on style as style:

> Truth will appear only when the writer takes two different objects, establishes their relationship – analogous in the world of art to the solid relationship in the world of science of the law of cause and effect – and encloses them in the necessary compass of a beautiful style; or even when, like life itself, comparing similar qualities in two sensations, he makes the way they essentially mark the here and how of this moment in time stand out clearly by joining them in a metaphor, in order so as to remove them from the contingencies of time, and links them together with the indescribable bond of an alliance of words.[14]

Now prolongation, as Claudel describes it and is haunted by the concept, is a primary agent of the continuation of relationships. In particular, Bonnefoy's thoughts on the phenomenon of the shadows cast by certain objects, thus prolonging themselves into the distance, in time and space, throw a particularly sharp light on literary and visual extensions. His musings on Piero della Francesca and on de Chirico form the structure for his thoughts on prolongation of this sort. Piero, believing in infinity, causes the horn of the ox to continue the line of an angel's guitar; de Chirico, knowing finitude to be our

lot, emphasizes the pair of compasses, seen from the exterior, like a project lost after it has been planned and executed.[15]

Thus, cast shadows reintroduce the idea of the instant into that of the temporal just as the shadow on the sundial signals what is important, the contingency of time as it constantly recurs in Proust. What matters is here and in this instant, which is our own measure; we have, in de Chirico's time, only this moment, only the finite. In one of the most moving passages of all his art commentary, Bonnefoy signals the strangely haunting quality of de Chirico's work:

> And perhaps the reason for the powerful grasp on the modern conscious-ness of de Chirico, who does not try like Piero della Francesca or Raphael the construction of essence on his canvas but limits himself to suggesting it as the horizon of a deserted town, depends on just his attachment to one glove, a mannequin or a piece of fruit, brute objects, in which the reflec-tion of the alignment of the arcades is effaced forever.[16]

On one side, we see the architect's room, with its compasses and its measuring instruments; on the other, the leisurely elegance of the figures under the arcades of eternity, lifting their ice-cream spoons. The spatial and temporal juncture of these pictures, the way in which they correspond with each other, is caught and held not just in the apertures and columns of the arcade, but also, and quite as essentially, in the poet's view; not just in the stone pillars, but also on his page, which prolongs them.

For our own inheritance from these and other interferences, we might choose a contemporary poet looking at art. René Char, for instance, belongs to a line of poet-critics in whose work we can see emerging an idea of continuation on the deep level as of interruption on the surface, and associated perceptions of a place apart as well as a place here. Typical is Char's great poem "Le Requin et la mouette" ("The Shark and the Seagull") about the epitome of contraries, emblematized by the shark and the seagull; it is also, and in particular, about the art of Braque and about poetry, as about the art of art; in turn it bridges color and prayer, a rainbow and faith in correspondence:

> Hier la noblesse était déserte, le rameau était distant de ses bourgeons. Le requin et la mouette ne communiquaient pas.
>
> O Vous, arc-en-ciel de ce rivage polisseur, approchez le navire de son espérance. Faites que toute fin supposée soit une neuve innocence, un fiévreux en-avant pour ceux qui trébuchent dans la matinale lourdeur.

> (Yesterday nobility was empty, the branch was distant from its buds. No communicating between shark and seagull.
>
> O rainbow of this sweeping shore, bring the ship to its hope. Make every supposed end a new innocence, a feverish forwards for those stumbling in the heaviness of morning.)[17]

Joining the elements of poetry, as of the natural world, as of perception itself, the rainbow touches both sides in this "new innocence," for a fresh joining. Such a poem shows what poetry and art and the perception of both are about.

Simplifying

The poets mentioned here are understandably little given to the ornate. Bonnefoy's own simplicity – simple as perception is simple, permitting all the complexities of the philosophical mind to enter therein – exemplifies their attitude.

Bonnefoy's poem of bridging, like Char's arching over the correspondences in his poem of a rainbow, a shark and a seagull, retains strongly the feeling of correspondence inscribed in a quiet space. Those two poems can be seen as the bridge for a necessarily partial discussion of the long line of poet-critics who begin with interruption and non-referentiality, and who end with the quiet wish of joining. Bonnefoy's "Le Pont de fer" ("Iron Bridge") speaks for itself and for the linking of shores within the limits of human constructions, built by memory in a world of muted form and still moment. Poetry, if it cannot do without its road, can neither do without its outer images, and its memory of the other bank from the one on which we find ourselves. It is quite as if only what had been separated – like art and poetry – could be joined, in order to nourish our present language and vision. Of this poetry Bonnefoy says,

> Elle nourrit
> Un long chagrin de rive morte, un pont de fer
> Jeté vers l'autre rive encore plus nocturne
> Est sa seule mémoire et son seul vrai amour.

> (It feeds
> A long chagrin of stagnant riverbank,
> An iron bridge cast towards the other darker side
> Is its only memory and its true love.)[18]

The little pool of black oil which has led to this end brings about the resurrection of the entire picture from the elements which were seen as separated. Just as white and black go further sometimes than the most vivid colors of painting, our own works of dust and iron may serve to join, and to correspond: some of them may indeed be visible where we would least expect it. The art of surprise doubles, and enhances, the art of interference.

16

COLLECTING and CONTAINING: JOSEPH CORNELL and MALLARMÉ

Memory is more important to me than my boxes.
Joseph Cornell[1]

I want to reflect on collecting, on containing, on committing to memory, and on a way of reading that commitment.

What we keep

Hoarding thousands of objects and mementos, choosing which treasured elements to insert into a box frame to echo each other and objects outside, as well as to recollect the past in the present, projecting what he called his "explorations" forward into ideal constructions to come, Joseph Cornell combined history and future desire on his always oddly present building site. His extraordinary and peculiar will toward the spanning of time, and his double passion for collecting and containing link him above all to the Victorians; his collections and the "shadow boxes" in which he displayed them recall the Victorian museum and, on a smaller scale, the Victorian cabinet of curiosities.

But the most appealing cabinet of curiosity was Joseph Cornell himself. We think of him in his later years on Utopia Parkway in Queens as a shy recluse making frequent Manhattan pilgrimages to further his collections, as a worshipper of the cinema's and the ballet's stars and starlets, whom he followed about on their daily rounds, and as the anguished genius whom his sister found moaning with anxiety on a bench in Madison Square Park, after his work in what he called the "nightmare alley" of Lower Broadway.

The despair of the creative artist is still one of the givens of twentieth-century artistic folklore. Curtis Bill Pepper describes the basis of Red Groom's

large canvas *Chance Encounter at 3 a.m.* of 1984 as the meeting of De Kooning and Rothko, both suffering from doubts, and from fears of losing their creative powers, hunched up on a park bench in Washington Square at three o'clock in the morning.[2] The anguish typical of the Victorian past is, of course, not identical to that of the New York art scene in more recent years; yet something about the former can serve to illuminate the latter, as both are gravely visible, audible, and understandable now.

Cornell's collection mania raises questions about the containment of anguish, as it does about the construction of worlds: I can see only a few points clearly, looking back from here, but can sense the anguish with great clarity indeed.

Anguish in its detail

Selecting and preserving the fragments of a happier and bygone time, the artist recluse given over to the past and to the theatricalization of the present makes himself a celebrant of his own poetic cabinet of subjective choice. Therein he tries to retain what he cherishes – in all its idiosyncratic multiplicity – by a framing construction or composition, so as to capture and hold a more valid and lasting view than that of the present.

Like the super-Victorian John Ruskin, one of the greatest and most anguished geniuses adored by our contemporaries, Cornell was endowed with an intense nostalgia, whose urges caused him to reject present "progress" in order to recapture a supposedly simpler time. Ruskin's particular anguish was caused, of course, by other factors than artistic self-doubt: his excess of sentimental outpouring was matched only by his extraordinary style of language, resplendent with detail. The same artist who would hover for hours over an ornament in St Mark's in Venice, who would draw a peacock feather in perfection and in perfect scale, or a leaf or twig or rooftop as no one else could do it, was a hoarder also of memory. His favorite towns and mountains, in France, Switzerland, or Italy, were to be captured by their detailed image and so held and possessed; the obsession with preservation informed all his large and small keepings and hoardings, in endless cases and sketches, even as he lost his mind itself.

One of Cornell's most revered figures in the ideal landscape he finally came to inhabit was a great reader of Ruskin.[3] Completely refusing the social world about her, as Ruskin refused his, Emily Dickinson displayed in her own reclusive life a spiritual wholeness the Christian Scientist in Cornell admired. Mary Baker Eddy's *Science and the Key to the Scriptures*, the textual foundation of Christian Science, uses as its principal key the word and the concept of wholeness: we might therefore see, in Cornell's attempts to preserve his fragmentary treasures in a setting which would make them whole, a key to his constructions and his explorations. His shadow boxes, which he

called "poetic theaters," are idealizing and totalizing constructions, as are his later "explorations," all readable as his attempts to experience the integrity he knew possible, and that he found in those reclusive figures he so admired.

This timid personality confronted with what was most opposite to him took constant refuge in dream. From the anguish that set him moaning on that park bench (even before the Depression caused him to lose his job on Lower Broadway) Christian Science gave him some relief;[4] yet from the anguish of the everyday only his prolonged contemplation of the faces of the stars in that constellation he privately set up could relieve him. This quite remarkable transformation of the banal, of the faces and voices a whole public celebrates, into such a personal constellation as that of Cornell, is as much of an aesthetic triumph as Mallarmé's own transformation of the erstwhile vocabulary and reading customs of our own tribe into what we see as his personal skywriting. Cornell did with his pin-ups of starlets and swans what he did with cut-out forms: he framed them into a poetic theater, celebrating the mystery of art he saw them pointing to, and made of it a world. His object, like that of Virginia Woolf, was the saturation of space and the textual instant until a seemingly prosaic display of hoarded moments should turn into poetry. The box form plays on filling and filling-up, on space and its significance as pointed to by frontal and background forms, until the game, and the box, are used up.

Re-reading the banal

"No one knows himself so long as he remains merely himself and not at the same time himself and another."[5] Cornell quotes Novalis, whose affection for the color blue he shared, tinting various of his boxes with that hue, and one of his more successful film remakes: blue brings the sky down for human happenings, giving them a celestial surround. Borrowing and lending color, Cornell's lifelong homage to the figures we know he loved was tinted over with a cast preventing us from always seeing clear and straight. So much the better for the poetry and poetics of theater, dealing more in tints than in truth.

As imbued with the spirit of metamorphosis as any romantic, Cornell saw in his theater of the stars, in his own remaking of each *étoile* (star), a whole history of myth, from the Magi and the flight to Egypt to the face of Hedy Lamarr, to whom he addressed the most poetic of all his written texts, "The Enchanted Wanderer." Each of his chosen celebrated figures, singers, dancers, and film stars evokes a whole atmosphere of the artistic past captured in the present, in a great "mystique of lost voices," faces, and symbols. Malibran, Pasta, and Jenny Tourel, Fanny Cerrito, Allegra Kent, and other luminaries (including Susan Sontag) appear in Cornell's frames as both mythical and real. They are used even as they are celebrated, each figure engendering a whole suggested world, each expanding into a universe beyond itself, from metonymy to meaning.

One step beyond in complication, being himself and another, Cornell used the figures already consecrated by art, myth, and time, of Cassiopeia and Berenice, for example, and more specially the figures used by other artists to give the same stellar and constellar dimensionality to his work that collage as first invented gave to art. Part of the real is included in the artistic frame, its depiction adding increased problematic layers of representation to what is already the problem of meaning as it is rebuilt and represented, and as we read it. The figures seem, to some extent, interchangeable, signs in potential substitution for each other, as Malibran's, Pasta's, and Jerry Tourel's voices resound from the enclosing walls.

To use a figure from a constellation, for example, to insert an old photograph – even any old photograph – into a presently constructed box brings one form of art to another, one figure to another setting, and the trace of the real to the presentation of the idea. So too is past time brought into the present moment, and the idea of the discard refused. Nothing is wasted – for the artist, for the reader – and so we have not read our past in vain. What we can imagine we can build on and so keep.

The act of bringing into a collage or a montage a scrap of paper painted or inscribed serves the same purpose as Emily Dickinson's inscription of her poems on brown paper bags, the margins of newspapers, the insides of used envelopes, or discarded bills: what has been already consecrated to human use is reused and so reconsecrated. "It is strange," said Dickinson, "that the most intangible thing is the most adhesive."[6] Retrieving what might be lost becomes the obsession of Cornell's poetic theaters, with all their elements tangible and intangible, as their very repetitions of themselves in some great self-referring and other-referring network make for the observer a universe both familiar and transformative, as it is separated out, ongoing, from the rest.

This obsession with past accumulation – with retrieval, repetition, and reclaiming, with reinstituting and revaluing – makes its own hierarchical order. If Cornell dwells on the clay pipe, referring to his own Dutch ancestry, he refers also to Chardin's blower of bubbles; if he rejects plastic as the most empty of elements because it has no past, he retains the box like those his father used to construct because the combination of shallow presentational object and its recesses or shadows speaks to his past and of what memory would retain from it, of game and of lost time: in his own definition of his work, "Shadow-boxes become poetic theaters or settings wherein are metamorphosed the elements of a childhood pastime." Like boxes or spiritual caskets stored within each other, these reflections on the past as they are themselves reflections on a *mise-en-abîme* construction are sanctuaries for the mind and incantations for the spirit of what is worth preserving into the future. What they exclude is soon lost, but in them childhood is regained.

They serve also as a twentieth-century form of the traditional *vanitas* – containing, as clearly as Mallarmé's wine glass in his poem "Salut," with its play on and in *verre* (glass) and *vers* (verse) the potential saving of our literary

high spirits, preserving behind glass a "crystalline composition." Cornell's glass objects, with their accumulations and containments, of sand and time, those cups and goblets as hourglasses, keep the past and the sense of running present. They preserve, even as they signal the presence of that which destroys all that is somehow preserved. They frame and set aside, into the margin of time as it flows, the idea of preservation itself.

Like Mallarmé that great glass-worker, one of the principal figures in Cornell's constellations, Cornell invites us to dwell not in the center but in the margin, in "this vast white space left deliberately at the top of the page as if to produce a separation from everything, from what has been read elsewhere."[7] What is here framed is set aside, and yet made central.

But what form can writing about a box take, being already marginal to, outside of, the box? One of the more appropriate presentational styles is Robert Motherwell's lyric "Preface to a Joseph Cornell Exhibition," written for a Minneapolis show in 1953. It appears as a letter on two separate pages as if freshly sent, enfolded in the Castelli *Cornell Portfolio Album* in 1976. Sent all these years later, as it were, or at least received, it has something surrealist about it: the proposed Minnesota catalogue itself never having been published, the letter is displaced to New York, to a different moment, and inserted in a different frame. Mallarmé would, had he been invited to, have partaken of Motherwell's musings on the way in which Cornell uses "the white light of early morning – he and Herman Melville in this country have understood the concept of white the most richly."[8] But, closer still to the symbolist spirit Cornell and Mallarmé share lies one rhetorical question posed by Motherwell: "What kind of man is this, who found on Fourth Avenue the only existing film of Loie Fuller's serpentine dance that entranced the intellectuals of Paris long before Isadora Duncan, who recovered her dance for himself, when all that we had left were the descriptions by Mallarmé, Apollinaire, and the others?" The serpentine dance of his recovery "for himself" picks up the curving lines of Mallarmé's great essay on Fuller, included in his essays on the ballet. Within the formal outline of a box are inscribed both margin and serpentine line, composing the native poetry of this multiple androgynous presentation Cornell offers. "So long as he lives and works," says Motherwell, "Europe cannot snub our native art." What kind of man is this indeed, even dead?

Measures against containment, or the transgression of boundaries

In relation to Joseph Cornell's collections, and his constellations of souvenirs, Susan Stewart's reflections in *On Longing* are enormously valuable. She does not talk of Cornell, but what she says is eminently applicable to his souvenir boxes, insofar as they participate in both memory (of the singers, of the

dancers) and classification (in his own constellations). The magic of the souvenir, she maintains, "is a kind of failed magic. The place of origin must remain unavailable in order for desire to be generated." The collection, she says, is lent its authenticity by the past.

> The collection replaces history with classification, with order beyond the realm of temporality. . . . all time is made simultaneous or synchronous within the collection's world. . . . The collection is a form of art as play, a form involving the reframing of objects within a world of attention and manipulation of context. Like other forms of art, its function is not the restoration of context of origin but rather the creation of a new context, a context standing in a metaphorical, rather than a contiguous, relation to the world of everyday life. . . . The spatial whole of the collection supersedes the individual narratives that "lie beyond it."[9]

This aesthetic value is clearly tied to the cultural, she says, with its value system that of the cultural, including deferment, exchange, and redemption. All the myths of the museum enter here also. Stewart quotes Eugenio Donato on the museum and fiction: "The fiction is that a repeated metonymic displacement of fragment for totality, object to label, series of objects to series of labels, can still produce a representation which is somehow adequate to a nonlinguistic universe."[10]

Stewart's study of the placement of signs as in the interior of the self is exactly in accord with Cornell's strategies and hopes: "In order to construct this narrative of interiority," she says, "it is necessary to obliterate the object's context of origin."[11] (What better way than to place around the souvenir the heavy frame of the perfect box, like the parentheses so lightly placed around this interrogation, rhetorical as it is?)

Looking back

How did the items of Cornell's favorite collections find their way into his shadow theater of presentational memory? Looking back through a Cornell box, we find traces as clear as direct reference, the very opposite of what Whistler pencilled down of Loie Fuller's "whirling traces," in a sketch he made during a performance.[12] But, ironically, it is these traces which will permit us to inscribe the original choreography of the figure whom part of this essay on dance and art and memory is intended to honor, Mallarmé the modern.

Cornell is outspoken about his encounters with his beloved predecessors, with French poets such as Baudelaire and Mallarmé, his brother spirits, and American poets such as Emily Dickinson, his sister recluse. Of his most cherished books, the one, he said, which had permitted him his first great adventures in literature was the artist Marsden Hartley's own *Adventures in Art*. Here Hartley sets out to express himself in an informal manner:

"Reactions, then, through direct impulse, and not essays by means of stiffened analysis."[13] Without needing to spell out further the split between the dancer's whirling trace or the imaginative tale and the rigid walls of the box construction, I might remark that Cornell's leaning toward the side of the impulsive swerves of the idea, toward the curving lines of the dance, are part and boxed parcel of his inheritance from the American symbolists or romantics, as the terms strangely converge in Hartley's descriptions. Cornell managed to preserve both whirl and box.

Noting that he has been reading all the James family's writings, including their fairy tales, Hartley concludes that he prefers William, who is the "most like life as idea."[14] This formulation serves him well, and us also, for his preoccupations are our own here:

> I am preoccupied with the business of transmutation – which is to say, the proper evaluation of life as idea. . . . The person of most power in life is he who becomes a high magician with the engaging and elusive trick. . . . It is what you do with the street-corner in your brain that shall determine your gift.[15]

Cornell's own gift, and the one he most noticeably employs to engage us, is surely not a transmutation of any ordinary street corner, but rather a theater district of the soul, a 42nd Street of the American imagination, where Pavlovas come to perform, but also Hedy Lamarr; where a Renaissance prince or princess can be found as readily as Susan Sontag, reading a subway map or a chart of the stars with equal passion. Here glamor meets reclusiveness on familiar ground, in what Hartley cites from Dickinson as "an oblique integrity." Dickinson, in Hartley's wonderfully Pre-Raphaelite rendering, "loved all things because all things were in one way or another bright for her, and of a blinding brightness; from which she often had to hide her face."[16]

Now, her attitude toward the things she loved, "looking out gleefully upon them from that high place in her mind,"[17] is not so far from that of the alternately mournful and exalted Cornell. In his own high intelligence, he built a palace to celebrate the American way of performing art, where the whirling trace of the dancer is contained for the moment of art – and, by resonance, forever – in the walls of the presentational box, where shadow play re-creates luminous and textual vision, and the street corner of the brain becomes an imaginary universe of containment both improbable and possible. "One need never question appearances," Hartley taught him. "One accepts them for their face value, as the camera accepts them, without recommendations or specialized qualification. They are as they become to one."[18] One can say of this observer what André Breton said of the surrealists: "What we imagine tends to become the real."

What Cornell brings us in his bright, or darker, gift boxes is our own imagination through his past. If what he has done for the American vision is as immeasurable as any emblem, it is no more than what he has kept of Europe as

it envisions itself. How the box – in its seemingly perfect closure – in fact opens, not just on the world but on the interpretive imagination as it can be creatively misinformed, is a speculation that would have delighted the massive intellect of the Europeanized American Henry James, that other teller of the best symbolic fairy tales.

In the journals he left behind,[19] Cornell shows the ups and downs of exaltation and depression to an extraordinary extent, repeatedly lamenting the impossibility of bringing over into communicable words the experiences he coded into a language of his own. Over and over he feels "overtones," "warm music," the "warm miracle", and over and over finds it "something rich and wonderful, inexpressible" (undated entry, 1956). The experience unfolds to his wonder, and this unfolding of something until then hidden lends a terrible and sublime eroticism to the language of these journals.

The occasion is always simple, as of the joy he repeatedly feels: it happens all of a sudden, usually as he watches the individual lives moving about in the street, prosaically, in their trivial concerns, from behind the plate-glass windows of a cafeteria in New York or Flushing – usually the Horn and Hardart in New York, or Bickford's or Nedick's in Flushing. For instance, on February 13, 1956, he mentions going for a "jaunt" in Flushing with a book to read: "the random selection from the shelf of the Lorca for a very early jaunt to Main Street – the complete joy of this . . . that elusive rapture all the words cannot hold." And yet, in his transcription, even as he remembers the Lorca book becoming "vibrant with inspiration," his joy springs less from the verses of Lorca than from his own feeling for the city and for life. The props and the places – books, cafeterias, streets and cellars – were always the real referents of what the boxes contained.

And those clearly etched memories – his delight in Bickford's butter strip, with an almond taste, or in the coffee, or, once at home, in the newly opened tin of Huntley and Palmer biscuits with the pink center – all evoke Proustian memories in the reader, seeming all the while remarkably real. Constantly he makes an effort to retain his "overemotionalism" about such episodes. Like some reluctant hero of the surrealist life, of the artistic pilgrimage, Cornell takes up by his writing a world we could not have known about only through his boxes.

Yet they, of course, contain the essence of his exultation: over and over, emerging from the cellar where he constructs them in the dawn, standing by the wash as it blows in the wind, watching the few passers-by, Cornell inscribes his joy into these modest and magnificent notes for himself:

again freshness of early morning no words can express – cellar about 6:30 and feeling at one with environment, quiet of garden, early morning light, slight mist, people passing in distance, east windows – "framing" – . . . standing by the wash tubs with the cool air blowing in – peaceful outlook on feeding table under quince tree. . . . (Thursday morning, May 31, 1956)

In 1957, when he was experimenting with the word "constellations" for his selections of past experiences, another such epiphanic feeling swept over him, connected with the processes of his own constructions: "a billowy sunny white cloud sailing alone in the clear blue cerulean What a beautiful *sign* what a blessed (benediction) what a (pure joy) this kind of thing that happens with the boxes" (April 11, 1957).

The wonder of apparently the most trivial things – putting out the wash, having a jaunt with a favorite book to the cafeterias that made up his existence – the very "simplicity of joy," as he calls it, defines his view of his entire existence, and that of his boxes. The light they cast on both existences is as far removed from pride and showy presentation as it is possible to get.

Circumferential reality

The essential is that the box open out and still keep its sense of significant closure. "My business," said Emily Dickinson, "is circumference."[20] So is that of Cornell, as it was of the cosmic Mallarmé. What they took in they would not, and we perhaps shall not, lose. What they inscribed and celebrated may even now realize its potential energy, being central to an inner scene which set its very static figures in mental intertextual and intervisual motion.

After Magritte has transfixed time and reflected on the art of his own time with a train (having perhaps stopped at one of de Chirico's stations, before stopping in a fireplace, as in *Le Rêve d'Icare* (*The Dream of Icarus*), Cornell preserves that train for his invalid brother Robert, making art serve love. Proust lovingly preserves his memories of Holland and of Holland's own Vermeer by his windows and his doors, so framing, in the glass of his own retrieving hours, that past so threatened also with loss; Cornell, for whom Vermeer was "gyroscopic," preserves in his boxes that glassed-in transfiguration of fragments into wholes, preserves with the care of a thrifty Dutchman what he most loves. Watteau celebrates the *commedia dell'arte*'s Pierrot figure, and Cornell preserves that figure, already reflected, mirrored, and walled, unto what we know of as eternity. Dante's Paolo and Francesca, whose reading their love interrupted that memorable day in literary and textual history for our uninterrupted memory of them, repose in the sanctuary of Cornell's own construction to their memory and then doubly in our minds.

What is thus taken out of its historical and literary moment, and brought before us in our own time, remains. Cornell, obsessively working over each of his boxes "to take up the slack in it," captures in tense perfection the plain or subtler reference of his few elements back out to where they came from and further out still to where our memory might once more be able to wander, in his recapture of our own lost time. Distilled, decanted, isolated, and preserved, the elements he so consecrates make part now of our own circumferentially remembered history and of our future rereading.

Homages

Above all things, Cornell celebrates performance. In their dramatic settings and insettings, these boxes perform representations of performing. He constructs most particularly in honor of the dance, and all his various multiple constructions in honor of ballerinas could be subsumed under his title *Homage to the Romantic Ballet*.

In one construct, a swan drifts gracefully by against a background of leaves and blue forest, the box itself inset with feathers and placed in another box, the whole insetting called *Swan Lake for Tamara Toumanova* (1946). *Taglioni's Jewel Casket* (1940; plate 16.1) includes blocks of glass like ice, a replica of a diamond necklace and the tale of Marie Taglioni, who, summoned once to dance upon the snow and under the midnight sky by a masked man, kept the diamond necklace he bestowed then upon her in a jewel casket with artificial ice to remind her of that night; this is a replica of a replica of memory.

The boxing-in of performance comments tellingly on Cornell's notions of collection and memory – nothing is lost within the shadow theater, or within the mind grasping the box as a metonymy for performance itself, in its surest

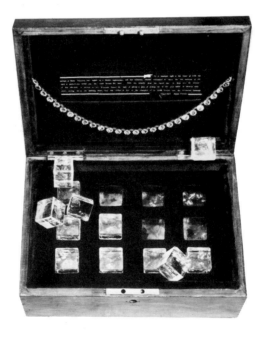

Plate 16.1 Joseph Cornell, *Taglioni's Jewel Casket*, 1940. Wood box containing glass ice cubes, jewelry, etc., $4\frac{3}{4} \times 11\frac{7}{8} \times 8\frac{1}{4}''$. (12 × 30.2 × 21 cm). Collection, The Museum of Modern Art, New York. Gift of James Thrall Soby.

memory preserved. Cornell had a whole collection of souvenirs associated with the romantic ballerina Fanny Cerrito and her ballet *Ondine*, about a mermaid figure plainly suggesting all the ambivalences of symbolism and surrealism, as of Cornell himself. These preservations keep before us the ballet's great names, early to recent, and the names themselves resound all the more within the constructed and celebratory wallings-in – Philoxène Boyer, Lucile Grahn, Zizi Jeanmaire – just as the homages to singers preserve their lost voices: Lucia di Lammermoor's tears sparkling in a box, to celebrate the singer Anna Moffo; Delacroix's memory of Marie and Pauline Malibran; and Cornell's own strange tale of an operatic prima donna, "The Bel Canto Pet," for Julia Grisi. Inside his rebuilt stories with their heroines of the stage or screen, from the nineteenth century right up to his own time, all elegantly boxed in with their memories ordered on the other side of the clutter of life, Cornell sets apart and consecrates a world in perfect miniature closure.

In a hieroglyphic designation reaching toward a meaning far beyond its neat borders, a Cornell construct isolates as a nostalgic keepsake a nineteenth-century figural grouping in a twentieth-century frame, keeping its past safe within it, remembering little landscapes of games and the philosophical toys de Chirico taught us to play with. Part of a series, the suggestive construct links figure to figure, idea to idea, until a subject is, like poetry, "thickened" by all the reflections upon it. Within the box construct, the elements are related as in a poem, static frame and mobile contents in equilibrium, giving off lights as in Mallarmé's "reciprocal fires," those charges that words exchange when their contrasting elements are brought close together.

Within this network all in lyric echo, the ramifications of the constructed theater of memory – however small, however neat, and however reminiscent of dollhouse or hobbyhouse its presentation – display a deep representational power, extending far past the fairy-tale and pin-up make-believe of a peeping Tom's universe to state a universal connection. Cornell was, in his own words, a constant seeker after a " 'link' – the 'reassurance' and 'continuity' of a thread so tenuous, so hard at times to keep hold of (or perhaps to communicate to others is what I mean)."[21] Following Mallarmé's own spiderweb of connections, he was himself gathering up into the animal and human realms all the possible links Igitur was heir to.

"The fabric of adorable improbabilities must," Cornell said, "be made a trifle more subtle the older we grow, and we are still at the stage of waiting for this kind of spider."[22] These toys with which we organize our aesthetic life let our imagination unfold, and through them we experience those "signs" or accidental signals by which the universe seems to penetrate the neat boxing-in and the mounted set-ups, for the observers' own "unfoldment," as he was to call it.

In Cornell's favorite archives or collections, such as that exhibited at the Garden Center in 1944, he arranged his elements in what he termed a "constellation," further described as "a diary journal repository laboratory,

picture gallery, museum, sanctuary, observatory, key ... the core of a labyrinth, a clearing house for dreams and visions. It is childhood regained."[23] All his boxes were meant to "invite the spectator to 'chart' further," elicit further dreams and musings if such he might care to do. Characteristic of this sanctuary process, for the development of the personality and the aesthetic experience, is the emblematization of an art object, such as that illustrated in the following incident.

This story is a combination of the moving and the still, of the remembered and its extension into vision and into what had to remain, after Cornell's death, only projected art. Here I shall quote Cornell at length, as he is reminded of Jan van Eyck's *Adoration of the Lamb* by a painted emblem on the side of a delivery truck and telescopes the double experience into a single vision: "upon contemplation," he says, "the van Eyck shows as a beautifully realized, metamorphosed sublimation of the original commercial enseigne of the experience." The memory of a summer countryside adds to that "with the feeling of the grasses, the field, the flowers and the rarified and spiritual quality of the dream," until finally he sees – and we with him – "The manner in which all unsuspectingly the Floral Still Life comes to life naturally, spontaneously, completely, an 'unfoldment' or 'extension' in which the Flemish master has been obligingly pressed into service for the concrete presentation of a vision."[24] So here art, religion, business, and nature combine into a sublime text for the eyes and mind, portable and sanctified in the memory.

"Emblem is immeasurable," we hear Dickinson say again, and realize that is poetry as Cornell thought of it: "Suddenly the sense of completeness, poetry."[25] Cornell extended or unfolded his emblematic treatments of the universe into the transcendent moments he found sufficient to overcome lost time: "This one day is an eterniday in the world I have come to be enveloped in." The wholeness Christian Science seemed to give him is indisputably the support for this willed extension of vision and experience, this distillation of time and space into one moment separated out, reconstructed to be shared and to be seen as symbolic of what transcends the domestic limits of personal vision.

Cornell's microcosmic art of emblem and of metonymy makes room for the fairy tales of an adult mind at once virgin and learned. He would have us learn to read both transcendence and preservation into the saturated limits of his poetic theater of collective and separate memory, in which there takes place the "final distilling where the subject is almost transcended or briefly caught sight of in a window."[26] His window pane before which he places us for his sights to become our own, like his obsessions, combines in its American glass both *verre* and *vers*, the glass and the poetry through which Duchamp would have us contemplate himself and Mallarmé, and through which we in our turn contemplate them and Cornell.

Still another box

From many of the aviary boxes of Cornell, that "maestro of absence,"[27] the birds have taken flight. Only the perch remains, or some opaque white trace signaling their escape from the window box toward the Milky Way. These are portraits of absence, of course, and other figures have departed their scenes as well. And yet what these presentational settings most clearly bring before our eyes is a sort of presence no other artist has been able to capture, evoking at the same time an overpowering nostalgia.

I would compare Cornell to Mallarmé in this also, comparing his poetic theaters to Mallarmé's own inner staging; but I want especially to make my point here with no exterior pirouettes, rather with an imaginary homage, or a homage of the imagination. I shall look back at Mallarmé as through a Cornell box, seeing what elements it would most naturally – or rather artfully – include, what figures they most obviously share.

Swans, ballerinas, and birds of flight – these and their tokens figure forth in my framed construction, which I shall call, in honor of both poetic constructors, "Constellation of Memory," or "Box for Stéphane." My own Cornell box or jewel casket of memory should be pictured as having nothing tomb-like or cage-like about it, being closer to a souvenir case than to any "Tombeau for Anatole," for Joseph, or for Stéphane. Within it appears the same swan as in Cornell's *Swan Lake* construction, looking backwards over its shoulder, floating serenely still against its branched backdrop, and surrounded by a few detached feathers in a containing box. Here the swan contains, implicitly, as do the others Cornell offers us, a ballerina in her hieroglyphic work ("not a woman, not a dancer," as Mallarmé would have said, and thus pure symbol), with her feathery surround as ambivalent poetic plumage, the pen for writing and designation taking its fully potential flight. A whole panoply of intertextual suggestions is now set in boxing play by plume dance and pen work: ballerinas as stars and their diamonds material and symbolic. The jewels refer back to Baudelaire's *bijoux* poems, and to the other fleshly treasures they set sparkling, still among the ice of lakes and midnight snows, in the oxymoronic setting of souvenirs boxing in and concentrating both glacial surround and feverish passion.

All the signs of *cygne* (swan) as *signe* are set in clear rubrics by Mallarmé and remembered by Cornell, the best mental choreographers ever to take up plume and paintbrush: "Quand s'isole pour le regard un signe de l'éparse beauté générale . . . fleur, onde, bijou . . ." ("When, before our glance, one sign of the scattered general beauty sets itself apart . . . some flower, wave, cloud, jewel . . ."),[28] he would have it presented to our intelligence playing on its own inner scene, "juxtaposing it to our spiritual bareness." Against the midnight-blue backdrop, the pinpricks of the stars leave a message readable only by our own immeasurable emblematic consciousness.

In an implicit homage to Allegra Kent, one of Cornell's dancer heroines, I

see an allegorical text accompanying my box and handed out to spectators. For, explains my imagined text, this is no mere pin-up to peep at, but a sheerly impersonal dancer as a pure sign; not a woman dancing, but dance itself, consecrating the richness of observation we are called upon to demonstrate as "la preuve de nos trésors" ("the proof of our own treasures"). For the reading of this text as it is staged, printed, and danced out, this soul made art and visibly suspended before our intelligence, transcending the exterior steps toward the interior stage where swans, dancers, and signs ultimately correspond, is to be the proof of our accumulated mental richness. However small its model stage of a theater seems – as if a scene and an observing box were combined – this is no dollhouse of a dance, but much more, if only we know or learn how to read it.

"Pour l'allégorie," my text is called – "For Allegra," as "For Allegory," and it is bilingual. It tells a tale about the framed but moving fiction we are observing and how on its exterior face we can in fact see nothing but a simulacrum of a marriage between some swan dancer and some sign-maker: "A déduire le point philosophique auquel est située l'impersonnalité de la danseuse, entre sa féminine apparence et un objet mimé, pour quel hymen: elle le pique d'une sûre pointe, le pose" ("We must deduce the philosophic point of the dancer's impersonality, located between her feminine appearance and some object mimed, and for what marriage: she points at it with a sure toe, placing it exactly").[29] What a marriage, indeed, as she picks out, points quite exactly, and has a go at it. Any dancer, almost, will do – Fanny Cerrito, Loie Fuller, Philoxène Boyer, Lucile Grahn, Zizi Jeanmaire: the dancer does not even have to be a reader of the dance.

As her costume shakes its pleats in an airy "impatience de plumes vers son ideé" ("impatience of feathers towards its idea"),[30] the dancer, unconscious both of her own sign-making and of us as spectators, establishes as an expansion of herself a place totally free of anything but the sign, unfolding and then retracting it into her costume, with only the slightest rustle of crêpe-de-Chine: "le plancher évité par bonds ou dur aux pointes, acquiert une virginité de site pas songé, qu'isole, bâtira, fleurira la figure" ("the boards left by the airy leaps or hard to the points, acquire a virginity of place never yet imagined, which the figure will set off, create, and cause to flower").[31] The figure is, explains the accompanying text, an expansion of a letter which might seem a reduction, through a book into just a sign. The theater boards flower in a total semiotic faith. What boxes that figure in and sets it or her apart encourages her expansion, as it brings forth the latent possibility of a site completely devoid of self-interest, virgin to let bare meaning show through, and so the surest of stages, beyond personal drama and pride.

Figures of closure

I see another sight with that circumferential vision Dickinson helps us develop, one last picture oddly juxtaposed and interwoven with my ballerina and my swan, in the implicated triptych of my own shadow box. Three figures sit now on a park bench at 3 a.m. in Lower Manhattan, or anywhere at all. Rothko and De Kooning are still there, worrying about creativity and about loss; Cornell is there too, anxious still, about wholeness and his fragmentary genius. He has been a textual builder, a visionary, a manager of ellipses. By what is left out of his willed constructions, the included and excluded take on a new light: for within his walls he knows how to point always to another side, being a master of metonymy, a great framer of fictions, apparently static, but in truth saturated with meaning and suggestive of motion as of emotion.

He has tried all the techniques available to him, in all the forms of art: he has written criticism, in which he has been at his most lyric, written stories and films and played with those of others, running their films backwards and upside-down (as with a film of Stan Brakhage), tinting them, making his own scenario for a film half black-and-white and half in color, *Monsieur Phot.*[32] It has all been brilliant, without assuaging his anguish of the fragmentary. No matter what patterns and constellations he finds for it, aided by his whole bevy of starring figures,[33] no matter what explorations he sets his future mind to, and no matter how he frames and boxes and sets apart his stages, that completeness he sought[34] eludes him.

But now a fourth figure sits down on the bench to the side of which the ballerina dances and the swan glides, a figure wrapped in a cape and humming a little tune, a great preceding poet who like Cornell is a maestro of absences and is no less present to our mind. He too was dedicated not just to swans and ballerinas, not even just to signs and to all the "tokens and traces" of chance. Toward the artist to whom I am paying homage now, this poet turns in a prospective and prefatory interest.

If that is all we see, it is not all we know for Cornell and Mallarmé will always be found in and will always share, whether on a park bench or in some street corner of the brain, the same high place of the mind. This shared mental palace, containing all the figures implicit and explicit in their haunting double dance of signs, ambivalent in a virgin site, instantiated across the flowering boards, is a palace forever committed to our memory· I would like to call it poetry.

17

RE-PRESENTATION as RECALL, or the VECTORS of READING: TINTORETTO, STEVENS, and ARAKAWA / GINS

Jamais une pensée ne se présente à moi détachée.

(A thought never presents itself to me in isolation.)
Mallarmé, applied to Arakawa by Gins[1]

Initial mechanisms, for meaning

In all the editions of *The Mechanism of Meaning* and the other books by Arakawa and Madeline H. Gins,[2] ambiguity abounds: usually the editions are in two languages, and are composed of texts at once pictorial and verbal, with visual exercises, touching on such areas as ambiguity itself, energy, feeling, and memory, and on such techniques as reversing, dividing, localizing, transferring, and neutralizing.[3] My list is not all-inclusive, and it reads, already, as neutralized, as a consciously and necessarily partial mapping.

Yet an attempt at "thorough thinking" lies behind Arakawa's endeavor, partly humorous, partly in dead and, as he says, desperate earnest. This too complicates the issue, for the reader has already been thought and rethought by the verbo-visual text. These are not the ordinary blanks in meaning left on purpose, as Wolfgang Iser and others would have us perceive them, but more fundamental ones: the readiness of our own act of reading mapped out by these pages is already put in question or on trial by the time the reading zeros in to frame its focus. My effort to think out the reframing of three of the pictures enframed in this volume is parallel to and as partial as one of the initial exercises: given a great mass of Xs and of circles, one is to ignore them

An earlier version of this essay was published as "Representation as Recall: Arakawa, Stevens, and Tintoretto" in *Enclitic*, vol. VII, no. 1 (1983).

all and think only of the one tiny black dot included somewhere among them. Thus the mind is trained for the finding of specific objects, and the reader's choice of, say, just three objects is excused, and even, perhaps, predicted.

Models for the mind

Within the edges of this volume are inscribed, among the rest, three pictures I want to repicture: Tintoretto's *Susanna and the Elders* (exercising our "neutralization of subjectivity"), Mantegna's *Deploration of Christ* (half of it, illustrating the "splitting of meaning"), and Vermeer's *The Love Letter* (exemplifying the "texture of meaning"). Each retrains the view, repictured and realigned in reverse order, the way I read them.

1 The Vermeer, in which we are to seek at least three different "textures" and their dividing lines, sets back the woman reading and her attendant into a doorway (note the later "portal") which has its own scene of reading (a manuscript to the right, curtains overhead with figures) and is led up to by a series of black and white tiles. As they gesture back to her reading, a ghostly finger made by the outline of a pair of slippers, a domestic interruption – seems to point from the lower tile, white-gloved but cropped by the cleaning instruments, as if the broom so pointed to were intended to sweep clear the visual text or the seeing mind. These two interruptions play against the closing off and the enframing of the reading scene by the doors and by the curtains. (We might add responding tiles to those, from other scenes or from some chess game, whose board we have been instructed to see as yet further tiles: for instance, Paris Bordone's *Chess Game*.[4]) From this scene, I take as my principal lesson that of sweeping clear the mind, or freeing the frame.

2 In the Mantegna halved, the mourners of the dead Christ are removed, so that an apparent diminution seems to take place. And yet the half of it that we see manages to magnify both halves, the seen and the unseen, if we relate it to those two halves of the glove pictured on its right: they are to be sewn together, as the double set of twins pictured on the same page is already four. Less makes more. I think here of the reader's desire to sew together, with the needle lent by the lady sewing, her visage averted from our eyes, the legs of the pictured Lazarus (whose torso is out of frame from the picture) and the bare torsos of the two ladies in their hot water in the celebrated *Double Portrait* of the School of Fontainebleau.[5] The lesson might apply further: how to join any of this with any of that, our perceptions with our desires, or our own representations with those exposed in front of our viewing eyes? Does a partial presentation make more effect? For we may read the winding sheet, our guiding link of linen in the Mantegna, backward on to the bathing linens

of the ladies, back on to their curtains, for a re-presentational effect which at once links the scene of death to that of life. What curtain shuts them off from each other? The sheet will lead us back to Susanna bathing, with her clothes about her as a towel – unless the underlying desire of that scene should force a reading of the clothes as bedclothes, themselves leading back and on to some winding sheet, wrapped about the representation of Christ laid out upon the page.

3 In the Tintoretto, Susanna, bounded by her linen and eyed by her elders, neutralizes herself, according to Arakawa, by her mirroring of herself, as by her immersion, by the cloth between arms and leg as by the angles of her body and her body spread out "on different textures," by her diffusion of aspects, as she disperses her property and divides her hair. She *gives the key* to the elders, themselves "neutralized" in their own subjectivity, by not seeing her, by their touching trees and clothing, and by their own angles. Our own subjectivity as readers is lessened or suppressed in this seeing of the picture repictured, but it does not in any way rule out our obsession with the act of framing and re-presentation as such.

Are we entitled to read back now into this picture enframed only by the Arakawa text (for its own frame is removed to be set into the page), *insertions* of our own, based first on his, and then upon what our mind supplies us? The divisions practiced in the Mantegna, whose splitting itself echoes the splitting of a Leonardo within these same pages, helps to divide Susanna from the spying eyes, to sever her leg from her torso – as, in the Fontainebleau *Double Portrait*, the Lazarus legs are split from the bathing ladies – to emphasize the hedge, a division, and the mirror a further division of self from image. Into all of that we will *read back*.

Reading in and on

Into the Tintoretto I shall now read or inset two texts, a poem already *keyed* to the subject, and a scene from a novel extraneous to it, except in the representing space of the mind in which I am rereading. Arakawa's first tenet stated in the space of Susanna's rendering – that is, within Susanna's space – is this: "For instance – scratch an object (to neutralize what?)" Taking this up, we shall scratch the surface of Wallace Stevens's poem "Peter Quince at the Clavier"[6] and in so doing neutralize Arakawa's own text, setting it and its enframed picture at some distance from itself, divided and then refound.

The *keys* to the whole thing strike first:

> Just as my fingers on these keys
> Make music, so the selfsame sounds
> On my spirit make a music, too.

As in Goffman's games,[7] the space within the frame of the poem is to be keyed in, and the harmonics of the situation are carefully matched also to the spirit. By the same sounds, the reader is swept into the poem's own desiring space, localized (as in Arakawa's "localization of meaning"): "Here in this room, desiring you."

The desire is then equated with a waking tension, that ambiguous and dual-sounding *strain* (as in Arakawa's "ambiguity of meaning"), set up in a *play* of instruments, erotic in their suggestion, and tense in opposition to elderly bodies. Their watch is anguished and envying, red-eyed against the green of youth and evening, so that the melodious pitch is undermined by the baseness sounded in their *basses*, whose throb and rhythm pulse in longing, so that their "Hosanna" makes an ironic echo to the picture of "Susanna," and a prediction of the final constancy of the poetic and visual "praise." The pulse is set up between the two poles:

> It is like the strain
> Waked in the elders by Susanna.
>
> Of a green evening, clear and warm,
> She bathed in her still garden, while
> The red-eyed elders watching, felt
>
> The basses of their being throb
> In witching chords, and their thin blood
> Pulse pizzicati of Hosanna.

Strain and throb introduce the central section of the poem, itself bounded by the other sections as her still garden, in all its senses, is framed by the walls of trees around – if we remember the Tintoretto hedge and read it in. This is the lay of Susanna, as the melody grows grave with the increasing stress of the verbs, searching and finding and sighing, standing and feeling and quavering, still in the melodic vocabulary here heavy with suggestiveness:

> In the green water, clear and warm,
> Susanna lay.
> She searched
> The touch of springs,
> And found
> Concealed imaginings.
> She sighed
> For so much melody.
> . . .
> She walked upon the grass,
> Still quavering.
> The winds were like her maids,
> On timid feet,
> Fetching her woven scarves,
> Yet wavering.

> A breath upon her hand
> Muted the night.
> She turned –
> A cymbal crashed,
> And roaring horns.

Now the springs, once touched, gush forth, and the formerly concealed turns to open tune, the dew wakening "devotions" and the weaving by the wind of a further tale.

As the quavering text, woven of windy sounds, expends itself, "in the cool / of spent emotions," the breath is mute. A moment of search is ended by a time of silence, corresponding to the privacy and stillness of the garden. But, after the muted instruments have made their momentary peace, the poem *turns* at the crash of the symbol as it is reread. Horns rear like wild animals, the wordplay increasing the suggestiveness, and roar over the text; danger menaces. The noisy corridor leading from the previous cool of the text awash to the "lamp's uplifted flame" upon Susanna confronts the baroque contraries of ice and fire (as in Arakawa's second tenet for the Tintoretto text: "For as long as possible, keep one finger frozen one extremely hot"). This juxtaposition was intended, as we remember, to neutralize the text, but here it serves also to reveal what was concealed, the ardor of the flame after coolness, noise after silence, symbol after picture, until the majestic final section enframing the poem in its ending, as a portal leading out, with delicate and nervous patterning:

> Beauty is momentary in the mind –
> The fitful tracing of a portal. . . .

The final section of the frame is anchored firmly and is heavy with repetitions, like a chorus of tragic voices dying down the page, echo repeating echo:

> The body dies . . .
> So evenings die . . .
> So gardens die . . .
> So maidens die . . .

Now the green and going evening is no longer played against the subjective red of the watching eyes, themselves neutralized, but played against the white of a flat page, where the choral line surrounds the lonely figure:

> Susanna's music touched the bawdy strings
> Of those white elders; but, escaping,
> Left only Death's ironic scraping.
> Now, in its immortality, it plays
> On the clear viol of her memory,
> And makes a constant sacrament of praise.

After the primary statement of the theme, quietly sounded – "She searched / The touch of springs": here now the transferred touch of a set of bawdy strings, with one syllable changed in the transfer – no melody is forthcoming but only the deadly *scraping* of strings. It is to this that the melodious sadness of Verlaine's symbolist violins had led. The harsh sound directs the reading line of this poem, to the horrendous and yet celebratory *viol* playing in the passage, as an instrument doing its violation even of memory. Violence is done to the still garden, as to the maiden even if by longing only, in the *base* viols still playing in the garden, with a rasp and a rape no longer concealed.

As play changes to praise in this highly wrought text, the painting itself is textured by its resetting. But what exactly is neutralized here? Is the private angle taken and twisted in this or any reading equivalent to the subjective eyeing of the text and of the figure, so that the reader's watching of the scene is equivalent to a second violation, *keyed up* to its own intricately woven texture? Do the strings and brushes of the triple composition, visual, verbal, and audible, enjoy their own veils, scarves, and scrapes with a practiced touch? Is the final "praise" to be equated with the celebration of a maiden's choral in its dying chords or with the production of the composition of the picture to be read and sung?

Seeing more

A further addition can be made in the developing bath of the picture caught in the net of reading, emphasizing rather than neutralizing its subjectivity. In Susanna's waters yet another maidenly song and scene may be seen to rise, clouded over by a steamy and overworked style, all the more fully reflective upon reflection. The shower scene in Henry Green's *Party-Going*[8] adds the Narcissus theme to the bathing motif: Annabel in the shower contemplating herself unclothed in the mirror reflects Susanna by the pool contemplating herself in the mirror, and the two Fontainebleau ladies in their bath exposing their naked torsos. They might all seem, were it not for the mannerist elements, to be about to suffer the "dissolution of the personality" to which Arakawa gestures. But, on second glance, the "neuter" in "neutralization," that no man's man floating between two genres, is appealed to. The image of Annabel in her self-admiration calls finally upon itself in its own disappearance:

> The walls were made of looking-glass, and were clouded over with steam; from them her body was reflected in a faint pink mass. She leaned over and traced her name Annabel in that steam and that pink mass loomed up to meet her in the flesh and looked through right at her through the letters of her name. She bent down to look at her eyes in the A her name began with, and as she gazed at them steam or her breath dulled her reflection and the blue eyes went out or faded.

So the image disappears and self-love dissolves in the dispersion of name and property, like the spread of Susanna's body at the center of all the texts and questions in the Arakawa rendering.[9]

For the dividing wall between our gaze and the exposed figure is only the glass wall of a shower, seen as a division just as Tintoretto's green wall of a hedge is eventually to be read. And in that wall of looking-glass, as we apply the mirror to the wall, the looking-glass becomes a spy-glass for the peering eyes. To the image, the reader bids farewell along with its owner, in a repetitive passage equivalent to the repeated "So . . . die" of the Stevens text:

> She rubbed with the palm of her hand, and now she could see all her face. She always thought it more beautiful than anything she had even seen, and when she looked at herself it was as though the two of them would never meet again, it was to bid farewell; and at the last she always smiled, and she did so this time as it was clouding over, tenderly smiled as you might say goodbye, my darling darling.

The light goes out in the text upon the farewell scene, glimpsed through this glass but darkly, from its clouding over, and from its mannered smile.

Sign and sequence

In Arakawa's more recent work, notions of sequence and intensity force a more thoughtful coherence on the part of the spectator/reader. These are, often, indications of how to read, quite as if reader-reception theory had encountered at once a genial oriental mind and a dangerously irreverent conceptual wit, leavening the Germanic into a heady froth.

How shall we chart thinking? Arakawa's creations are, as they have always been, paintings, or rather diagrams, of thought processes, the *production of the text* as cited and slanted, here taken through towns and charts and labyrinths. Superimposed levels of involvement, with visual lay-overs, paste-overs, see-throughs and see-overs, sufficiently indicate the will to complexity, so that, on the outside plastic sheet, a coffee cup and pot repose on what might be the sill of the work, while in the inner sheets the sequence is indicated by arrows we may think of as vectors or, in Arakawa's terms, as "cleaving agents" that track an openness through the energized form of thought these paintings and constructions represent. We read, in *The Forming of Nameless*, a sort of left-sided prose poem:

> Everything is cleaving.
> Energymatter cleaves itself,
> Cleaves to and from itself.
> In this way, it makes of
> and from itself dimensions

and various tissues of
densities all wrapped
in blank or in blank power.

This text is dated 1983–4, and the interior arrows carve out their path with a remarkable effect of vectoring and shaping, increasing at once our intensity and our common attentiveness. Certain densities are sensed in groupings, and these relate to the power of "blank," the positive side of those gaps left – as in reader-reception theory – for us to fill in.[10] The references to Mallarmé's white page and to Octavio Paz's *blanco* – the color white as *target* for the mind – are of course deliberate, as are, specifically, such diagrammatic marks as a small black hole with a white halo around it – references to the black holes in the universe, around which physicists can wax so lyrical.

Our involvement with the texts and paintings of "blank" depends on what we can fill in, and the intensity sensed in the forms and the fields of play or of thought, whether visually or verbally inspired or both, dynamizes our entire attention. The quotidian, the poetic, and the dynamic all combine in Arakawa's homage to Mallarmé's great sonnet "Le vierge, le vivace et le bel aujourd'hui" rendered by him as "The Vivid, the Virgin, and the Lively Today." To take, and stretch, a point made by Arthur Danto in his essay on *The Mechanism of Meaning*,[11] the title is for Arakawa a self-instantiating entity, in that today's perception is indeed rendered livelier, more vivid, and fresher by this working-out itself.

"Blank," as Arakawa and Gins picture it or as I see it pictured by them, seems to be both time and space and their blind working-out as the reader's intentions toward the subject. "Blank arises out of time–space with each individual. Some of this blank is in turn used by the individual as a means of representing time–space. In this way blank and space come to serve as stations or goals for one another," as in the very large canvas called *Critical Mass* of 1984.[12] Gins had photographed her thumb upon the pages of her prose.[13] The thumbprint refers to process and to a sort of signing in defiance of the word, a signing by a sign, with the opposite of the butterfly lightness of one of Whistler's signs, the weight instead of a laying-on of hands.

The spelling-out of the sign makes the point, as blank itself makes its own point, as on the painting *Point Blank*, "its knotting with itself," to engender, as the texts would have it, attentiveness on the part of the reader, and, on the part of the thought processes they concern, the thinking equivalent of space and time. At its most dense, the passionate reading of this concept-become-point reaches a sort of exaltation of nothingness that is, precisely, nothing if it is not convincing, and very much nothing if it is. It is perhaps a matter of *Forming or Becoming Blank* (see plate 17.1).

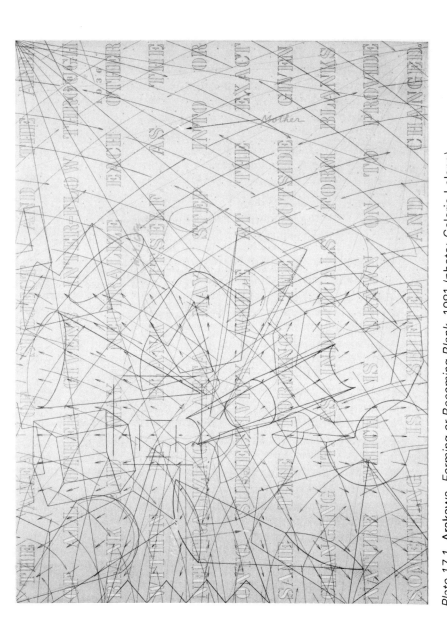

Plate 17.1 **Arakawa**, *Forming or Becoming Blank*, 1981 (photo: Galerie Lelong).

Tentatives

Madeline Gins says of Arakawa's work that it is best called a painting of "tentatives." This revealing term sends us straight back to the notion of essays and the trying-out of the self, as in Montaigne's *Essays*. Arakawa invites us, or wants to force us, to try out our thought. Gins would, she says, call it a "matrix of consciousness . . . how he has proceeded to define a world in which they (such abstract terms) are no longer of much use."[14] This *thinking field* in which his works move seems to be the ideal positive/negative representative of the field of all of our thought, eluding, in an almost deconstructive intentionality, our too-binary systems. His mental *move*, his project always vibrant with possibility, at once diagrams part of our imagination, as he says, and helps it realign itself to fit the charts and vectoring indications he supplies to the reader ready to accept or oppose the imperatives so strongly inserted into his earlier work. "You cannot subtract the imperatives from the paint," comments Danto, "though in fact there is nothing that requires imperatives to be painted."[15]

It is, of course, possible that the dimensionalizing consciousness he lends or forces upon us can be of inestimable value in reading contemporary criticism. A line, he says, is a crack – a crack of lightning, of thunder, like a fracture rejoined. Although the idea of the crack preceded the idea of cleavings in his work, it prefigures the cleaving agents. We want to provide, says Arakawa, the new givens for the reader to make himself over as his author. "I want to construct for subject and subject matter the presence they have been denied for centuries."[16] This intensified presence is enhanced by the awareness of texture ("texture is a relation and makes relations"[17]), through the rethinkings of such notions as "linear burps" and by the "layered approximations" which he takes as the results of receivability, of certain impressions of internal direction.[18]

Whether the directions be given or taken externally or internally, the ways in which Arakawa encourages reading are productive of a new attention to process we might well want to retain and to intensify.[19] Invaluable for reading Stevens and Tintoretto before and with him, Arakawa's "few words" and painted thinkings are no less invaluable for reading our contemporaries, such as Creeley, who has written upon Arakawa, and the other poets who give our thought and its field of play enough room in which we can play out our vectorial desires.[20]

To Not to Die, yet

Yet: much contemporary work, Arakawa's not excluded, has withdrawal as its major mode. Our attention is seized first by the very bizarre prolongation, wonderfully agrammatical, of the title *To Not to Die* – any way we read it, there is certainly a "to" too much. To not to die, in 1987, when this volume

was published, or, if possible, later either. Much of Arakawa and Gins' work, as I read it, is about possibility rather than impossibility. It is just that we may not feel up to that kind of possibility prolonged.

But the prolongation is a sort of fiction, arguably a "fiction of place,"[21] through which experience is observed; that term longed for and repeated, that "blank" toward which the combined trinity of (bracketed) desire – perception – will pushes to find its own sort of space, "in the land of configurated energies."[22]

Fictions are made by acts of perception, arising from the most minimal source: "perceiving from little or nothing."[23] From the minimal, maximal energy – that of "cleaving" – somehow is produced, sensed even in the most partial definitions of the major *moves* of the mind. For example, the arrows in some of the larger works are marked as vectorial and as *cleaving* – the term itself again doubled in possibility, as the nominal cleavage or division of a breast, and as the energy of the verb that cleaves through something. Redoubled, in fact, for the previous cleavage (see displayed quotation on p. 222) was already powerful with the energy of "blank," and with the density of Arakawan thought:

> To cleave:
> Random, partial shrinking and increasing
> close and leave
> cuts off
> around impressionable stretching
> to not to die
> open constricting
> through and/but across configurational coverings, on all and any scale.[24]

"On all and any scale": that in itself is energizing, all-inclusive, cleavage only in the positive sense between the all and the any. It has all the privileges of a totalizing project, and its own specificity along with openness.

Here, as elsewhere, proliferating ambiguities have the force of increase; often a truism becomes more than true, without any of us really pushing it into any kind of ditch. A return to peaceful language, from which, however, the sad abyss beckons: "Even when the entire body is perception, it still has to it another side, and that side is blank."[25]

Now, this project, of perceiving and forming and rendering dense the whole concept/thing called (in total condensation) "spacetime", is a positive one. It is marked by the will to build, the intention to agree, the density of self-perception in the smallest possible (brightest) point: that of the spark, even as the vastness is stretched beyond any possible appellation: "out of room":

> Forming spacetime:
> Of the same thickness as agreeing . . .
>
> *To build this.[26]

The world, seen by Arakawa and Gins, is very large, but no larger than the mind, always itself "out of room" and always illuminated from within.

To build this.

More meaning

In the new edition (1988) of *The Mechanism of Meaning* the whole idea of "room" is re-examined, with furniture for thinking, walls of brick and yet like mesh to move through, active invitations to imagining. Chain mail ("mail": from the Latin *macula* or "spot"), is, like the *macula lutea*, say the authors, at the center of the vision. All this construction is that, exactly that – at the center of our vision, for the play of mind. Each "I" is itself a mechanism of meaning, the way of taking in and taking into account the energy matter set up so vividly in these zanily energetic pages.

But – how do we get in? They point out that the passage is outside, and that only one passage actually "admits of entry." It all depends on "what the access is for." Accumulation turns into action, access into ways of imagining, and art into projection. A line reads, and on this the meaning will be left, not without regret: "Unable to project enough . . ."; and, below it, "The collapse could go much further."

The body of meaning

The material support of Arakawa's art is its "Determining Body" and does as it undoes its figuration, an image "to be walked on"; so indeterminacy meets the brilliantly already determined, deferred, and displaced perception as a detour which is – by some miraculous misunderstanding – superbly enabling to the viewer as actor. We tend, and are encouraged to tend that way, to see this kind of process art as not just image and not just use: architectural conversation also, as in the discussion of Tschumi and Derrida in their own conversation with Mallarmé, Valéry, and some others, including us all, still to come.

For we are not to look at this just as some image of the recycling of perception, but to step on it: it is overminding, underminding, and underfoot. (I, writes this observer, *did* step on it, and state it here parenthetically, like some quiet but also blatant underfooting, a sort of participatory understanding upside down.[27])

18

ARCHITECTURE and CONVERSATION: DERRIDA, BERNARD TSCHUMI, and PETER EISENMAN

Tout est toujours à remailler du monde.

(Everything in the world still has to be stitched together.)
Yves Bonnefoy

Delight – observe.
John Ruskin[1]

Initial impulse

The textual impulse has to do not just with weaving or stitching together (*le tissu*), for what is woven has already covered a great deal of space in literary criticism. It has also to do, and mightily, with building, making other spaces for the mind to dwell in. In particular, *poeisis*, or the making of things, makes and keeps relations of all kinds, so that poetry is both building and holding together. So poetry converses – on some deep level – with architecture by the relational questions both involve, to which they extend some structural replies, more open than answers. These replies then reach towards a living space, at least in metaphor.

Metaphors, as they refer to and interlock with one another, facilitate our mental building in its interreferential reality – it wills itself into stability. "Poetically," said Hölderlin, all too famously, "man dwells on the earth." We have only to look at the titles and declarations of, for example, recent French poetry: Edmond Jabès declares, "Je bâtis ma demeure" ("I build my dwelling"), whereas René Char builds his "Contre une maison sèche" ("Against a Dry House"), or, more sadly and no less deeply, confesses, "J'habite une douleur" ("I inhabit a suffering"). "I would wish," says André Breton, founder

of surrealism, "for my house, for everything I write, to have the form of crystal." Whatever material the contemporary French poet longs for, that which he writes seems to take on at once a weight of desire and a weight of death: a written stone, as Yves Bonnefoy says of his poems. The bridge poetry builds can only use the matter it has – that is, the very knowledge it keeps of the end of our things, and the density of interlocking metaphors as they *interfere positively with each other*.

The stasis of our willed poetic constructions – intentionally clear and clouded at once is this will – tends toward the challengeable construction, precisely in that these structures know their own finality. Not that stone crumbles as quickly as lives, but that its very inscription marks its true place, deep as the tomb. "Not the peacock, but the stone." This line of Yves Bonnefoy resounds in antiphony with Wallace Stevens's "cry of the peacock." The baroque splendor of Juno's bird – its color-flashing feathers proudly spread, escort to that raucous voice with its fearful shriek – salutes what is passing in its pride, whereas we must celebrate what remains, in its terrible monolith given to dwell in, mentally and then finally.

For all these sad and stony reasons, the modern poem sings the metaphor of passage, at least doubly. It celebrates the passage as that structure which leads from one place to the next, like a corridor, and celebrates too the going-on itself. As in a theater, a French *passage* lies behind the scenes and leads from one loge to another, one dressing room to the next: so it signifies at once stage or costume, and concealment backstage. As in a text, a passage connects the parts, in textual relation. As in a life, a passage takes the person on further, leaving the known for the unknown, the once-loved for the uncertain emotion to come. For the surrealists, the Passage de l'Opéra presented all the attraction of the covered and the open, glassed-in and watery: simultaneously brothel (a *lieu de passe*), shopping place, theater, and place for meditation: its particular joy was that it was soon to be torn down, so that it could be only a passing mystery, a permanent poetic transit place, articulation between night and day, dream and what we may think of as reality.

Louis Aragon describes it, in *Anicet, ou Le panorama* (*Anicet, or The Panorama*), as a covered gallery creative of dizziness, as the magic box of all imagination, a "transfigurer of worlds". "The false daylight born of the conflict of the lamps in the windows and the murky brightness of the ceiling allows every error and all interpretations."[2] Six years later, in *Le Paysan de Paris* (*The Paris Peasant*), he describes the real, if temporary, Passage de l'Opéra: "Let's take a look at it. . . . Opening upon the long corridor you might mistake for the corridors of a theatre there are the loges, I mean the rooms, all on the same side towards the passage. A double system of stairs lets you emerge at different places in the passage. Everything is arranged to make escape possible."[3] That is to say, a contemporary way of thinking, a perfect text.

In French romanticism and symbolism, and in their inheritor, surrealism,

the theme of the passer-by – *la passante* – has no equal in its sentimental charge or in its symbolic gravity. Charles Baudelaire's poem to "La Passante" is bound to endure, ironically, even as it salutes what is only transient for our perception: "O toi que j'aurais aimée, ô toi qui le savais!" roughly rendered as "Oh you whom I would have loved, oh, that you knew full well." The glory of the passing, of course, is just that, that it is passing, and merits our homage, since it cannot – as we cannot – possibly stay. We take well, if tragically, to reading and writing out our very undwellingness, as if we were to domesticate our tragedy, having our sadness and using it too.

Our longing for liminality, for that stage between, where everything remains uncertain, our very passion for the topics revolving around borders, our very dwelling on the threshold of the notion of threshold, are these not indicative at once of a desire for going where we would stay, and staying in just that going stage? Our poetry is perhaps best defined, even now, by its passion for the border, the threshold, and the in-between; initiatory rites of passage, threshold states, and liminal perceptions are so many *portes-fenêtres* or door–windows opening out on another space, unknown and therefore all the more greatly valued. Our longing for liminality, for that stage between, where everything remains uncertain, is it not exactly what Bonnefoy describes in his last book, saying of the word "Farewell," as he takes leave of it forever, "No, it is not the word I know how to say" ("Adieu? Non, ce n'est pas le mot que je sais dire")?[4] Our poetry is, like German romantic poetry, torn by its longing for twilight, but equally by the criticism of our modern poetics, knowing that twilight longing to be itself another lure: the lure of the threshold, as Bonnefoy has said, in the title to his epic poem *Dans le leurre du seuil* (*In the Threshold's Lure*). We are eager to be seduced by the notion of presence (what would lie beyond the threshold), to be made optimistic about a future by the suspicion that behind this country of the here and the now lies another country, what Bonnefoy calls the "back country," that *arrière-pays* of the mind, as of the land. And the lying-beyond already implies the furthering of projects and of steps – that too is what we long for, against mortality, against what we know as having an ending, a terminus, a death. What we know of as our own ending.

The threshold, again

As for the structure of the threshold itself, after it has, as a metaphor, penetrated our consciousness, it cannot fail to make an efficacious and irreparable attack on the simpler notions of inside and out. In relation to the text itself, Jacques Derrida, in his reading of Kant, has shifted attention from the porch of the text to the "parergon," or the frame around it. His reading of the paratext has brought to light all that surrounds the object of our gaze as

readers and that we might have considered of less importance than the text "proper," as we say. Proper. Proper, neat, enclosed, the text now under siege.[5]

Gerard Genette's volume on the paratext, justly called *Seuils*, or *Thresholds*, studies at some length beginnings, attributions, prefaces, and notes as they surround the text itself. These are what he calls the "peritext," and, as we dwell on them, they serve the purpose of keeping us as readers about reading on the threshold of the work. They are presentational devices, and presentation can indeed divert us from substance, as we so frequently desire.[6]

What greatly appeals in the notion of the threshold is precisely the notion of not having to enter the building; on the other hand, it is not yet deciding *not* to enter the building. Thresholds are about lingering, as porches are, or used to be, for sitting. Neither is about deciding. That they are also about presenting is clear; they are a presentational apparatus, to be taken on the same metatextual level as the frame. They are both within and without, participating in both and belonging ultimately to neither.

And when the stable structures of the universe of the text – such, precisely, as thresholds and frame – begin to feel too static, it becomes increasingly urgent to give the dynamizing of the structure its space of play. At this point, the notion of exchange enters, wherein the crucial in-betweenness of the border puts it in the primary position of privilege for the dynamics of shift. Thus, the border is the place for revaluing, where the whole currency takes on a new format.

Entry into dialogue

> La vérité est sans partage.
> Elle est, à l'origine, déjà partagée.
> Reste à légitimer le partage.
>
> (Truth is without sharing.
> It is, at its origin, already shared.
> Sharing is still to be ruled on.)[7]

We have known, since Mallarmé (as others knew before him, before us) that our writing is always in exile; that, no matter what exchanges we transact, what permutations we urge, what metamorphoses and transfigurations we bring about, we shall not, even in spite of Heidegger's insistence and Hölderlin's hope, feel at ease in any dwelling, whether real or verbally inscribed. The stones will endure, but endure without persuading us of our endurance. More probably, our dialogues will remain our truest place. I borrow the notion of "true place" from Yves Bonnefoy, hoping to convey its tinge of sadness and its equal tendency toward hope – a double postulation like Baudelaire's bipolar longing, half desperation and half exaltation. The

expression looks toward the tradition of dwelling and the anticipation of some discovery or refinding.

Some notion of community remains, then, in our dialogues; some notion of "conversation," in the philosophical sense Richard Rorty gives it,[8] informs whatever we hope for. This is not to be a solipsistic wish, because sharing is part of this mental dwelling, when the individual habit is defamiliarized and set at risk. René Char's *tête habitable* or inhabitable head[9] seems to make of the mind a dwelling of lasting possibility, and of sharable substance, beyond the lonely singular of modular dwellings. Behind the notion of community, and the conversation we can dwell in, the thickness of shared ideas suggests itself – a suggestion not to be received without irony: here I would willingly take up also Rorty's distinction between the ironic and the metaphysical attitude, the former impregnated with doubt as to its own vocabulary, its own too-individual point of view.[10]

Claims, even of ironic appellation, have their moments of possibility and empowerment, and it may well be easier to empower others than to feel oneself empowered – thus the point of conversations, beyond the habitual personal constructions through which autobiographies have fictionalized and justified a past. When ideas are shared, conversations build in common, even in the utterest state of some irony equally shared. What we can best give, we can best share. Lewis Hyde's extraordinary study of the economy, anthropology, and sociology of exchange, *The Gift*,[11] lays down a kind of path giving can take: simply to state our ideas aloud is to give them, to share them and our conversational hope along with them, even if ironically.

So, then, we build or speak, in response. Jacques Derrida's "Point de folie: maintenant l'architecture"[12] offers a chance to respond – a chance of continuing conversation, for a sharing of that space which he (and we with him) claim that discourse is built on, that architecture happens through. Am I referring, in my part of the conversation, "correctly"? But, and as a prelude to conversation, what is an *appropriate* response?[13] What might resemble a reply made *rightly*, uniquely, fittingly, and in proper proportion? At this point I want to sketch out two factors that I see fitting into this conversation, about metaphoric interference as building matter, past reference and inference.

First, Alberti's notion of proportion, in his *De re aedificatoria* (*On Building Matters*), seems to have gone past the single term *proportio* to the associated notions of *aptus*, *commodius*, *decens*, *dignus*, *integer*, *proprius* – in short, to have contained also the notions of what was appropriate, measured, and correct, fitting, as in the appropriate space (*aptis locis*), so that an appropriate form would yield an identity "transcending the sum of present purpose and desire."[14] So, an "appropriate" answer in this sense would fit in its proper place, and transcend the purpose of any present conversation toward, as at least I want to consider it here, the idea of community dwelling.

Second, Ruskin's idea of moral passion is relevant here, much as it may smack of another era.[15] Ruskin would have had our human constructions

noble; it does not seem to me that our multiple and multiplying doubts about any one right reading or comportment should rule out that quality from the discourse we dwell in, however ironic our sense of dwelling. Description and redescription entail some belief in words as building: Ruskin's demand that our building should be difficult, but its *working easy*, and (as he said in an address to the Architectural Association in London in 1857) that we should love our own way of doing our art, whatever it is, in no way contradicts the possibility of whatever community we build, thinking together, in the same place:

> If jest is in you, let the jest be jested: if mathematical ingenuity is yours, let your problem be put, and your solution worked out, as quaintly as you choose; above all, see that your work is easily and happily done, else it will never make anybody happy; but while you thus give the rein to all your impulses, see that those impulses be headed and centred by one noble impulse; and let that be love . . . for the art you practice.[16]

I want, then, to respond to Jacques Derrida, to continue his building on Bernard Tschumi's constructions at La Villette, as if, indeed, we were all to dwell in the same inhabitable head. "We appear to ourselves only through an experience of ourselves which is already marked by architecture. What happens through architecture both constructs and instructs this us."[17] Just as the concept of architecture has been constructed, through its own program of transformations and transfers, those operations that Derrida describes show exactly why the experience of meaning must be that of dwelling;[18] the interpretation of that experience implies a marking, a violence, and a passage:

> An architectural writing interprets (in the Nietzschean sense of active, productive, violent, transforming interpretation) events which are *marked* by photography or cinematography. Marked: provoked, determined *or* transcribed, captured, in any case always mobilized in a scenography of passage (transference, translation, transgression from one place to another, from a place of writing to another, graft, hybridization). Neither architecture nor anarchitecture: transarchitecture.[19]

Bernard Tschumi's constructions called "La Folie" at La Villette are thinking devices also: they make us think about what takes place when the event goes through a space, a church for some ritual, a mark laid upon some stone: here I think again of Bonnefoy's *pierres écrites*, those poems laid upon stone. And I think in reply to Derrida, to whom this text is, in its own way and mine, responding, and who is thinking in reply to Tschumi's *folie*, of the moment "when a date, seal, the trace of the other are finally laid on the body[20] of stone, this time in the movement of its dis-appearance."[21]

Through these rituals, not in the slightest empty, except with the same full emptiness as possessed by those empty cases in the grid of which Derrida's text speaks, we make our own grid of conversation, to dwell in. About the

rituals of poetry, not empty except in fullness, we speak in just the same way – carrying through our spaces, one into the other, making the grids to live with and by. And, even as we speak of one grid, we are remembering others – those of Mary Douglas's celebrated grid and group, in her sociological studies:[22] on those grids too we build our textual discourse with each other, and between their lines. As we hear of *folies*, in the sense of madness, but also in the sense of a building signed, as Tschumi points out, by its builder, we remember that third sense of "foliage," the *feuillée* that a French ear hears rustling within. These too we sense in Bonnefoy, in his constructions of the *feuillée* or the foliage of words and the leaves of those stones written like ruins but like celebrations, too, of dwelling. And we hear, of course, as we heard all along, implicit in Derrida's risk, and his dice, and his chance, or fortune – becoming ours, should we choose it – the strong voice of Mallarmé, creating in his *Igitur* a theater of the mind. Igitur's *folie* was in direct correspondence with his *fiole* or flask of poison, his mental drama dangerously in correspondence with ours. What we do not need to see, in the mental theater, is a material stage. What we do not need to say, in this conversation, is often what makes the conversation. Its building blocks are never of concrete; if they are of stone, then it must be a stone the leaf can penetrate, where all the foliage entailed within it may rustle. A true substance for a true, if poetic, dwelling place.

Is this conversation madness? But the preceding and illuminating *folie*, response to the other building of La Folie, was written in just such a leafy space. Stone is just what signifies, and on it can be inscribed the violently interpretive rituals of building and constructing and writing, even as they are in transformation, always de- and reconstructing. Deconstruction is not any one thing, but rather, and I am quoting Derrida again,

> the obligatory route of deconstruction in one of its most intense, affirmative and necessary implementations. Not *deconstruction* itself, since there never was such a thing; rather, what carries its jolt beyond semantic analysis, critique of discourses and ideologies, concepts or texts, in the traditional sense of the term. Deconstructions would be feeble if they were negative, if they did not construct, and above all if they did not first measure themselves against institutions in their solidity, *at the place of their greatest resistance.* . . .[23]

Here I end my quotation, but not my response: a constructive conversation might well end in questions, openly, thus.

Against what institutions, then, should we test our own will to build? In what space could we, should we, construct? That wandering is more part of our project than dwelling we know, even as we find ourselves bitterly regretting that fact, or at least imagining that we do. Walter Pater's "imaginative sense of fact"[24] may well be what best allies our conversational project with our poetic impulse to construction.

In echo, to an "architecture of architecture"

The most fundamental concept of architecture, Derrida reminds us, was *constructed*, and remains an inhabited *constructum*.[25] Deconstruction, measuring up to construction and to institutions in the place of their greatest *resistance*,[26] finds – if I can put it like this, echoing Tschumi's words in "dis-" and "de-" and "trans-" – ways of transit. Reassembling after all the disassembling, in the renewed energy that comes from just those very words (*energeia* as in the original impulse for the ekphrastic model, discussed in chapter 19), the extraordinary *Choral Work* that Peter Eisenman and Derrida are doing profits also from the energy of the *chora*, from Derrida's reading of Plato's text on the *chora* in the *Timaeus*, and transmitted to us now reading.

A quite remarkable convergence takes place, a sort of *Manhattan Transfer* transferred into post-Dos-Passos Tschumian *Manhattan Transcripts*. Its first stage is the notion of a *working follies* or a constructive madness developed, along with a working trace, in the "dis-tracted" or spaced-out reader; the *folie* of the one is matched to that of the other, so that the "chance" – that random luck on which Derrida ends – is made available to us all. For the notion of inter-ruption recurs here, with its rupture and its relation, its attraction and its breaking, relating back to the ideas of interruption and stress discussed in the introduction – many times interrupted – to this book itself. Interruption creates stress, and stress in all its architectural/psychological senses is what Derrida and Eisenman and Tschumi can be seen to be playing with in their La Villette projects: the garden of Eisenman and Derrida (a *hortus* which will never be, conceptually at least, a *hortus conclusus*) and Tschumi's *folies*, reconceived by Anthony Vidler[27] and Derrida.

The thirty follies by Bernard Tschumi are, not insignificantly, bright red. Since he explains them as having been "exploded on the site"[28] (and since, parenthetically, but no less obviously, he is part of the small band of architects called "deconstructivists" – that is, not just deconstructionist by leaning but leaning back to the Russian constructivists), the ambivalent implications of that color and its tradition in art and literature run rampant through the mind reading the constructions now. For in addition to the Mallarmean reference attached for us to the concept of *la folie* and the musical *foglia* and the leaf to be printed or red, madly, there is a Valéry-inspired pomegranate lurking behind that explosion; his burst from the excess energy of their seeds like foreheads bursting with discoveries past their ruby-hued partitions, exploding in liquid red:

> Cette lumineuse rupture
> Fait rêver une âme que j'eus
> De sa secrète architecture.

> (That luminous breaking
> Sets my former soul to dreaming
> Of its secret architecture.)[29]

Sensual, propagating its seed through just that explosion, the mental fruit bursts into physical fullness, metaphor here become building and "useful," if madly so, like the equally seminal concept propagated by Andre Breton, of "mad love."[30]

Across this space will play the moving arrows (that moving eros so crucial a part of all this) which direct their own vectors, in the space I am setting up here, back to Arakawa's directional and ambivalent arrowings in his texts on "blank," and point, in some internal sense, to the most wonderfully complex image, played out, forged, (and worked), like the sieve or sifter that Plato's text first announced as *chora*.[31] Derrida makes the *chora* into a quarry, digs out all its possible meanings, then transfers the image itself to the visual, standing the sieve on its corner, making of it a sort of grid and lyre combined, then spins out the notions of *liar* and *layer* in *lyre*, just as "the lyre accompanies the chorus." Thus the instrument Derrida chooses and stands on its end carries on the resonance and the work from one concept and space to another: spaced out, indeed, and putting the stress where it should be, on the words that relate – like so many arrows – one thing to another. "You have to know how to stop an arrow," remarks Derrida.[32] This one will stop, for the time being, here.

Part IV

SHOWING, TELLING, and RELATING

19

MORAL PASSION and the POETICS of STRESS

I cannot see how in time it will be possible to look at
it without making all kinds of mistakes: not so much about what
means what, or about how it all was done (subtly, Oh quite subtly
enough) but just in thinking that something need be said at all . . .
. . .
But what is time? something paintings take to finish, or to rot, or
to become the ways things look in. Time devours. I know about it.
 John Hollander, "The Altarpiece Finished"[1]

Great art stops us in our tracks. In literary terms, the whole tradition of the beheld moment in which our arrest takes place is so heavy as to inspire at once a certain awe and a no less certain list of common references to stock titbits of ekphrastic description, from Homer and Virgil on to Hawthorne's *Marble Faun*, and everyone's favorite contemporary *mise-en-abîme*, starting with Gide's *Les Faux-monnayeurs* (*The Counterfeiters*), that great shielding device.

The ekphrastic moment, in which visual art is inserted into the art of words, is supposed to stand still and to stand out, to present an especial *stress*, be couched in an especially vigorous style, and to bear witness to both past and future action held in a quintessentially vivid clasp.[2] Such a moment, mimetic in origin,[3] catches action at its crest, preserved in always incipient vigor, as it transports the visual into the verbal. I want to place two literary celebrations of visual stopped moments in sculpture here, at the outset of my discussion, like two portal statues.

Two statues and a tradition

Goethe's description of the *Laocoön* emphasizes the passingness of the moment seized, distinct from the ones preceding and following it. His

proposed exercise for the beholding of such a moment perfectly illustrates the excited observation to which the ekphrastic passage enjoins us, as if our reception were needed to cooperate in the sustained and momentary intensity. Like St Ignatius instructing us in the proper exercises for the deepest meditation, Goethe insists that we experiment with our seeing: it is this special moment that calls forth such detailed suggestions. We are supposed, confronting it, to shut our eyes, open them, and then shut them again instantly, in order to see the "whole marble in motion," all the time fearing that the next instant will show a totally different grouping. "It might be said that, as it stands, it is a flash of lightning fixed, a wave petrified in the moment it rushes towards the shore." The same effect can be experienced, he says, if we examine the group by torchlight. The point is never being sure that the action will be the same – being beheld once, then again differently, it is and must remain unique.

The tension of the ekphrastic moment is equally illustrated by Walter Pater's eulogy of Myron's statue *Discobolos* of the fifth century BC: it combines, he says, motion and rest, being "rest in motion." We have now only the marble translations of the bronze original, of which Pater says,

> it was as if a blast of cool wind had congealed the metal, or the living youth, fixed him imperishably in that moment of rest which lies between two opposed motions, the *backward* swing of the right arm, the move-ment *forwards* on which the left foot is in the very act of starting. The matter of the thing, the stately bronze or marble, thus rests indeed; . . . the artistic form of it . . . may be said to rest, at every moment of its course. . . .[4]

The youthful body statuesque moves in an instant of good fortune, says Pater, between the animal and spiritual worlds. His intonation of Pindar's prayer as he gazes at the ancestor of our cricketer is moving for us exactly because of the impossibility of what is prayed for – exactly because the held moment is not lasting in the living form, but only in the statue: "Grant them with feet so light to pass through life."[5] The moment, passing as it is, is forever inscribed in stone: we who pass can only regard it, with longing. Our very desire for its endurance puts us in a different relation to art as to ourselves.

Ekphrasis, from its origins, is then – at least to some extent – about relations: about, first, the telling or relation of the pictured art, or its showing as it is inserted into the rest of the story; second, how that picture relates to the rest; third, and crucially undervalued up to now, the relation of the speaker, teller, or shower of the visual effect to that effect itself, in its absence or distance, in its presence and nearness, and – corollary to that – the relation of the reader to the speaker and to that effect. The relation I shall finally stress is a further one: ours to ourselves, in what I am choosing – after Ruskin – to call a moral passion. The rest of what I have to say, to show, and to tell must be understood as leading there. But there is no doubt about the inescapable

subjectivity of the stressed relation itself, in this case and in every other: that of the critic to her own criticism – what is chosen to be shown and stressed, and what is chosen to be not shown, elided, or suppressed.

Treasured moments

Like a family treasure, coming from our whole literary tradition, oral or written, the *Ur*-examples of ekphrasis – those given us by Homer, by Virgil, by Dante, and by Chaucer – cannot be stolen from us, just because the arms engraved on the shield are too easily recognized. Listening to them even then, when we first knew of all this, seeing them still now, we have grown up – and are still growing up – into them.

Each of these examples is firmly bordered and set apart from the narration as a remarkable and highly textured passage, as if in relief upon the original shield. Homer's shield in the *Iliad*, XVIII, 482–608, contains five layers, as we are told, and this layering of complexity is intensified by the repetitions of the deliberate pictorial process markers, translated as "Therein . . . therein . . . therein, nine times in all. Its rim is plainly marked, so that the border of the inset text makes a vivid frame for the inset tale: "a bright rim, threefold and glittering," we read at the outset of the description, and, at the conclusion, the liquid rim beyond even that rim: "therein he set also the great might of the river Oceanus, around the uttermost rim of the strongly wrought shield."[6]

In Virgil's *Aeneid*, VIII, 796–809, Cytherea embraces her son, and then prepares her visual scene for reading, so entwining the reading with the love. A classic set-up, for all the trappings of future fame – arms, sword, helmet, corselet, spear all preparing the shield as the major text:

> She sought her son's embraces, then set up
> his glittering arms beneath a facing oak.
> Aeneas cannot have enough: delighted
> with these gifts of the goddess, this high honor,
> his eyes rush on to everything, admiring;
> with arm and hand he turns the helmet over,
> tremendous with its crests and flood of flames,
>
> . . .
>
> the shield, its texture indescribable.[7]

Here the shield, containing the story of Tarquin and others, is hung on a tree alongside the other armorial and battle-worthy possessions. Aeneas, who contemplates it without being able to interpret all its symbols, understands it as a confirmation of tradition, and lifts above him his offspring and the "fame and fate of his son's sons" – lifts, that is, his past and his future, in his present gesture, before and ahead of all of us. Of our own reading, I would like to maintain that understanding, at least as we have always understood it, is not a

necessary part – any more than it was for Aeneas. For, here, the reader of that tale and in the tale we in turn read becomes the self he was destined to be, and that is surely what most matters. In our turn, presumably, our own act of reading helps us become our changing selves.

The reading must be prepared. Canto X of Dante's *Purgatorio*, in which the white marble wall to be read is contained, opens with multiple signs of unusual preparatory limit and bordering, including a threshold, a gate slamming shut, the cleft or crack of rocks like a needle's eye:

> When I had crossed the threshold of the gate
> that – since the soul's aberrant love would make
> the crooked way seem straight – is seldom used,
> I heard the gate resound, and, hearing, knew
> that it had shut. . . .
> Our upward pathway ran between cracked rocks . . .
> the declining moon had reached its bed
> to sink back into rest before we had
> made our way through the needle's eye; but when
> we were released from it, in open space
> above, a place at which the slope retreats,
> I was exhausted. . . .[8]

The very exhaustion of the narrator sets this scene also apart as if in dream, and the canto ends with the most patient of the damned, in tears, appearing to say – and these are the final words – "I can no more" ("Non posso più").

In this moving way, the reading of the wall is associated with the images of exhaustion, and the text is tightly bound to an empathetic relation of the narrator to the inserted characters, and of us to all of them. The deciphering of inscriptions is not to be separated from feeling: this is the major lesson of these *Ur*-texts as I read them.

Chaucer's *House of Fame* contains a reading dream within a glass temple, on whose walls Virgil's *Aeneid* is portrayed – an insetting within an insetting. The story ends with the exit of the narrator from the temple doors:

> What I out at the dores cam,
> I faste about me biheeld
> Thanne sawgh I but a large feeld,
> As fer as that I mighte see. . . .[9]

The absolute contrast between the ekphrastic scene to be read within the temple and the rest of the story without the temple, in a space whose literal field is large, makes a point about insertions and their borders not easily forgotten. We are destined, it would seem, to dream and read the dream text within borders, and no less destined to issue forth from that dream reading as from a figure onto a wider ground.

These, then, are the classic texts bound up with ekphrasis, the figures which

help us read it, and write of it. Some highly funny baroque mockeries come to mind, one of my favorites being Saint-Amant's, of a night passed by a traveler in a seedy inn, where – in what passes as a spoof of the classic dream sequence – he espies, in the spots left by spittle upon the walls, a series of visionary events.

> Encore, ô mon Coeur! mon rognon!
>
> . . .
>
> Les flegmes jaunes et séchez
> Qu'en sa vérole il a crachez,
> Lui servent de tapisserie,
> Et semble que ses limaçons
> Y rehaussent en broderie
> Des portraits de toutes façons.
>
> (Again, oh my Heart! my kidney!
>
> . . .
>
> The yellow dried phlegm
> He spat out in his syphilis
> Serves him as a tapestry,
> Which its spirals seem
> To enhance, embroidering
> Portraits of all sorts.)[10]

Imitations – intentional or not – bring into focus the problems both of reference and of presence and distance. The classic examples have so marked our reading that they themselves form the definition that we follow in reading more recent renderings, making, as it were, the border for them. But, in meditating on later ekphrastic forms, the enthusiastic reader may find other ways of defining and caring about, of showing directly and indirectly telling about, the inserted works of visual art in the literary surround.

The overall question remains, beyond reference and behind every passage become problematic: what, if any, is the relation between ekphrasis and empathy? Does showing indicate closeness or presence, and does telling indicate distance from the action? Does it resemble the tie between picture and discourse about it? When it is set aside in a vision, as a heavily rimmed shield, or an elaborately engraved wall, or removed in space, as in a temple, the very framing, like a perspective deliberately invoked, might be thought to distance the perceiver from the subjective entanglement of passion.

Yet, when the moment is framed, is so stressed, our attention is seized at its height. Thus the paradox of perspective, illustrated by a good cartoon example of distance and proportion, one which is, as I read it, about the difficulty of perception and of stance, about the distant and the close, and how what seems one may be the other. It captions a Grecian urn set in a museum by a wide-eyed "wonder of it all", properly ironic New Yorker fare: it is our

literary memory that is amused by the framing. The cartoon is about our perception and our response, our relations to art, to tradition, to ourselves.

When the object perceived is of a completely different size – Keats's Grecian urn, for example – the relation of the perceiver to the perceived is one not of closeness but of non-participatory distance – that is, admiration. "Forever wilt thou love, and she be fair," indeed. But the loving and the beauty take place in a small and speechless realm: "Thou, silent form, dost tease us out of thought." What is encased is a tease, *and* a wonder.

Cold Pastoral can, of course, englobe the most ardent passion; can, as we know, represent the space of the most pressing unfulfilled desire: "though thou hast not thy bliss. . . ." But in some profound sense it does not pose for the contemporary reader the same anguishing ambivalence as posed by texts nearer to our time and our measure, often more urban and no less ironic.

We used to know where we stood, in relation to the *evocation*: with Aeneas, with the pilgrim, with the spectator – impressed, admiring, or, later, amused, with Saint-Amant's overnight traveler. We listened to or rather looked at the telling of the tale. But, in a closer range of *invocation*, where our distance is overcome by participatory presence, showing replaces telling. This exhibition concerns what is cared about, distancing what is only cold.

The scene evoked before us and in us becomes not just an excuse for admiration from afar, but one for re-evaluation of something. It has to teach us to care, about enduring and living, about creation and response.

Problematics of the visual

What is problematic, as I see it, is our obsession with sureness – our ceaseless desire to know what is behind what, to which canvas some passage refers, as if knowing the precise object to look at were always and surely to help reading. My contention is that it does not, unless locating the exact object solves the issue of knowing how to look.

Our own often maniacal need to refer to what we read behind what we read is at fault, more than just rarely, in a reductive decoding. So many footnotes, for example, are of value only on the first reading – not on the second nor in the depth at which we read. Thus, the countless disquisitions on which Bronzino Milly in *The Wings of the Dove* is contemplating as the inspiration for her moving lament about her own imminent and inexplicable death – "Dead, Dead" – do no more than to affix a label on the canvas, as if in some, precisely, lifeless museum of a text. Does this help us know how to read Bronzino or, for that matter, Milly?

As helpful, surely, as a translation of the verbal passage back into the original visual source is the tracing of the imaginative use of the picture itself through the network of Jamesian texts. Thus, for example, in *The Awkward*

Age, the use and handling of photographs as if one were pointing to, handling, and using the young women they represent:

> "... there's the young lady." He pointed to an object on one of the tables, a small photograph with a very wide border of something that looked like crimson fur.
>
> Mr Longdon took up the picture; he was serious now. "She's very beautiful – but she's not a little girl."
>
> "At Naples they develop early. She's only seventeen or eighteen, I suppose; but I never know how old – or at least how young – girls are, and I'm not sure.... The frame is Neapolitan enough, and little Aggie is charming." Then Vanderbank subjoined; "But not so charming as little Nanda."
>
> "Little Nanda? – have you got her?" The old man was all eagerness.
>
> "She's over there beside the lamp – also a present from the original."[11]

The surrounding of the small photograph with the crimson fur speaks for itself, in this eroticized version of pictured *having*. There is no distinction made between the holding of the framed object and the holding of the represented one – one is just, perhaps, easier than the other.

The held visual moment in *The Ambassadors* is justly celebrated. When Strether steps into the Lambinet canvas, he is framed in and up:

> The oblong gilt frame disposed its enclosing lines. . . . He really continued in the picture – that being for himself his situation – all the rest of this rambling day . . . and had . . . not once overstepped the oblong gilt frame. . . . For this had been all day at bottom the spell of the picture – 'hat it was essentially more than anything else a scene and a stage.[12]

The events he perceives have significance only for him, not for us – we just see a lady coming towards us in a boat with a pink parasol and a companion. This, of course, is the point, and we are prepared for it by a passage almost 200 pages earlier, when the art critic Gloriani contemplates at great length one of the young man's pictures which has a frame out of proportion to itself. In this case, we know that it is not what is caught that matters, not what is held that is held, but the ways they are, and we are, set up.

By the time of *The Wings of the Dove*, where the Bronzino already referred to is so deeply inscribed in the house and its history, all bathed in a mid-summer glow, we recognize the marks of the revelation that will take place for the dying heroine, as well as for us, contemplating her, before the picture:

> [Lord Mark:] "Have you seen the picture in the house, the beautiful one that's so like you?" . . . She was the image of the wonderful Bronzino. . . . The Bronzino was, it appeared, deep within, and the long afternoon light lingered for them on patches of old colour and waylaid them, as they went, in nooks and opening vistas.

. . . Once more things melted together – the beauty and the history and the facility and the splendid midsummer glow: it was a sort of magnificent maximum, the pink dawn of an apotheosis, coming so curiously soon. What in fact befell was that, as she afterwards made out, it was Lord Mark who said nothing in particular – it was she herself who said all. She couldn't help that – it came; and the reason it came was that she found herself, for the first moment, looking at the mysterious portrait through tears. Perhaps it was her tears that made it just then so strange and fair – as wonderful as he had said: the face of a young woman, all magnificently drawn, down to the hands, and magnificently dressed; a face almost livid in hue, yet handsome in sadness and crowned with a mass of hair rolled back and high, that must, before fading with time, have had a family resemblance to her own. The lady in question, at all events, with her slightly Michelangelesque squareness, her eyes of other days, her full lips, her long neck, her recorded jewels, her brocaded and wasted reds, was a very great personage – only unaccompanied by a joy. And she was dead, dead, dead. Milly recognized her exactly in words that had nothing to do with her. "I shall never be better than this". . . . She was before the picture, but she had turned to him and she didn't care if, for the minute, he noticed her tears.[13]

The pictured scene has by now become the container of the significance we all take to be centrally conveyed by the text. The scene is not, or not just, about reference, not just about the Bronzino and the specific portrait or portraits to which this refers, but about our reading Milly's reading of it and of herself. It is understated and moving on another level from the earlier works.

Finally, in *The Golden Bowl*, Maggie learns to see her father afresh by the early Florentine "sacred subject" he had given her on her marriage; she reads him and his farewell, herself and her past and future relations through it. This scene is given a strange depth by our reading of the preceding scenes in the other and previous novels.

He might have been, in silence, taking his last leave of it; it was a work for which he entertained, she knew, an unqualified esteem. The tenderness represented for her by his sacrifice of such a treasure had become, to her sense, a part of the whole infusion, of the immortal expression; the beauty of his sentiment looked out at her, always, from the beauty of the rest, as if the frame made positively a window for his spiritual face; she might have said to herself, at this moment, that in leaving the thing behind him, held as in her clasping arms, he was doing the most possible toward leaving her a part of his palpable self. . . .

"It's all right, eh?"

"Oh, my dear – rather!"

He had applied the question to the great fact of the picture, as she had spoken for the picture in reply, but it was as if their words for an instant

afterwards symbolized another truth, so that they looked about at every-thing else to give them this extension.[14]

This scene is usually read by critics as the sharp-eyed knowledge of things, and people as things, by two collectors of people as objects who enjoy amassing worthy things, aesthetic and material. This light shows the evaluation by these two of the nobility and splendid effect of Mrs Verver and the Prince "placed" as "high expressions of the kind of human furniture required, aesthetically, by such a scene," so that the father's final remark to his daughter about her husband – "*Le compte y est*. You've got some good things" – gives the main investment to the scene and the story.

I would like to maintain, however, the reading of the picture and its subject, its traditional depth of reference, as singularly important to them, to the story, and to all of us. What the couple, father and daughter, look about at, to give the extension to the pictorial expression, we have to learn to look at, in their terms and not just our own hypercritical ones. I too have treated this scene as a scene of investment, and in fact had, and have, quite a lot invested in that reading. But I have learned to reread, through James and through art, and hope to make investments of other and deeper sorts. Just as in Woolf's *To the Lighthouse*, to which I shall be returning, like some beacon none of us wish to forget, the Madonna and Child picture is an essential part of the whole pictured story, precisely as it is pictured; the sacred matter here and its very spirituality lend their strength to the sentiment, to keep the picture close: "held as in her clasping arms." This is not sentimentality of the squishy kind, but rather deep and real art, making its own reference to itself and to its tradition, reinforcing the verbal surround in which it is inserted, and saying more, far more, than it says. Speaking for the picture, as they do, they are speaking indeed, as the text so faultlessly says, to symbolize another truth, an extension into "everything else." It's being "all right" in its perfection and their speaking of it together reveals, not the "early Florentine sacred subject" within it, but the truth of the emotional situation – everything around the picture. The pictured subject disappears to make the revelation. This is, in my view, true showing, and does not have to be told or referred to at greater length. We are made to care. And that is, in fact, what the ekphrastic moment at its summit is to do: to condense knowledge and vision, action and wisdom, and to hold them steady before us, intact.

The overall question remains, beyond reference and behind every passage become problematic: what, if any, is the relation between ekphrasis and empathy or presence? Does it resemble the tie between picture and discourse about it? When it was set aside in a vision, as a heavily rimmed shield, or an elaborately engraved wall, or removed in space, as in a temple, did not the framing protect the reader from involvement like a perspective deliberately invoked to distance the perception from subjective entanglement?

Obsessive seeing

Some figures, proven obsessive by the *bulge* they make in our texts, provide unforgettable test cases for certain strategies for seeing and not seeing, for thinking and for shutting the eyes to art works, within the norms of poetry and poetic prose. The night before, or after, the burial of his father, Freud dreamed of an inscription reading (in the translation of Michel de Certeau's post-humous book on writing historiography) "Please Shut The Eyes." Thereby hangs many a possible tale.

Whose eyes, in this translation? "Yours", "ours" or "those of the others"? I want to worry about seeing, not seeing, and about what happens when we are told to see or not to see, to think or not to think, by a verbal text already in reaction to a visual one. I want to worry about the power certain texts have over us, or over me, and to illustrate it – thus making, in my own text, an obsessive bulge, chosen but in strange correspondence with (or so is my supposition) the obsessions of other readers and seers. Such is the power of the image; and so I shall begin by a text that deliberately plays upon what it is to *raise* an image we are all already pretty high on.

Writing big, or magnifying Moses

Much of the ekphrastic tradition we have loved has been associated with themes and landscapes of grandeur – in their tragedy and in their triumph, these texts have been noble and have ennobled. Such a text is the brief and unforgettable depiction of those "vast and trunkless legs of stone" in the desert in Shelley's "Ozymandias," with the despairing inscription on the pedestal itself of that colossal wreck as it was meant to strike fear and to claim endurance:

> "My name is Ozymandias, king of kings:
> Look on my works, ye Mighty, and despair!"

The "lone and level sands" stretching far away around that wreck of a ruin of a monument have a wide and unembarrassed sweep, exercising just such a hold over our imaginations. This was exactly what the ekphrastic moment was meant to do: to focus the attention on the moment held, and to elevate the entire text to a meditative height, deepening and reinforcing the lyric or the narrative around it. That tradition is massively continued in the rhetorical dialogue form of Browning's translation of an Italian poem on Michelangelo's *Moses* (plate 19.1): a poem which is entirely situated, in its initial interrogation and its response, at the height of Browning's voice. If we read it now as paradoxically platitudinous even on those heights, it is that reading has

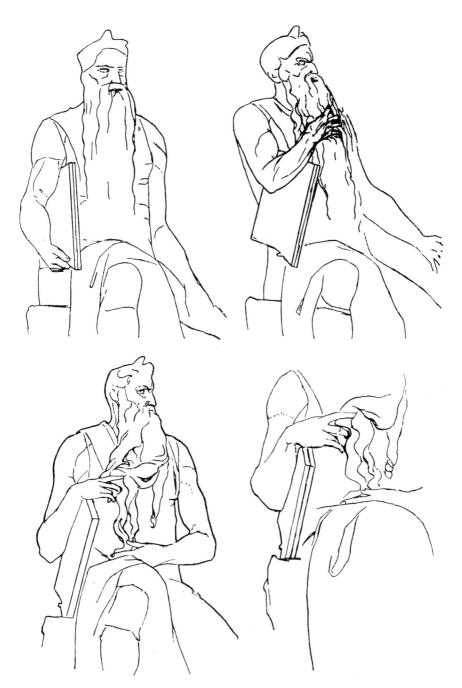

Plate 19.1 Four photographs of Michelangelo's *Moses* from *Moses and Monotheism*, vol. XVI of *The Complete Psychological Works of Sigmund Freud*, Standard Edition (London, Hogarth Press, 1953–74), (reproduced by kind permission of Sigmund Freud Copyrights Limited, The Institute of Psycho-Analysis. Thanks also to The Hogarth Press for permission to quote from *The Standard Edition of the Complete Works of Sigmund Freud* translated and edited by James Strachey. Photo: The Bodleian Library, Oxford).

changed – but the intentional heights are at least visible, if not audible. This is stress by magnification:

The "Moses" of Michael Angelo

And who is He that, sculptured in huge stone,
 Sitteth a giant, where no works arrive
 Of straining Art, and hath so prompt and live
The lips, I listen to their very tone?
Moses is He – Ay, that, makes clearly known
 The chin's thick boast, and brow's prerogative
 Of double ray: so did the mountain give
Back to the world that visage, God was grown
Great part of! Such was he when he suspended
 Round him the sounding and vast waters; such
 When he shut sea on sea o'er Mizraim,
And ye, his hordes, a vile calf raised, and bended
 The knee? This Image had ye raised, not much
 Had been your error in adoring Him.[15]

The poem is written precisely in order to raise up an image, exactly for the reasons the statue was made. Its very framing is gigantic. On the top left, the massive figure is already seated as a capitalized "He," introduced by the classical interrogation: who is this? The answer, coming four sculptured lines later, "Moses is He," retains the capitalization, and directly leads to the conclusion at the lower right of the poem, the final "Him" seated still in adored mightiness.

The marks of majesty are clear, and cram into the first half of the poem, filling it with the characteristics of giant size, both physical and moral: "huge," "giant," "thick," "boast," "double," "mountain," "God," "great," "!" All this to indicate that no straining art of a paltry human sort can reach the magnificence of such seated splendor. As if, in some overreaching way, the poem were able to naturalize the figure, through art, in a way superior to art itself. The topics of representation, nature, and scale are posed drastically, and addressed in loud tones: how to make a poem as big, in the limits of a constraining sonnet, as the massive statue of the massive hero created by the massively celebrated artist? How to heroize heroism?

Thus the thick boast of chin for decision-making and power of resolve almost tablet-breaking, thus the doubled radiance of eye, with the force of a metonymy twice over (not just the ray, but the double ray, in a case where not just Cyclops but ordinary heroes have a single ray). Thus too the very mountainness of the face, as large as Moses's legend, so large that God Himself would participate in it, not just within time, but growing there greatly. Small wonder, in this greatness, that the exclamation point comes to round off this hugeness of description, before this legendary hero is made

central to the vastness of the surrounding seas, sea on sea. For to move from the initially capitalized "He" to the conclusively capitalized "Him" is itself to *raise* this capitalized image for adoration, maintaining its value, through the ages that poems and stones will last, far above the reach of "straining" art: the act is to capitalize upon an image, a legend, and a hugeness of language on the rise.

And yet precisely here we sense a certain embarrassment, before this poem, like Freud before the statue of Moses – not that we, like him, suspect that the statue will or might move, but, rather, that we ask how we can relate to such a willing work of art presented as if it were to naturalize what it images, through art, against art. Here is the sense of stress, perhaps only from a contemporary point of view reading back into another age; it is very much like hearing a *Magnificat* at a range too close, when we have, in all likelihood, lost our faith in heroes and perhaps even in images, if not completely in art. The power of poetry is to capitalize and to magnify, in a time of lost ekphrastic faith, when the "thin-lipped Hephaestos" may indeed hobble away while Thetis weeps. Few are our shields and our heroes, few even our heroic poets. Does something about the overspeech of the poets of the past undo the very notion of grandeur that the exaggeration of such huge stone and such huge speech wants to convey?

The question will of course arise each time we tackle the ekphrastic tradition: what has happened to our sense of heroism, and how can, how should, we express or use the texts of halted action caught at its very summit, whether in tragedy or triumph or both, without embarrassment? I want to argue that the *poetics of stress* I am defending here, with all its built-in ambivalence, struggles to retain just such tension in its own involvement, albeit differently slanted at different moments, rarely seated in great might by some vast waters. But more on Moses.

Taking the exclamation point as the central pivot, between the two question marks, we read,

?

!

?

The frame is not only huge; it is massively, artfully structured. For it is not only the punctuation that has this firm line, but the vocabulary, small and large. The eye rhyme goes from the initial "who?" to the "no" to the doubled "so" surrounding the simple "to." More importantly, the all-important double "so" is echoed by the double "such" to define what a hero this is, to sketch out his acts, his imagined speech, his almost-livingness in his gianthood. He communicates, as this poem is supposed to, and the proof is yet again trinitarian: the pronouns are set up in listening form – "He," "I," and "ye" – and when I listen, claims the narrator, I hear, and, hearing from those very lips

"so prompt and live" that it is Moses, I see it too: "Moses is He – Ay, that, makes clearly known / The chin's thick boast. . . ." Unmistakably Moses, this statue, and, as if in overdetermination, the yea-saying "Ay" responds to, echoes to, the statement of personal narration, "I" to "Ay."

Even so, the legendary and huge He becomes non-capitalizable upon within his action, so that the move from the first part, with all its huge stationary force, to the second, with its narration, is necessarily a move from capitalized "He" within question and answer: "And who is He . . . Moses is He" to the simple "Such was he when he . . . such / When he . . . and ye." This is the only way to permit the hero to involve himself in the actions, however great – those acts of suspension and shutting-off – and yet retain the hugeness of the Seated Image, which should be raised, statically and stably, on high: "This Image" to be unerringly adored in the final shape of the poem, an image the reader can grow great part of.

These are the fictions of shaping and seeing, wrought by the power of art disguised as hugely and miraculously, naturally, legendary. Some obsessive figures shape, and hugely, our imaginations, beyond any straining of a single art, into the poetics of stress mostly strongly felt in that interval – that *Zwischenraum* – between the layers of the double text.

For us, now after Freud, the Moses affair, as I shall call it, has become particularly complex, tied up, as it is presumed to be, with the paternal.[16] Browning had not the same problematic relation to Moses that we post-Freudians are bound to have. Insofar as Moses is, for Freud, the symbol of the father, as well as being – like Freud himself – the smasher of idols, the representation of Moses-in-image is itself, as we now are enabled to read it, the very representation of the undoing of image. To raise *this* image, as Browning would have us do, to adore *this* representation of the undoer of representation, would be for us to commit a doubly transgressive act, both of the laws of the Old Testament, as we raise the image prohibited *qua* image, and provocatively paradoxical, in refusing the parricide called for as we, precisely, elevate what signifies the doing-away with elevation.

One degree more of complication: Freud applied Leonardo's ambiguating approach to such images, stressed and twisted (hooked on the image, we reduce it in size, even as we are its prey – we would exorcize it). About such images, there is no telling and no explaining – there is only showing. But the density of images so elevated, written of, pointed at, manages to arrest us before them. What we are arrested by, in this case, is the double point of view. What we should raise is the image made more poetic by the accumulations of discussion. We would, of course, choose to be neither reductive nor passive in front of an image so mighty and so emblematic of sculptural power, or in front of a poem so willingly magnifying.

This Moses is, of course, the perfect example of the *terribilità* of the sublime.[17] Striking fear into the heart by his glance, he is the very image of the hero. So Browning's poem, in raising up the image of the Moses-in-marble,

raises at once the image, the image-maker – Michelangelo, in this case – and the image-breaker.

Moses seems to have gathered around himself a most extraordinary group of admirers and enemies: the statue of Michelangelo works as a test case *par excellence* of the notions of terribleness and the sublime. Shelley's utter loathing of the kind of energy represented by Michelangelo and in particular by his Moses pours out in letters to Thomas Love Peacock, and to Leigh Hunt. To Peacock, on February 25, 1819, he wrote,

> I cannot but think the genius of this artist highly overrated. He has not only no temperance no modesty no feeling for the just boundaries of art . . . but he has no sense of beauty. . . . What is terror without a contrast with and a connection with loveliness? . . . What a thing his Moses is; how distorted from all that is natural and majestic only less monstruous and detestable than its historical prototype. . . .[18]

And to Leigh Hunt, on August 20, 1819:

> With respect to Michael Angelo I dissent, and I think with astonishment and indignation on the common notion that he equals and in some respects exceeds Raphael. He seems to me to have no sense of moral dignity and loveliness; and the *energy* for which he has been so much praised appears to me to be a certain rude, external, mechanical, quality. . . . As to Michael Angelo's *Moses* – but you have a case of that in England. – I write these things heaven knows why –[19]

Not just heaven knows, but the reader does, or at least suspects, according to my supposition. There are, like this, natural (artificed) foci of attention, throughout the ages, that not only have in themselves their own *energy* and their own *terribleness* but also serve as catalysts for poetic and prose discussion that, because of the passions aroused, seems seldom to lapse into the prosaic. Of these, Michelangelo's *Moses* is a doubly determined case in point, heroic in intention and representing, in some sense already iconoclastically, an iconoclastic hero, even before Freud reached him. If this Moses had not existed, others before Freud might well have invented him. And, in some degree, they did.

Ruskin's stunning monograph *The Relation between Michael Angelo and Tintoret* originally formed his Seventh Lecture on Sculpture at Corpus Christi College, Oxford, on May 1, 1872, and was printed for the use of strangers visiting the college galleries(!). It opens with the disingenuous caution, to these very strangers: "But they must observe that its business is only to point out what is to be blamed in Michael Angelo, and that it assumes the facts of his power to be generally known."[20] So much for even-handedness. Ruskin sets up a neat chiasmus: whereas Tintoretto conceives of his painted figures as solid statues and sees around them, Michelangelo conceives of his sculpture

"as if it were painted,"[21] occasionally using his chisel like a pencil. Signs of weakness and overwork abound; to cap it all, these statements, rising in scorn:

> Nearly every existing work by Michael Angelo is an attempt to execute something beyond his power, coupled with a fevered desire that his power may be acknowledged. He is always matching himself either against the Greeks, whom he cannot rival, or against rivals whom he cannot forget. He is proud, yet not proud enough to be at peace; melancholy, yet not deeply enough to be raised above petty pain; and strong beyond all his companion worksmen, yet never strong enough to command his temper, or limit his aims.[22]

(Is this not, in an oddly apt way, Ruskin's own story, or at least his own temptation? Is not Michelangelo serving for him as Moses will for Freud, as a sort of brother case?) Ruskin continues, his voice rising, "By the most grotesque fatality, as if the personal bodily injury he had himself received had passed with a sickly echo into his mind also, Michael Angelo is always dwelling on this satyric form of countenance. . . ."[23]

Now in relation to image-making and breaking, those of Michelangelo and his Moses, and a further raising and breaking, a most remarkable conglomeration of documents is given us by Freud, and the latter-day commentators on Freud. *The Moses of Michelangelo*, written in 1913, and published anonymously in *Imago*,[24] discusses Freud's reaction to the fierce gaze of the statue, found in S. Pietro in Vincoli in Rome, as a fragment of the tomb Michelangelo was to have erected for Pope Julius:

> For no piece of statuary has ever made a stronger impression on me than this. How often have I mounted the steep steps from the unlovely Corso Cavour to the lonely piazza where the deserted church stands, and have essayed to support the angry scorn of the hero's glance! Sometimes I have kept cautiously out of the half-gloom of the interior, or as though I myself belonged to the mob upon whom his eye is turned – the mob which can hold fast no conviction, which has neither faith nor patience, and which rejoices when it has regained its illusory idols.[25]

There follows a lengthy and most curious description of Moses in marble, as his right foot rests on the ground and his left leg is raised so that only the toes touch; of how he will, in another moment, no doubt spring to his feet to dash the tables to the earth, and let loose his wrath "upon his faithless people." Freud, so he narrates, used to sit down to await the statue's leaping-up, transfixed with the expectation, and then, repeatedly, disillusioned that the statue in its "oppressively solemn calm . . . would remain sitting like this in his wrath forever."[26]

The inexhaustible inner force of this *vir activus* as he struggles against his anger, keeping his temptation in check, is of particular fascination to Freud – as Paul Roazen reminds us – because of his recent break with Jung, whom he

had chosen to carry on the psychoanalytic tradition as an eldest son, a Gentile, and an aristocrat.[27] His anger was, then, like the scorn of the statue, that of a conflict – like Moses' own – between "the reforming genius and the rest of mankind."[28]

But, of all this long obsession – leading to the far more celebrated *Moses and Monotheism* of 1939 – the obsession with certain details is the most strange. In the course of three exhausting pages, Freud describes the way in which the "main mass of the beard is thrown to the right of the figure, whereas the head is sharply turned to the left," and stresses the "riddle of the knot in the beard of his statue" and the oblique hold, with the left side of the beard under pressure from the index finger. In fact, the index finger holds back the beard, pressing it down so deeply that the masses of the hair bulge out, and one strand rolls over and forms a scroll. In a contrasting fashion, the anger is expressed by the head and eyes, turned toward the clamor of the mob, and the right hand is making a retreating or restraining motion, the figure of the hero venting his wrath and rage against his own body. His hand must prevent the tables from slipping, as they had begun to do, and they are now held upside-down, the protruberance on the lower edge instead of the top.

These signs of motive forces, analyzed at length, are accompanied by Freud's illustrations of an earlier possible pose, which he posits. Such a pose had been discovered in 1863 by Watkiss Lloyd, who had then devoted forty-six pages to this statue, showing that the beard had been where the hand was, and tracing the "wake" of the course of the hand. Freud's discussions of the projected action and the retreat, the impulse and the control, all aim at showing the movement that impels the enraged hero towards the gesture of breaking, and the retraction of that motion. A more remarkable case of double intention, of mannerist *contrapposto* and intense stress, cannot be conceived of, and can certainly not be illustrated. This is surely the ekphrastic imagination at its height, showing and telling and dealing with stress, stressfully. Freud quotes Morelli,[29] whose stress of the significant detail which the copyist would neglect to imitate so greatly impressed him.

This, concludes Freud, is the new Moses, not throwing away the tables, and placed by Michelangelo as a warning to himself, "in self-criticism, rising superior to his own nature."[30] Just so, Freud would rise above anger. But what if both interpreters have taken the wrong path? Freud concludes that in that case the artist is no less responsible than his interpreter "for the obscurity that surrounds his work."[31] *Moses* is, then, a test, like all works of art: but in this case the test certainly seems to concentrate an obsessive passion, working – I would maintain – in the same way as poetry to heighten the object looked at. This case study could itself be taken as emblematic of artful stress, of ekphrastic passion, of poetic insistence on detail.

Looking in detail, and after

Part of the notion of *arrest* concerns the holding in suspension of the observer's attention by something *remarkable* in the etymological sense, something to be noticed, remarked upon. This arresting occasion can be of many kinds, but it must – like Barthes's notion of the *punctum* piercing the surface of the gaze – condense in itself some peculiarity sufficient to freeze the moment of looking. This is not unlike the new historical focus on anecdote as "historeme,"[32] as the smallest possible unit that matters, referring to the real, against the narrative teleological sense, making a digressive opening against the apparent closure of traditionally conceived history. For such an arresting moment or detail, whether verbal or visual, bears in itself a potential energetic charge capable of invigorating the look from passivity into participatory activity.

The noticeable or outstanding detail, overdetermined and overstressed, creates a detectable *bulge in the text*, like Breton's lengthy analysis of the haunting single glove – shifting, in life, from the pale-blue leather one left on his table by the semi-hysterical woman, to Nadja's drawing of a female face and a hand, opened at the top like a glove, to the bronze glove on his writing desk at 42, rue Fontaine, as if he had placed in his study a heavy double of the other, delicate and feared one, *to last*. (See chapter 3, where the awkwardness of language corresponding to the glove left behind is described as the *long side* of an ellipsis, compensating for what falls short. This bulge in the text would include, as it does there, the passages of Proust's Marcel's Albertine Carpaccio's cloak, rendered by Fortuny, also in the double presence of too-muchness and noticeable ellipsis.)

The notion of, the theory of, and the archaeology of detail are studied by Naomi Schor's *Reading in Detail*, where they are placed in relation to a feminist concern with what I would call, roughly, the *taking-over* of a subject as object by the male subject:

> The modern fascination with the trivial, the playground of fetishism, is exhibited throughout the variegated work of Roland Barthes. . . . Though Barthes's deliberate undoing of the romantic sublimation of the detail appears here as a sort of happy end, spelling the demise or temporary retreat of idealist aesthetics, from a feminist perspective a new and nagging question emerges: does the triumph of the detail signify a triumph of the feminine with which it has so long been linked? Or has the detail achieved its new prestige by being taken over by the masculine, triumphing at the very moment when it ceases to be associated with the feminine, or ceasing to be connoted as feminine at the very moment when it is taken up by the male-dominated cultural establishment?[33]

Now, Freud maintains that the greatest creations *dominate* us, taking hold of our intellect and disorienting it: we cannot say what the experience means. Sacred terror strikes us in front of the statue of Moses and his furious look – we are touched, pierced, taken: Freud's experience of decoding the gesture verges on sacrilege, for him. Remarkably, the decoded gesture's *awkwardness* (again, the heavy, tell-tale weight) as seen by another interpreter, is indicated by Freud in English, in the German text: "Unless clutched by a gesture so awkward, that to imagine it is profanation." Profanation and *pleasure*, in the Barthesian sense, are analyzed, together with Freud's Michelangelo's Moses, both by Jane Gallop in *Thinking through the Body*, and by Jean-Michel Rabaté, in relation to Barthes's *punctum* that pierces, delights, arrows in, and points out. Rabaté's *La Beauté amère: fragments d'esthétiques*[34] presumes upon an aesthetics powerful enough to "suppose a sublime law forbidding representations" and thus lead to such destruction as that of Moses, Savanarola, and Michelangelo, before which the observer is bound to tremble: Freud and we too.

Freud hesitates to interpret Moses, between vengeful anger and pardon, between destructive rage and restorative magnanimity; could Michelangelo's writing be so double, so ambiguous? Rabaté sees this "exchange of hesitations and reversibilities, this mixture of indeterminacy and contradictory simultaneity" as the illustrative conflict of a terrible beauty "between two":

> in the between, between two fathers – the father of the Jews who founds the Law and the father of psychoanalysis, who, in another "novel," means to "dispossess" the elected people of its own founder by an act of speech resumed in the verb *absprechen* of the first sentence of *Moses and Monotheism* . . . – between two words between two gestures. . . .[35]

All interpretation here takes on the "trembling" of "*another* calligraphy,"[36] what I am calling the writing-in-stress of the splendidly interfering double work of art.

Freud's reading of Moses the figure as well as of Moses the statue is outlined in uncertainty: not only does he remove *Moses and Monotheism* from the domain of fact, bracketing it off, but he also – as a disarming gesture, says Malcolm Bowie in his *Freud, Proust, and Lacan*[37] – comments in noticeably erudite terms upon the "factor of doubt" hovering over it; "I have, as it were, placed that factor outside the brackets and I may be allowed to save myself the trouble of repeating it in connection with each item *inside* them."[38] Bowie remarks,

> It is characteristic of Freud . . . that he should cast himself as algebraist at the very moment of embarking on a work for which he was elsewhere to suggest the subtitle "a historical novel." . . . He was an expert observer powerfully drawn towards grandiose unobservables. Freud's writings derive something of their extraordinary intellectual density

from their capacity to superimpose and interconnect these alternative views of knowledge. They are works of strict psychological science bathed in epistemological dreams and phantasies.[39]

Freud's obsession with the Moses figure and statue and the notion of uncertainty connected with them link on to his fascination with Leonardo and his ambivalence mirrored in the *St Anne of the Rocks* and his *Mona Lisa*: we might see the intense masculine figure in rage and meditation as the figural opposite of the mysterious feminine figures. In any case, Freud's own self-picturing was deliberately non-hesitational, and involved with what Bowie calls "the admiring side-glances that he took at professions other than his own . . . his self-images as archaeologist and as *conquistador* – the two favorite means whereby this redoubtable theoretician of a timeless unconscious sought to endow his discoveries with the resonance and prestige of history."[40] That such figures as Michelangelo's *Moses* should hold in arrest their observers and the subsequent readers of their obsessional observations is a tribute at once to detail, passionately read, and to passionate reading as a whole.

Concerning Freud's Michelangelo's Moses, and, parallel to it, Freud's Leonardo's Mona Lisa, the French psychoanalytic critic and Freudian Sarah Kofman has, if not the last, then a recent and respected word. She analyzes the difficulties of Freud's analysis of Moses as an Egyptian (*Moses and Monotheism*) as a removal the importance of which Freud himself points out, taking away from the Jewish people the man they celebrate as the greatest son they have, and simultaneously stripping himself, in a sense, of his own Jewishness.[41]

In her *L'Enfance de l'art: une interprétation de l'esthétique freudienne*, Kofman discusses Freud's attack on the work of art itself in its narcissism, and his fascination with the Leonardo legend, according to which the artist called himself as "the father of his works," and thus treated them the way his father had treated him, abandoning them uncompleted. Freud's desire to become the father of his work led him to offer the creation to his mother, to enter into her womb, and receive the semen of the father; this homosexual attitude drives him to treat art as a double, as the internal division "of the self with the self, as repetition (whereas a life as full presence, conforming with our phantasms, would be pure originality), and as producing an effect of disquiet and oddness in which repetition occurs where difference would have been expected."[42]

Thus the need, in the absence of the smile of the mother, of the smile in art (whence the odd smile of the Mona Lisa and of the Virgin of the Rocks), to break the idol who is the artist – a murder "in response to a murder which is the deformation of the repressed as it returns."[43] The murder of the original Moses, as Freud tells the story in *Moses and Montheism*, returns in the memory as guilt; all of this gives depth to the legend, tragedy to the Moses figure, and a portentous sense to the statue as Michelangelo's expression of holding-back, of the restraint of his rage which would have broken the images,

yet again. It is the legend of breaking that Freud, in his turn as reader, does away with, supplanting the story with his own.

Freud's reading, then, according to his own analytic desire, instead of raising on high the work of art, makes of him its father and its destroyer at once, undoing, by his obsession with its detail, its general legend. When he finally is able to place his own name on the early essay called by the names both of Moses and of Michelangelo, he gives, as he says, to the illegitimate child a father, and gives, as he does not say, by his bizarre reading, a triumphantly poetic text to his own obsession with art.

Among the strongest figures of obsession, Moses as Freud's repeated subject cannot be ignored, even as he did not rise to hurl down the tablets in Michelangelo's statue. Michel de Certeau, in his recent book on historiography,[44] devotes a chapter to "The Fiction of History: The Writing of *Moses and Monotheism*." This work that Freud himself called a "fantasy" plays between legend (*Sage*) and construction (*Konstruktion*), between the fiction of production and that of deceit: "my novel," Freud says of it to Arnold Zweig.

In order to displace the legend, he sees himself as setting up the statue – he the Michelangelo of his Moses, he the creator of the semblance of the absent founding father – on feet of clay, so that it can be easily toppled. But the problematics overcome the construction, and "*Moses*, which has been laid aside," is bequeathed to a silence "where nothing takes its place."[45] One of the ironics of the construction is the fiction's "disallowal" of mastery in its being as the oppositional, fragmented, partial, polyvalent, "text of an old man, burdened and coming apart because of his age." De Certeau here draws on Freud's letters to Zweig and Pfister about his body disaggregating like his writing, both unitary only by deception. "Thus," says de Certeau, the Freudian fable presents itself as "analytical" because it restores or admits the rupture that recurs and shifts; and as "fictional" because it grasps

> only substitutes for other things and illusory stabilities in relation to the division that makes them castle within the same place. . . . Freud's narrative has much to do with *suspicion*, which is rupture, doubt; and with *filiation*, which is both debt and law. Membership is expressed only through distance, through traveling farther and farther away from a ground of identity.

Freud speaks, according to this view, always as an other, his text authorized by neither "his" language, "his" culture, "his" land, nor "his" competence – "he is still a foreigner to the opaque intimacy of every place and even of his own ground." The place of writing is uncertain, and never authorizes the subject; always left over, he never has any ontological ground to base anything upon.

And his text on Moses will *go away*, sorrowing because of the separation from, if I have understood de Certeau, Freud, and his own *Moses* correctly,

that very ground of being. Writing cannot restore lost content, and (Benjamin on Proust) it assumes only the "form," not the "content" of memory ("memory is packing its bags, while oblivion is content"[46]). *Moses and Monotheism* becomes narrative, conscious of the *will to lose* both the father and the truth; it makes the inscription of mourning: "The fiction," says de Certeau, "is built on the 'nothing' of past existence from which nothing (*nichts*) subsists. . . . Great poetry is made from great ruins."

What does Freud's conception of Michelangelo's *Moses* "mean" (in itself, for us, for him)? De Certeau's answer is categorically unreassuring: "What it '*means*' can only be *silenced*, infinitely *repressed*, forever remaining *to be expressed*. . . . Fiction has the characteristic power of *having us understand* what it does *not express*." And yet, says de Certeau, "*Producing the text* amounts to *making a theory*." And the text is riddled with a whole list displayed: "substitutions," "disguises," "disfigurements," "deformations," "eclipses," "reversals" – it defends something that can only be removed or *silenced*. To the elimination of voice, circumcision, as transferred and retained from Egypt, bears witness, as mark and sign, of the very *act* of losing; ellipsis as repression signals this role in the text of the withdrawn and the silenced. (Lacan notes Freud's own elision of the fundamental speech "I am . . . I am that I am, that is, a God who is put forward as essentially concealed."[47]) Freud replaces the graph "Yahweh" with the Judeo-Egyptian writing on the body, circumcision, says de Certeau, continuing with the overt statement, "Freud is Jewish, and I am not," so what can I understand, ultimately, "about this *other* without whom I could not be a Christian, and who evades me by being behind," the necessary figure who stays inaccessible, the repressed who returns?"

This Moses occasions, as a problematic figure, constantly returning, the very intensity of conceptual and verbal response to the visual which a poetics of stress can take as its emblematic model.

Writing in stress, writing in passion

The linking of stress or difficulty with poetic response can take various forms of reiteration, of an emotional tenseness and intensity. In particular, in the insertion of works of visual art in a literary context, the very meditation by the verbal upon the visual may work to summon our attention to what it is to surround and to stress what this tradition makes concrete. The issue is a double concentration, where the emotional charge of the sharply focused verbal passage is often raised to an extraordinarily high pitch, as if even in prose the visual object and its verbal relations had become – suddenly – charged with poetry.

Of all critics, Ruskin seems the nearest to a poet in the descriptive part of his essays, and I want to take him as a model for a style lending its high passion to

the objects observed until the essay, in part poem, reaches its crux or its final height.

Ruskin's plea for the authentic over the imitation is based on just this real passion for the real. His real, his truth, may not be our real, or ever our truth, but his high passion or difficulty – his difficult passion – forces his inimitable style of seeing and of caring:

> all the short, and cheap, and easy ways of doing that whose difficulty is its honour – are just so many new obstacles in our already encumbered road. They will not make us happier or wiser – they will extend neither the pride of judgement nor the privilege of enjoyment. They will only make us shallower in our understanding, colder in our hearts, and feebler in our wits. And most justly. For we are not sent into this world to do any thing into which we cannot put our hearts.[48]

But there is of course another side to the intensity and verve at issue here: to care so terribly about seeing, about truth, and about so many other things besides, may imply enormous prejudice and do enormous harm. Ruskin's burning of Turner's most vividly erotic works cannot, after all, be undone, ever. Even as we deplore it, the extraordinary vigor of the *gaze behind the act* can only be marveled at, in its dreadful and wonderful passion.

It is not, I think, that Ruskin teaches us how to see only, but that he is uniquely able, for those who are burned by his passion, to show what seeing is, and how superbly strange are its effects, upon relations as upon what is seen and the subject seeing. One of our major fascinations with Ruskin is what he blocks out, exactly as it might seem to call for stress.

It may well be that we can best appreciate the heights of Ruskin and what he situates upon them by comparing his most sublime passages with those in which he is simply stating (yet never only simply) or poking fun; the latter are real fun for the reader, as in his remarks about Millais's *Mariana* ("I am glad to see that Mr. Millais's lady in blue is heartily tired of her painted window and idolatrous dressing table"[49] and about Charles Allston Collins' *Convent Thoughts*, although here his real seriousness about truths on a small scale penetrates:

> and I have no particular respect for Mr. Collins' lady in white because her sympathies are limited by a dead wall, or divided between some gold fish and a tadpole – (the latter Mr. Collins may, perhaps, permit me to suggest *en passant*, as he is already half a frog, is rather small for his age). But I happen to have a special acquaintance with the water plant, *Alisma Plantago*, among which the said gold fish are swimming; and . . . I never saw it so thoroughly or so well drawn. . . . For as a mere botanical study of the water lily and *Alisma*, as well as of the common lily and several other garden flowers, this picture would be invaluable to me, and I heartily wish it were mine.[50]

This is, then, Ruskin's plainer style, which, alternating with the other, sets up the reader for any number of baroque swerves into emotion. It moves with an astonishing rapidity, precisely as his caring about detail and his caring about caring have their own odd ways. The difference is no less marked in his references to truth, or to truths, that of fact or detail and that of system. To the English landscapists of his time Ruskin addresses a cautionary tale with example, sober and straightforward, about Wordsworth's feeling in the lines about the celebrated mountain daisy:

> The beauty of its star-shaped shadow, thrown
> On the smooth surface of this naked stone.

"This is a little bit of good, downright foreground painting – no mistake about it; daisy, and shadow, and stone texture and all." But let our painters beware, he says, of putting such finish all over the canvas. "The ground is not to be all over daisies, nor is every daisy to have its star-shaped shadow; there is as much finish in the right concealment of things as in the right exhibition of them. . . . the rule is simple for all that," he continues.

Now what Ruskin is *not* for concealing is emotion. In his high language, which now takes over from the straightforward, it is unembarrassed emotional strength that creates exactly that larger system of truth he so cherishes:

> if the artist is painting something that he knows and loves, as he knows it because he loves it, whether it be the fair strawberry of Cima, or the clear sky of Francia, or the blazing incomprehensible mist of Turner, he is all right; but the moment he does anything as he thinks it ought to be, because he does not care about it, he is all wrong.[51]

"As he knows it because he loves it": what more forceful statement could we ever make about knowledge or about love, literary and/or other? This sublime meditation seems to be the perfect carrier for Ruskin's celebration of the difficulty of work, the sublimity of moral passion, and the revelation of cosmic truth.

Ruskin's justifiably famous description of Turner's *Slave Ship* places, beyond all dispute, and above all question, upon "the noblest sea that Turner has ever painted, and if so, the noblest certainly ever painted by man" a ship both buoyant and bending. The sea is verbally worked to the height of the visual rendering, with its repeated alliterations and assonances like obsessive marks of fiery death. I am excerpting: "the fire of the sunset falls . . . dyeing . . . the splendour which burns like gold and bathes like blood . . . fantastic forms . . . a faint and ghastly shadow . . . the illumined foam . . . fitfully and furiously . . . flashing . . . now fearfuly dyed . . . fall upon them in flakes . . . their own fiercely flying . . . its flaming flood . . . fearless. . . ."

The conception Ruskin now lauds as daring, placed as it is, bears witness to

"the purest truth ... and concentrated knowledge of a life," and the whole picture is "dedicated to the most sublime of subjects and impressions (completing thus the perfect system of all truth ...) – the power, majesty and deathfulness of the open, deep illimitable sea." (I am quoting here from the seventh edition of *Modern Painters*. That one recent version of Ruskin's writings on art should leave out the crucial words, albeit in parentheses in Ruskin's real text – "completing thus the perfect system of all truth" – is emblematic, I fear, of what a typical twentieth-century rendering cannot stand: so much for truth of larger reference. We avert our gaze from what seems foreign, or too grand.[52])

This truth, pure and systematic, is nonetheless an emotionally held and charged one, and it is in that that it differs from the detailed but small "truth" of such Pre-Raphaelite painters as Holman Hunt, who renders every blade of grass and every moment of light as legend would have had it: "they will draw either what they see, what they suppose might have been the actual facts of the scene they desire to represent, irrespective of any conventional rules of picture-making."[53] It is rather the larger truth of caring that inspires the greatest surges of Ruskin's greatest style.

But the stress and the passion have their own peculiarities, for Ruskin's gaze can strangely avert itself from what might seem to us the center of the picture – what he looks away from is often what we are used to looking at. This characteristic has an odd effect, given the verve of his writing; the expression often used about ekphrasis – "vigor of style" – was surely never better used than in his case.

The reader/observer is usually, in the case of Tintoretto's *Susanna and the Elders*, given to contemplating Susanna as she is spied upon by those elderly eyes: our own spying is a good part of the deal. Wallace Stevens captures just this secret watching in his highly wrought poem on the subject, strung between musical chords and the vibrators of erotic desire, keyed to the strain of the whole thing. His reference to Susanna's still garden calls back the theme of the *hortus conclusus* into the poem, itself a garden and a water primed for touch and feel, as for show and tell, and then violated by an elderly bawdy baseness itself touched by Susanna's harmonies. The preservation of such beauty, escaping except from that last deathly strain, ennobles the clavier piece now keyed to praise beyond violation, into the viol strings. All this urgently requires that we see Susanna in whatever rendering we choose, but that we see her. Tintoretto saw her, at least twice; Veronese saw her; Stevens sees her; and so do we.

Ruskin, contemplating the Tintoretto and the Veronese renderings, sees Susanna's face only "quite calm and somewhat animal." He sees the grove, sees the tree trunks, sees the ivy, sees the elders seeing, sees what is in the water, but sees Susanna (or so he says, ironically or not; who is to tell?) simply as plain, and thus of less interest: "as plain as the Susannah herself." Susanna isn't Susanna, but just the central object or theme, like some table or chair:

"the Susannah." It is nature that gets all his passionate observation, including a sketch of the tree trunks, the real object of his love here:

> a magnificent grey grove, in which the bending and twining symmetry of successive trunks, wreathed with lovely, sharp-edged, exquisitely drawn ivy, is more like architecture than ever architecture was like vegetation (how utterly different in its sculpture-like severity of sentiment from flowing trunks of the same kind with Rubens) leads back in steep perspective to an opening to the sky, whence the two elders, with Tintoret's usual caprice, look over in a kind of altar cloth; the foreground is occupied by a water full of reeds and flags, and frogs, and two white nondescript fish tails; but close to the spectator, down among the reeds and water, is a dark grey animal like a rabbit, with long ears, and malignant human face. There is no doubt, no obscurity about it, it is as plain as the Susannah herself. . . .[54]

In the Veronese, he sees Susanna's posture as she sits, sees her gathering her dress, and her expressive face, and sees the laurel leaves, "exquisitely painted, natural size."[55] And from there to a consideration of how Titian does draperies, and so on. Now, my point is that what he cared about he talked about, at length, and with a pen more vigorous than almost any other. But her body makes no part of his truth system, and therefore needs no reference. It is, quite simply, quite plainly in fact, draped up and blocked out. (Too bad Effie couldn't do that for the female features that so bothered him, but that is another relation, not my story here.) So this is the other and terrible side of his caring: I cannot defend it, nor must I block it out. I see it as a sort of negative ekphrasis: he stresses for us, by his very blocking-out, what we so plainly see. His obsessive ignorance of what we find it hardest to ignore retains – in its turn – our most obsessive gaze. We now collude in spying, on them all.

Caveat lector

My text is no more innocent than those passages wherein the ellipsis makes both a lack, on one side, and, on the other, a protrusion, sensed as a too-muchness.

The large and obsessive figures, as I read them, were exactly those we could not have wanted not to notice. They are both private fascinations and public property, like some obsessive objective correlative. The *Moses* of Michelangelo and the *Susanna* with those elders watching of Veronese or Tintoretto, and that reclining *Olympia* of Manet, hold the same place as the sacred subjects or object: from the founding tablets of Mosaic tradition down to the glove of Breton's *Nadja* or Proust's Vermeer's "little patch of yellow wall," they make the same bulge in the commenting text that they make in the imagination, and thereby serve as the focus – or the fetishized moment – from

which derives the energy of the stressed reading I am placing here at the outset. They are at once concentrations of difficulty and fertile points for the reading to dip into, doubly symptomatic of unevenness and of renewal.

To show, among countless other reproductions of paintings, Tintoretto's *Susanna* and Ruskin's game with seeing and non-seeing is tantamount to stopping the rest of the show. Repeatedly, it has been proved to me, in the most different of circumstances, that every voice will be raised to discuss why he did not see, or not discuss, what is so very "plain" there before us, like some bigger statement about discourse and sight. Everything seems to pale before this pale creature, gratifying in her singledom.

Speaking of Susanna, we tend to overspeak, as if to compensate for the non-seeing of others. To the extent that we *see* Susanna, and *speak of* seeing Susanna, and want Ruskin to *see, and say he sees her*, we are complicitous with the whole system of desire in representation, and that desire at two and three removes: the story of Susanna, Tintoretto's rendering of that story, and Ruskin's partial response to that rendering. Foucault convincingly shows how sexuality is linked to language itself, and to the power of expression: "Sexuality is only decisive for our culture as spoken, and to the degree it is spoken."[56]

Purloined peeking

The issue is often the ironic and deliberate misreading Ruskin pretends to be performing, when he cannot but be seeing otherwise – that is, the way we presumably do. The ways in which we are forced into the "rational" mold are not subtle, nor do they need to be: he simply overlooks what would seem to be the point, so that we have to state it. Mariana, bending back with hand to hip, when read by Ruskin as just some backaching female, weary of just some waiting, seems to lose her whole representative status as the attentive solitary in a stance of self-deception, more poetic than pitiable. Harold Bloom says of Tennyson's "Mariana" that it is "entirely a poem of the autonomous imagination running down into isolated and self-destructive expectation,"[57] and indeed one of the more comic sidelights of the Ruskinian strategy is that we the observers and readers are forced into the momentary and hanging expectation that, for example, he will see, perhaps even remark upon, the uselessness or sadness of her waiting. not just her backache.

Such strategy is more crucial still *in regard to*, in a relooking at, Susanna's naked obviousness – whatever she is, Tintoretto's or Veronese's Susanna, she is not plain, and the strategy is not light-handed. To put her into ellipsis and place the bulge of the text in the trees and the ivy is a heavy move, handling the image and playing with the sight. First we are made to be complicitous with the peeking of the elders and then with the voice of the flat-footed reader of the scene made for such an outright stare.

As any purloined letter circulates among us, its figure larger with each infolding, and certainly larger than its apparently specific detail, its "performance of its reader"[58] is efficacious to the extent of our own interference with it, as it holds us in arrest.

In relation to Susanna – "the Susannah" plain as day, and large, and white, like some power of the naked presiding over the suppression of language – Ruskin's blocking-out serves to stress the true terribleness: the *terribilità* of the object willingly, tactically rejected.[59] (Very much the same sort of blocking occurs in Rossetti's reading, discussed in the next chapter, of the "brown faces" in Titian's *Concert champêtre*, which in his time was considered a Giorgione: naked female figures are referred to only in their "listlessness.")

I repeat, then, my claim for Ruskin as the inheritor of the celebratory ekphrastic moment, of the vigorous holding-in-stress of the object passionately ignored or observed: held up, in words, for our admiration. The objects may not be the ones we would stare at most avidly, but, just so and just there, his style serves to impassion us about what he cares about, which is – as long as we are under his truly ekphrastic spell – what we care to care about.

Who knows what surges deep beneath the odd combination of willed innocence and a sort of underlying prurience that we find in, for example, Ruskin's instructions for Kate Greenaway to make her pictures for him just so? This strange combination lends its own layering to our rereading of Ruskin.

Ruskin's touch was just as surely laid on Pater, whose own passion of presence gives its unequalled strength to his rendering of the Mona Lisa, his truest Lady Lisa. The lyric density is enhanced by the reminiscences of reminiscence, from Wordsworth, Gautier, Baudelaire, and, in particular, Swinburne – his meditation, in his "Notes on Designs of the Old Masters at Florence," on Michelangelo's drawings of a woman "beautiful always beyond desire and cruel beyond words . . . the deadlier Venus incarnate . . . Lania re-transformed . . . the Persian Amestris . . . Cleopatra . . ."; and these lines from *Rosamond*:

> Yea, I am found the woman in all tales,
> The face caught always in the story's face;
> I Helen, holding Paris by the lips,
> Smote Hector through the head; I Cressida
> So kissed men's mouths that they went sick or mad,
> Stung right at brain with me; I Guenevere. . . .[60]

Of the celebrated description of Lady Lisa, the introductory sentence was rewritten several times: what you care most about, you may well stressfully rewrite. The presence of this sentence, rising "so strangely beside the waters," itself rose from its initial "thus so strangely rose" through its "that thus rose so strangely" to the final and superbly strange and wonderful rise:

The presence that rose thus so strangely beside its waters, is expressive of what in the ways of a thousand years men had come to desire. Hers is the head upon which all "the ends of the world are come," and the eyelids are a little weary. . . . She is older than the rocks among which she sits; like the vampire, she has been dead many times, and learned the secrets of the grave; and has been a diver in deep seas, and keeps their fallen day about her; and trafficked for strange webs with Eastern merchants: and, as Leda, was the mother of Helen of Troy, and, as Saint Anne, the mother of Mary; and all this has been to her but as the sound of lyres and flutes. . . .[61]

Pater's move – itself so wonderfully strange – from such stressed writing to such fluted sound exemplifies exactly the technique that permits the holding of the poetic double image before our eyes as before our ears. The intensity of the passage depends to a large extent on exactly that temporally oriented paradox with which this discussion began, of holding what is passing. It holds, in the initial present of Presence, the weariness and legends of the past, the trouble of beauty and the absolute conviction of past legends. It is symbol by its juxtapositions, strength by its lofty interrogation, and poetic truth as Ruskin would have had it by its intense work and moral passion. It is emblematic of a delayed or unfinished[62] dreaming of the sublime – in which "something most sinister" plays over Mona Lisa's lips most unfathomably, and indeed over all Leonardo's work: this is the essence of femininity, says Freud, sending us back to Pater's ambivalent reading of Leonardo, Mona Lisa, and himself.[63]

The case of this celebratedly ambivalent lady concerns, of course, the no less celebrated ambivalence and uncompletedness of Leonardo's own attitude as interpreted by Freud, whose reading, having to do with unsteadiness and shifting positions, with incapacity for decision determined by the absent father and too-loving mother, is reread by Leo Bersani at length in his *Freudian Body: Psychoanalysis and Art*. Freud himself, says Bersani,[64] "is continuously shifting positions on the question of shifting positions," is unable to be conclusive. If "Leonardo is nowhere except in a certain readiness always to begin again his experimental representations of how and by what he has been shattered,"[65] Freud is nowhere – in his relation to Leonardo's sexuality, and in the turbulence of his theory, his fantasmatic energies released by and within the *Leonardo case*, and his paralyzing "mobility in repetition, an arresting movement of thought which somehow makes the statements of thought impotent or inoperative."[66] The obsessive impulses of an "eroticized . . . consciousness" are translated into repeated moments of instant stasis, each betraying the textual embarrassment (again, that *bulge in the text*) which marks both ellipsis and its longer, talkative, encumbering side. Bersani is developing, it may well be, an "aesthetics of masochism" in whose self-shattering, sexualized delight Leonardians can revel, as does Freud in the

subversions by literature and its repetitions of any "project of meaning in language."[67]

So the obsessing smile makes its way into the field of sight. Jacqueline Rose's *Sexuality in the Field of Vision* deals again with the *Mona Lisa* and the problem of ambiguous mysterious woman – the woman problem – as it is strangely and powerfully linked with the Gertrude problem in *Hamlet*, as T. S. Eliot read it. As the "Mona Lisa of literature," *Hamlet* poses the question of insufficiency, of that "maimed or imperfect quality of appeal" that Lady Lisa radiates. As Ernest Jones disarmingly points out, "Hamlet was a woman,"[68] and we all know how problematic that can be. Eliot deplores the unmanageability of the play, because of all that "stuff that the writer could not drag to light, contemplate, or manipulate into art."[69] The hero's emotion is, says Eliot, "in excess of the facts as they appear," and Gertrude, not disgusting enough to represent disgust, symbolizes the aesthetic failure, as he sees it, of the play, and is thus the cause of failure in the representation itself, as it is different, deficient, and repetitious. She is, for him, paradigmatic of all women, inscrutable in her femininity like Mona Lisa: in short, she incarnates, in her excess, all the difficulties of interpretation. "Good and wicked, cruel and compassionate, graceful and feline she laughed" (Rose,[70] citing Angelo Conti, citing Freud, in a notable distancing from all origin – thus holding the smile at arm's and thought's length). Gertrude is unreadable for Pater, for Freud, for Eliot, for us, until, says Rose, "The principal danger, femininity, thus becomes the focus for a partly theorized recognition of the psychic and literary disintegration which can erupt at any moment into literary form."[71]

Excess, ambivalent excess, as what woman is, and what Hamlet partly is, is the source of creativity: D. W. Winnicott's "Creativity and its Origins" maps out the enabling space as that feminine locus originally created by the mother – before representation takes place – and ends with a move towards *Hamlet*, which André Green then takes up in an integral interpretation of cross-gendering:

> Writing *Hamlet* had been an act of exorcism which enabled its author to give his hero's femininity – cause of his anxieties, self-reproaches and accusations – an acceptable form through the process of aesthetic creation. . . . By creating *Hamlet*, by giving it representation, Shakespeare, unlike his hero, managed to lift the dissociation between his masculine and feminine elements and to reconcile himself with the femininity in himself.[72]

But, notably, the self is still very much cloven, the feminine very much negativized. The problem of the play – and the reflection that smile casts upon it – has in any case, quite clearly, to do with difference. Lacan places it, as Rose points out, "in the symbolic, on the side of the father we might say; Green in the 'before' of representation where the mother simply *is*.[73] The problem of the "regulation of subjectivity, of the Oedipal drama and the

ordering of language and literary form . . . is not, to put it at its most simple, the woman's fault."[74] It is hard, I do hope, to take the opposite point of view – but not unusual.

Finally, Rose points out that Hamlet can be, and has been taken as, a certain model of the European mind. "Western tradition, the mind of Europe, Hamlet himself – each one the symbol of a cultural order in which the woman is given too much and too little of a place."[75] It is perhaps here, in relation to that order and to the order of representation it relies upon and is obsessed by – as instanced by these choice moments of ironic, ambivalent, magnificent arrest – that we should take to heart Freud's "factor of doubt," letting it hover everywhere over the tales we tell, and the showing we must do.

Material work

The working-out of the problematic holding of the instant may be mirrored in the difficulty of working the poetic material: the despair of living may find itself caught in the momentary intensity so joyously paradoxical. Yeats wrote a singularly revealing letter about both materials that serves to illuminate his great poem "Lapis Lazuli," that tribute to the triumph of human perseverance in the midst of suffering:

> All things fall and are built again,
> And those that build them again are gay.[76]

Speaking of the piece of stone, on which three Chinamen sit playing their instruments upon a slope, playing mournful melodies with glittering eyes, Yeats describes the present he has received of a great piece of lapis carved by some Chinese sculptor, on which every discoloration or crack seems a "watercourse or an avalanche." It is carved, he says,

> into the semblance of a mountain with temple, trees, paths and an ascetic and pupil about to climb the mountain. Ascetic, pupil, hard stone, eternal theme of the sensual east. The heroic cry in the midst of despair. But no, I am wrong, the east has its solutions always and therefore knows nothing of tragedy. It is we, not the east, that must raise the heroic cry.[77]

Now, what has happened to our texts of heroism in our own moment? How can we express or use our passages of halted action and passion, about tragedy as about triumph, without embarrassment? It is easier to reduce our concern to a specific focus about reference or self-reference. We are thus reduced.

Twenty years after the Yeats letter just quoted, Auden (in "The Shield of Achilles") gives a response, as heart-rending as it is convincing, to the upbeat inspiration of Achilles' shield with which the ekphrastic tradition took its start. He imagines, upon the gold and silver and other metals on that shield,

the deliberate artifice of Hephaestos replacing the natural scene he had once rendered both durable and natural by artifice itself, replacing the dancing-ground by a bare weed-choked field and barbed wire, replacing a time of peace by a time of war. This is the terribly present answer, in 1955, to the Greek sense of possibility gathered in poetry, as the goddess Thetis gazes stricken at the armor her son is being given. We are given just to gaze at it with her, helpless all of us:

> She looked over his shoulder
> For vines and olive trees,
> Marble well-governed cities
> And ships upon untamed seas,
> But there on the shining metal
> His hands had put instead
> An artificial wilderness
> And a sky like lead.
>
> . . .
>
> The thin-lipped armorer,
> Hephaestos hobbled away,
> Thetis of the shining breasts
> Cried out in dismay
> At what the god had wrought
> To please her son, the strong
> Iron-hearted man-slaying Achilles
> Who would not live long.[78]

Upon this new armor befitting a bereft peaceless universe, the artificer represents the only world he knows, for he had never heard

> Of any world where promises were kept,
> Or one could weep because another wept.

The hardness of the material backdrop for the painted, carved, or imagined scene seems to be a constant in this tradition, whether it concerns a shield of many and raised metals, as in Homer and Virgil, the walls of a temple as in Chaucer, a single stone wall, as in Dante, the walls of a cheap hotel room as in Saint-Amant, on which the spittle must do the inscribing, or the hardness of lapis luzuli in Yeats's poem by the same name.

Hardness corresponds, mentally, to difficulty, and to the ultimate value of what is inscribed upon it, or made from or through it, publicly or privately, in our own passionate inscriptions.

Stressing moral passion

Something about the privacy and the public nature of art remains far more than just another highly vexed issue. It calls for urgent address, by all of us. The distinction between private and public discussion or display is aggravated beyond measure when it is a question of such delicate questions as how we are, now, all these years after Ruskin, to conceive of "moral passion." Ruskin's term and Ruskin's attitude are likely to undergo, to have already undergone, the same fate as the shield Homer, along with Hephaestos, made for Achilles, changed by the hands of Auden and taken into the thought of all of us. We are unlikely to use such terms without embarrassment, unlikely to have or be able to borrow or to forge the weapons to deal with them.[79]

This is not because we have no nostalgia for nobility, or passion, or for the miraculous naïveté of Ruskin's odd and mad brand of purity, ironic or not; but because this reaction is not, in any case, something we know how to speak about. It is not available to semiotic display or analytic ardor, only to an inner responding passion probably impossible to illustrate, and visibly translating itself only as a stress. Were I pressed to illustrate it, all the same, I would take a particular passage from Bach's *Musical Offering*, that strange and repeated heartrending descent of the scale, sounding *other* and oddly off-key.

Or, in a more familiar context, I would take a highly private passage from the diary of Dora Carrington, who so wonderfully and – in the eyes of the world and Bloomsbury – stupidly loved Lytton Strachey, who could not love her. On January 1, 1916, she writes an entry at once for Lytton and for herself, about her extraordinary picture of him reclining with his long fingers around a book – the portrait could only have been painted by someone as much in love as she was. Of it, of her love for it, of the indecency of anyone's else's seeing it, she has this to say; about her showing and non-showing, she has this to tell:

> I wonder what you will think of it when you see it. I sit here, almost every night – it sometimes seems – looking at your picture, now tonight it looks wonderfully good, and I am happy. But then I dread showing it. I should like to go on always painting you every week, wasting the afternoon loitering, and never showing you what I paint. It's marvellous having it all to oneself. No agony of the soul. Is it vanity? No because I don't care for what they say. I hate only the indecency of showing them what I have loved.[80]

Not to want others to see one's picture-as-possession, and the only possible one, reminds us of Balzac's Frenhofer, in "Le chef d'oeuvre inconnu" ("The Unknown Work of Art"), erasing what he had lovingly painted, until only the trace of a foot remains – this fragment only, for fear of, for panic of, some showing. Carrington's particular passion far transcends a loving obsession, to enter that realm of individual artistic truth where Ruskin joined with Turner in

a double celebration easily surpassing the subject itself. We know this from looking at the portrait, but would probably have known it simply from reading Carrington.

Far more celebrated, Virginia Woolf's verbal picture of Lily Briscoe's painting of Mrs Ramsay in *To the Lighthouse* is in itself emblematic of such passion, as she undertakes it, struggles with it, presents it, and completes it with the completion of that novel than which there is none more moving.[81] Her painting of Mrs Ramsay and James, with its implicit reference back to the beauty of Julia Duckworth (a dangerous because partially impossible nostalgic emulation by depiction), with its explicit backdrop of all the tradition of Madonna and Child (Michelangelo's creation behind her, draped with a green shawl), is nonetheless her private creation; the dread of its public contemplation, even by one pair of eyes, those of Mr Bankes, is no less intense than Carrington's dread of the intrusion of another gaze upon what she had so greatly loved:

> He had put on his spectacles. He had stepped back. He had raised his hand. He had slightly narrowed his clear blue eyes, when Lily, rousing herself, saw what he was at, and winced like a dog who sees a hand raised to strike it. She would have snatched her picture off the easel, but she said to herself, One must. She braced herself to stand the awful trial of some one looking at her picture. One must, she said, one must. . . . But that any other eyes should see the residue of her thirty-three years, the deposit of each day's living mixed with something more secret than she had ever spoken or shown in the course of all those days was an agony. At the same time it was immensely exciting.[82]

In this erotics of hiding and revelation, the stress is evident and entire. That is, no doubt, what it is like when creation first coincides with love, and, later, when private anguish leads to the art and artlessness of public exposure and all the exultant agony of that. The revelation of one's love: that must surely be the closest thing to Ruskin's morally passionate involvement in his celebratory writing. It is, I think, protected from indecency by just that passion.

What does it matter what the referent object of one's love is called: Turner or Lytton Strachey or Mrs Ramsay? It is the very engagement of rendering, in paint or words, that visual love that matters and informs the rest of living and working, and, probably, dying. Carrington committed suicide shortly after Lytton's death, and wrote, shortly before that, how she thought Virginia Woolf would most understand her, Virginia who ended as we know.

And it is that intense caring that enables us all to respond to such passages as the final celebration in words of Lily Briscoe's Lighthouse canvas, placed there before all of us, exposed but without the slightest indecency, showing and telling, as if love were always to provide its own passionately private morality, stressing what is most secret about seeing:

Quickly, as if she were recalled by something over there, she turned to her canvas. There it was – her picture. Yes, with all its greens and blues, its lines running up and across, its attempt at something. It would be hung in the attics, she thought; it would be destroyed. But what did that matter? she asked herself, taking up her brush again. She looked at the steps; they were empty; she looked at her canvas; it was blurred. With a sudden intensity, as if she saw it clear for a second, she drew a line there, in the centre. It was done; it was finished. Yes, she thought, laying down her brush in extreme fatigue, I have had my vision.[83]

Whatever it is that enables our work to find the infusion of our greatest and most moral passion, of our clear and most sudden intensity, for whatever or whomever it is that we have cared and do care about, that is the one point of stress that is not subject to mockery even if exposed. Passion has, of course, nothing to do with the intrinsic value of identity of referent, little to do with what the world perceives as the worth of the subject, but only to do with what it makes of us. This is the danger and the value of personally passionate criticism, and upon this further debate will turn.[84]

The work of stress, as I see it, that work I want to celebrate in closing, has nothing to do with Turner's artistic talent for the painting of slave ships, with the real or pictured Lytton's bookish intelligence, or with Julia Duckworth's or Mrs Ramsay's beauty in radiance. Those are things *other*, our starting points only. Where we go on to, in picturing, writing, and working, is what matters, and that is where enabling passions matter: those no one can choose for us. They should and must matter for each of us and what we work at, and work at loving, believing in, and caring about, now and without apology. If that very statement is unexplicit, embarrassing or overwrought, so, often, is art.

20

NARRATIVE VOICE and SECOND READING: RELATION and RESPONSE

What concerns me, in the issue of interference, is finally the reading of the two texts, visual and verbal, and our relation to them, as reader of this double object and as willing subject. I intend both senses of the expression "willing": we are willing to be the ones looking doubly, but also wish to retain our own control over our perception and reception. We would, to the extent it is possible, assure a multiplicity of viewpoints and nuances in our reactions, choosing to look at the object not just by the leave of the artist and the writer, but by our own will to see, taking the latter as a success verb.[1]

My initial supposition goes as follows: in each work of art, there are posed implicit questions, some of which the keen observer – writer or critic – will feel impelled to answer, whether consciously or not. There may of course be a prior conception on the observer's part of what the object to be read will be read as, in which case the work observed will serve simply as a vessel for that subjectively held idea, receiving what is projected upon it. Into that holding, in the more interesting cases of reading, the antiphonal response set-up of implicit question and partial answer will be put in play, folding in, making a *pli* or pleat for further *complication*. The very density resulting from projection, interrogation, and answer all doubling in upon each other provides the sort of written text that elicits the most intense responses, of any genre.

Call that, then, the first reading. Now my own point of focus, or my singular working problem, concerns the reaction of the second reader, the comer-after. This belated reading, to borrow for my own different purposes a Bloomian term,[2] may undergo a particular stress in the case of a response to an unusually strong first reading, strong in its particular view or in its vitality of statement or both. And, to push this one step further, the case of poetry, whether in verse or prose, poetry as designating felt intensity and heightened

This essay was published in *Politics Today*, 10:2 (1989).

expression, may, and certainly should, call into being a dynamics of response unlike any other. It is the second reader's involvement in that dynamics that forms what we could term a *problematics of response*. It has to be understood, therefore, as applying in special cases and as stirring up special perplexities, complications with pleats only some of which can be unfolded, even partially.

Special pleating

In the cases I have chosen, some illustrate work, some the work of celebration, and some that more quiet work of meditation. The former cases can be seen as turned towards the exterior – the world of work, of the singing of that work, and the rest from it – and the others as turning towards the interior, that silent world where the soul or its representation turns towards the center of its being, within. In this and the preceding chapter, the double texts considered are half formed of a poetic reading so strong as to pre-empt, as it were, the space of our own belated commentary, or reading-after. We do not just read after Michelangelo and Tintoretto, for example, not just after Brueghel and Titian, de La Tour and Courbet, but after Browning, Ruskin, and Rossetti, after Williams and Char. The problematics of our response is implicitly concerned with the rejection of the reader, and in some cases even the artist, from the world of the work itself, from the labor and from the meditation: where have we our place, in a world whose limits exclude us by definition? The issue here is that of prior reading, in several layers of complication.

Additionally, it may be seen to concern a certain possible resistance to the narrative voice of the *first* reader telling us how to read: where do we place ourselves in relation to this poetically voiced command? A poetic reading – whether in prose or in poetic form – is, I think, likely to exercise a more powerful sway over us than a flatter reading. The interrogative form – where do we place ourselves? – is used here deliberately, as I reflect upon my or our reading. It demands not one, univocal answer, but rather that we consider a fuller range of the problematics of response by which and to which this reflection is, literally, entitled. Setting a title may serve the purpose of putting down a rubric for reading (in) one's own voice.

Each of the texts involved will bring up a special problem, and none will find what in prose readings might be thought of as resolution. Poetry and the poetry of responsive reading are both concerned with the unresolved, in my view – scarcely an original one on this point, but nevertheless one that bears restating. They draw their very density from their continuing question. And the crux of the poetic predicament is precisely how to hold that question as an intensity of *unresolution*, different in every way from *irresolution*. This resolve to distinct and unrelenting unresolution will not allow the second reading to capitulate to the strength of the narrative poetic voice; will, in fact as in theory, hold to complication or the folding-in of a problematics, as

opposed to a subordination or a folding under its sway. This could be considered, from a feminist point of view, as just a further chapter in a continuing study of the resisting reader.[3]

Working, keeping, and holding close

What we show, what we work at, and what we lay our stress upon we can be presumed to want to share – ekphrastic moments are just the moments held in a collective consciousness. They can be told of, and they can be grasped in some sense, even if not always understood. That sense of their sense surrounds them and makes them available for our perception or work of reading. Just so, working poems, celebrating function or process, stress the difficulty of it all, exercising an especial grip on reading. I am choosing, among so many others, two working poems by William Carlos Williams on Brueghel's paintings; these show us how to read even as they tell us how a painting is organized. Within all these poems, in fact – and some of us have tried to point this out – there importantly figures a good deal of surrounding and metapoetic material, around a center that shows, tells, or both. Pictures *from* Brueghel, after all, not the pictures *of* Brueghel or *by* Brueghel: I want to read the preposition as both showing us what to look at and telling us what is taken from what, as deictic and narrative.

Brueghel's and Williams's "Haymaking" and "The Corn Harvest"

The first poem of working I want to meditate on is "Haymaking," responding to the painting of the same name in a correspondence that responds to all Brueghel's painting and reaches it at its own depth.

> The living quality of
> the man's mind
> stands out
>
> and its covert assertions
> for art, art, art!
> painting
>
> that the Renaissance
> tried to absorb
> but
>
> it remained a wheat field
> over which the
> wind played

men with scythes tumbling
the wheat in
rows

the gleaners already busy
it was his own –
magpies

the patient horses no one
could take that
from him[4]

This poem grows with us, in our own age, dealing as it does with what cannot be taken away. Beginning in the present, it begins with living, with the living mind, that same alert mind dissatisfied and standing out against all others and in front of the landscape, material and mental, that it chooses for itself visually and verbally. The only living and enduring assertions that can be made for art, art, art! or any other exclaimed thing must be at least in part covert. Because Williams so rarely uses punctuation, because we are used to his intertwining verses that lead on and on, the commas and exclamation point of this phrase here are the quiet poetic equivalent of breath-taking.

Now, when we tell our students what Mallarmé's students wrote on their blackboard, to laugh at it, they are not surprised. There Mallarmé's students wrote the overt statement as a repetition of his own, his repeated and overt assertion about what he saw: "L'Azur! L'Azur! L'Azur! L'Azur!" So, Williams's poem, the only almost-overt statement of the covert assertions of art (phrased remarkably as "art, art, art!") refers us back to the tradition of open and closed celebrations, artistic and other. Here the wonderfully paradoxical juxtaposition of the expression "stands out" with the verbally open assertion of the covert caring in Brueghel's mind prepares the no less wonderful struggle by the Renaissance to comprehend what it could not, and we cannot fully, take in. What remains to be wondered at, then, is Brueghel's own rendering of the play of wind and work of men, his great work about work, always only his own. As the surprise of the exclamation point worked before in relation to our knowledge of Williams's own style, here a strong dash after "it was his own" stresses the fullness of that stop, even through the centuries of time-taking. What cannot be taken from him, or, again, from us, is that painting and living, both mental and physical. But – and of course this is what we still do wonder at, through Williams and in Brueghel – the now open assertion that there is something that cannot be taken from him or us creates it as fully for us as for him, makes it our own through its being his. These perceptions of the moment as they are lasting, and this preserving art as it is moving, are what cannot be taken from us, even in a time of loss.

The second poem is "The Corn Harvest":

> Summer!
> the painting is organized
> about a young
>
> reaper enjoying his
> noonday rest
> completely
>
> relaxed
> from his morning labors
> sprawled
>
> in fact sleeping
> unbuttoned
> on his back
>
> the women
> have brought him his lunch
> perhaps
>
> a spot of wine
> they gather gossiping
> under a tree
>
> whose shade
> carelessly
> he does not share the
>
> resting
> center of
> their workaday world[5]

In this rereading by Williams of Brueghel's *The Corn Harvest* (or *The Harvesters*) (plate 20.1) in the heat of this summer season so exclamatorily announced, the problem is exactly the complete separation between the shade and the sun, the nourishers and the nourished, the female and the male, each designated as connected with some centrality. The male is said by the poet to be the center of the painting – "the painting is organized / about a young / reaper" – and indeed he occupies the central position, and the primary one in the poem. Just as the world of his work is distinct from that of the women's work, the nourishing work – "they have brought him his lunch / perhaps / a spot of wine" – they are represented as having a center from which, as from the shade marking off their limits from his, he is apart. He is resting sprawled near the tools and the results of his labor, and they, in some sense, are shown with theirs.[6] He appears, in fact, dead, and they are like watchers by the body, at some noon wake.

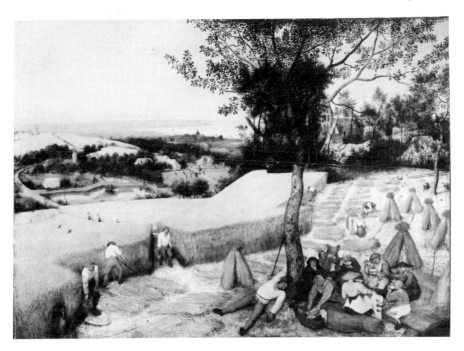

Plate 20.1 Pieter Brueghel the Elder, *The Harvesters (July)*, The Metropolitan Museum of Art, New York, Rogers Fund, 1919 (19.164).

Yet the question of the division of male and female worlds might arise for some readers in relation more to the poem than to the painting. Working, resting, bringing, eating, shading, sunning – these might not necessarily seem to demarcate the world of women from that of men until we read the poem, where the two domains are separate and distinguished as such. And separated exactly at the moment of repose, where the verb "sharing" is in fact further marked by the structure of the poem's own tools, its language. The ambiguity of the expression "under a tree / whose shade / carelessly / he does not share the / resting / center of / their workaday world" makes him, ironically, not share in the visual or verbal representation of either of the parts of the sentence he linguistically shares.

Just so, the second reader, divided between the two centers, is perplexed by having to hold the two readings, to share, as it were androgynously, in the two centers, to resist both, in resisting any noonday repose from this textual *relation* of visual and verbal facts. The ambiguity works perfectly, however, to highlight the divisional consciousness that gender reading is heir to: this is, in a sense, the problem of all of us, and will not take shading. The stress of the poem and of the reading lies just here.

Courbet's and Char's "Les Casseurs de cailloux"

If we compare René Char's difficult response to the lost Dresden version of Courbet's *Les Casseurs de cailloux* (*The Stone-Breakers*, plate 20.2), it seems hard as those stones, as unbreakably hard as the life of the sand of the path and the straw for the wine basket seems easy. The wine in its straw basket is brought, with some difficulty, by the girl at lunchtime to the father and son laboring. But the poem places, by its difficulty, a hermetic stress upon the viewing of picture and of poem, not unrelated to final value.

> Sable, paille, ont la vie douce, le vin ne s'y brise pas.
> Du colombier ils récoltent les plumes,
> De la goulotte ils ont la langue avide.
> Ils retardent l'orteil des filles
> Dont ils percent les chrysalides:
> Le sang bien souffert tombe dans l'anecdote de leur légèreté.
>
> Nous dévorons la peste du feu gris dans la rocaille.
> Quand on intrigue à la commune,
> C'est encore sur les chemins ruinés qu'on est le mieux.
> Là, les tomates des vergers, l'air nous les porte au crépuscule,
> Avec l'oubli de la méchanceté prochaine de nos femmes,
> Et l'aigreur de la soif tassée aux genoux.

Plate 20.2 Gustave Courbet, *Les Casseurs de cailloux*, 1851, photograph supplied by the Archiv für Kunst und Geschichte, Berlin. The painting, formerly in the Gemäldegalerie, Dresden, was destroyed during the Second World War.

Fils, cette nuit, nos travaux de poussière
Seront visibles dans le ciel:
Déjà l'huile du plomb ressuscite.

(Sand, straw, have an easy life, wine doesn't shatter in them
They gather feathers from the dovecote
Their tongue is eager for the gullet
They slow the girl's toes going
Whose chrysalids they pierce
Blood fitly suffered falls in talkative lightness

In the rock we devour the grey fire's plague
When gossip spreads in the town
We fare better even on ruined paths
There, a breeze brings us orchard tomatoes at twilight
A disregard for our wives' nastiness
And thirst's sharp taste amassed in our knees

Son, tonight, our works of dust
Will be visible[7] in the sky
Already oil returns to life from lead.)[8]

The poem's hardness relates above all to the transcendence of the real work of constellations beyond the dull dailiness of the actual labor. This is the point about what is shown and felt – what it pushes towards, by its effort. For this initially modest, if somewhat covered, reflection on the modest themes of human labor and human thirst, on the passers-by and the paths by which they pass, on the work itself, is suddenly raised into massive dignity by the father's announcement to the son of the far from workaday results, as the final image, of his creation also, serves to transport the imagination skyward to the stars. This is what the work of the poem seems to be about, that returning to life. It is also, of course, about our own perception – that is to say, our work of reading.

In rereading this canvas, in the light of René Char's poem about it, we are struck by a repetition of the Brueghel–Williams problem. The world is, once more, supposed as double: the girls bringing the lunch to the men working, chatting as they come along, are marked out as "light" in every way, by their talk, rather like the sand and straw of the bottle in which the wine does not shatter. Their domain, unlike that of the man and boy involved in serious labor, with rocks and pickaxe, is both light and trivial, is of the "father-gathering" variety. The older women, as absent from the actual painting as the younger ones, are supposed as nasty and – by extension – as participating in the gossip and the intrigue, far from the hard work on solid things the man and boy are pursuing, on these ruin-filled roads that test a manly character. The painting is, of course, related to the revolutionary realism of Courbet's own stone-breaking courage, part of Char's point in commenting on this particular lost canvas.

Now the point is, I think, double. The world of work, that of men, is separated, gravely distinct, from that of the women, which is only supposed, and added in supplement as in supposition. Supposed in its gossip, its nastiness, its lightness, whereas the male world, both pictured and presented in the poem, is that of hard work, thirst, and dust. Readers of René Char will remember another poem, "Les Lutteurs ("The Strugglers"), wherein the comradeship of the heroes of work is felt in the exchange of their masculine handshake, and in the sweat shining upon them, like the reflection of so many stars. Here again, of course, the work of dust is uplifted towards the work of the heavens:

> Fils, cette nuit, nos travaux de poussière
> Seront visibles dans le ciel;
> Déjà l'huile du plomb ressuscite.

Two separations, then: the separation of the world of the night, tonight in fact, from that of today, where all that is visible is dust, and that of the world of men from that of women, those gossiping, nasty creatures.

That is, a certain simplification of the male and female domains seems to be taking place, and the reader may well be troubled by it. What about, for example, the place of female work, single or collective, when it is not involved in nourishing the Other? Do anecdote, gossip, and mischief necessarily comprise the female lot, or are there some roads we can work on and not just some paths we are invited to bring lunch upon? Is there some transfiguration of female work into a meliorated status, equivalent to the dust rising to celestial stardom? What we *see* in the composition is only the male labor, young and older: *added* are the heroic perspective on the two generations of laborers, the political intrigue of the community, and the chatter and negative comportment of the female. We know this heroic *stance* already from the poems of Char, whose division of the world seems highly gendered: demonstrated, for example, in the poem "Louis Curel de la Sorgue," where the reaper stands profiled high against the land, larger than a whole village. We learn to read, in a group of poems, a certain stance, a way of figural standing. The second reading we do is required at least to respond to this sort of first reading, in its presuppositions about the division of labor and its supplement concerning the relations of person, role, and gender, as well as what it thrusts into the foreground, what it throws into highlight and into relief, or casts into the shadows, what it rests from and works at.

In the painting, there is more to trouble us. As Linda Nochlin points out in her study of Courbet, even as the large-scale format threatens to make a political statement about work, the handling of the topic prevents any glorification of it. Unlike Millet's pictures, which in general have an implication of something beyond the performance of a routine task, suggesting a comforting religious and moral beauty, a sense of the continuation of labor as value, Courbet's *Casseurs de cailloux* lacks "reiterations of meaning in the

richly-detailed landscape . . . rising up behind the figures rather than fading away poetically in some infinite distance behind them."[9] The figures are not visibly joined together according to "traditional concepts," and in fact the folds of material and the neckscarf cover the places where one might have seen some articulation between their parts. The attention is held neither by articulated interest, nor by focus: the lines of the tool handles disperse the concentration.

Similarly, T. J. Clark points out how the details of the two figures' clothing register the substance of the body beneath them, as the old man's waistcoat rides up his back, or the shoes gape open on the socks gone blue. And the thick, resistant folds of his trousers at knee and thigh work in the same direction, making this

> a painting whose subject is the material weight of things, the pressure of a bending back or the quarter-inch thickness of coarse cloth. Not the back's posture or the forms of cloth in movement, but the back itself and the cloth in its own right. Pressure, thickness, gravity: these are the words which come to mind. . . . But the image he gave us is rather different from what this implies. It is an image of balked and frozen movement rather than simple exertion: poses which are active and yet constricted, effort which is somehow insubstantial in this world of substances. What Courbet painted was assertion turned away from the spectator, not moving towards him: it is this simple contradiction which animates the picture as a whole.[10]

The point was to show an image of labor gone to waste, turned stiff by routine, says Clark, making a harsh summary of the whole: here, he says, "men are things, and the things ugly and monotonous."[11] Indeed Courbet, writing of his intentions in this picture, states that it is composed of two people very much to be pitied: "deux personnages très à plaindre . . . une vieille machine raidie par le service et l'âge . . . par la poussière et la pluie . . . un jeune homme [qui] a aux pieds les vieux souliers de son père qui depuis longtemps rient par bien des côtés" ("The old man is like a machine, hardened through working and age, by dust and rain, and the young man wears the old shoes of his father which have been out on both sides for a long time").[12] He has invited the two into his studio to model for him, and, observing their aspect, makes the following remark, ambiguous in interpretation: "Hélas, dans cet état c'est ainsi qu'on commence, c'est ainsi qu'on finit." This has been interpreted as, "If you start that way [like the young man, considering he seems to have more energy], you finish like that one [the old man]" and as an even more despairing cry: "You begin like that, you end like that" – not a statement about youth and age, but one about social class and desperation: out of this state, there is no way. The remark is, in either case, an outcry against hopelessness, and without hope.

A sort of lyric revolutionizing can of course be applied to the painting. Max

Buchon's advertisement on June 7, 1850, in *Le Peuple, journal de la Révolution sociale*, tells us to notice the tobacco pouch, with the friendly offer of sharing for whomever comes; and likewise the soup pot, with its spoon and black bread, and so on. And in *L'Evénement* on March 11, 1866, we find a recollection of the youthful reaction in 1851, by those eighteen and younger:

> All at once we stopped in front of a canvas which, in the catalogue, was called *The Stonebreakers*, and which was signed in red letters: G. COURBET.
>
> Our emotion was profound.
>
> We were all enthusiasts. It was the time when heads were brim-full of ideas! We had a deep-rooted respect for everything that suffered and was defeated, and we asked the new art to play its part in the triumph of justice and truth.[13]

But Courbet's own refusal of the transcendence of this scene by any horizon, material or psychological, is categorically stated: "that's the way you end up."

It is all the more difficult to see, then, how the view in and of the poem, which seems to have the narration read itself as optimistic, as sky-reaching and life-enhancing – tonight, our works will be visible in the heavens – is to be either resisted or rescinded. The poetic *hold* on our reading may be, like this one, so strong as to compel our viewing the picture in its light, even as we know the prose versions to be more veridical; the stress exerted by their opposition may serve to concentrate the energy upon the text, which is, I would think, the point of the process of dialogic reading.

Moving towards meditation

Mantegna's Parnassus *and Rossetti's "Dance of Nymphs"*

A Dance of Nymphs, by Andrea Mantegna; in the Louvre

(It is necessary to mention, that this picture would appear to have been in the artist's mind an allegory, which the modern spectator may seek vainly to interpret.)

Scarcely, I think; yet it indeed *may* be
 The meaning reached him, when this music rang
 Sharp through his brain, a distinct rapid pang,
And he beheld these rocks and that ridg'd sea.
But I believe he just leaned passively,
 And felt their hair carried across his face
 As each nymph passed him; nor gave ear to trace
How many feet; nor bent assuredly

His eyes from the blind fixedness of thought
 To see the dancers. It is bitter glad
 Even unto tears. Its meaning filleth it,
 A portion of most secret life: to wit: –
Each human pulse shall keep the sense it had
With all, though the mind's labour run to nought.[14]

One of the odder elements of the Pre-Raphaelites' version of the relations
between the visual and the verbal is a drastically visible undoing of the
evidence of relations themselves. When we look at the poem Rossetti wrote
about a portrait he says he has painted previously, and we know that the
presumed portrait is an impossibility, because he would have been thirteen
years old, and the woman he says it was done for he hadn't even met, the very
reflection upon that portrait in the text is bound to give non-referentiality a
good name. The poem is called, outright, "On Mary's Portrait Which I
Painted Six Years Ago." Now it does not much matter that he didn't, and that
he didn't in any case know the woman of whom it is purported to be the
image; but quaint to the point of funny, in this light, is the beginning of the
poem with its positive assertion:

 Why yes: she looks as then she looked;
 There is not any difference;
 She was even so on that old time
 Which has been here but is gone hence.[15]

We would have little grace were we to say, why no, she's not like that; there he
is, gazing backwards at the portrait, thinking of the times when he saw her
thus: does it matter that he didn't? The truth value of the statement is surely
less important than the verse value and the preservation of the legend:

 So that I gaze round from my chair
 To see her portrait where it stands. . . .
 I mind the time I painted it.
 Drinking in Keats – or Hunt mayhap. . . .[16]

There is, we would love to point out, a difference between the poet Keats and
Holman Hunt the renderer of details in art. But he might as well drink in both;
the mixed reference is not one that should bother us, true or false. What is,
after all, false in reference?

And his other poems seem frequently, emblematic as they are of Pre-
Raphaelite thinking, to be refusals of this and that. Rossetti's poem "A Dance
of Nymphs, by Andrea Mantegna; in the Louvre" is framed by a statement
about the incapacity of the "modern spectator" to interpret this picture which
"would appear to have been in the artist's mind an allegory." The poem itself
begins with an uncertainty about the meaning reaching the mind, even though
the body, leaning passively, keeps its own sense. It already begins by refusing:

"Scarcely, I think; yet indeed it *may* be / The meaning reached him. . . ." What fills that imagined visual text with meaning is that, even in the mind's absence of futility, another *sense* remains. That, we presume, is the sense of the poem as of the pulse. It is quite as if such corporal and sensuous joys were to depend on this particular delight in the mind's labor running to nought. You would think we could not think and feel simultaneously.

In fact, however, these nymphs are not dancing about by themselves in their own painting, but rather in Mantegna's *Mars and Venus*, otherwise known as *Parnassus*. So much, again, for reference. To delight in mental undoing is as odd as it is stressful. Odder and more stressful still is the writing of silence to respond to the necessarily silent picturing. Pictures may speak, but it is on their own terms; poems that, in response to pictures, refuse that voice, open another and more complicated stress route. So that this mental allegory, as Rossetti would have it, is already included in another allegorical surround, like a dance danced about. There is a further step: Yeats's "Her Vision in the Wood" pictures the same dance, still in a sense "thoughtless":

> All stately women moving to a song
> With loosened hair or foreheads grief-distraught,
> It seemed a Quattrocento painter's throng.
> A thoughtless image of Mantegna's thought.[17]

We are in any case not enjoined to further thinking; all art aspires, says Pater, to the condition of music, the direction in which this celebration of rhythm surely is meant to move us. This meditative scene introduces a still more problematic one.

Titian's Fête champêtre *and Rossetti's "Venetian Pastoral"*

A Venetian Pastoral, by Giorgione; in the Louvre

(In this picture, two cavaliers and an undraped woman are seated in the grass, with musical instruments, while another woman dips a vase into a well hard by, for water.)

> Water, for anguish of the solstice, – yea,
> Over the vessel's mouth still widening
> Listlessly dipt to let the water in
> With slow vague gurgle. Blue, and deep away,
> The heat lies silent at the brink of day.
> Now the hand trails upon the viol-string
> That sobs; and the brown faces cease to sing,
> Mournful with complete pleasure. Her eyes stray
> In distance; through her lips the pipe doth creep
> And leaves them pouting; the green shadowed grass

Is cool against her naked flesh. Let be:
Do not now speak unto her lest she weep, –
Nor name this ever. Be it as it was: –
Silence of heat, and solemn poetry.[18]

In his response to Titian's *Fête champêtre*, Rossetti, along with his contemporaries in the nineteenth century, attributes this ancestor of Manet's *Déjeuner sur l'herbe* to Giorgione.[19] A feature of half of the first versions of these "Sonnets for Pictures" published in *The Germ* is a prose description prefacing the text (see above), and it makes an odd contrast, in its unadorned style, with the relatively ornate text following.

Both the early and later versions of the poem accentuate the slowness and listlessness of the gestures and of the nature they are involved with: the water gurgling in, or sighing, the heat lying still, the slow dipping of the vessel and the hand trailing, as the eyes stray, the faces cease singing, and the lips stop piping. The ambiance is intentionally devoid of action and concentration: the eyes are vague, the music just sobs a bit to match the gurgle of the water, and the heat marks a blue pause. Everything is as soft and understated as the shadow of the grass on the bare female flesh. To this remarkably static rendering of a musical representation, about which Walter Pater remarks that all art should aspire to this musical condition, there corresponds a demand on the part of the poet that the observer – of the painting, of the poem – be as silent, as struck with dumbness and inaction as the inhabitants of the pictured landscape. No word, no action, no disturbance: the anguish of the natural solstice is to be met by the stillness of the human.

Water, for anguish of the solstice, – yea,
Over the vessel's mouth still widening
Listlessly dipt to let the water in,
With slow vague gurgle. Blue, and deep away,
The heat lies silent at the brink of day.

The second version even shifts the initial mild yea-saying to a double nay-saying, followed by an injunction to listening and to silence, put as a command, thus, four times:[20]

Water, for anguish of the solstice: – nay,
But dip the vessel slowly, – nay, but lean
And hark how at its verge the wave sighs in,
Reluctant, Hush! beyond all depth away
The heat lies silent at the brink of day.

The first version, less hortatory, ends with the definition of the painting itself as a poem:

Let be:
Do not now speak unto her lest she weep, –
Nor name this ever. Be it as it was: –
Silence of heat, and solemn poetry.

The second ends, I think more weakly, with the static scene uplifted from still-ness and solemnity into absolute everlastingness: "Life touching lips with Immortality."

The ceremony of nudity, then, was met in the first instance by that of the utter solemnity of non-utterance, further qualified as that of poetry itself. The second plays on the silencing of the lips from speaking and from music and lifts that play to eternity, replacing the assonance of the sibilants ("speak," "Silence," "solemn") with that of the liquid ("let," "lest," "life," "lips"), but loses, in a sense, the stillness, which had been found in the naked state itself, of figures as of poetry – *la poésie à l'état nu* (poetry in the naked state). Such a stark ceremony of nakedness seen as poetry at the very moment of the arrest of action and of music must have been unbearable for the Pre-Raphaelite imagination; this specific problem posed by the painting was seen first in its own naked state, only to cover itself up after the moment of exposure, nay – saying.

This naked lady, according to the second version, is pictured in order not to be spoken to, as the poem is written not to *say* anything, not to *tell*, either about secrecy or about openness. In this refusal, it resembles the previously discussed Rossetti sonnet about the Mantegna painting in the Louvre. That poem seems written in order to put a stop to thought, as we would be led, in Rossetti's observations on the dance, to imagine the dance also, the pulse of sensation not in accordance with the rhythms of thought. In both pictures as poetically refigured, music seems allied to a vague, non-specific, and unfocused meditation, in a Paterian aesthetic of impression. The poems seem to envisage not speaking and not thinking as the only ways of leaving the scene "as it was" (as "Venetian Pastoral" says), and – neither poem needs to say – of celebrating being as it should be, pulsing or quiet, but not *thought*.

This meditative scene is meant here to introduce another, more problematic still.

Georges de La Tour's and René Char's "Madeleine à la veilleuse"

Madeleine à la veilleuse, par Georges de La Tour

Je voudrais aujourd'hui que l'herbe fût blanche pour fouler l'évidence de vous vois souffrir: je ne regarderais pas sous votre main si jeune la forme dure, sans crépi de la mort. Un jour discrétionnaire, d'autres pourtant moins avides que moi, retireront votre chemise de toile, occuperont

votre alcôve. Mais ils oublieront en partant de noyer la veilleuse et un peu d'huile se répandra par le poignard de la flamme sur l'impossible solution.

(Madeleine with the Vigil Lamp, by Georges de La Tour

I'd wish today that the grass were white to trample the visible proof of your suffering. I'd not look under your hand, so young, at death's hard form without rough-cast. Some day perhaps, others, though less avid than I am, will remove your homespun shirt, occupy your alcove. But they will forget, leaving, to extinguish the lamp, and a little oil will spill out by the dagger's flame onto the impossible solution.)[21]

The response of René Char to de La Tour's *Magdalen* is well-known, as familiar in the poetry of Char as his responses to the Lascaux cave-painting or to the great *Orion* of Poussin. Char's Madeleine, for he prefers the familiar form to the religious "Magdalen," is presented as a woman paradoxically both revered and desired. Baudelaire's double postulation towards heaven and hell, his celebration of the Madonna figure naked in her jewels, his architectural oppositions held simultaneously, might serve as preparation for this meditation, highly problematic in nature. A mixture of erotic desire and of respectful salute, of suggestion and of silence in a shared repentance, this Magdalen may well seem as troubling as it seems troubled. In the most solemn and vibratory voice of the poet, we hear the desire for the white page of snow to gather the traces of the red passion of suffering: the traces of this baroque blood shed in the poetic imagination mark every line of the brief poem and its own long trace in anthologizing. The poem is as red as the painting's reds in all its various forms. As for the focus, the meditative central image – the Magdalen with two candles, the Magdalen with her hand on the skull, on the Bible, on the plain rope of her penitent's sash, the Magdalen invoked and then invaded – how are we to read Char's reading in its impossible solution? Is it not also an invasion of the image, to imagine the others come to inhabit her alcove, even as this text replaces theirs? This invasion, only imagined, manages to speak volumes as Char presents it implicitly. Is involvement necessarily invasion?

How can a man, even a poet, speak of or with the meditation of a woman, even mythical, even legendary, even as she is already in our texts? Does not the very interruption of this meditation compose an invasion, exposing the flame of the small candle to, precisely, too much light? How can an intense poetic resonance restrain itself from replacing the silence of a penitent by a tone completely other?

From the pagan world of music and of the forest feast, the torment of repentance is distant. Men and women share the same universe, if not quite the same state of dress and undress. But the poet wanting to answer is no less excluded from the world of art than the reader wanting to reply, in turn, to

poet and painter. No text, poetic or critical, can keep utter silence, and it is – as we are – just as intrusive as the *indiscrets* who will invade the painting of the Magdalen, by the discreet invitation of de La Tour, as Char reads him, and by the implicit suggestions of René Char, following him.

And, to turn this question out toward the general one, how can a reading not invade the world of work and the world of meditation as they are figured before it? Even as we pose this question in front of the first reading, we must pose it also for ourselves: are we as obliged as the poet to invade the scene of representation? Shall we, men and women, be obliged to choose our domain – of work or nourishing, of music or of silence, of celebration or of repentance? Is there not some hope still for the androgynous spirit Pater and Woolf would have us combine our opposing impulses in, lending nuance to our readings of sunlight, candlelight, and shade?

We have to ask now, I think, if anything in the paintings has encouraged us *not* to think, *not* to be involved: the poem may wish to stay the hand, close the lips, and put a halt to thought, even as the painting does the contrary. Poetry may indeed be about silence, as prose may be, and allegories may indeed be uninterpretable. Speech and interpretation are not necessarily more the crux of the issue than is the truth of some specific visual referent lying behind what we see and do not see, say or do not say, understand or not. Yet our very involvement in the scene, by our own will, may be what, in the long run, counts for most, in which case we may be far from willing just to "let it be," to leave it "as it was," read always by another than ourselves. The poem may, in short, appear to call upon us not to do just what the painting seems to urge. It may well be that our meditation should concern this difference, and that our own impassioned involvement in this paradoxical and peculiar state of affairs is what most will matter.

We want, as spectators, not to interrupt, not to impose another reading or another self and yet retain that willing thought, that chosen involvement, that openly embarrassing moral passion which seems most crucial. It is this double complication, the most personally troubling of all for some among us, that most efficaciously develops what I am calling the poetics of stress. Whatever response is still to be sought. I believe that seeking should be carried out in terms of conviction, compassion, and emotion, in the art of personal criticism working itself through.

NOTES

Chapter 1 Dialogue and Stress, Arrest and Interference

1 T. J. Clark, *Image of the People: Gustave Courbet and the 1848 Revolution* (London: Thames and Hudson, 1973), p. 21.

2 Michael Baxandall, *Patterns of Intention: On the Historical Explanation of Pictures* (New Haven, Conn.: Yale University Press, 1985).

3 For the classic essay on the subject, see Walter Benjamin, "The Work of Art in the Age of Mechanical Reproduction," in *Illuminations*, ed. Hannah Arendt (New York: Shocken Books, 1969), pp. 217–51.

4 See Naomi Schor, *Reading in Detail: Aesthetics and the Feminine* (London and New York: Methuen, 1986).

5 Mikhail Bakhtin, *The Dialogic Imagination*, ed. Michael Holquist (Austin: University of Texas Press, 1981), p. 7. "The language of the novel is a system of languages," he says, "that mutually and ideologically interanimate each other" (p. 47). And, more crucially, for our purposes: "Language in the novel not only represents but itself serves as the object of representation. Novelistic discourse is always criticizing itself" (p. 49).

6 Ibid., p. 280.

7 Roland Barthes, *The Pleasure of the Text* (New York: Hill and Wang, 1973). Barthes's discussion of the *punctum* in his *Chambre claire*, of that detail that seizes and holds the gaze, obsessive and vivifying, has been widely influential in readings such as Jean-Michel Rabaté's *La Beauté amère: fragments d'esthétiques* (Paris: Editions du Champvallon, 1986), a remarkable treatise on Barthes, Rousseau, Mishima, Sade, Broch, and the contraries implicitly baroque holding in bitter and beautiful stress. *Le Texte et l'image* (Paris: Le Pavillon des Arts, Centre Pompidou, 1986), an anthology of Barthes's readings of art, includes a section from the *Chambre claire* (p. 118); the relation to the erotic, Barthes suggests, is itself necessarily and sharply punctual: "Le désir étant expulsé, le discours revient

en force: l'art devient bavard, dans le moment même ou il cesse d'être érotique" ("Once desire has been expelled, discourse returns in force: art waxes talkative, in the very instant when it ceases to be erotic"). This sharpness punctuates much contemporary reading. Rabaté claims first that Barthes has, therein, taught him to read, and perhaps to love, and then that these "points" change rapidly into "pointes", "sur lesquelles je vais pouvoir accrocher la toile du souvenir, le voile de ma vie" ("points on which I am going to be able to hang the canvas of memory, the veil of my life" – *La Beauté amère*, p. 26).

8 Hans-Georg Gadamer, *Philosophical Hermeneutics*, tr. and ed. David E. Linge (Berkeley, Calif.: University of California Press, 1976), pp. xx–xxii.

9 Francis Jacques, *Dialogiques: recherches logiques sur le dialogue* (Paris: Presses Universitaires de France, 1979), and *Dialogiques II: L'éspace logique de l'interlocution* (Paris: Presses Universitaires de France, 1985).

10 Richard Rorty, *Philosophy and the Mirror of Nature* (Princeton, NJ: Princeton University Press, 1980). I rely on his idea of conversation also in my presidential address to the Modern Language Association, 1983 (*PMLA*, May 1984).

11 Norman Bryson, *Vision and Painting: The Logic of the Gaze* (New Haven, Conn.: Yale University Press, 1983), pp. 121–2.

12 Wendy Steiner, *The Colors of Rhetoric: Problems in the Relation between Modern Literature and Painting* (Chicago: University of Chicago Press, 1982), especially the chapters on the analogy between painting and literature, and "Thoughts that fit like air."

13 Rosalind E. Krauss, *The Originality of the Avant-Garde and Other Modernist Myths* (Boston, Mass.: MIT Press, 1985); and Rosalind E. Krauss, Jane Livingstone and Dawn Ades, *L'Amour fou: Photography and Surrealism* (Washington, DC: Corcoran Gallery of Art/Abbeville Press, 1985).

14 David Silverman and Brian Torode, *The Material World* (London: Routledge, 1980).

15 Ed Cohen, "Writing Gone Wilde: Homoerotic Desire in the Closet of Representation", *PMLA* (March 1987), pp. 801–13. My thanks to Gerhard Joseph for pointing this article out to me.

16 W. J. T. Mitchell, "On Poems on Pictures: Ekphrasis and the Other", *Poetics Today* special issue, *Literature and Art*, ed. Wendy Steiner, vol. 10 (1989).

17 See also W. J. T. Mitchell, *Ideologies* (Chicago: University of Chicago Press, 1986).

18 Susan Stewart, *On Longing: Narratives of the Miniature, the Gigantic, the Souvenir, the Collection* (Baltimore, Md.: Johns Hopkins University Press, 1984), especially pp. 135 and 151–73.

19 Mikhail Bakhtin, *Estética de la creación verbal* (Bogotà Siglo Veintiuno de Colombia, 1982), pp. 75–6. My thanks to George Yúdice.

20 Fredric Jameson, *The Political Unconscious: Narrative as a Socially Symbolic Act* (Ithaca, NY: Cornell University Press, 1981), p. 10.

21 Robert Pinksy, *The Situation of Poetry: Contemporary Poetry and Its Traditions* (Princeton, NJ: Princeton University Press, 1976), p. 6.

22 William Butler Yeats, *Collected Poems* (New York: Macmillan, 1952), p. 211.

23 Neil Hertz, "Blockage in the Literature of the Sublime," in Geoffrey N. Hartman (ed.), *Psychoanalysis and the Question of the Text* (Baltimore, Md.: Johns Hopkins University Press, 1978), pp. 62–85. See also, on askesis, Geoffrey Galt Har-

pham, *The Ascetic Imperative in Culture and Criticism* (Chicago: University of Chicago Press, 1987).

24 Yves Bonnefoy, "Léda", translation of Yeats's "Leda and the Swan", in *Argile*, no. 1 (1976), p. 3.

25 In relation to my title, see also Michael Serres, *Hermes II: L'Interférence* (Paris: Editions de Minuit, 1972).

Chapter 2 Literal or Liberal: Translating Perception

1 Arthur Danto, *The Transfiguration of the Commonplace* (New York: Cambridge University Press, 1981), p. 208.

2 See Marc Shell, *Money, Language, and Thought: Literary and Philosophical Economies from the Medieval to the Modern Era* (Berkeley, Calif.: University of California Press, 1982), especially pp. 1–8.

3 "De Gustibus," *New York Times*, December 7, 1985, p. 32.

4 Lewis Hyde, *The Gift: Imagination and the Erotic Life of Property* (New York: Vintage Books, 1979), pp. 75, 57.

5 See E. L. Doctorow, "False Documents", *American Review*, vol. 26 (November 1977), pp. 215–32.

6 Roger Shattuck, *The Innocent Eye: On Modern Literature and the Arts* (New York: Farrar, Straus, Giroux, 1984), p. 287.

7 Ludgwig Wittgenstein, *Zettel*, ed. G. E. M. Anscombe and G. H. von Wright, tr. Anscombe (Berkeley, Calif.: University of California Press, 1967), pp. 76e–7e.

8 Of course, Breton says it more elegantly, with a rhetorical and interrogative flourish: "La médiocrité de notre univers ne dépend-elle pas essentiellement de notre pouvoir d'énonciation?" ("Doesn't the mediocrity of our universe basically depend upon our powers of enunciation?"). André Breton, *Point de jour* (Paris: Gallimard, 1934), p. 25.

9 Doctorow, "False Documents", p. 227.

10 Wittgenstein, *Zettel*, p. 77e.

11 Tristan Tzara, *Approximate Man and Other Writings*, ed. and tr. Mary Ann Caws (Detroit, Mich.: Wayne State University Press, 1973), p. 135.

12 See Shattuck, *The Innocent Eye*, pp. 37–8.

13 Wittgenstein, *Zettel*, p. 119e.

14 See ibid., p. 42e.

15 Ibid., p. 36e.

16 Ibid., p. 96e.

17 See Shattuck, *The Innocent Eye*, pp. 101, 297.

18 John Berger, *About Looking* (New York: Pantheon, 1980), p. 60. See also Berger's *Sense of Sight* (New York: Pantheon, 1980), along the same lines.

19 Berger, *About Looking*, p. 131.

20 Ibid., p. 133.

21 Ibid.

22 See Shattuck, *The Innocent Eye*, p. 8.

23 Berger, *About Looking*, p. 46.

24 Ibid., p. 141.

25 Ibid., p. 27.
26 Barbara Johnson, "Taking Fidelity Philosophically," in Joseph E. Graham (ed.), *Difference in Translation* (Ithaca, NY: Cornell University Press, 1985), p. 142.
27 Ibid., p. 143.
28 Ibid., pp. 146, 147.
29 Ibid., p. 147.
30 Ibid., p. 148.
31 Philip Lewis, "The Measure of Translation Effects," in Graham (ed.), *Difference in Translation*, pp. 40–1.
32 Ibid, p. 62.
33 See my *The Eye in the Text: Essays on Perception, Mannerist to Modern* (Princeton, NJ: Princeton University Press, 1981), p. 10. This passage discusses the *texturality* or knottiness of the text, which forces us to hold, resight, and reread; in *Reading Frames in Modern Fiction* (Princeton, NJ: Princeton University Press, 1985), I take up the issue, at length, of the *delay*, particularly in regard to Henry James.
34 Wittgenstein, *Zettel*, pp. 123e–4e.
35 Berger, *About Looking*, p. 35.
36 Ibid., p. 193.
37 Ibid., pp. 197–8.

Chapter 3 Representing Bodies from Mannerism to Modernism: Cloaking, Re-Membering, and the Elliptical Effect

1 Georges Bataille, *Madame Edwarda*, with *Le Mort* and *Histoire de l'oeil* (Paris: Pauvert, 1973), p. 48.
2 José-Marie de Hérédia, "Antoine et Cléopatre," *Penguin Book of French Verse* (Harmondsworth: Penguin, 1974), p. 422.
3 Georges Bataille, *Histoire de l'oeil* (Paris: Pauvert, 1967), p. 176. The reference is to *Blindness and Insight*, by Paul de Man (New Haven, Conn.: Yale University Press, 1971).
4 Michel Foucault, *Language, Counter-memory, Practice: Selected Essays and Interviews*, ed. Donald F. Bouchard (Ithaca, NY: Cornell University Press, 1977), p. 46.
5 Erwin Panofsky, "The Neoplatonic Movement in Florence," *Studies in Iconology: Humanistic Themes in the Art of Renaissance* (New York: Harper and Row, Icon Editions, 1972), especially pp. 151–60.
6 André Breton, "Free Union," *Selected Poems of André Breton*, tr. Jean-Pierre Cauvin and Mary Ann Caws (Austin: University of Texas Press, 1982), pp. 48–9. In French the poem begins, "Ma femme à la chevelure de feu de bois," which can be translated as "My wife with . . " or 'My woman with . . ," and so on. See also Albert Sonnenfeld, "Eros Desnos," in *Dada/Surrealism*, no. 12 (1983), on the use of single parts of the eroticization of surrealism; and my *Eye in the Text: Essays on Perception, Mannerist to Modern* (Princeton, NJ: Princeton University Press, 1981).
7 See Johann Winckelmann, *History of Ancient Art* (New York: Ungar, 1968),

vol. II, p. 296. For more on fragments, see the *Fragments* issue of *New York Literary Forum* (Winter 1982).

8 Robert Desnos, "Désespoir du soleil," *Domaine public* (Paris: Nouvelle Revue Française, 1953), pp. 135–7; tr. Mary Ann Caws in *The Surrealist Voice of Robert Desnos* (Amherst: University of Massachusetts Press, 1977).

9 Jacques Dupin, "L'Onglée," *Dehors* (Paris: Gallimard, 1975), pp. 49–58.

10 Antonin Artaud, *Oeuvres complètes*, vol. I (Paris: Gallimard, 1956), pp. 138–9.

11 Dupin, *Dehors*, p. 149.

12 Ibid., p. 131.

13 Ibid., p. 71.

14 Sigmund Freud, *The Interpretation of Dreams* (New York: Avon, 1965), p. 40.

15 Ibid., p. 154.

16 Jacques Derrida, *La Vérité en peinture* (Paris: Flammarion, 1978), pp. 279ff.

17 René Char, *Le Marteau sans maître* (Paris: Corti, 1970), p. 44.

18 Hélène Cixous, *Le Troisième corps* (Paris: Grasset, 1970), pp. 39–40.

19 Georg Simmel, "Der Henkel," *Philosophische Kultur: Gesammelte Schriften* (Leipzig: Alfred Kramer, 1919), pp. 116–24.

20 Michel Leiris, *Mots sans mémoire* (Paris: Gallimard, 1969), pp. 94–5.

21 Desnos, *Domaine public*, pp. 230–2.

22 Desnos, "Comme une main à l'instant de la mort," ibid., p. 103.

23 André Breton, *Nadja* (Paris: Gallimard, 1964), p. 64.

24 See note 8.

25 Dupin, "Le Lacet," *Dehors*, p. 73.

26 Quoted in Georges Bataille, "Manet," *Oeuvres complètes*, vol. xx (Paris: Gallimard, 1979), p. 141.

27 Ibid., p. 144.

28 Michel Leiris, *Le Ruban au cou d'Olympia* (Paris: Gallimard, 1982), p. 140.

29 Ibid.

30 Michel Leiris, *Aurora* (Paris: Collection L'Imaginaire, Gallimard, 1973), pp. 30–7.

31 Ibid.

32 André Breton, "Je rêve," *Clair de terre* (Paris: Poésie/Gallimard, 1966), p. 160; Louis Aragon, *Anicet ou Le panorama* (Paris: Gallimard, 1923), especially pp. 164–5; Robert Desnos, "L'Idée fixe," *Corps et biens* (Paris: Poésie/Gallimard, 1968), p. 110. All three texts are discussed in my chapter on film in *The Eye in the Text*.

33 Leiris, *Aurora*, pp. 120–1.

34 *Le Minotaure*, nos 3–4 (1933), p. 82.

35 Jules Michelet, *La Femme* (Paris: Flammarion, 1981), p. 86.

36 See, *see*, Louise Lame, naked under her leopard skin, wandering everywhere, in Robert Desnos, *La Liberté ou l'amour!* (Paris: Gallimard, 1928), *passim*.

37 See Foucault's interpretation of Velázquez's *La Meñinas* in *Les Mots et les choses: une archéologie des sciences humaines* (Paris: Gallimard, 1966).

38 Francis Barker's *The Tremulous Private Body: Essays on Subjection* (London: Methuen, 1982) turns about "a unitary *presence* of meaning of which the spectacular body is both the symbol and the instance" (p. 24).

Chapter 4 Speed-Reading, or Zipping up the Text

1 Recounted by Marinetti, speaking of speed and futurism; see also "The New Religion of Speed" (1916), in Tommaso Marinetti, *Selected Writings*, ed. R. W. Flint (New York: Farrar, Straus, Giroux, 1971), pp. 94–6.

2 In "Four Futurist Manifestos," Appendix A of Joshua C. Taylor (ed.), *Futurism* (New York: Museum of Modern Art/Doubleday, 1961), p. 125.

3 Discussed on pp. 116–31 in the catalogue for the Boccioni exhibition at the Metropolitan Museum of Art, ed. Ester Coen (New York: Abrams, 1988). One of the more remarkable pieces in this catalogue is the frontispiece, a photograph from 1906 of Boccioni standing many times around in a circle, labeled *Io–noi–Boccioni* (I–We–Boccioni), after which, plainly, the photograph of all the Marcel Duchamp(s) around a table is patterned.

 John Golding's important remarks on the way the Boccioni trilogy looks back to the trilogy of the Breton painter Charles Cottet, exhibited in 1898 at the Venice Biennale, and moved the next year to the Museo Bottancini (now the Museo Civico) in Padua, where Boccioni spent his student yeaers, show how futurism looked, in fact, back to look forward. Cottet's titles run: for the center, *Les Adieux*, on the left, *Ceux qui partent*, and on the right, *Ceux qui restent* – in short, exactly the same as Boccioni's own titles. One can only suppose the coincidence of their own states of mind.

4 Quoted in catalogue, pp. 118–20.

5 Max Kozloff, *Cubism/Futurism* (New York: Harper and Row, Icon Editions, 1973), p. 190.

6 Taylor (ed.), *Futurism*, p. 191.

7 *Tommaso Marinetti*, ed. Giovanni Lista, Poètes d'aujourd'hui (Paris: Seghers, 1976), p. 166.

8 Ibid.

9 In Mary Ann Caws, *The Surrealist Voice of Robert Desnos* (Amherst: University of Massachusetts Press, 1977), p. 162.

10 Taylor (ed.), *Futurism*, p. 124.

11 *BLAST*, nos 1–2 (repr. New York: Kraus, 1967), p. 135.

12 *Wyndham Lewis on Art*, ed. Walter Michel and C. J. Fox (London: Thames and Hudson, 1969), p. 66.

13 Ibid.

14 Ibid., p. 77.

15 *Marinetti*, p. 146. From *La Conquête des étoiles*.

16 *Wyndham Lewis on Art*, p. 72.

17 Ibid., p. 95.

18 See for example Valentine de Saint-Point, "The Manifesto of the Futurist Woman," in Giovanni Lista (ed.), *Futurisme: Manifestes, Documents, Proclamations* (Lausanne: L'Age d'Homme, 1973), pp. 329–31.

19 Tristan Tzara, *Approximate Man and Other Writings*, ed. and tr. Mary Ann Caws (Detroit, Mich.: Wayne State University Press, 1973), p. 167.

20 Ibid.

21 Francis Picabia, *Oeuvres*, Poètes d'aujourd'hui (Paris: Seghers, 1966), p. 59.

22 Ibid., p. 141.

23 *Marinetti*, p. 162.
24 Ibid., p. 163.
25 Guillaume Apollinaire, *Oeuvres*, Poètes d'aujourd'hui (Paris: Seghers, 1956), p. 149.
26 John Russell, *The Meanings of Modern Art* (New York: Harper and Row, 1974), p. 147.
27 Taylor (ed.), *Futurism*, p. 128.
28 Ibid., p. 126.

Chapter 5 Partiality and the Ready Maid, or Representation by Reduction

1 For an elaboration see my *André Breton* (New York: Twayne's World Author Series, 1975), pp. 53, 75, and *passim*.
2 Arthur Danto, *The Transfiguration of the Commonplace* (New York: Cambridge University Press, 1981). See also his "The Appreciation and Interpretation of Works of Art," in Betty Jean Cragie (ed.), *Relativism in the Arts* (Athens, Ga: University of Georgia Press, 1983), pp. 21–44.
3 Georg Simmel, "Der Henkel," *Philosophische Kultur: Gesammelte Aufsätze* (Leipzig: Alfred Kramer, 1919), pp. 116–24.
4 On the Golden Bowl and its ironic holding of its contents and our tongue, see my "Moral-Reading, or Self-Containment with a Flaw," *New Literary History* (Autumn 1983), and *Reading Frames in Modern Fiction* (Princeton, NJ: Princeton University Press, 1985).
5 Francis Haskell and Nicholas Penny, *Taste and the Antique* (New Haven, Conn.: Yale University Press, 1981), p. 313.
6 In the *Fragments* issue of the *New York Literary Forum* (Winter 1982), pp. 17–30, David Rosand's "Time the Torso-Maker" examines at length, and poetically, the *Belvedere Torso*.
7 "The navel is quite deep, especially in female figures. There are a few figures in which the execution of the part is more beautiful than on the *Venus de Medici*, in whom it is unusually deep and large." Johann Wickelmann, *History of Ancient Art* (New York: Ungar, 1968), vol. II, p. 296.
8 Danto, *The Transfiguration of the Commonplace*, p. 195.
9 Wickelmann, *History of Ancient Art*, vol. II, p. 295.
10 Ibid., p. 379, n. 6.

Chapter 6 The Meaning of Surrealism, and Why it Matters

1 André Breton, *Point du jour* (Paris: Idées/Gallimard, 1970), p. 147. Further references appear in the text, prefixed *PJ*.
2 André Breton, "Non-lieu," *Clair de terre*, in *Poèmes* (Paris: Gallimard, 1948). English translation from *Poems of André Breton*, tr. and ed. Jean-Pierre Cauvin and Mary Ann Caws (Austin: University of Texas Press, 1984).
3 André Breton, *Le Surréalisme et la peinture* (Paris: Gallimard, 1965), p. 69. See

also Breton's *Les Vases communicants* (Paris: Gallimard, 1955), tr. Mary Ann Caws as *The Communicating Vessels* (Lincoln, Neb.: University of Nebraska Press, 1989), and my discussions in *André Breton* (New York: Twayne's World Author Series, 1971) of the interconnections (pp. 59–61) and the *point sublime* (*passim*), and in *The Poetry of Dada and Surrealism* (Princeton, NJ: Princeton University Press, 1981), of the *fil conducteur*, and the communicating vessels (pp. 71ff.).

4 Breton, *Les Vases communicants*, p. 198.

5 Paul Eluard, *Capitale de la douleur* (Paris: Poésie/Gallimard, 1966), p. 49.

6 For the theatrical concept, see also such texts as "Devant le rideau" and "Rideau rideau."

7 André Breton, *L'Amour fou* (Paris: Gallimard, 1937), p. 55; tr. Mary Ann Caws as *Mad Love* (Lincoln, Neb.: University of Nebraska Press, 1987).

8 Robert Desnos, "La Mort," *La Révolution surrealiste*, no. 1 (December 1, 1924), p. 22.

9 Charles Baudelaire, "A la passante," *Les Fleurs du mal* (Paris: Editions de la Pléiade, 1975).

10 Desnos, "La Mort," p. 22.

11 Salvador Dali, *Hidden Faces* (London: Picador, 1973), p. 301.

12 Antonin Artaud, *Oeuvres complètes* (Paris: Gallimard, 1956), vol. I, p. 251.

13 In *Le Minotaure*, nos 3–4 (December 10, 1934), p. 76.

14 Ibid.

15 Dali, *Hidden Faces*, p. 137.

16 Ibid., pp. 32–3.

17 André Breton, *Les Pas perdus* (Paris: Gallimard, 1924), p. 76.

18 Dali, *Hidden Faces*, p. 17.

19 André Breton, *Nadja* (Paris: Gallimard, Livres de Poche, 1964), p. 11.

20 André Breton, *Arcane 17* (Paris: Editions du Sagittaire, 1947), pp. 43–4.

21 Breton, *Les Vases communicants*, pp. 197–8.

22 This thrust towards the future is the basic determinant of surrealist optimism, together with the concept of the conducting wire and its connections.

23 Breton, *Les Vases communicants*, pp. 169–70.

24 Breton, "On me dit," *Poèmes*, p. 179.

25 Ibid., p. 150.

26 André Breton, *Manifestes du surrealisme* (Paris: Pauvert, 1962), p. 220.

27 Ibid., p. 221.

Chapter 7 Pointing at the Surrealist Image

1 Salvador Dali, *Hidden Faces* (London: Picador, 1973), p. 301. Further references appear in the text, prefixed *HF*.

2 André Breton, *Poèmes* (Paris: Gallimard, 1952). Further references appear in the text, prefixed *P*.

3 See also Magritte's *L'Usage de la parole* (*The Use of Speech*), with its finger pointing up through the floor.

4 *Selected Poems of André Breton*, tr. and ed. Jean-Pierre Cauvin and Mary Ann Caws (Austin: University of Texas Press, 1982), pp. 64–5.

5 Rosalind E. Krauss, "Photography in the Service of Surrealism" and "Corpus Delicti," in Krauss, Jane Livingstone, and Dawn Ades, *L'Amour fou: Photography and Surrealism* (Washington, DC: Corcoran Gallery of Art/Abbeville Press, 1985), pp. 15–114.
6 René Magritte, *Les Ecrits complets* (Paris: Flammarion, 1978), p. 111.
7 Rosalind E. Krauss, *The Originality of the Avant-Garde and Other Modernist Myths* (Cambridge: Mass.: MIT Press, 1984).
8 Octavio Paz, *A Draft of Shadows* (New York: New Directions, 1979), pp. 154–5.
9 Julio Cortázar, *The End of the Game* (New York: Random House, 1967), p. 65.
10 Ibid., p. 116.
11 Ibid., p. 124.
12 Ibid., p. 130.
13 Ibid., p. 131.
14 W. S. Merwin, *The Miner's Pale Children* (New York: Atheneum, 1976), p. 5.
15 Ibid., p. 143.
16 John Ashbery, *Self-Portrait in a Convex Mirror* (New York: Penguin, 1975), p. 1.
17 Ibid., p. 5.
18 Ibid.
19 Ibid., p. 1.
20 Ibid., p. 5.
21 Ibid., p. 61.
22 Ibid.
23 Ibid., p. 14.
24 Ibid., p. 21.
25 Ibid., p. 20.

Chapter 8 Contrary Relations: Surrealism in the Books

1 *Manifestes du surréalisme* (Paris: Pauvert, 1962), p. 63.
2 André Breton, *Les Vases communicants* (Paris: Gallimard, 1955), p. 57, tr. Mary Ann Caws and Geoffrey Harris as *The Communicating Vessels* (Lincoln, Neb.: University of Nebraska Press, 1990).
3 John Russell, "Ernst's Collages; Journeys of the Imagination," *New York Times*, January 29, 1989, p. 35.
4 See Nancy Vickers on the Renaissance *blason*, in "This Heraldry in Lucrece' Face," in Susan Rubin Suleiman (ed.), *The Female Body in Western Culture: Contemporary Perspectives* (Cambridge: Mass.: Harvard University Press, 1985), pp. 209–21.
5 André Breton, *Poèmes* (Paris: Gallimard, 1948), pp. 149–50.
6 André Breton, *Nadja* (Paris: Gallimard, 1928), p. 20.

Chapter 9 Ladies Shot and Painted: Female Embodiment in Surrealist Art

1 See *La Révolution surréaliste*, no. 11 (1928).
2 As for the painter or the photographer, he can keep himself at a certain distance

from his creation or then enter it: he manipulates, that is, his stance. Michael Fried, in examining the ways in which Courbet represented himself in a painting by a woman's gesture which would seem to repeat the very gesture of painting, absorbing himself corporally within it, undoing his pose as a simple observer before the painting conceived as a spectacle, describes Courbet as putting into question "the ontological impermeability of the bottom framing-edge – its capacity to contain the representation, to keep it in its place, to establish it at a fixed distance from both picture surface and beholder" – Michael Fried, "Representing Representation: On the Central Group in Courbet's *Studio*," in Stephen Greenblatt (ed.), *Allegory and Representation* (Baltimore, Md.: Johns Hopkins University Press, 1980), pp. 100–1. Some of the techniques Courbet uses to reduce his own separation to undercut the territory of the one who would be looking from the outside, to abolish any possibility of an objective or impersonal point of view – these techniques are not neutral or neutered, but often serve, in *Les Baigneurs* (*The Bathers*), for example, through the use of a feminine body and a female gesture, to affirm the corporality of the link between the painting and the one who looks at it as the object of desire and union, corporality affirmed as natural and also cultural, as if nature were to take pleasure in her representation in art.

3 Xavière Gauthier, *Surréalisme et sexualité* (Paris: Gallimard, 1971).

4 Rosalind E. Krauss, *The Originality of the Avant-Garde and Other Modernist Myths* (Cambridge, Mass.: MIT Press, 1985), p. 106.

5 Ibid., p. 109.

6 Ibid., p. 112.

7 Ibid., p. 88.

8 Annie Le Brun, *A distance* (Paris: Jean-Jaques Pauvert, aux Editions Carrière, 1985), pp. 183, 185.

9 See above, chapter 3.

10 See above, chapter 5.

11 Linda Nochlin, "Eroticism and Female Imagery in Nineteenth Century Art," in Nochlin (ed.), *Woman as Sex Object: Studies in Erotic Art, 1730–1970* (New York: Newsweek, 1973).

12 John Berger, *Ways of Seeing* (Harmondsworth: Pelican, 1972), p. 54.

13 Ibid., p. 55.

14 René Char, "Artine" (1930), *Selected Poems*, ed. and tr. Mary Ann Caws and Jonathan Griffin (Princeton, NJ: Princeton University Press, 1976), p. 13.

15 Michael Fried, *Absorption and Theatricality: Painting and Beholder in the Age of Diderot* (Berkeley, Calif.: University of California Press, 1980), p. 96.

16 Berger, *Ways of Seeing*, p. 47.

17 Julia Kristeva, "Politics and the Polis," in W. J. T. Mitchell (ed.), *The Politics of Interpretation* (Chicago: University of Chicago Press, 1983), p. 80.

18 Norman Bryson, *Vision and Painting: The Logic of the Gaze* (New Haven, Conn.: Yale University Press, 1983), p. 93.

19 Ibid., p. 99.

20 André Breton, *Le Surréalisme et la peinture* (Paris: Gallimard, 1928), pp. 199–200.

21 Joseph Graham (ed.), *Difference in Translation* (Ithaca, NY: Cornell University Press, 1985).

22 See in particular the essay by Philip Lewis on "misusing" ("The Measure of Translation Effects"), in Graham (ed.), *Difference in Translation*, pp. 31–62. Barbara Johnson uses the term "pressure points" for the moments when an ambivalence in sense is sensed as necessary ("Taking Fidelity Philosophically," ibid., pp. 142–8).

23 Krauss, *The Originality of the Avant-Garde*, p. 109.

24 Gayatri Chakravorty Spivak, writing on the "politics of interpretation," points out the hidden marks of ideology at work, such as "excluding or appropriating a homogeneous woman," and points out the totalizing appropriations of the "masculist" critic in relation to feminist criticism and to Third World criticism. But, it is clear, "Male critics in search of a cause find in feminist criticism their best hope. ... Feminism in its academic inceptions is accessible and subject to correction by authoritative men; whereas for the bourgeois intellectual to look to join other politico-economic struggles is to toe the line between hubris and bathos" – "The Politics of Interpretation," in Mitchell, *The Politics of Interpretation*.

25 Berger, *Ways of Seeing*, p. 51.

26 Lewis Hyde, *The Gift: Imagination and the Erotic Life of Property* (New York: Vintage Books, 1979), p. 92.

27 Ibid., pp. xiv, 4.

28 Ibid., p. 77.

29 Stanley Fish, *Is There a Text in This Class? A Theory of Interpretive Communities* (Baltimore, Md.: Johns Hopkins University Press, 1983).

30 Richard Rorty, *Philosophy and the Mirror of Nature* (Princeton, NJ: Princeton University Press, 1980), p. 318.

31 Hyde, *The Gift*, p. 79.

32 Ibid., p. 108.

Chapter 10 Eye and Film: Buñuel's Act

1 Quoted in J. H. Matthews, *Surrealism and American Feature Films* (Boston, Mass.: Twayne, 1979), p. 30.

2 Inez Hedges, *Languages of Revolt: Dada and Surrealist Literature and Film* (Durham, NC: Duke University Press, 1983), p. 5.

3 *Selected Poems of André Breton*, ed. and tr. Jean-Pierre Cauvin and Mary Ann Caws (Austin: University of Texas Press, 1983), pp. 48–9.

4 De Chirico's writing on Max Klinger in *Il Convegno* (Milan), May 1921, quoted in Massimo Carrà et al., *Metaphysical Art* (New York: Praeger, 1971), pp. 133–4, leans heavily on Klinger's etchings called *Paraphrase on the Finding of a Glove*, in which the glove of a woman is found, snatched by white horses, swollen by the seas, pulled along in triumph in a shell behind marine horses, laid upon a rock, and then – once again its normal size – found upon a table in a shop, and finally snatched by a bird. But this is all a dream, and it reposes on a little table by the dreamer's bed.

5 Nancy K. Miller, "Writing (from) the Feminine: George Sand and the Novel of the Pastoral," in Carolyn G. Heilbrun and Margaret R. Higonnet (eds), *The Representation of Women in Fiction*, Selected Papers from the English Institute, 1981 (Baltimore, Md.: Johns Hopkins University Press, 1983), pp. 133–4.

6 Breton, *Selected Poems*, pp. 108–9.
7 Hedges, *Languages of Revolt*, p. 59.
8 Hans-Georg Gadamer, *Truth and Method*, tr. and ed. Garrett Barden and John Cumming (New York: Seabury Press, 1975), p. 56.
9 Luis Buñuel, *Mon dernier soupir* (Paris: Belfond, 1984), pp. 17, 22.
10 Ibid., p. 83.
11 Ibid., p. 23.
12 Ibid., p. 42.
13 Hedges, *Languages of Revolt*, pp. 41–73.
14 Ibid., p. 52.
15 Ibid., p. 119.
16 Robert Desnos, *Cinéma*, ed. and presented by Andre Tchernia (Paris: Gallimard, 1966), pp. 190–2.
17 Ibid., p. 193.
18 William Rubin, *Dada and Surrealist Art* (New York: Museum of Modern Art, 1968), p. 15.
19 Anton Ehrenzweig, *Psycho-Analysis of Artistic Vision and Hearing* (London: Routledge and Kegan Paul, 1953); Adrian Stokes, *The Invitation in Art* (London: Tavistock, 1965).
20 Adrian Stokes, "Form in Art," in *New Directions in Psycho-Analysis* (London: Tavistock, 1965), pp. 406–20.
21 J. H. Matthews, "Du cinéma comme langage surréaliste," *Etudes cinématographiques*, nos 38–9 (1965): *Surréalisme et cinema*, pp. 65–82.
22 Hedges, *Languages of Revolt*, p. 72.
23 Breton, *Selected Poems*, p. 71.
24 Ibid.
25 André Breton, *Les Vases communicants* (Paris: Gallimard, 1955), p. 17.
26 Rubin, *Dada and Surrealist Art*, p. 16.
27 Breton, *Selected Poems*, p. 79.

Chapter 11 The Great Reception: Surrealism and Kandinsky's Inner Eye

1 Wassily Kandinsky, *Klange/Sounds*, tr. Elizabeth R. Napier (New Haven, Conn.: Yale University Press, 1981), p. 21. Further references appear in the text, prefixed *K*.
2 Wassily Kandinsky, *Complete Works on Art*, ed. Kenneth Lindsay and Peter Verbo (Boston, Mass.: G. K. Hall, 1982), p. 363. Further references appear in the text, prefixed *CWA*.
3 I am referring to the anecdote about Kandinsky seeing Monet's haystacks upside-down.
4 *Encyclopaedia Britannica*, 11th edn (1956), vol. XX, pp. 377–9.
5 André Breton, *Le Surréalisme et la peinture* (Paris: Gallimard, 1965), p. 4.
6 André Breton, *La Clé des champs* (Paris: Editions du Sagittaire, 1953), p. 100.
7 Ibid., pp. 111–13.
8 Vivian Endicott Barnett, "Kandinsky and Science: The Introduction of Biological

Images in the Paris Period," in *Kandinsky in Paris: 1934–1944* (exhibition catalogue) (New York: Solomon R. Guggenheim Museum, 1985), pp. 61–88. See also her *Kandinsky at the Guggenheim* (New York: Solomon R. Guggenheim Museum/Abbeville Press, 1983).

9 André Breton, *Point du jour* (Paris: Gallimard, 1934), p. 35.

10 *Selected Poems of André Breton*, ed. and tr. Jean-Pierre Cauvin and Mary Ann Caws (Austin: University of Texas Press, 1983), p. 109.

11 René Char, *Poems*, tr. Mary Ann Caws and Jonathan Griffin (Princeton, NJ: Princeton University Press, 1976), p. 23.

12 Breton, *Le Surréalisme et la peinture*, p. 286.

13 About flexibility and freedom, Breton's remarks on the Douanier are telling. In his pictures, he says, the older the person portrayed, "the gentler is the look in the portraits." *Les Pas perdus* (Paris, 1924), p. 30.

14 That exchange was to some extent modeled on innocence: Rousseau was loved for it by Apollinaire, who was able to pass on, according to Breton, his affection for "ce pauvre viel ange qu'était Henri Rousseau" (ibid., p. 40). This "poor old angel" was strong precisely in his innocence.

15 An instinctive expression which led him to dwell on the details, for example of a single tree, before those who, like Derain, cared so much about penetrating its "mystery." "Henri Rousseau was almost alone in worrying about it; although he still tended to see the leaf to the detriment of the whole" (ibid., p. 106).

16 Breton, *Le Surréalisme et la peinture*, p. 199.

17 Meyer Schapiro, *Modern Art: 19th and 20th Centuries* (New York: Braziller, 1978), p. 199.

18 Tristan Tzara, *Approximate Man and Other Writings*, ed. and tr. Mary Ann Caws (Detroit, Mich.: Wayne State University Press, 1973).

Chapter 12 Edging and Hedging, or Reading in the Concrete

1 Gregory Bateson, *Steps to an Ecology of Mind* (New York: Ballantine, 1972). This and the following quotations from Bateson are taken from pp. 132–3.

2 In Eugene Wildman, *Anthology of Concretism* (Chicago: Swallow, 1969), p. 95.

3 Ibid., p. 69.

4 In Richard Kostelanetz, *Precisely: 345, Visual Lit Crit, West Coast Poetry Review*, vol. 5 (1976), no. 3. This text and the following ones are found on pp. 138 and 139.

5 Ian Hamilton Finlay and Ron Costley, *The Wartime Garden*, catalogue to exhibition at the Serpentine Gallery, 17 September to 16 October 1977 (London: Arts Council, 1977).

6 Erwin Panofsky, "Et in Arcadia Ego: Poussin and the Elegiac Tradition," in *Meaning in the Visual Arts* (Garden City, NY: Anchor, 1955), pp. 295–320; Louis Marin, "Toward a Theory of Reading in the Visual Arts: Poussin's *The Arcadian Shepherds*, in Susan Suleiman and Inge Crosman (eds), *The Reader in the Text* (Princeton, NJ: Princeton University Press, 1980), pp. 292–304, first printed in *Etudes sémiotiques* (Paris: Editions Klincksieck, 1971).

7 Ian Hamilton Finlay with John Borg Manduca, *Homage to Poussin* (n.p.: Wild Hawthorn Press, 1977).

8 The furor over the Bastille opera house at the time of Daniel Barenboim's dismissal brought back to the British press memories of the commissioning of Finlay in 1986 to do a neoclassical garden for Versailles as a memorial to the 1789 declaration of the rights of man. His contract to do the project was then summarily canceled in March 1988 by the French Ministry of Culture, after a broadcast on the government-controlled Europe 1 in which he was accused of anti-semitism and neo-Nazism, and given no right of reply.

In the *Independent* of January 19, 1989, Patrick Marnham takes up this issue, in which, to date, there has been no explanation by the French government. I quote him on Finlay: "His work, *Osso*, which is symbolic of the destructive violence of nature, was described as 'Nazi' merely because it used the double-lightning flash of the Nazi SS. His garden in Lanarkshire was said to be divided up into war zones – which it is not – by people who have never seen it. He was said to decorate his work with swastikas, which is untrue. On this contemptible evidence he was equated with Klaus Barbie, accused of an obsession with blonde gods and accused of being 'a racist and antisemitic' artist."

9 Stephen Bann, "An Imaginary Portrait," in *Wartime Garden* catalogue.

Chapter 13 Seeing the Snag: Optical Poetry and Beyond

1 Jacques Dupin, "Moraines," *L'Embrasure* (Paris: Poésie/Gallimard, 1975), p. 139.

2 Lionel Ray, *La Métamorphose du biographe* with *La Parole possible* (Paris: Gallimard, 1971). Page references are given in the text.

Lionel Ray's signature is, wonderfully, among his oddities. For it is a newborn name, created by the manipulation of his own: "First there was Robert Lorho, then an attempt at coinciding with the other, a quest for identity, taking off from the inversion of the initials, a face turned inside out, like a glove. What a rebirth! . . . To leave the image of oneself. . .". Lionel Ray, *Nuages, nuit* (Paris: Gallimard, 1983), p. 13. At the conclusion of the volume this introduction begins, he describes his fascination as a child with toy soldiers that could be melted down to make other things, and how it endures into his adult intrigue with everything undoing itself, as it returns to its original material, provided it retains the transformative reverie: "I would like my poem to be this place of passage and of fusion . . ." (p. 122). Everywhere in his text, the reader feels the eyes pictured as staring back from the page. See the illustration that ends my *Eye in the Text: Essays on Perception, Mannerist to Modern* (Princeton, NJ: Princeton University Press, 1981).

3 Edmond Jabès, *Ça suit son cours* (Montpelier: Fata Morgana, 1975), pp. 108–9.

4 Dupin, *Dehors*, p. 100.

5 Ibid., p. 177.

6 Ibid., p. 91.

7 Lorand Gaspar, *Approche de la parole* (Paris: Gallimard, 1978), p. 91.

8 Lorand Gaspar, *Egée* with *Judée* (Paris: Gallimard, 1981), p. 67.

9 Gaspar, *Approche de la parole*, p. 144.

10 Ibid., p. 145.

Chapter 14 A Double Reading by Design: Brueghel, Auden, and Williams

1 Virginia Woolf, "Walter Sickert," *Essays* (New York: Harcourt Brace, 1950), pp. 197–8.
2 Mary Ann Caws, *The Eye in the Text: Essays in Perception, Mannerist to Modern* (Princeton, NJ: Princeton University Press, 1981).
3 Henry James, in his preface to *The Golden Bowl* (Harmondsworth: Penguin, 1966), p. 17, makes an interesting case for re-viewing as rereading.
4 William Carlos Williams, *Pictures from Brueghel* (New York: New Directions, 1962), pp. 2, 3, 11, 40 for these poems. See Wendy Steiner's discussion of these poems in her *Colors of Rhetoric* (Chicago: University of Chicago Press, 1982).
5 See, for example, J. J. Gibson, *Perception of the Visual World* (Boston, Mass.: Houghton Mifflin, 1950), discussed at length in my *Reading Frames in Modern Fiction* (Princeton, NJ: Princeton University Press, 1985), pp. 9–29 (ch. 2: "Perceiving Borders").
6 We see how unicorns come to be, on the other hand, because they are, in Rilke's *Sonnets to Orpheus*, and in his prose poem on the tapestry, in *The Notebooks of Malte Laurids Brigge*, both in Stephen Mitchell's superb renderings of Rilke: *Selected Poetry of Rainer Maria Rilke* (New York: Vintage, 1984).
7 W. H. Auden, *Collected Poems* (New York: Random House, 1945), p. 3.

Chapter 15 Interferences, or Reading Between: Whistler, Claudel, Bonnefoy, and Char

1 Yves Bonnefoy, *Le Nuage rouge* (Paris: Mercure de France, 1977), p. 319.
2 Paul Claudel, *Traité de la co-naissance au monde et de soi-même*, in *Art poétique* (Paris: Mercure de France, 1913), p. 32.
3 Ibid., p. 114.
4 Ibid., p. 116.
5 Paul Valery, *Pièces sur l'art* (Paris: Gallimard, 1934), p. 156.
6 Ibid., p. 143.
7 Ibid.
8 James Abbott McNeill Whistler, *The Gentle Art of Making Enemies* (New York: Dover, 1967), pp. 3, 113, 313, 312.
9 Ibid., p. 312.
10 Yves Bonnefoy, *Trois remarques sur la couleur* (Paris: Thierry Bouchard, 1978), pp. 11–16.
11 Yves Bonnefoy, *Tout l'œuvre peint de Mantegna* (Paris: Flammarion, 1978), p. 5.
12 Jacques Dupin, "Malévitch," *Dehors* (Paris: Gallimard, 1975), p. 149.
13 Ibid., p. 151.
14 Marcel Proust, *A la recherche du temps perdu* (Paris: Gallimard, Editions de la Pléiade, 1956), vol. III, p. 889.
15 Yves Bonnefoy, "L'Humour les ombres portées," *L'Improbable* (Paris: Mercure de France, 1980), p. 191.

16 Ibid., p. 192.

17 René Char, *Poems*, ed. and tr. Mary Ann Caws and Jonathan Griffin (Princeton, NJ: Princeton University Press, 1966), p. 111.

18 Yves Bonnefoy, *Poèmes* (Paris: Mercure de France, 1980), p. 205.

Chapter 16 Collecting and Containing: Joseph Cornell and Mallarmé

1 Diane Waldman, *Joseph Cornell* (New York: Braziller, 1977), p. 19.

2 Quoted in the catalogue to the exhibition *Aspects of the City* (New York: Metropolitan Museum of Art, 1984).

3 See Emily Dickinson, *Selected Poems and Letters*, ed. Robert N. Linscott (Garden City, NY: Doubleday, 1959).

4 Information in Lynda Roscoe Hartigan, "Joseph Cornell: A Biography," in Kynaston McShine, *Joseph Cornell* (New York: Museum of Modern Art, 1980), pp. 91–120. Other essays in this volume are by Dawn Ades ("The Transcendental Surrealism of Joseph Cornell," pp. 15–42); Carter Ratcliff ("Joseph Cornell: Mechanic of the Ineffable," pp. 43–68); and P. Adams Sitney ("The Cinematic Gaze of Joseph Cornell," pp. 69–90).

5 Dore Ashton, *A Joseph Cornell Album* (New York: Viking, 1974), p. 20. Ashton's essay is at the origin of my comparison with Dickinson, and the source of my quotation of Mallarmé's reflection on the margin.

6 Ibid., p. 43.

7 Ibid., p. 61.

8 *The Joseph Cornell Portfolio Album* (New York: Leo Castelli Gallery, 1976), published in conjunction with an exhibition of Cornell's work, contains the Motherwell letter, reminiscences of Cornell by Allegra Kent, a comment on his films by Jonas Mekas, and has its own *containing* quality.

9 Susan Stewart, *On Longing: Narratives of the Miniature, the Gigantic, the Souvenir, the Collection* (Baltimore, Md.: Johns Hopkins University Press, 1984), pp. 151–3. See also her poem "Joseph Cornell, 1967," in *The Hive* (Athens, Ga.: University of Georgia Press, 1987), pp. 58–60.

10 Eugenio Donato, "The Museum's Furnace: Notes towards a Contextual Reading of Bouvard and Pecuchet," in Josue Harari, *Textual Strategies: Perspectives in Post-Structuralist Criticism* (Ithaca, NY: Cornell University Press, 1979), pp. 213–38. Quoted in Stewart, *On Longing*, p. 162.

11 Stewart, *On Longing*, p. 158.

12 This sketch featured in a Whistler exhibition at the Isabella Stewart Gardner Museum in Boston, Mass., 1985.

13 Marsden Hartley, *Adventures in the Arts* (New York: Boni and Liveright, 1921; repr. New York: Hacker, 1972), p. 1.

14 Ibid., p. 6.

15 Ibid., p. 7.

16 Ibid., p. 201.

17 Ibid., p. 203.

18 Ibid., p. 6.

19 In the Joseph Cornell Papers, Archives of American Art, Smithsonian Institution. Gift of Elizabeth Cornell Benton.

20 Dickinson, *Selected Poems and Letters*, p. 25.

21 Quoted in Ades, "The Transcendental Realism of Joseph Cornell," p. 38.

22 Ibid., p. 31.

23 Ibid., p. 33.

24 Ibid.

25 Cornell Papers, journal entry for October 14, 1950.

26 Quoted in Ades, "The Transcendental Realism of Joseph Cornell," p. 39.

27 The term "maestro of absence" comes from Carter Ratcliff ("Joseph Cornell: Mechanic of the Ineffable," p. 43).

28 Stephane Mallarmé, *Igitur, Divagations* (Paris: Poésie/Gallimard, 1976).

29 Ibid., p. 181.

30 Ibid., p. 195.

31 Ibid., p. 199.

32 *Rose Hobart* is tinted blue. It is Stan Brakhage's film *Wonder Ring* which Cornell runs and edits backwards; Cornell's version is sometimes called *GniR RednoW*. Cornell originally commissioned the film to celebrate the Third Avenue El in New York before its destruction. In his re-editing, he added more people, flipped the film from left to right and projected it upside-down and backwards, adding at the end the title "The end is the beginning," to be read right side up. Information in Sitney, "The Cinematic Gaze of Joseph Cornell," especially p. 80.

The reference to the scenario half in black and white and half in color is based on the published version of Cornell's scenario *Monsieur Phot*, in Julien Levy, *Surrealism* (New York: Black Sun Press, 1936), pp. 77–88. *Monsieur Phot*, about a photographer, has color passages, signaled every time by a pheasant flying across the lens and associated with the verses of Reynaldo Hahn "si mes vers avaient des ailes" ("If only my verses had wings"): the wings of association here take us back to the birds flown from Cornell's boxes and to the whole network of light between poetry, dance and the swan as sign (*cygne* reread as *signe*).

33 I am thinking of his work for *View*, and of his prose poem for Hedy Lamarr, "Enchanted Wanderer."

34 "Suddenly the sense of completeness, poetry" (see note 25).

Chapter 17 Representation as Recall, or the Vectors of Reading: Tintoretto, Stevens, and Arakawa/Gins

1 A remark made in conversation.

2 Arakawa and Madeline H. Gins, *The Mechanism of Meaning: Work in Progress* (1963–71) (New York: Harry Abrams, 1979; new edn 1988). *Le Mécanisme du sens: Work in Progress* (1963–1971, 1978), *The Mechanism of Meaning No. 3* (New York: Abbeyville Press, 1988); *Basé sur la méthode d'Arakawa* (Paris: Maeght, 1979); Arakawa, *For Example (a Critique of Never)* (Milan: L'Uomo e l'Arte, 1974).

3 These techniques are illustrated, partially, in the Tintoretto–Susanna exercise I refer to, and to which the cover of this book refers.

4 Which has played a multiple role in my *Eye in the Text: Essays on Perception,*

Mannerist to Modern (Princeton, NJ: Princeton University Press, 1981), pp. 8, 54, 67, 77.

5 Ibid., the chapter called "Look and Gesture," especially pp. 53–60.

6 Wallace Stevens, *The Palm at the End of the Mind*, ed. Holly Stevens (New York: Vintage Books, 1972), pp. 8–10. On the feminine part of the imagining of Wallace Stevens, Frank Lentricchia's long imagining in his *Ariel and the Police* (Madison: University of Wisconsin Press, 1988) is at once thoughtful and helpful ("Writing after Hours," pp. 136–244).

7 Erving Goffman, *Frame Analysis* (New York: Harper, 1974). I have played my own frame games in *Reading Frames in Modern Fiction* (Princeton, NJ: Princeton University Press, 1985).

8 Henry Green, *Party-Going* (New York: Greenwood Press, 1974).

9 Arakawa and Gins, *Le Mécanisme du sens*, p. 10.

10 Arakawa, "Properties of Blank," *Derrière le miroir* (Paris: Maeght, 1982).

11 Arthur Danto, "*The Mechanism of Meaning: Work in Progress*," *Print Collectors' Newsletter*, vol. X, no. 4 (September–October 1979), p. 87.

12 In conversation with the author, 1984.

13 Madeline Gins, *World-Rain (or a Discursive Introduction to the Intimate Philosophical Investigations of G, R, E, T, A, G, A, R, B, O, It Says)* (New York: Grossman, 1969), n.p.

14 Madeline Gins, "Arakawa's Intention (to Point, to Pinpoint, to Model)," *Arakawa* (Düsseldorf: Städtische Kunsthalle Dusseldorf, 1977), p. 9. See also Arakawa, "Some Words", the introduction to *Arakawa*.

15 Danto, "*The Mechanism of Meaning*," pp. 88–9.

16 Arakawa, "Some Words," p. 37.

17 Ibid.

18 For directions (partial, of course), see also Jean-François Lyotard, "Longitude 180 W or E," tr. Mary Ann Caws, preface to Arakawa exhibition catalogue (Milan: Padiglione d'Arte Contemporanea, 1984).

19 On Wittgenstein, Bachelard, Thomas Kuhn, and Arakawa, see Armin Zweite, "Arakawa: Versuch einer Annäherung," in *Arakawa: Bilder und Zeichnungen, 1962–1981* (Munich: Städtische Galerie im Lenbachhaus, 1981), pp. 8–51.

20 As for the room, it is textured: "HOW ANONYMOUS IS THIS DISTANCE WHICH IS A TEXTURE" (text for *Point Blank*).

21 Arakawa and Madeline Gins, *Pour ne pas mourir/To Not To Die*, French tr. by François Rosso (Paris: Editions de la Différence, 1987), p. 8.

22 Ibid., p. 6.

23 Ibid., p. 8.

24 Ibid., p. 64.

25 Ibid., p. 84.

26 Ibid., p. 116.

27 See also Madeline H. Gins, *Helen Keller or Arakawa* (New York: Abbeville Press, 1990).

Chapter 18 Architecture and Conversation: Derrida, Bernard Tschumi, and Peter Eisenman

1 Yves Bonnefoy, *Ce qui fut sans lumière* (Paris: Mercure de France, 1987), p. 22; John Ruskin, *The Lamp of Beauty: Ruskin's Writings on Art*, ed. Joan Evans (Ithaca, NY: Cornell University Press, 1980), p. 278. Ruskin's definition of architecture is enough to dwell in: "Architecture is the art which so disposes and adorns the edifices raised by man, for whatsoever uses, that the sight of them may contribute to his mental health, power, and pleasure." *The Art Criticism of John Ruskin*, ed. Robert L. Herbert (New York: Da Capo, 1964).

2 Louis Aragon, *Anicet, ou Le Panorama* (Paris: Gallimard, 1920), p. 48.

3 Louis Aragon, *Le Paysan de Paris* (Paris: Gallimard, 1926), pp. 23 5.

4 Bonnefoy, *Ce qui fut sans lumière*, p. 16.

5 Jacques Derrida, *La Verité en peinture*, tr. Geoff Bennington as *Truth in Painting* (Chicago: University of Chicago Press, 1987).

6 See Paul de Man, *Allegories of Reading* (New Haven, Conn.: Yale University Press, 1977); and Marc Shell, *Money, Language, and Thought: Literary and Philosophical Economies from the Medieval to the Modern Era* (Berkeley, Calif.: University of California Press, 1982).

7 Edmond Jabès, *Le Livre du partage* (Paris: Gallimard, 1987), p. 27.

8 Richard Rorty, *Philosophy and the Mirror of Nature* (Princeton, NJ: Princeton University Press, 1980).

9 René Char, "Robustes météores," *Le Marteau sans maître* (Paris: Corti, 1933).

10 Richard Rorty, the Clark Lectures, Cambridge University, 1987 (three lectures on irony by Richard Rorty).

11 Lewis Hyde, *The Gift: Imagination and the Erotic Life of Property* (New York: Random House, 1983). I have used his most useful ideas in my study (chapter 9 above) of a possible female view of the photographs and paintings of females undertaken by surrealists.

12 Jacques Derrida, "Point de folie: maintenant l'architecture," *Annals of the Architectural Association School of Architecture*, no. 12 (Summer 1986).

13 Of course, to take something into the mind is at once to appropriate it and to be interfered with by, as to interfere with, it. Our prejudices are necessary, says Gadamer: "The knower's boundness to his present horizons and temporal gulf separating him from his object" is the ground of all understanding, the enabling condition for the directedness of our ability to experience. And, to some extent, the moral function of art depends upon this relation to our subjective presentness: for Gadamer, the work of art is the "absolute present for each particular present," and holds simultaneously the future in readiness. It says "This art thou" but also "Thou must alter thy life." Hans-Georg Gadamer, *Philosophical Hermeneutics*, tr. and ed. David G. Linge (Berkeley, Calif.: University of California Press, 1976), pp. xiv and 104. I am reminded of Ruskin's saying, if someone commented on having taken pleasure in reading something of his, "Yes, but what did it teach you?"

14 Roger Scruton, in "Alberti and the Art of the Appropriate", *Politics of Culture and Other Essays* (Manchester: Carcanet, 1981), examines *proportio* in the terms I have stated here.

15 In chapter 19 I discuss the idea of personal criticism in the light of Ruskin's "moral passion." We could find worse things to build upon.

16 John Ruskin, "The Use of Imagination in Modern Architectural Design," quoted in the 1986–7 prospectus of the Architectural Association School of Architecture (London, 1986), p. 2.

17 Derrida, "Point de folie," p. 65. Bernard Tschumi's presentation of the project at the Architectural Association in London, March 17, 1987, continued this conversation: it was entitled "Open."

18 Ibid., p. 69.

19 Ibid., p. 67.

20 Francis Baker's study of Foucault, the text, and the body, *The Tremulous Private Body: Essays on Subjection* (London: Methuen, 1985), traces the body of the world and of the text as places of the inscription of meaning not always visible, because covered over by social structures and strictures: "a vital, full materiality ... already touched by the metaphysics of its later erasure ... This spectacular visible body is the proper gauge of what the Bourgeoisie has had to forget" (p. 25). Society he calls "the associative name we give to lived isolation."

21 Derrida, "Point de folie," p. 70.

22 See Mary Douglas, in "The Individualist Environment," in Mary Douglas and Baron Isherwood, *The World of Goods: Towards an Anthropology of Consumption* (London: Allen Lane, 1979), pp. 38–43.

23 Derrida, "Point de folie," p. 70.

24 Walter Pater, *An Imaginative Sense of Fact*, ed. Phillip Dodd (London: Cass, 1981).

25 Jacques Derrida, *Psyché: ou inventions de l'autre* (Paris: Editions Galilée, 1987), p. 480.

26 Ibid., p. 488.

27 Anthony Vidler, "Follies," in *Architecture for the Late Twentieth-Century Landscape* (exhibition by Leo Castelli and James Corcoran in Los Angeles) (New York: Rizzoli, 1983), pp. 10–13.

28 Profile with Bernard Tschumi, *Columbia Magazine*, October 1988, p. 48.

29 Paul Valéry, "Les Grenades" (from *Charmes*), *Poésies* (Paris: Poésies, Gallimard, 1959), p. 97.

30 André Breton, *Mad Love*, tr. Mary Ann Caws (Lincoln, Neb.: University of Nebraska Press, 1987).

31 Derrida, *Psyché*, p. 502.

32 Ibid., p. 507.

Chapter 19 Moral Passion and the Poetics of Stress

1 John Hollander, *Spectral Emanations: New and Selected Poems* (New York: Atheneum, 1978), pp. 187–8.

2 The definitions of "ekphrasis" I follow here are three. First, and most obviously, *ekphrasis* is the Greek word for "description," and as a rhetorical device is defined by Richard Lanham in *A Handlist of Rhetorical Terms* (Berkeley, Calif.: University of California Press, 1969), p. 39, as "a self-contained description, often on a commonplace subject, which can be inserted at a fitting place in a discourse."

Second, ekphrasis is a type of inscription and commentary on works of art. See Emilie Bergmann, *Art Inscribed: Essays on Ekphrasis in Spanish Golden Age Poetry* (Cambridge, Mass.: Harvard Romance Languages Department, 1979). This tradition, discussed at length by Jean Hagstrum in *The Sister Arts* (Chicago: University of Chicago Press, 1988), pictures the poet contemplating a real or imaginary work of art and giving voice to its otherwise mute presence, causing it to endure, doubly.

A third definition, connected yet more problematic, is the one I wish to dwell on here. This is the tradition, discussed by Wendy Steiner among others, of the stopped moment, wherein the past and future are held in stasis. In *The Colors of Rhetoric* (Chicago: Chicago University Press, 1982), Steiner says, "The literary topos of the still moment is an admission of failure, or of mere figurative success" (p. 42); thus the attempts by poets to forestall the closure of their poems, trying to let the reader "experience the illusion of the poem as a single perpetual now" (p. 47).

Lanham points out the associations of ekphrasis with *energeia* or activity and "vigor of style": it catches a vivid moment. Martin Meisel's *Realizations* (Princeton, NJ: Princeton University Press, 1983) contains a highly intelligent discussion of the arguments of Lessing on the "most fruitful moment" after Shaftesbury's doctrine of "Anticipation and Repeal in the presentation of an action," as it announces and yet leaves traces: "notwithstanding the Ascendancy or Reign of the principal and immediate passion, the artist has power to leave still in his subject the Traces or Footsteps of its Predecessor." The problem concerns how the mind reorients itself, and how that is represented: see, in particular, Meisel's chapters "The Moment's Story" (pp. 18–28), and "Pre-Raphaelite Drama" – the section entitled "Holman Hunt and the Moment of Truth" (pp. 359–72). The discussion in this section turns around Holman Hunt, Augustus Egg, and Millais, and the notions of the internalization of kinesis, the compression of the story "into a counterpoised situation" (p. 359), and the "refinement of the pictorial moment into an essential and instantaneous peripetcia" or moment of change.

In relation to the Pre-Raphaelites, see also Richard Stein's quite detailed analysis, in *The Ritual of Interpretation: The Fine Arts as Literature in Ruskin, Rossetti and Pater* (Cambridge, Mass.: Harvard University Press, 1975), of some of the works discussed in this essay, including Turner's *The Slave Ship* as Ruskin looks at it, Titian's *Fête champêtre* as Rossetti looks at it in the second version of his sonnet (I discuss here principally the first version, appearing in *The Germ*), and Leonardo's *Mona Lisa* as Walter Pater looks at it.

3 In *The Order of Mimesis* (Cambridge: Cambridge University Press, 1986), Christopher Prendergast makes a clear and convincing ordering of problematic mimetic forms and discussions, particularly in the opening chapter, "The Economy of Mimesis" (pp. 24–83). See also Jacques Derrida et al., *Mimesis: Désarticulations* (Paris: Aubier/Flammarion, 1975).

4 Esther Singleton (ed.), *Famous Sculpture Described by Great Writers* (New York: Dodd Mead, 1910), p. 16.

5 Ibid., p. 47.

6 Homer, *The Iliad*, tr. Robert Fitzgerald (Oxford: Oxford University Press, 1984).

7 Virgil, *The Aeneid*, tr. Allen Mandelbaum (New York: Bantam, 1971).

8 Dante, *The Divine Comedy: Purgatorio, a Verse Translation*, tr. Allen Mandelbaum (Berkeley, Calif.: University of California Press, 1980), p. 84.

9 Geoffrey Chaucer, *Poetical Works of Geoffrey Chaucer*, facsimile of Cambridge University Library MSS, ed. H. B. Parkes and Richard Beadles (Cambridge: Brewer, 1979–80).

10 Saint-Amant, *Les Oeuvres* (1629), ed. Jacques Bailbé (Paris: Didier, 1971), p. 218.

11 Henry James, *The Awkward Age* (Harmondsworth: Penguin, 1978), p. 36.

12 Henry James, *The Ambassadors* (Harmondsworth: Penguin, 1973), pp. 142–6. Mariana Torgovnick, in her study of James, Woolf, and Lawrence, *The Visual Arts, Pictorialism, and the Novel* (Princeton, NJ: Princeton University Press, 1985), discusses the vagueness in Strether's perceptions: he doesn't want to know the name of the river; the one painting "he would have bought" is just the one he "could not afford"; and so on. But his consciousness is forced to work: "When the frame of the Lambinet ceases to expand, Strether's consciousness must itself grow to encompass less tidy views of experience than it has hitherto allowed" (pp. 182–3).

 She also points out, and it is of particular interest for my discussion here, that implicit to the use that James and Strether make of visual references is "a view of art" closely parallel to that of Keats's "Ode on a Grecian Urn": "the view that art is static and knowable and safe, while life is dynamic, and therefore, dangerous" (p. 182).

13 Henry James, *The Wings of the Dove* (Harmondsworth: Penguin, 1964), pp. 156–9.

14 Henry James, *The Golden Bowl* (Harmondsworth: Penguin, 1966), p. 541.

15 Robert Browning, translation of Gian Battista Felice Zappi's sonnet, *Sopra la Statua de Mose*, dealing with this *Moses* (*Cornhill Magazine*, XXXVII, 1914). The statue of Moses is in San Pietro in Vincoli, Rome. I am grateful to my colleague Patrick Cullen for this information.

16 The starting point for this discussion is Sarah Kofman's analysis of Freud's "Moses of Michelangelo" and *Moses and Monotheism: L'Enfance de l'art: une interprétation de l'esthétique freudienne* (Paris: Galilée, 1985), pp. 61 and *passim*. Cf. also Jack J. Spector, *The Aesthetics of Freud: A Study in Psychoanalysis and Art* (New York: McGraw-Hill, 1974); Malcolm Bowie's masterful *Freud, Proust, and Lacan: Theory as Fiction* (Cambridge: Cambridge University Press, 1987); and Jane Gallop's *Thinking through the Body* (New York: Columbia University Press, 1988), on Freud's delight in the *non-mastery* of the image ("The Seduction of an Analogy," in the chapter called "The Anal Body," pp. 21–39).

17 Samuel Monk, *The Sublime: A Study of Critical Theories in XVIII Century England* (Ann Arbor: University of Michigan Press, 1960).

18 In *Letters of Percy Bysshe Shelley*, ed. Frederick L. Jones (Oxford: Clarendon Press, 1964), vol. II, pp. 80–1 (no. 16).

19 Ibid., p. 223 (no. 510). See also Frederic S. Colwell, "Shelley and Italian Painting," *Keats–Shelley Journal*, no. 29 (1980), pp. 43–66, where Shelley is quoted as railing against the "heavy-built dreams, neither natural nor supernatural, of Michael Angelo," and where the public debate on the supremacy of the two painters is discussed. My thanks to Professor Marilyn Butler of Cambridge for pointing out this article and the Shelley passages to me.

20 John Ruskin, *The Relation between Michael Angelo and Tintoret* (London: Smith, Elder, 1872).

21 Ibid., pp. 5–6.

22 Ibid., p. 18.

23 Ibid., p. 32. Irresistible, even if it is not about *Moses*, but about the artist's incompetence at drawing: "you will perhaps be surprised to find how many of Michael Angelo's figures, intended to be sublime, have their heads bandaged." Side-splitting.

24 Sigmund Freud, *The Complete Psychological Works of Sigmund Freud*, Standard Edition, ed. and tr. James Strachey (London: Hogarth Press, 1953–74), vol. XIII: 1913–14, pp. 211–30. Published in *Imago*, vol. 3, no. 1 (1914), pp. 552–3 ("Nachtrag zur Arbeit über den Moses des Michelangelo"). The anonymity was lifted in 1924.

25 Freud, *Complete Works*, vol. XIII, p. 213.

26 Ibid., pp. 216–20. It is perhaps not surprising that David Bleich should use Freud's relation to the Moses figure Michelangelo so powerfully wrought as an example in and of his *Subjective Criticism* (Baltimore, Md.: Johns Hopkins University Press, 1978). For Freud, as he puts it, "resymbolizes his response" by his three-stage reaction: first, his "obsequious creeping" into its presence and the humiliation he consequently and constantly felt; next, his interpretation of the hero's clutching his beard at the mob's betrayal, as an anger turned against the self; and, last, the hero's assertion of his own leadership, having subdued his anger within his giant frame (p. 93).

27 Paul Roazen, *Freud and His Followers* (New York: Knopf, 1971; Harmondsworth: Peregrine, 1979).

28 Freud, *Complete Works*, vol. XIII, p. 221. Jung, taller and larger than Freud, had dominated the Freud family table, Freud's son recounts, and the relation had been impossible to break without traumatic results – to which this document of suffering and effort at control bears witness. Roazen contemplates various similarities between Moses and Freud: for instance, Moses had a stammer and Freud, with his cancer-stricken throat, had difficulty in talking (*Freud and His Followers*, pp. 293ff.).

29 Freud, *Complete Works*, vol. XIII, p. 222.

30 Ibid., p. 234.

31 Ibid.

32 I am thinking of the work of Joel Fineman on the anecdote and its importance in rewriting of historiography (lecture at the Graduate School, City University of New York, February 19, 1988).

33 Naomi Schor, *Reading in Detail: Aesthetics and the Feminine* (London and New York: Methuen, 1987), pp. 6, 14.

34 Jean-Michel Rabaté, *La Beauté amère: fragments d'esthétiques* (Paris: Editions du Champvallon, 1986), especially pp. 16–20.

35 Ibid., p. 21.

36 Ibid.

37 Bowie, *Freud, Proust, and Lacan*, p. 16.

38 Freud, *Complete Works*, vol. XXIII, p. 31.

39 Bowie, *Freud, Proust, and Lacan*, p. 16.

40 Ibid.

41 Roazen also stresses this (*Freud and His Followers*, pp. 301ff.). See Spector, *Aesthetics of Freud*, for the threesome of Freud, Moses, and Michelangelo; also Gallop, *Thinking through the Body*, pp. 135–48.

42 Kofman, *L'Enfance de l'art*, p. 190.

43 Ibid., pp. 31.

44 Michel de Certeau, *Writing Historiography* (New York: Columbia University Press, 1988).

45 Freud to Zweig, June 13, 1935: *Letters of Sigmund Freud and Arnold Zweig*, ed. Ernst L. Freud (New York: New York University Press, 1987), p. 107.

46 Walter Benjamin, *Mythe et violence* (Paris: Denoël, 1971), p. 71.

47 Jacques Lacan, "L'Ethique de la psychanalyse," lecture of March 16, 1960, cited in de Certeau, *Writing Historiography*, ch. 9, n. 65.

48 See "this great moral change in the temper from passionate to mechanical": John Ruskin, *The Lamp of Beauty: Ruskin's Writings on Art*, ed. Joan Evans (Ithaca, NY: Cornell University Press, 1980), p. 274.

49 Ibid., p. 48.

50 Ibid.

51 Ibid., p. 34.

52 John Ruskin, *Modern Painters*, 7th edn, vol. I (London: Smith, Elder, 1867), p. 378; *The Lamp of Beauty*, ed. Evans, p. 30.

53 Ruskin, *The Lamp of Beauty*, p. 48.

54 Ibid., pp. 44–5.

55 Ibid., p. 45.

56 Michel Foucault, *Language, Counter-Memory, Practice*, ed. Donald F. Bouchard (Ithaca, NY: Cornell University Press, 1972), p. 50. See also pp. 30–1.

57 Harold Bloom, *The Ringers in the Tower: Studies in Romantic Tradition* (Chicago: University of Chicago Press, 1971).

58 Barbara Johnson, "The Frame of Reference: Poe, Lacan, Derrida," *Literature and Psychoanalysis, the Question of Reading: Otherwise, Yale French Studies*, nos 55–6 (1977), especially pp. 478–93.
 John Berger's *Ways of Seeing* (Harmondsworth: Pelican, 1972) deals briefly with the problematics of female self-seeing. A woman's whole presence, he says, "expresses her own attitude to herself, and defines what can and cannot be done to her. . . To be born a woman has been to be born within an allotted and confined space, into the keeping of men . . . The surveyor of woman in herself is male: the surveyed female. Thus she turns herself into an object and most particularly an object of vision: a sight" (pp. 46–7). Thus, in the case of the two Tintoretto Susannas (p. 50), he shows us how in one of them we in fact "join the Elders to spy on Susannah taking her bath," as she looks back at us looking at her, whereas in the other – the one on which Ruskin comments, on my cover here – when she is looking at herself in the mirror, "she joins the spectators of herself."

59 My colleague Norman Kelvin points out that by this time (1849) Ruskin had rejected Renaissance painting, so his avoidance techniques have another motivation behind them. They are, Kelvin says, a comment on the "institutionalized gazing" – the authorized peeping, as I would put it – that these paintings represent. Ruskin's relation to painting was a *stronger* one than that of Rossetti, for instance, whose poems as the correspondents of the Mantegna and the Titian (formerly ascribed to Giorgione) enter into a duplicity, a non-competitive follow-

ing along with the visual works: Ruskin's prose, in its intense vigor, serves, precisely, to *raise the image* to intensity, the passion to the extreme, as in the Browning sonnet.

60 Citations in Walter Pater, *The Renaissance: Studies in Art and Poetry*, ed. Donald L. Hill (Berkeley, Calif.: University of California Press, 1980), p. 380.

61 Ibid., pp. 98–9.

62 Malcolm Bowie, in his *Freud, Proust, Lacan*, remarks on this form of statement. He refers to the work of Alan Tyson, on Leonardo. See also Kofman, *L'Enfance de l'art*, p. 184, on the way Leonardo abandoned his works as his father had abandoned him.

63 Freud, "Leonardo da Vinci and a Memory of His Childhood" (1910), *Complete Works*, vol. XI.

64 Leo Bersani, *The Freudian Body: Psychoanalysis and Art* (New York: Columbia University Press, 1986), p. 44.

65 Ibid.

66 Ibid., p. 45.

67 Ibid., p. 67.

68 Quoted in Jacqueline Rose, *Sexuality in the Field of Vision* (London: Verso, 1988), p. 124.

69 Quoted ibid., p. 125.

70 Ibid., p. 127.

71 Ibid., p. 130.

72 Quoted ibid., p. 137.

73 Ibid., p. 139.

74 Ibid.

75 Ibid., p. 140.

76 *Norton Anthology of Poetry*, ed. Alex W. Allison et al. (New York and London: Norton, 1985), p. 932.

77 Letter dated July 6, 1935; ibid.

78 Ibid., pp. 1122–3.

79 Gerhard Joseph has made the double resonance of "forging" heard, in the sense of the strength of creation and of stealing, in his "Framing Wilde," paper delivered to the Modern Language Association, December 1986, and in a previous article on double coinage: "Chaucer's Coinage: Foreign Exchange and the Puns of the *Shipman's Tale*," *Chaucer Review*, vol. 17, no. 4 (1983), pp. 341–57.

80 Dora Carrington, *Carrington: Letters and Extracts from her Diaries*, ed. David Garnett (Oxford: Oxford University Press, 1979).

81 Carolyn Heilbrun is responsible, along with Virginia Woolf, for keeping Lily Briscoe's creation in my mind and in that of countless other readers and friends, and she is also the source of the view of Mrs Ramsay as "dangerous" (paper delivered to the Modern Language Association, 1986).

82 Virginia Woolf, *To the Lighthouse* (New York: Harcourt Brace, 1927), p. 81.

83 Ibid., p. 310.

84 I reflect on the work of art in the life and the mind of some creators associated with Bloomsbury – Virginia, Vanessa, and Carrington – in my *Women of Bloomsbury* (New York: Routledge, 1990).

Chapter 20 Narrative Voice and Second Reading: Relation and Response

1 I am using the notion of "success verb" as elaborated by Gilbert Ryle in *On Thinking* (Oxford: Basil Blackwell, 1979). He sketches out his concept of "achievement verbs" such as "to win," "to see," and "to hear" in *Dilemmas* (Cambridge: Cambridge University Press, 1954), Lecture VII, pp. 108–9; and in "Sensation," *Contemporary British Philosophy*, 3rd ser., ed. H. D. Lewis (London: Allen and Unwin, 1956).

2 Harold Bloom uses the term "belated" of the after-coming poet who, in a "strong" reading of his father or antecedent poet, "belatedly" reads, redoes and undoes his predecessor. See Bloom's *The Anxiety of Influence: A Theory of Poetry* (New York: Oxford University Press, 1973) and *A Map of Misreading* (New York: Oxford University Press, 1975).

3 Judith Fetterley, *The Resisting Reader: A Feminist Approach to American Fiction* (Bloomington: Indiana University Press, 1978).

4 William Carlos Williams, "Haymaking," *Pictures from Brueghel* (New York: New Directions, 1954), p. 8.

5 Williams, "The Corn Harvest," ibid., p. 9.

6 Here I am thinking of John Barrell's brilliant study of the working world, and the world of the poor as it is represented in Constable, Morland, and Gainsborough: *The Dark Side of the Landscape* (Cambridge: Cambridge University Press, 1986). The worker is to be represented, even if in repose, near the tools of his labor, so that his position is clearly marked.

7 I would far prefer, poetically, to put "seen" for visible: "will be seen in the sky." But that presupposes the ability to see and thus predetermines the success of the looking, which cannot be presumed.

8 René Char, *Poems*, ed. and tr. Mary Ann Caws and Jonathan Griffin (Princeton, NJ: Princeton University Press, 1976), p. 39.

9 Linda Nochlin, *Courbet* (New York: Garland Press, 1976), pp. 149–50, quoting Courbet on the painting in a letter to M. and Mme Francis Wey, November 26 1849. The passage ends, "Hélas! dans cet état, c'est ainsi qu'on commence, c'est ainsi qu'on finit."

10 T. J. Clark, *Image of the People: Gustave Courbet and the Revolution* (London: Thames and Hudson, 1973), pp. 33–4.

11 Ibid., p. 80.

12 Ibid., p. 166.

13 Quoted ibid., p. 135.

14 Dante Gabriel Rossetti, "Sonnets for Pictures," *The Germ*, no. 4 (April 1850).

15 Dante Gabriel Rossetti, *The Works*, ed. William Michael Rossetti (Hildesheim and New York: G. Olms, 1972), p. 67.

16 Ibid., p. 68.

17 William Butler Yeats, *Collected Poems* (New York: Macmillan, 1952), p. 270.

18 Rossetti, "Sonnets for Pictures," *The Germ*, no. 4, p. 180. For the second version of this poem, see Rossetti, *The Works*, p. 538.

19 See for example Walter Pater's "School of Giorgione" in *The Renaissance: Studies*

in Art and Poetry, ed. Donald H. Hill (Berkeley, Calif.: University of California Press, 1980), pp. 102–22.

It may seem so obvious to us that we tend to overlook the particular importance of the Titian (still, oddly enough, attributed to Giorgione by Michel Foucault) in its interreferentiality; as Foucault says, Manet's *Déjeuner sur l'herbe*, based on it, and his *Olympia* are perhaps the first "museum" paintings in European art, they being "less a response to the achievement of Giorgione, Raphael, and Velásquez than an acknowledgement (supported by this singular and obvious connection, using this legible reference to cloak its operation) of the new and substantial relationship of painting to itself, as a manifestation of the existence of museums and the particular reality and interdependence that paintings acquire in museums." Michel Foucault, *Language, Counter-memory, Practice: Selected Essays and Interviews*, ed. Donald F. Bouchard (Ithaca, NY: Cornell University Press, 1977), p. 92.

As Elaine Scarry points out in *The Body in Pain: The Making and Unmaking of the World* (New York: Oxford University Press, 1985), in a secular context, to be "intensely embodied . . . is almost always the condition of those without power," and there is an "emphatic inequality in the representation of female and male bodies in western art. . . . men have no bodies and women have emphatic bodies" (pp. 207 and 359–60, no. 20). Thus the female model upon the grass, in both the Titian and the Manet, or by the well, posing classically, clotheless, and, as it were, naturally, is the naturalized object of the gaze, paid to draw water, to be the source and the stared-at, or to join the picnic in come-as-you-are attire.

20 In *The Ritual of Interpretation: The Fine Arts as Literature in Ruskin, Rossetti, and Pater* (Cambridge, Mass.: Harvard University Press, 1975), Richard Stein compares the commentaries of Ruskin and Pater and Rossetti on the same group of art objects. He is particularly interesting on the repetitions in Ruskin's description of Turner's *Slave Ship* and this Rossetti poem, as they work incantation-like to weave a ritualistic spell for the reader (pp. 12–30, especially p. 21).

21 Char, *Poems*, p. 93.

Index of Names and Titles

Index of Subjects